FACE
of the
GODS

For Daniel Dawson and Felipe García Villamil.

FACE
of the
GODS

Art and Altars
of Africa
and the African
Americas

Robert Farris
Thompson

The Museum for African Art, New York

Prestel, Munich

Face of the Gods: Art and Altars of Africa and the African Americas is published in
conjunction with an exhibition of the same title organized and presented by The Museum for
African Art, New York.

The exhibition is supported by grants from the National Endowment for the Humanities and
the National Endowment for the Arts.

Text editor: David Frankel
Design: Linda Florio Design
Design assistant: Nadia Coën
Publication coordinator: Karen Milbourne

Trade edition distributed by Prestel-Verlag, Mandlstrasse 26, D-8000 Munich 40, Federal
Republic of Germany, Tel. (89)38-17-09-0; Telefax (89)38-17-09-35. Distributed in
continental Europe by Prestel-Verlag, Verlegerdienst München GmbH & Co. KG,
Gutenbergstrasse 1, D-8031 Gilching, Federal Republic of Germany, Tel. (8105)2110; Telefax
(8105)5520. Distributed in the USA and Canada on behalf of Prestel-Verlag by te Neues
Publishing Company, 16 West 22nd Street, New York, NY 10021, USA, Tel. (212)627-9090;
Telefax (212)627-9511. Distributed in Japan on behalf of Prestel-Verlag by YOHAN-Western
Publications Distribution Agency, 14-9 Okubo 3-chome, Shinjuku-ku, J-Tokyo 169, Tel.
(3)208-0181; Telefax (3)209-0288. Distributed in the United Kingdom, Ireland, and all other
countries on behalf of Prestel-Verlag by Thames & Hudson Limited, 30-40 Bloomsbury Street,
London WC1B 3QP, England, Tel. (71)636-5488; Telefax (71)636-4799.

Library of Congress catalogue card no. 93-078261
Clothbound ISBN 3-7913-1281-2
Paperbound ISBN 0-945802-13-7

Front cover: Umbanda altar, Copacabana Beach, Rio de Janeiro, Brazil,
31 December 1984.
Back cover: *Ibeyi*, Cuba, nineteenth century. These twin figures' white costumes connote
the ritual purity of the religious initiate; their red sashes identify them as children of Changó.
Fernando Ortiz Collection, Casa de Africa, Havana.

Printed and bound in Japan.

Contents

Current Donors

Charles B. Benenson
Bernice & Sidney Clyman
Mr. & Mrs. Richard Faletti
Lawrence Gussman
Jane & Gerald Katcher
Drs. Marian & Daniel Malcolm
Adrian & Robert Mnuchin
Don H. Nelson
Mr. & Mrs. James Ross
Lynne & Robert Rubin
Daniel Shapiro & Agnes Gund
Cecilia & Irwin Smiley

William Brill
Lance Entwistle
Roberta Entwistle
Alain de Monbrison
Drs. Nicole & John Dintenfass
Irwin and Madeline Ginsburg
Denyse & Marc Ginzberg
Helen & Robert Kuhn
Lee Lorenz
Maureen Zarember

S. Thomas Alexander
Henry Van Ameringen
Felix Beck
Alan Brandt
Charles & Kent Davis
Gaston T. de Havenon
Lofton P. Holder
Charles Inniss
Linda Barth Janovic
Mr. & Mrs. Charles A. Jones
Helen & Martin Kimmel
Lincoln Kirstein
Helene & Philippe Leloup
Diane & Brian Leyden
Barry Lites
Carroll McEntee & McGinley Inc.
Nancy & Robert Nooter
Richard Parsons
Mrs. Harry Rubin
Edwin & Cherie Silver
Merton Simpson
Marsha & Saul Stanoff
Dan S. Sterling
Thomas Wheelock
Vaughn C. Williams
Mr. & Mrs. William Ziff

Ernst Anspach
Michael Berger, M.D.
Lynn & Samuel Berkowitz
Damon Brandt
Pam & Oliver Cobb
Frederic Cohen & Diane Feldman
Nancy & Dave DeRoche
Marc Felix
John Giltsoff
Rhoda & Gilbert Graham
Rita & John Grunwald
Jay & Clayre Haft
Udo Horstmann
Regina & Stephen Humanitzki

Oumar Keinde
Reynold C. Kerr
Stanley Lederman
Barry D. Maurer
Mrs. Kendall Mix
John Mors
Klaus G. Perls
Fred & Rita Richman
Dorothy Brill Robbins
Eric Robertson
Mr. & Mrs. Milton Rosenthal
Ana Roth & Abraham Vorster
Hans Schneckenburger
Dr. & Mrs Jerome H. Siegel
Mr. & Mrs. Morton Sosland
S. Van de Raadt & Kathy Van de Pas
Christian & Sandra Wijnberg

Arnold J. Alderman
Susan Allen
Barbara & Daniel Altman
Pierre Amrouche
Ann Anson
Sandy Baker & Siliki Fofana
Neal Ball
Walter Bareiss
Joan Barist
Mrs. Saretta Barnet
Armand & Eva Bartos, Jr.
Ralph Baxter
Stephen Benjamin
Sallie & Robert Benton
Sid & Gae Berman
Anita Birkland
Mr. & Mrs. Joseph S. Blank
Jean Borgatti & Donald Morrison
Martin & Shirley Bresler
Rev. Raymond E. Britt, Jr.
John & Barbara Buxton
James G. Caradine
Lenore Casey
Joyce Chorbajian
Carroll & Katherine Cline
Jeffrey Cohen & Nancy Seiser
Betsy & Alan Cohn
Mr. & Mrs. Herman Copen
Annette & DuVal Cravens
Marie-Eliane d'Udekem d'Acoz
Grassi Daniele
Gerald & Lila Dannenberg
Rodger Dashow
Peggy & Gordon Davis
Carl A. De Brito
Bernard De Grunne
Mary & Kurt Delbanco
Bunny & Jeff Dell
Jill Dempsey
Morton Dimondstein
Nancy B. Doan
Christine Dolan
Alan & Suzanne Dworsky
Noble & Jean Endicott
Dr. & Mrs. Aaron H. Esman
John Falcon
George & Gail Feher
Kate & Newell Flather
Donald & Serene Flax

Charles Flowers
Gordon Foster
Mr. & Mrs. Charles Frankel
Marc & Ruth Franklin
Jean Fritts
Dr. & Mrs. Murray B. Frum
Clara K. Gebauer
Walt Gebauer
Michael George
Marianne Gerschel
Mary Gibson & Harry Kavros
Mr. & Mrs. Joseph Goldenberg
Audrey & Arthur Greenberg
Linda & Irwin E. Gross
Jimmy Hancock
Joyce & Tyrone Harley
Dennis J. Henderson
Janine & Michael Heymann
Elizabeth R. Hird
Bernard & Fern Jaffe
Judith & Harmer Johnson
Lucy Black Johnson
Christiaens Joseph
Jerome L. Joss
Margaret Kaplan
Janet Karatz
Jill & Barry Kitnick
Joseph & Margaret Knopfelmacher
Leslie & Linda Koepplin
John W. Kunstadter
Alvin S. Lane
Roxanne & Guy Lanquetot
Alida & Christopher Latham
Mr. & Mrs. Seymor Lazar
Jay C. Leff
Ray L. LeFlore
Nancy Lensen-Tomasson
Guylene Lindquist
Guy Loudmer
Lester & Joanne Mantell
Heide Marie
Marian & Thomas Marill
Vivione Marshall
Sally Mayer
Lloyd & Mary McAulay
Raymond J. McGuire
John McKesson
Jane B. Meyerhoff
Marguerite Michaels
Peter & Nancy Mickelsen
Charles D. Miller III
Sam Scott Miller
Cavin-Morris, Inc.
Marshall and Caroline Mount
Werner Muensterberger
Charles J. Mus
Judith Nash
D. Nathan-Maister
Mr. & Mrs. Milford Nemer
Roy R. & Marie S. Neuberger
Teruko & Herbert Neuwalder
Peter Norton
Jack Odette
Michael Oliver
Carolyn Owerka & Alyasha
Owerka-Moore
David T. Owsley

Margaret Pancoast
Francesco Pellizzi
Professor & Mrs. John Pemberton
Paul Peralta-Ramos
Linda C. Phillips
E. Anne Pidgeon
Lesley & Jonathan Plutzik
Mr. & Mrs. Joseph Pulitzer, Jr.
Ana Ricart
Mr. & Mrs. George Rickey
Beatrice Riese
Betty J. Roemer
William Jay Roseman
Elsa & Marvin Ross-Greifinger
William & Joan Roth
Philip & Marcia Rothblum
Barbara Rubin
Mrs. Stephen Rubin
Arthur & Joan Sarnoff
Stephen K. Scher
Franyo Schindler
Eleanor & Herbert Schorr
Sydney L. Shaper
Shirley & Ralph Shapiro
Mary Jo Shepard
Kenneth & Katherine Snelson
Barbara H. Stanton
Lucille Sydnor
Howard Tanenbaum
Ellen Napiura Taubman
Farid Tawa
Mr. & Mrs. William E. Teel
Edward Thorp
Lucien van de Velde
Prof. Jan Vansina
Carolyn Carter Verleur
Anthony & Margo Viscusi
Nils von der Heyde
Dr. & Mrs. Bernard M. Wagner
Frederic & Lucille Wallace
Dr. & Mrs. Leon Wallace
Allen Wardwell
Stewart J. Warkow
Shelley Weinig
Barbara & Michael Welch
Kariamu Welsh
Monica Wengraf-Hewitt
George F. Wick
Oswald & Doris Williams
Ruth E. Wilner
Ruth M. Ziegler
Vera & Aristide Zolberg

Acknowledgments

First and foremost, many, many thanks to Susan Vogel. She commissioned this exhibition. Her courage and professionalism guided this complex project to fruition. That gratitude also includes Tom Wilson, who helped me translate academic phrasing into grant-worthy diction, Polly Nooter, and Karen Milbourne, all of the Museum for African Art.

Time and again in the making of this book, and in many different ways, colleagues kindly instructed a new pupil, meaning me. I refer especially to David Hilary Brown, who generously gave me superb photographs from his fieldwork among the *santeros* of New Jersey and New York City. Ivor Miller gave me photographs of two Lucumí altars in Cuba that are among the best ever documented. I am similarly in debt to Christopher Healey, of Paramaribo, Suriname, who years ago sent me a package containing extraordinary photographs of headstones from an old plantation cemetery in Suriname, as well as color Xeroxes of treasures of Saamaka altar statuary from the villages of Soolán and Gódo. John Nunley telephoned news to me from the Afro-Caribbean artistic front and let me leave Saint Louis with scintillating slides of a garden of pinwheels in black Illinois.

Labelle Prussin: her photographs and her scholarship and her spirit enliven and strengthen the Mande section of this book, as does the research of Bernard de Grunne. The Suriname maroon section of the same chapter was vetted by Richard Price and Ken Bilby, who enriched the phrasing immeasurably by applying the pressure of their linguistic and ethnographic expertise.

Colleagues at Yale helped in many ways. Jim Ponet, rabbi at Yale, checked the section on the altars of the Jews, and the Roman Catholic chaplain Father Baranowski kindly did likewise for his religion. John Hollander took time out from an extraordinarily busy season to find an English typographic "altar poem" for me, and to compose, as well, a cameo paragraph to accompany the illustration. I heartily thank Professor William Foltz and the Center for International Area Studies at Yale for various grants that allowed me to do fieldwork in Africa and South America in preparation for this text. Junellen Sullivan, Trish Cauley, and Kellie Jones kept the practical side of my life going whilst I lived in constant communion with the flickering spirits of a glowing word-processor. Stephen Majoros and Susan McQuade turned up the lights so that I could see to write some of this text on the ample butcher paper of their restaurant, Scoozies, in New Haven.

I read portions of the Yoruba chapter to John Mason and Roland Abiodun, both superbly versed in the lore and art of the Yoruba. Each time they responded things leapt to a higher level.

Similarly, the section devoted to the San would have been critically diminished had not J. D. Lewis-Williams generously read and critiqued the manuscript, sending slides of rock paintings along as well. Lewis-Williams also relayed word of my arrival in the Bloemfontein area, so that I was able to plunge immediately into field research in a number of important rock-art sites to the southeast of that city in the summer of 1992. I thank Serge Bahuchet, who, during a pleasant informal seminar in Paris, strengthened my sense of the importance of fire as a kind of altar among the Pygmies. Thanks also to Louis Sarno for introducing me to several Pygmy camps near Gbayanga in the Central African Republic in the summer of 1990.

The Kongo section would have been impoverished without Wyatt McGaffey, ritual physician to the texts of K. E. Laman and K. Kia Bunseki Fu-Kiau. As always the merits of the Kongo section build on the metaphysical richness of the life and work of Fu-Kiau, who generously wrote the foreword. I also thank Ramona Austin for sharing data about *mpú* (royal hats) from her Kongo fieldwork.

José Bedia, one of Cuba's outstanding artists of the late twentieth century, personally arranged for my initiation into the *Regla de Mayombé* religion in Vedado in 1988 and spent hours glossing the precious medicines of God. On separate occasions, Gerardo Mosquera and María Teresa de Linares accompanied me on field trips to Matanzas and opened doors to altars there. The yard-show portion of the Kongo chapter would simply have been infeasible without the parallel research of Grey Gundaker and Judith McWillie. Their findings, richer than mine, gave me the courage to forge ahead. Their friendship resulted in contact with the richest minds of the self-taught art world in the South.

In Brazil, Pierre Verger and Pai Balbino de Paula were spiritual lode stars, as were Gutenberg of Bualeji and the late and great Aildés of Jacarepaguá, near Rio. "If you come back tomorrow," she told me and my son in January 1987, "we have a surprise waiting for you." We did. And were astonished by a rich vein of Egúngún worship in the Americas, qualitatively richer even than Itaparica, which the literature had assured us was the only place to see Egun. Aildés, Olga de Alaketu, and Mai Jocelinha, extraordinary women, sat me down in front of their altars and patiently glossed the meaning and the powers of the icons.

Every time I visited the Umbanda shrines of Buenos Aires, Alejandro Frígerio, a leader of South American Afro-Americanist research, dropped whatever he was doing and made certain that open doors were waiting.

Janina Rabinowitz I remember in a section all her own because, dear heart, how can I thank you for commissioning an Ndjuká altar just for this exhibition, years before this catalogue was even written, "just in case." I also thank her for introducing me to *Gaanman* Gazon Matoja, the paramount chief of the Ndjuká, who kindly supported my research on his river.

In Africa the strongest allies and preceptors were the late Aràbà Ekó of Lagos and Onimeko, the current king of Mko in Ketu Yoruba country. Babatunde Lawal, Roland Abiodun, and Wande Abimbola made summer 1989 a banner year in my Yoruba research; I especially thank them for arranging lodging in Ilé-Ifè. I thank the Nididem of Big Qua Town for help in Ngbe research and Chief Defang in Cameroon. *Ntondele* to the chiefs of Loango in northern Kongo and to the chiefs of Manianga and Vili, and to Balu Balila, who labored valiantly to make masks and *minkisi* seen and documented. I owe a special debt to Kim Barkan, who always let me use his flat in Brazzaville as a base.

As in all projects at the Museum for African Art, there were many people involved in bringing this exhibition and catalogue to fruition. Chris Muller, the installation designer who said anything was possible: to you I offer my special appreciation. The Museum staff: Erica Blumenfeld, the registrar, Patrice Cochran, the controller, my friend in Membership TJ Oladele, Elizabeth Bigham the Administrative Assistant, and Kathy McAuliffe the new Deputy Director; thank you all. Hats off to Carol Thompson and the education department — Lubangi Muniania, June Gaddy, Marjorie Ransom, and their many volunteers, who are making the educational opportunities and public programs come to life. A special thanks should always go to those who gave of their time freely — Lauri Firstenberg and Erin Gilbert, the Museum interns, and Patricia Blanchet, the Development volunteer.

A special section is reserved for Linda Florio and David Frankel. Linda brilliantly caught the spirit of the altars in her imaginative design. David Frankel, my editor, somehow always translated the pressures of deadline into grace and continued understanding. To Nadia Coen, and all those who have assisted David and Linda, I offer my sincere thanks. I cannot wait to work with them again.

Deep thanks finally to five persons who made all things possible: my son, Clark Hood Thompson, who red-penciled a hundred pages; Laura Watt, his fiancée, whose perceptive reactions to altars, from the point of view of a practicing New York painter, were always illuminating; Chris Munnelly, always a great guy, editing chapters at first-draft level and generously offering beautiful photographs of Khami, the Havana Casa de Africa collection of Afro-Cuban art, Angolan graves, and a festival for Oya and Egúngún at Oyotunji; and Dan Dawson and Felipe García Villamil. These two colleagues did so much that the only thing to do in recompense was to dedicate the volume to them. To all, *tibi corde vero*.

Robert Farris Thompson
1 July 1993
New Haven

Foreword

K. Kia Bunseki Fu-Kiau, Ph.D.

In this world of societies, governments, systems, and institutions undergoing great and rapid changes, students of the African world must call not only for fundamental changes of their own, but for a new approach. The academic structure must take a second look at the way African studies are conducted. New words in a new academic language must be coined if "Africology," the field of the study of African culture and society, both in Africa and in the diaspora, is to emerge from its present infancy.

I believe that a significant break from the philosophical methods and mentality of the old colonial school is in fact imminent in the studies of developing nations — African nations in particular. But this endeavor requires unusual patience, talented individuals in the field, sharp tools to perform the job, and — because of the wide global dispersion of African art objects and printed materials—a worldwide collaboration in which sincerity, honesty, and objectivity must intertwine to bring the African aspect of real "knowing" to the universal forum of knowledge.

Professor Robert Farris Thompson is one of the leading scholars honestly and objectively breaking from the philosophy of the old school. In this book and exhibition, *Face of the Gods: Art and Altars of Africa and the African Americas*, Professor Thompson presents a body of information richly sculpted out of materials both new and old, and compiled from the study of African cultures in both "motherland" Africa and the Africa of the diaspora. He successfully reveals, not the "otherness" of some "uncivilized" or "primitive" man, but the "sameness" of humanity everywhere. As Professor Thompson writes,

> Afro-Atlantic altars, inherently open and ecumenical, provide one antidote to a world in desperate need of insight and intelligence. Westerners need not abandon Judaism or Christianity to recognize the parallel validity of the altars of the Black Atlantic world. It is simply a matter . . . of letting active awareness make us less afraid of one another. . . . Comprehension of the fundamentals of the Afro-Atlantic altar—"additive, eclectic, non-exclusivistic," ever dissolving opposition into unity—can inspire a stronger sense of the best Christianity, the best

Judaism, and the best Islam, reconfirming world cultural tolerance.

Face of the Gods focuses on the altars of African religions, particularly in their transition to the New World—to Cuba, Brazil, Suriname, the United States, and other regions. To verify its assertions about altars in the Americas it sets them against the *lumwèno* (mirror) of three principal civilizations of Africa: Kongo, Mande, and Yoruba. These great cultures have experienced the most brutal treatment of man by man. Professor Thompson writes, "They were pitted against one of the most horrible episodes in history, the Atlantic slave trade. . . . In pain and terror West and Central Africans came across the waters to the Americas. The Middle Passage, endured from the sixteenth to the nineteenth centuries, was horrific. . . . untold numbers died en route." Yet, as the author also insists, "Africans arriving on the shores of North and South America did not forget their ancestors nor their gods. . . . they honored them at points of reverence and honor. . . . under pervasive oppression, they managed to establish altars to their dead even while blending with the Christian world."

Professor Thompson has produced a great work on this subject, despite its sensitivity—a sensitivity that many have been unable to negotiate, unable to find Africans' human side. One cannot study a society the way one studies rocks. People have voices, rocks do not; people speak of what they are, what they think, what they create, and what they believe in, rocks do not. Western studies of other societies must involve a clear understanding of their world views or cosmologies. Many sociological studies of third world nations have failed in this respect; produced without attention to the cultures' cosmological realities, they have done more to create dissension among people and nations than to promote peace and mutual understanding.

J. William, author of *Pragmatism and Four Essays from the Meaning of Truth*, was not mistaken when he wrote, "The most practical and important thing about a man is still his view of the universe. . . . To fight an enemy, it is important to know the enemy's numbers, but still more important is to know the

enemy's philosophy (his worldview)."[1] New World African cultures are misunderstood and misconstructed, as are the cultures and philosophies of Africa, because scholars have failed to recognize the underlying forces of African cosmologies. Professor Thompson knows and understands these elements of these misunderstood civilizations. His work illustrates his command of African cosmologies, particularly those of the Kongo and Yoruba.

Professor Thompson's success lies in the simplicity of his method: "Better to work with what we know." *Face of the Gods* brings out religions, cultures, art forms, whole civilizations, all thriving underground for centuries because their builders, incarcerated inside walls of oppression both visible and unseen, were not allowed the seal of their own African identity. "Slaves weren't supposed to have a culture." Yet inside their religions one sees the flow of African icons, songs, language, and cosmograms, of African colors, gestures, dances, symbolic objects, *nkisi*. The "master" did not notice. He was "blind."

Our understanding of African world views, and especially of the cosmology of Kongo, has opened a new page in the study of the African world, both in Africa and in the diaspora. African-American arts — the painting, singing, writing, icon-making, that are ramifications of these African world views — can now be understood. Creolized worlds of black expression, meaningless yesterday, can today be traced back accurately to their African roots.

Richly illustrated, *Face of the Gods* is a monumental cultural pyramid rising from centuries of oppression to reveal the vital presence of African culture in the New World, in all its religious insight, artistic creativity, ingenuity, and philosophical depth, as it was and continues to be, in the present and into the future. Through its pages, new perspectives in African-American history unfold, so that ties between all Africans can once again be strengthened.

Professor Thompson has produced a book and an exhibition that are at once fascinating and emotional — fascinating because they fortify our pride in having found an important link in our history that had been buried in the sands of oppression and slavery; and emotional because they allow us to revisit, in our hearts, the sites of the unburied bones of our ancestors who were cast out of the A.F.C.C. because they could not make it to the shores of the New World.[2] This book is a wonderful gift to African people in Africa and in the diaspora. It is also, of course, a gift to all humankind. It must be read with both heart and mind by every African individual, as well as by every student of Africa, its culture, its world.

1. J. William, *Pragmatism and Four Essays from the Meaning of Truth* (New American Library, 1974), p. 17.
2. African floating concentration camps.

Preface

Susan Vogel, Executive Director

Face of the Gods brings to the fore two fundamental aspects of African art that have been implicit but unexplored in all of the Museum's past exhibitions: the sacredness of African art, and its lasting impact on the art and cultures of the African Americas.

This landmark book is the fruit of a lifetime of research by one of America's foremost Africanists. Robert Farris Thompson has devoted his life and career to understanding how ideas and art forms that spring from Africa have been transplanted and transformed in the Americas. His phenomenal intellect and energy have been trained on this subject like a searchlight for over twenty-five years. This occasion makes me remember myself as a young assistant registrar, thrilled to help log in and install the objects displayed in the awesome professor's first exhibition exploring this complex subject. It was "African and Afro-American Art: The Transatlantic Tradition," which opened at the Museum of Primitive Art in 1968. Thompson's research was complex and fascinating then, but the countless research trips, initiations, consultations with ritual specialists, and other work that he has completed since have vastly deepened and enriched the evidence he brings to bear on African-based aesthetic traditions in the western hemisphere. As a bystander on the edge of his high-velocity intellectual voyage all these many years, I am proud to be able to help bring his research discoveries and penetrating insights to a wide public.

Face of the Gods challenges previous assumptions about both art and religion. First, it explores not single works of art, but assemblages, environments, and even landscapes where objects, places, and people join to create loci of worship. Second, it contests the notion that religions must be insulated and discrete by showing how they can overlap and merge in meaningful, uplifting, and highly inventive ways. Some of the altars here represent a fusion of several distinct African religions with Christianity, and also with technology, science, and other aspects of modern life. They show the ways that certain African religious traditions, most notably Yoruba, Kongo, and Mande, continue to thrive in newly reconfigured ways in regions of the Americas ranging from Bahia to Brooklyn.

By focusing on the altar, the exhibition underscores a nearly universal religious phenomenon: the creation of sacred spaces as points of worship. In addition to conventional table altars adorned with items ranging from fruit and flowers to artworks and emblems, an altar may be movable, transportable, and even camouflaged in a domestic laundry bin or a closet. Altars can take the form of a rock or a tree, a yard or even a beach. Some of the most radical and spiritually charged altars are totally ephemeral—radiant candlelight, for example, or the dance and chant of possession. Altars are all the places where people commemorate and commune with ancestral spirits and deities. This book documents the visual languages of spiritual strength and sustenance that arose in Africa and have bridged several millennia and three continents to make the Afro-Atlantic altar one of the world's most enduring.

The publication of *Face of the Gods*, and the opening of the exhibition, mark the continuing explorations of the Museum for African Art. By presenting art forms of the larger African diaspora, *Face of the Gods* extends ideas expressed in previous Museum exhibitions to a broader geographical plane. The messages implicit in these altars tell how ideas transplanted from Africa to the Americas, and assimilated there, accommodate new social, historical, and geographical conditions for Africans and their descendants, and how such ideas have done so with poetic vigor and artistic resilience.

It is a great honor for the Museum and a deep personal satisfaction for me to host this momentous exhibition and to publish this book, which will serve as a resource for years to come. We do so in tribute not only to the authors of the great works that populate the book's pages, and to the millions of Africans who have sustained and continue to sustain the essence of African religions on both sides of the Atlantic, but also to Robert Farris Thompson, whose determination to forge a new field of inquiry and to bring new insights to the chronicles of African art history reverberates here with passionate intensity, and with a spirited belief in the essential beauty and richness of African and African-American religious and artistic expression.

Overture: The Concept "Altar"

Mysticism is not concealment of a secret, or ignorance; it consists in the self knowing itself to be one with absolute Being, and in this latter, therefore, becoming revealed.
 —G. W. F. Hegel, *The Phenomenology of Mind*, 1807

An altar is a place where you realize your belief.
 —*Gaanman* Gazon Matoja, traditional ruler of the Ndjuká maroons, eastern Suriname, 1981

In the West an altar is "a raised structure on which to place offerings to a deity," a "raised structure consecrated to the celebration of the Eucharist," and "a place consecrated to devotional exercises."[1] Altars, then, encompass sacrifice, prayer, and devotion. Anchoring men and women at life's deepest moments—baptism, marriage, celebration, investiture, death—they back up crisis or transition with the immortal presence of the divine.

The altar appears in the art history of virtually all of the world. The beauty and spiritual achievement of the Afro-Atlantic altar, made and used by followers of the ancient traditional sub-Saharan religions, compare in force and magnitude with those of the world's major religions, including the principal Western religions of Judaism and Christianity. No less than these others, the Afro-Atlantic tradition comprehends its world in moral and philosophical terms.

Afro-Atlantic altars spatially coincide with the Black Atlantic world. Servitors kneel before them among the Mande, Akan, Fon, Yoruba, Ejagham, and other civilizations of West Africa, and amongst Bakongo and their neighbors in Central Africa as well. New World traditionalists of African descent, particularly in Cuba, Haiti, and Brazil, worship at Afro-Atlantic altars also; and here, Amerindian- and European-descended persons too find spiritual sustenance and moral self-discovery in the worship of Yoruba *orisha* (deities under God), Kongo *minkisi* (animate medicines of God), and other sub-Saharan forces.

In this last decade of the twentieth century, in Ulster, Palestine, India, and elsewhere, men and women still clash over, they say, religion (though more often the real causes are invidious matters of class and privilege). Against this violence, Afro-Atlantic altars, inherently open and ecumenical, provide one antidote to a world in desperate need of insight and intelligence. Westerners need not abandon Judaism or Christianity to recognize the parallel validity of the altars of the Black Atlantic world. It is simply a matter, as Alan Lomax has pointed out, of letting active awareness make us less afraid of one another.[2] Indeed, comprehension of the fundamentals of the Afro-Atlantic altar— "additive, eclectic, non-exclusivistic,"[3] ever dissolving opposition into unity—can inspire a stronger sense of the best Christianity, the best Judaism, and the best Islam, reconfirming world cultural tolerance.

In pain and terror West and Central Africans came across the waters to the Americas. The Middle Passage, endured from the sixteenth to the nineteenth centuries, was horrific. The slave ships were floating concentration camps; untold numbers died en route. But Africans arriving on the shores of North and South America did not forget

their ancestors or their gods. Covertly at first, they honored them at points of reverence and honor. In North America, under pervasive oppression, they managed to establish altars to their dead even while blending with the Christian world: they coded their burial mounds as "graves" but studded them with symbolic objects, many deriving, in form and function, from the Kongo classical religion.[4]

In Cuba, according to a legend shared by the late Alejo Carpentier, police once burst into a meeting of an underground religion called Abakuá, deriving from eastern Nigeria. There they confronted four men calmly seated with Panama hats in their hands. Other men were standing. Two European dolls, apparently for children, reclined against a wall. The police could do nothing. There were no "pagan instruments" for them to seize and take away, no signs of a black religion for them to persecute, as they were wont to do in the late nineteenth and early twentieth centuries.

But the moment they left, the hats became drums, tapped lightly that none outside might hear, giving voice to moral admonitions (*nkame*) from beyond the seas. The "dolls" resumed their roles as icons of founding spirits of Abakuá. The room was in fact their altar.[5]

Everywhere across the early black Americas, in fact, covert altars encoded the richness of sacred memory to unite servitors in sustaining faiths, even as Christians once met secretly in the catacombs of Rome. In Nigeria, for example, devotees of Shangó, the Yoruba thunder god, had abstracted the flash of lightning in the sharp diagonals of a double-headed axe (*oshe*). This they had placed on altars as emblems of his power. When brought to Cuba, the Yoruba found homologies for storms as moral agencies in the Latin Catholic association of Saint Barbara with gunpowder and with lightning. Soon Afro-Cuban altars to Shangó, now emerging under the creole name "Changó," included a miniature medieval tower, the tower of Saint Barbara, in addition to the ancient red-and-white beads, thunder-suggesting mortars, and the axes of the thunder god.[6] By 1954 one inventive servitor had transformed the tower into a palace, red and white in color, with crenelated turrets, augmenting the belief that Changó was a king in Africa, and clearly demonstrating Afro-Cuban innovative strength.[7]

The builders of sub-Saharan altars had had the power to make scale models of heaven, and to animate them with hieroglyphs of nobility. They transmitted these special languages of reverence from Africa across two more continents, an achievement effected not only with objects but also with symbolic drumming, dancing, antiphony, gesture, prayer, and invocation. Sacrificial food and liquid joined art and gesture at the altar as hieroglyphs of the spirit. Red-and-white double axes, hard-driving music on *batá* drums, swathes of crimson cloth and paint, and red apples and pomegranates appear on Afro-Cuban Changó altars from Havana through Miami to New Jersey;[8] these sounds and these objects in red enable us to imagine ourselves into the moral fire of the thunder god.

A rationale of demographic comparison underpins this exposition. Consider, for example, a single class of Afro-Atlantic altars, representing a single stylistic aspect of the diaspora: the altars of the Suriname maroons, in the rain forests of northern South America. Assessment of the numbers and ethnic origins of the main African groups in Suriname reveals a unique equation: from the hinterlands north of Cape Lahou, a heavy late-eighteenth-century influx — a 49 percent population increase — of slaves from the Mande and Akan areas, plus earlier important numbers from Dahomey and Yorubaland, plus, of the total input of blacks at every period of Suriname's slaving history, a steady one-fourth to one-third from Loango/Angola in Kongo.[9] A search for the origins of the altars of the Suriname maroons must be placed, then, against this ethnic background.

In Kongo, as we shall see later in this book, a main form of altar is the tomb, a platform for entreaties between this world and the next. In 1887, R. E. Dennett illustrated ornaments destined to decorate the altar/tomb of an important departed leader as they were carried to the grave on a special funerary cart (plate 1).[10] This tomb included ceramic vessels for assuagement of the spirit by means of libation, stuffed leopards symbolizing royalty and transition, the skin of a civet indicating more or less the same meaning, and a porcelain *nsusu mpembe*, a "white chicken," probably offered that no one else might die. The coffin was covered with red material, crimson again denoting transition in Kongo terms. Visually assertive flags embellished and guarded the ends of the tomb; the Ki-Kongo word for "flag," *mpeeve*, also stands for "wind, breeze, spirit,"[11] so that the being honored beneath the altar became a spirit in the wind, a cloth set in motion by forces that could not be seen.

Among the Mande and the Mande-influenced Gur civilizations to the east and south of them, an altar to a male spirit may take the shape of a column of pure clay.[12] This brings an abstract perfection to the body of the departed, who stands beyond all natural incarnation. A plurality of forces may constitute such an altar. Atop an anthropomorphized clay-built column photographed by Katherine Coryton White at Miango, Mali, among the Dogon, in 1968 (plate 2), for example, appears a sacred vessel. Not only is the ancestor present here, he carries medicine, toting assuagement for his people.[13]

PLATE 1: ORNAMENTS FOR THE ALTAR/TOMB OF AN IMPORTANT KONGO LEADER CARRIED IN FUNERAL PROCESSION TO THE GRAVE, NORTHERN KONGO, 1880s. The funeral cart bears ceramic vessels for libation, two stuffed leopards and a flayed civet skin symbolizing royalty and transition, and a propitiary offering of a porcelain *nsusu mpembe*, a "white chicken." The tomb is ornamented with flags, expressing the victory of the spirit over time. Drawing by R. E. Dennett, from his *Seven Years among the Fjort*, 1887.

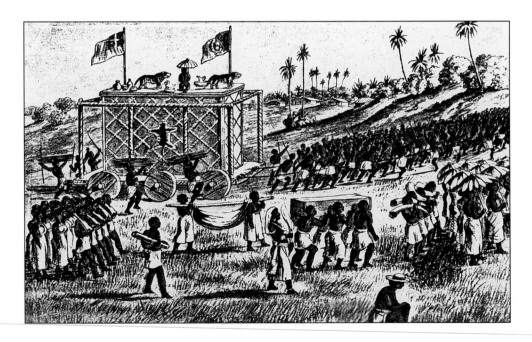

Overture: The Concept "Altar"

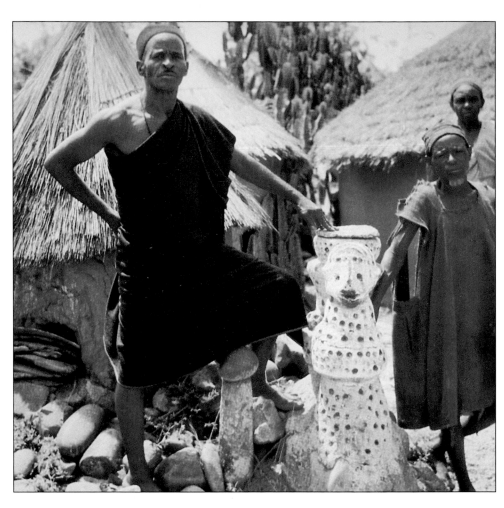

PLATE 2: CLAY COLUMN ALTAR, MIANGO, MALI, CA. 1960S. An anthropomorphic Dogon altar honoring a male ancestor spirit, and surmounted by a votive vessel. Photo: Katherine Coryton White, 1968.

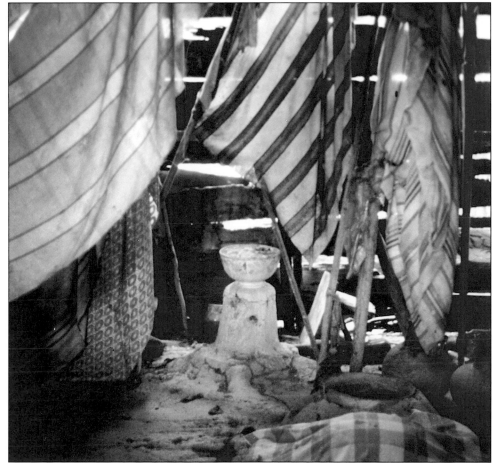

PLATE 3: NDJUKA ALTAR TO THE SPIRIT PAPA GADU, GODO OLO, SURINAME, BEFORE 1884. Cultural streams converge in this altar of Ndjuká maroons, descendants of African slaves who escaped to Suriname's upriver rain forests and, in 1760, won their independence from colonial plantation-owners. The altar includes both a clay pillar with vessel, in a Mande/Akan style, and flags suggestive of combined Kongo, Akan (plates 4 and 5), and European influences. Photo: Robert Farris Thompson, 1981.

PLATES 4 AND 5: AKAN ALTAR IN THE COURTYARD OF THE KING'S SLEEPING ROOM, KUMASI, ASANTE (MODERN GHANA), SEEN IN 1817. The detail (plate 5, below) focuses on the shrine's sacred elements, all of them elevated and tall: two tree altars (a stunted silk cotton tree and a manchineel), small brass cups supported high on forked sticks, and a pole bearing white and red flags. Drawing by T. Edward Bowdich, 1817, from Labelle Prussin, *Hatumere: Islamic Design in West Africa*, 1986.

The spirit advanced differently at a shrine in the courtyard of the king's sleeping room at Kumasi, Asante, in 1817. Here our document is T. Edward Bowdich's illustration (plates 4 and 5): "the stunted silk-cotton and manchineel tree are sacred, as are the white and red flags at the top of the pole, and the small brass cups supported by the forked sticks."[14] This royal Akan altar embodied three elements, and all were elevated, all were high: trees, supported cups, and flags.

But none of these three precursors prepares us for the creole ingenuity that bursts into view in an altar to the spirit Papa Gadu among the Ndjuká of maroon Suriname (plate 3). I photographed this altar at Godo Olo, on the Tapanahoni River west of the Ndjuká capital, on December 26, 1981. Here, ideas and images from Mande, Asante, Kongo, and Europe apparently combine and force an innovation.

Flags take over. They cluster festively around a classic Mande/Akan clay-pillar altar with suspended vessel. Spiritualizing space, brilliant cloth unfurled to the wind—on the coast of Suriname, "wind" (*winti*) means "spirit," as it does in Kongo—makes a halo over the hard vertical clay column altar. Among the maroons, flags are so much an essential element of altars that Ndjuká call their ancestral shrines *faaka tiki*, "flag altars," like their neighbors the Saamaka, whose term for "shrine" is *faáka páu* (staff with flag).[15] The banners are also said to recall memories of European and African battle flags during the maroon wars of liberation in the eighteenth century.

We shall meditate on further transoceanic sequences and rephrasings in this volume. When I say "meditate" I am thinking of the paramount ruler of the Ndjuká, who defined his flag altars in these terms: "the place where you realize your belief."[16] He stressed the last word by pressing thumb and forefinger, joined in a circle, to the center of his forehead, making a sign of thought and meditation.

European Altars: A Brief Comparison

Our understanding deepens if we juxtapose Jewish and Roman Catholic definitions with those of the Afro-Atlantic world. Begin with Judaism:

> The altar, or bema, is seen as a raised platform from which Torah is read. It is the reading of Torah—the inscribed word of God Himself to the People of Israel—that is at the crux of the Jewish service. Every reading of the word of God is a reenactment of Moses' meeting with God.[17]

The gist of the Jewish altar therefore is: elevation of the word. The bema is Mount Sinai, smoke and fire and text and glory, all mixed in quietude and grandeur.

Elevation is also the essence of the Roman Catholic altar, the word finding its roots in the Latin *altare*, "a high place." Another etymology suggests a parallel conceptual root, *ardere*, a place where things are meant to be burned in honor of the Lord, as in Exodus 38:1, "the altar of burnt offerings."[18]

Altare and *ardere*, or elevation and fire, suggest an Indo-European consensus on the altar. This understanding illumines what is meant when persons in the West define their shrines as a "raised structure, with a plane top, on which to place or sacrifice offerings to a deity."[19]

In England this comes to mean "the raised structure consecrated to the celebration of the Eucharist."[20] In the same country, after the Reformation of 1549, altars were removed from the Anglican church. The "holy table" of the English prayer book became the altar. In effect, this cut the shrine back to Jewish concepts of the elevated text.

English poets in fact intuited this development in a marvelous way, visualizing, through typographic conceits, the silhouette of the elevated sacred table within the very writing of their verse. Thus John Hollander notes, "Renaissance poets could manifest this metaphoric reformation of the actual altar in an interesting way. Among the Hellenistic Greek 'shaped' or 'patterned' versions they knew were two altar-shaped poems, one (late, from the reign of Hadrian) proclaiming that it was not a literal altar of stone, down which the blood of sacrifice ran, but, rather, built of language aided by the muses."[21] George Herbert's "The Altar" builds on this, and is reproduced here in the original typography, from *The Temple*, 1633:[22]

The Altar.

A broken A L T A R, Lord, thy servant reares,
Made of a heart, and cemented with teares:
Whose parts are as thy hand did frame;
No workmans tool hath touch'd the same.
A H E A R T alone
Is such a stone,
As nothing but
Thy pow'r doth cut.
Wherefore each part
Of my hard heart
Meets in this frame,
To praise thy name.
That if I chance to hold my peace,
These stones to praise thee may not cease.
O let thy blessed S A C R I F I C E be mine,
And sanctifie this A L T A R to be thine.

Hollander, in his *Vision and Resonance*, argues that these printed structures represented the poet's quest for authenticity of form.[23]

Elsewhere in Europe, the Roman Catholic altar richly serves worshipers as a cultural force. It sits at the crux of the cathedral's nave and transept, which enclose it in the very

PLATE 6: ROMAN CATHOLIC ALTAR TO SAINT TERESA OF LISIEUX, CATHEDRAL OF NÔTRE DAME, BAYEUX, FRANCE, TWENTIETH CENTURY. The statue is marble, expressing both purity and the eternal; the altar table itself takes the form of a Gothic Revival church, as if the saint had descended from the heavens to its roof. Photo: Robert Farris Thompson, 1981.

arms and trunk of Jesus, in the sign of the Cross. "Just as the Eucharist is the center of Christian worship, so the altar is the ideal center of the ecclesial edifice: all leads to and all leads from the altar. The altar is the 'place of concentration' of the purest liturgical spirituality and the most intense Christian piety."[24] And the table itself symbolizes Jesus, for the relation between stone and altar is clear: "The rock was Christ" (1 Corinthians 10:4). Hence the white cloth laid atop the stone table is the vestment of Christ Himself.[25] Chalices and containers, for wine and bread, complete the symbolic imagery of the blood and flesh of Christ, as given in Communion. Candles on the altar stress Christ as light.

As to smaller shrines within a Roman Catholic cathedral, consider an altar dedicated to one of the popular saints of modern times, Saint Teresa of Lisieux. I photographed this stone in the summer of 1981 in the Cathedral of Nôtre Dame in Bayeux, Normandy (plate 6). It reflects Teresa's perfected love of God.

First, the marble in which her image takes flesh communicates the strength and immortal purity of her belief. The figure of this modern saint — she was canonized in 1925 — stands on a polished stone altar table. Below, the support becomes a miniature church in Gothic Revival style. It is as if Saint Teresa, returning from heaven, alit upon the altar table and on the roof of the church. Flower offerings and the light of nearby candles complete an aura of spiritual beauty and illumination.

The Afro-Atlantic altar sustains itself by similar visions. Here also, divine focus and elevation appear as organizing elements, but the aspirations of black deities and ancestors define a different structure. Across West and Central Africa the proper way of honoring the dead is with sacrifices of rich cloth, reaching a climax in the cloth-laden *egúngún* and *niombo* structures of the Yoruba and Bakongo. Hence the high altar to the dead at the Saamaka capital of Asindoopo in Suriname, which I photographed in 1978 (plate 7), betrays its Africanness in the dramatic elevation of great cloth streamers. They read like winds of light above the central plaza of the town. The flags are not unfurled, as at the Ndjuká shrine at Godo Olo; they are carefully tied. They are rigged and draped. They stand like giant elders watching over us.

All altars overthrow time. Here the dead come back, not only as flags, but, in one commanding image, as a standing figure with a funereal white band around its forehead. It stands before a further cloth offering beneath the elevated banners. This image marks the center of the shrine.

The altar to Saint Teresa received three floral offerings. The Saamaka altar — in which we meet, for the first time, the Afro-Atlantic outdoor altar, fenced with raffia emblems (*azan*) of sacredness and initiation — offers apparent refreshment to spirits in the sky itself, with a towering platform bearing a green glass bottle. This altar takes from nature another way: before the image the earth is swept clean, meant immediately to absorb drops of cool water, or other libations to the spirits. These touches look back to sacred forest groves in Africa, also open to the air, also taking liquid direct upon the earth, also set off from ordinary happening by fences decked with warning raffia.

Overture: The Concept "Altar"

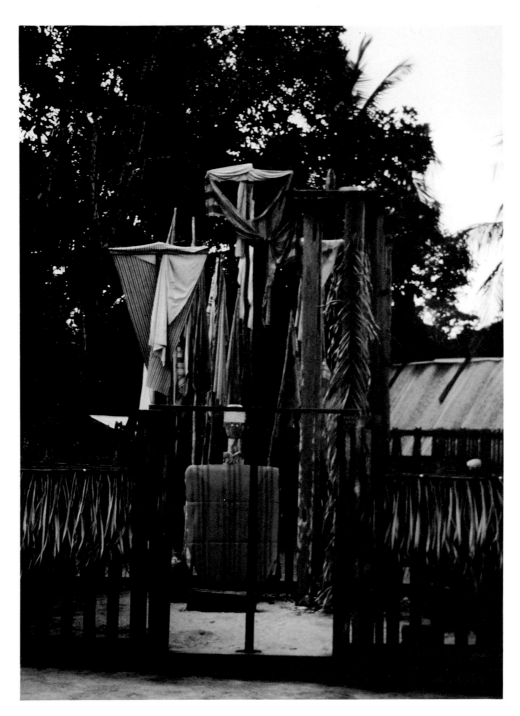

The Afro-Atlantic Altar

Change, infused with spirit, generates extremely powerful iconic histories. This truth defines the rise of major forms of the Afro-Atlantic altar. The clay-pillar and the calabash-in-the-fork-of-a-branch shrines of the Mande and the Akan, colliding with such stimuli as memories of banner-decorated tombs in Kongo, break into the dramatic flag-altars of inland Suriname. Equally phenomenal is the transformation, in Cuba, Brazil, and Miami, of the clay-dais altar of Yorubaland into shelves and tables laden with images of the Yoruba deities, in witty counterpart with icons of the Roman Catholic Church.

In Judaism and Christianity, as we have seen, the servitor at the altar confronts Mount Sinai and the Crucifixion. The followers of these religions meet, respectively, the word of God and the body of Christ, at an emphasized point between two worlds, a

boundary marked in both religions by sacred writings, Torah and gospel. Afro-Atlantic altars too emphasize a text at a crossing of two realms: in eastern and southwestern Nigeria, for example, Ejagham Ngbe-society altars focus on a table before a cloth, the latter brilliantly emblazoned with signs and ciphers that both announce and conceal the Voice of God.

The same formula—table, ideographic wall-hanging, Voice—reestablishes itself in Cuba, where followers of the same society serve the faith called Abakuá. Here, though, the splendor of the altar objects is enriched with Catholic touches. Their "drum of silence" (*sese*) begins, for instance, to take on certain trappings of the chalice. The Ejagham/Cuban altar becomes, at the end, a sensitive nucleus of beliefs.

The gist of the Kongo altar too is writing, though the script is often executed on the earth, as opposed to elevated on a table. In the Kongo imagination, the place where two paths come together is an automatic point for sacrifice and prayer. The crossroads is a classic Kongo altar, reverberating, ultimately, all the way to one of the primordial images of the Mississippi Delta blues. The operative term is: *mpambu nzila*, a phrase variously defined in the Ki-Kongo dictionary as "crossing of paths; crossing, ramification, branch, bifurcation, arm, point of reunion, point of separation."[26]

By this definition the grave is a crossroads, where one kneels to seek the insights and protection of the dead. But a forked branch, or a cross traced upon the ground, instantly generates the same altar. Rough-and-ready or carefully formed, all are cosmograms, their tops indicating heaven and the realm of God, their bottoms, earth, and the ancestors rooted deep within. Kongo-American root charms, like High John the Conqueror (any unusually shaped root), objectify in three dimensions the ancestral facet of the cosmogram.

As altar, sign, and object, the crossroads came with a thousand voices to the Americas. Haitian healers make "*congo pacquets*," bags with feathers inserted at the top to indicate heaven, and within them, earths, embedding spirit. In Africa, Kongo healer diviners are known as "leopards of the sky"—i.e., predatory birds like vultures—hence their feathered bonnets. Kongo feather headdresses were remembered in Brazil, and were compared to and combined with Amerindian feather bonnets, especially among the *caboclo* priests of the black religions in the northeastern part of the nation. In North America, in the low country of the Carolinas, the feathered bonnets apparently disappeared, but traditional African-American healers took names like Doctor Buzzard and Doctor Hawk.

The climax was New Orleans, city of Kongo Square. Here the all-over feather costumes of black Mardi Gras Indian groups compare directly with the all-over feather masks of the Loango region in Kongo (plates 8 and 9).

Kongo mediatory charms of visual astonishment also lead directly to the "dressing," with related and recurrent objects, of automobiles, suits, tombs, and yards in black America. Here visionary persons work with "exact materials that matter for working through vicissitude and stress."[27] In the process, originating impulses from Central Africa fuse with local loves and memories. Crossroads shrines with mystic medicines, recorporealizing the cosmogram, identify the Kongo altar world.[28]

Yoruba and other Kwa-language groups in West Africa (Fon, Igbo, Edo, Ijaw) define their traditional altars as the "face" or "countenance" or "forehead" of the gods.

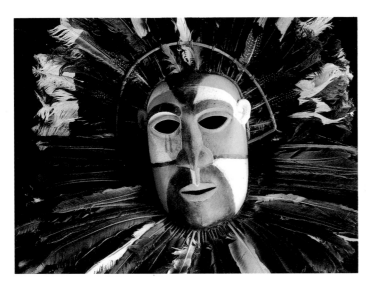

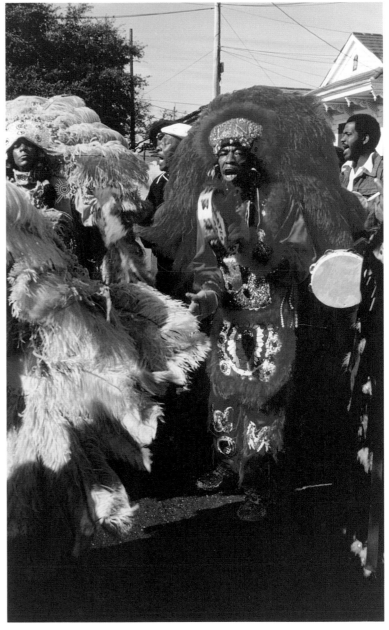

PLATE 8: VILI FEATHER MASK FROM THE AREA OF LOANGO, KONGO (MODERN REPUBLIC OF CONGO), COLLECTED IN THE LAST QUARTER OF THE NINETEENTH CENTURY. Plumed masks of religious inference are a longstanding tradition in Kongo. To borrow the power of the creatures of the air is to impart a message: Our power is soaring, we are no longer physical, nothing can stop us. Collection Museum für Volkerkunde, Berlin-Dahlem.

PLATE 9: MARDI GRAS INDIAN DANCER, NEW ORLEANS. Feather emblems recalling Kongo practices appear in the *congo pacquet* of Haiti and in the headgear of *caboclo* possession spirits in Brazil. In Cuba, too, certain priests wear feathers, again as spiritual headgear; certain *nkisi* are feathered also. And in New Orleans, at Mardi Gras, groups of festivalizing blacks have long dressed in elaborate versions of Plains Indian apparel, but spread feathers over their entire bodies, as in the Vili tradition, rather than concentrating on the head, as in the Native American one. Photo: Lisa Kaslow, 1981

Elaborating for the Yoruba, Babatunde Lawal remarks, "*Ojú*, in classical Yoruba, simultaneously refers to eyes, face, and surface. There is a further nuance, namely gateway, portal, door. Compare the phrases *ojú ona* [literally 'face of the road,' or 'gate'] and *ojú ilé* [literally 'face of the house,' or 'door']."[29] Yoruba building altars thus construct a face/surface/door, a complex threshold for communication with the other world. The concept is inherently poetic. Witness the Yoruba phrase for "railroad train," *oko ojú irin* — literally, "vessel moving on the face of iron." Moving, in other words, upon an altar made of iron. Significantly, massive railroad nails (*clavos de línea*) become prized elements of Havana, Miami, and New York shrines to the Yoruba deity of iron, Ogún.

From Nigeria to Bahia and back again, Yoruba priests and priestesses refresh the "countenance" of their gods, pouring liquid before the altar from ceramic vessels. One of the distinguishing traits of the Yoruba and the related Dahomean altar is precisely a plenitude of pottery for libations and ritual assuagement.

The aim of this book, in the words of Lawal, is "to address the concept of the altar as a focus of worship and as a locus of several artistic media—sculpture, ceramics, painting and textiles."[30] John Mason, a distinguished priest of the Yoruba in New York City, adds the following summary statement: "The aim is to view black Atlantic art, especially in the New World, in terms of thoughtfully selected [altar] objects belonging to specific philosophic constellations which help to define the face of divinity."[31] The time has come, then, to open the curtain on this exploration of the altar's form and civilizing grace in one of the planet's most active provinces of worship and religion, the Black Atlantic world.

Tree, Stone, Blood, and Fire:
Dawn of the Black Atlantic Altar

The eternal ideas [are] more clearly discernible in antiquity.
 –Karl Jaspers, *Socrates, Buddha, Confucius, Jesus,* 1957

No, it was not language; it was
what there was before language. . .
when men and animals did
talk to one another. . . .
 –Toni Morrison, *Song of Solomon,* 1977

Pygmy and San people have foraged the land south of the Sahara since remote antiquity.[1] Pygmy and San men hunt game; Pygmy and San women — and men too, sometimes — gather roots, berries, nuts, and other foods. The most important food San gather is the mongongo nut (*Ricinodendron rautanenii*), which has a nutritional value ranking with ground nuts and soybeans, among the richest foods cultivated in Africa.[2]

Until ten thousand years ago, every human being practiced hunting and gathering. It is a style of life characterizing ninety-five percent of the history of mankind.[3] The materially simple — but conceptually rich — points of sacrifice elaborated by the Pygmy and San, the two famous foraging civilizations of tropical Africa, register the depth of these peoples' history and the brilliance of their spirit. They mark the beginning to this study of the altars of the Black Atlantic world.

Carefully to be avoided, however, is any sense of Pygmy and San art and simplified altars as "primordial" — as inherited without change from a paleolithic past. The "contemporary Stone Age" interpretation attractive to earlier Western generations does violence to the facts of documented change and cultural contact in both societies. Pygmies, for instance, have interacted with nearby Bantu peoples for probably two millennia. Some speak Bantu languages, and not necessarily those of their currently immediate neighbors.

On the other hand, both San and Pygmies yodel, hocket, and elaborate polyphony, musical practices at the core of their cultures, and these sound styles are of great antiquity, to judge from their far-flung appearance among the bands of the two foraging civilizations. To yodel, oscillating the voice across an octave range in a single vocal snap, is a signal characteristic of both peoples' artistic cultures. It constitutes a mediating and healing vocal element. Forager yodeling, Alan Lomax suggests, may well trace back to the earliest stock of human sound.[4] Nevertheless, songs composed within this textless current of spiritual energy, freshened with constant variation, emerge forever new.

Both Pygmies and San lived interactively with their Bantu neighbors during the centuries of the Atlantic slave trade. Documents dating from this era can be found to trace the Pygmy and San roots of Afro-Atlantic altars, and to fathom this definite historical period bypasses the problems of "primordial" origins, mysterious and remote. Better to work with what we know.

Western awareness of Pygmies on the northern border of Kongo, a strategic Atlantic civilization, is recorded in 1625, when A. Battel noted "little [forest] people" near the city of Loango.[5] But archaeological evidence attests to the contact of Natal-area San, in

Tree, Stone, Blood, and Fire: Dawn of the Black Atlantic Altar

what is now South Africa, with Bantu cultivators far earlier—more than 1,500 years ago, according to J. D. Lewis-Williams and T. A. Dowson, who add that "[Bantu] farmers regarded the Bushmen experts in ritual matters and hired them to perform rain-making ceremonies."[6]

Koroca San have similarly interacted with neighboring Bantu in southwestern Angola, south of the famous slaving port of Benguela, for at least the past two centuries. Unsurprisingly, a Harvard scholar has discovered Southern Bantu blood types among a number of North Americans of African descent.[7] Forest-type yodeling in the Kongo civilization, notably among healers (*banganga*), clearly indicates contact with Pygmy groups, and recalls the analogous impact of San clicks in Southern Bantu languages.[8]

It is in this sense of ongoing cultural interaction, and not from any vague consideration of "primordialness," that I argue that Pygmy and San handling of the shrine concept, the point of sacrifice to forces from beyond, constitutes the dawn of the Afro-Atlantic altar. This is because the African areas they influenced became, in turn, major roots of black North and South America.

PLATE 10: PYGMY MASK OF DZENGI, CENTRAL AFRICAN REPUBLIC, LATE TWENTIETH CENTURY. "Dzengi, a forest spirit," we are told, "likes singing, vigorous dancing, and play." The mask is covered in raffia, which Pygmies may also use to mark an initiation precinct in the forest. Or an altar may be as simple a thing as a leaf laid in the fork of a tree, with a small offering of food. Photo: Guy Phillipart de Foy, from Serge Bahuchet and de Foy, *Pygmées: Peuple de la forêt*, 1991.

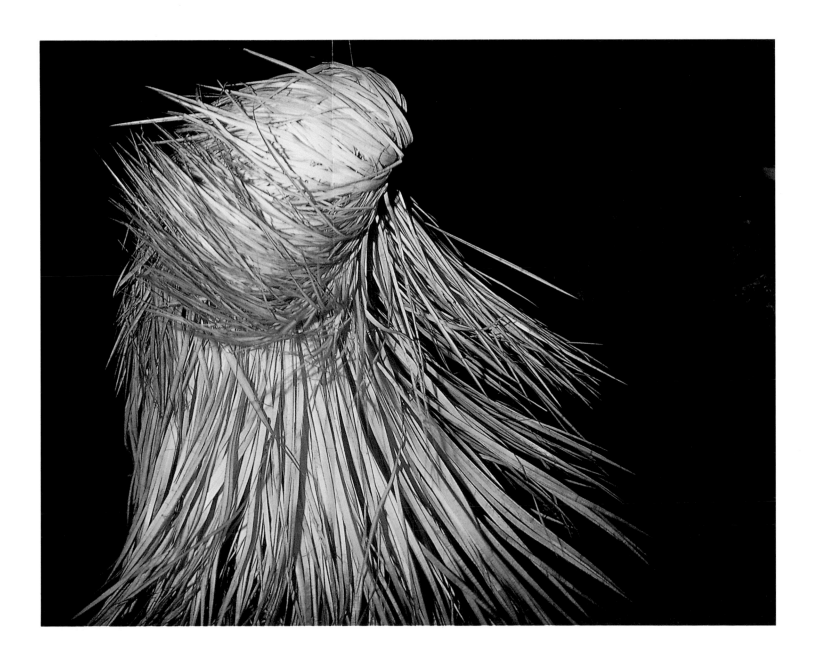

Pygmies honor their rain-forest setting as God. Within its shadowed recesses they make their prayers and sacrifices. Quite naturally, then, the forest—and such miniaturizations of its precincts as a twisted branch, the fork of a tree, or a single leaf — becomes their altar and their shrine.

PLATE 11: BIRA *AMATI A ONI GANZA* (TORTOISE-SAW-THE-CIRCUMCISION), CENTRAL ITURI, ZAIRE, 1950S. These wooden "found altars" are sticks of distorted or twisted shape to which Bira and Pygmies, coming across them in the forest, attribute spiritual presence. From Colin Turnbull, "The Mbuti Pygmies: An Ethnographic Survey," *The Anthropological Papers of the American Museum of Natural History*, 1965.

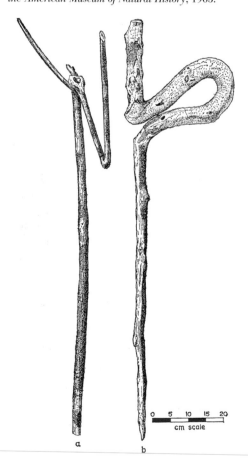

Pygmies honor the forest and its spirits with yodel-inflected song. They chant while dancing, round and round. These yodelizing cries, expertly intertwined, enchant the groves. They are the "language" that the forest spirits (*mokoondi*) comprehend. The forest "answers" Pygmy sacrifice, of songs and motion, by granting the worshipers abundant game and honey. Pygmy women of Kenye camp, near Gbayanga in the Central African Republic, stressed this in the summer of 1990: "Yodeling is the women's style of singing; it brings food."[9]

When yodeling and the dance attain the proper pitch, the forest also "answers" by dramatic acoustic and visual means: direct visitation via mystic sounds (the *molimo* sounding pipe among the five Pygmy groups of the Ituri forest) and raffia-covered maskers (the Jengi, Dzengi, or Ejengi masks among Pygmies of the Central African Republic).[10] "Dzengi, a forest spirit . . . likes singing, vigorous dancing, and play, and will disappear if these behaviors are not exhibited" (plate 10).[11] Pygmy aesthetic play sometimes so powerfully attracts the forest spirits that Birnam Wood indeed comes to Dunsinane:

> Out of the corner of my eye I noticed a small bush where I did not remember a bush before. . . . As I looked around, I saw other bushes I had not noticed. At the edge of a patch of [rain forest] an immense leaf, low to the ground, bobbed up and down like foliage caught in a breeze—only there was no breeze. . . . [a] giant leaf, twirling slowly, glided across the clearing and came to rest before the largest group of women. It tilted toward them and beat the ground, heaving up and down in rhythm. Sometimes it screeched with a strangely unhuman voice. . . . The leaf brought the music to an abrupt halt with a stabbing hiss.[12]

Intriguingly, the dress of these sylvan apparitions—leaf, bush, raffia covering (Jengi)—mirrors the natural altars that some Pygmies use for sacrifice: a leaf laid upon the ground, or in the fork of a bush or tree, and the raffia used by Pygmies to delineate forest precincts of initiation.[13] In this spiritualized equation, yodeling is similarly mirrored by the hooting of the forest spirit, through the *molimo* pipe of the Ituri, in northeastern Zaire, or in the cries of the animated leaves and shrubs—*mokoondi* spirits—in the southwestern forests of the Central African Republic.

Besides marking an initiation place with raffia as a visual sign or warning, Ituri Pygmies may cast meat from a successful hunt onto the forest floor in gratitude to the forest, or may deposit small pieces of cooked food on a leaf placed on the ground or set in the fork of a tree. A hollow tree may serve as a place to share gathered termites with Tore, spirit of the forest;[14] the forest, in other words, gets a symbolic share, and trees grant these gifts a focus. The Ituri foragers accompany a thank offering with a laconic address to the forest spirit: "That is for you."[15]

The number of cultural objects involved in these "found altars" is quite small, reflecting the material simplicity of a hunting-and-gathering band on the move, and when the

Tree, Stone, Blood, and Fire: Dawn of the Black Atlantic Altar

group moves on, it abandons all such points of sacrifice. Yet a richness of metaphor and poetic association is involved in these traditions. Thus: "A hunter with an invocation for the next day's hunt, puts his spear beside the fork of the tree where he exposed the gift for Tore. He may also put an arrow under his head. When he dreams about a successful hunt, he knows that [the forest spirit] is with him."[16] In other words, the proximity of the spear to the point of sacrifice may infuse the instrument with luck or aura that the sacrifice has summoned to that point, just as when arrow cushions head, and head is filled with pleasant dreams of good hunting, object and image, it is devoutly wished, fuse felicitously within the future.

This rite reveals the fork-of-the-tree altar, however rudimentary in appearance, as a shrine at which a spirit can be invoked. Which makes us appreciate another kind of Ituri "found altar" as an instrument for directing the spirit to a point: the *amati a oni ganza,* a staff of wood that nature has dramatically distorted. Ituri foragers collect such strangely twisted branches in the forest and place them in the ground near the hearth of their men's religious association (*molimo*) "as an indication of spiritual presence."[17] Their Bira neighbors place similarly tortured branches outside their doors as guards against thieves.

Such objects warn that the forest, come like a moving bush or sapling to the door, is ready to punish should the case require. The name of these guards, *amati a oni ganza* (tortoise saw the circumcision), strongly suggests mystical surveillance. *Amati a oni ganza* (plate 11) are drenched with visual surprise and feeling. Spirit complicates the wood with sudden loops, then, just as quickly, resumes a normal verticality. Breaks in natural patterning guard the hearth with a striking vitality that surpasses human understanding.

Besides spirit-inflected wood, something else, flickering, spontaneous, fluid, becomes an altar among the foragers of Central Africa: fire. As trees focus offerings of meat, so it is with fire:

> Leaves and twigs were piled around the base of a young tree, and an ember
> brought from the camp set them ablaze. More leaves were thrown on so that
> dense clouds of smoke went billowing up to the invisible sky, until finally
> the flames burst through with a great roar of victory. . . somehow this act
> put the hunters in harmony with the forest and secured its blessing and
> assistance for the day's hunt. The Pygmies regard fire as the most precious
> gift of the forest, and by offering it back to the forest they are acknowledging
> their debt and their dependence.[18]

Fire altars also focus divination. Spiritually imbued Pygmies in the Central African Republic "read" the flames of a communal hearth for clues to problems blocking a band's well-being. Similarly, fire also radiates healing or assuagement: among some Central African bands an iron blade is inserted in the communal fire and when it turns glowing red, a healer puts his foot upon it and takes its heat, which he mystically transfers from his naked foot to the body of a sick or afflicted person.[19] The ritual importance of fire links Pygmies to the religious culture of the San.

On the arid plains of Namibia and Botswana, and in neighboring territory in Angola and South Africa, live the San, the famous hunting-and-gathering civilization of southern Africa.[20] The core of their culture is a circling dance of healers, centered about a fire. As among Pygmies intent on raffia-clad beings or strange moving leaves, the sacred goal of these trances of dancing shamans is spirit visitation. The shaman-healers activate extraordinary powers. Ecstatic, "boiling" with the healing spirit, they flutter their hands about afflicted persons, anointing their patients with their sweat as medicine.[21] Healers in trance speak a textless chanted idiom of syllables—*á yéa, yéa a, a hoo hoo, a yéa, yéa, hoo hoo, a a*—not unlike the yodeled vowels attractive to *mokoondi* far to the north.[22]

Spirit crackles in the flames: when men go into trance they "rush to the fire, trample it, pick up the coals . . . fire activates the medicine in them."[23] Women's handclapping and yodeling augment this double warmth, the fire on the ground and the fire in the mind. Like the healer's textless shouts and cries, their chorus, too, has few if any words: "For the most part, the singing is in syllables [that] are mostly vowel sounds."[24] The medicine burns in shouted vowels, handled coals, and sweat-anointed dance. The very names of the dances embody "things [that] are strong, as the curing medicine in the music is strong": rain, sun, eland.[25]

What is this San healing dance if not a kind of moving altar? "The curing dance draws people of a band together into concerted action as nothing else does. They stamp and clap and sing with such precision that they become like an organic being. In this close configuration—together—they face the gods."[26] Such is the intensity of the San shamans' silhouetted circling—a sacrificial action, a total giving of breath, sweat, and motion—that servitors in trance ultimately become icons in a round that in turn becomes a perambulating shrine.

As all of this takes place, supernatural potency (*n/um*) "cooks" the members of the round:

> N/um becomes stronger when hot. To heat their n/um, the men roll glowing coals between the palms of their hands, tramp in the fire, and throw coals over themselves. The exertion of dancing also heats the n/um. Eventually the n/um becomes so hot that it boils. The men say it boils up their spinal columns into their heads, and is so strong when it does this that it overcomes them and they lose their senses. This is how they explain trance. N/um is at its greatest strength for curing at this time.[27]

Blood sometimes rushes from the nostrils of a healer in this exalted state.[28] The red of the blood matches the red of the flames. It dramatizes *n/um* heat, "boiling" up the shaman's back, vaporizing consciousness, driving the dancer to a higher plane. San associate this trance-hemorrhage with blood streaming from the noses of dying elands;[29] it is the sign or seal of passage from this world to the next. Such blood is medicine. In the belief that its smell repels all sickness, San shamans rub its crimson substance on their patients.[30]

These shamans thus embody energy. Their touch, their finger-snapping, their sweat, their very blood, sometimes streaming from their noses—all turn into strong medicine. Like the grace of a *mokoondi* visitation among Pygmies, the summoned *n/um* brings good luck in hunting and other blessings.

PLATE 12: //XEGWI ROCK PAINTING (TRACED COPY), DRAKENSBERG MOUNTAINS, SOUTH AFRICA, EIGHTEENTH/EARLY NINETEENTH CENTURY. For the //Xegwi, a crack in a rock face might represent an opening between the two worlds—the present world and the world of the spirits. Such breaks in the stone's regularity could have the same significance that "break-pattern" or unusually shaped branches, *amati a oni ganza* (plate 12), would have for Pygmies—a suggestion of spirit agency. From David Lewis-Williams and Thomas Dowson, *Understanding Bushman Rock Art*, 1989.

Tree, Stone, Blood, and Fire: Dawn of the Black Atlantic Altar

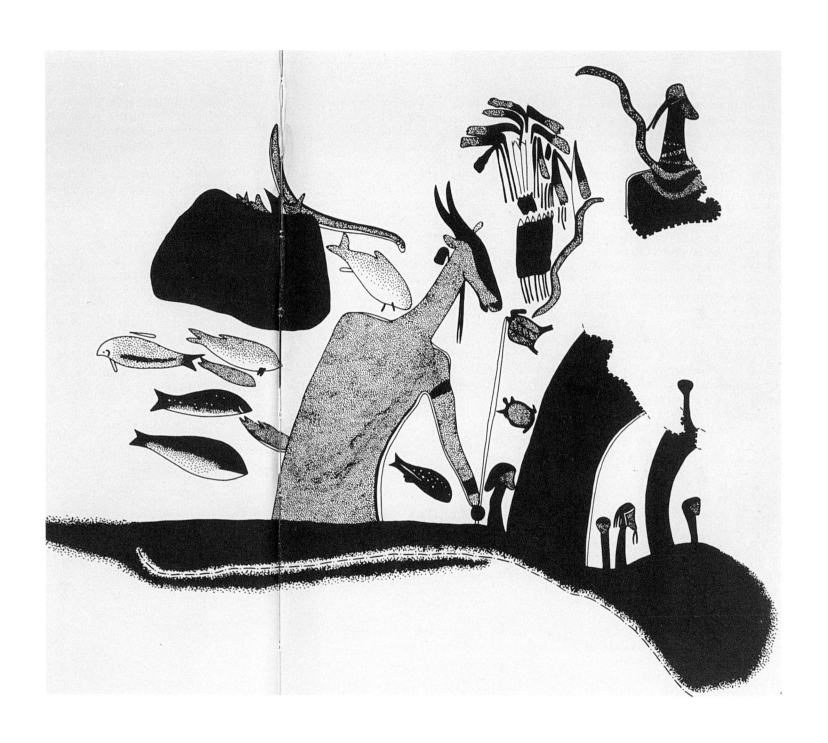

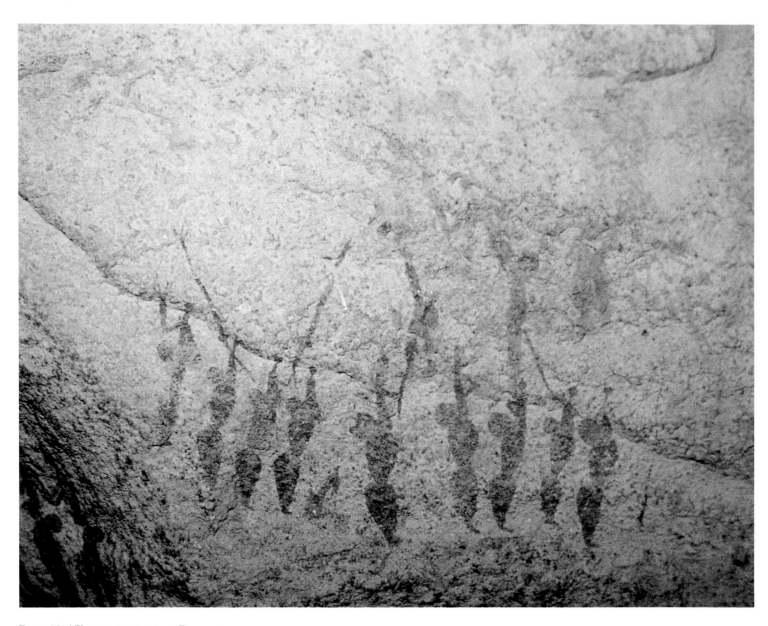

PLATE 13: //XEGWI ROCK PAINTING, DRAKENSBERG MOUNTAINS, SOUTH AFRICA, EIGHTEENTH/EARLY NINETEENTH CENTURY. This painting registers extreme sensitivity to cracks and ledges in the rock as natural frames for the figuration. Photo: Christopher Munnelly, 1992.

Tree, Stone, Blood, and Fire: Dawn of the Black Atlantic Altar

PLATE 14: //XEGWI ROCK PAINTING, DRAKENSBERG MOUNTAINS, SOUTH AFRICA, EIGHTEENTH/EARLY NINETEENTH CENTURY. The main figure, arms raised in apparent ecstasy, stands in or exits from a break within the rock face. Photo: Christopher Munnelly, 1992.

This dance is an altar built around a fire, galvanized by shouts plus constant dance and handclapping. It is sealed in sweat, blood, and the laying-on of hands. The fire and the circle are its light and its architecture. Dancers in trance become flesh-and-blood icons; their sweat and their blood are transformed from signs of exertion into gifts from above.

Among Western San, one instance is recorded of an altar given focus by a tree and fixed permanently upon the ground: O. Kohler, in his "Ritual Hunt among the Kxoe-San of Mutsiku," describes the placing of antelope heads upon a platform, a fixed altar that possibly reflects the cultural impact of Bantu neighbors.[31] But Southern San memorably translated their conceptually rich, materially simple healing-dance/altar into paintings on rock, the sovereign time-defying material. This tradition flourished among the //Xegwi, who once lived in the region of the Drakensberg Mountains, between what is now LeSotho and the coast at Durban in South Africa.[32] They, too, healed in dancing circles. Their genius, however, was to translate the legitimacy and power of shamanic healers—and their visions—into painted silhouettes in rock shelters (plates 12–16).

According to Lewis-Williams, excavations thus far provide no evidence for sacrifice in front of these rupestrine paintings.[33] But the rock face was, quite distinctly, a focus of "spiritual attention," a constituted altar. There are reasons for this estimation. First of all, a few //Xegwi painted-rock "shrines" (plate 17) were dramatic sites, selected at high points near the top of the escarpment of the Drakensberg Mountains. Such settings, where elevated, may possibly have encoded proximity to the divine: San believe that their gods and the attendant spirits of the dead all live within the sky.[34]

Second, many painters were shamans. This means that //Xegwi rock painting was a ritual act, and that their paint was power:

> Paint was prepared at full moon out of doors by a woman who heated it over a fire until it was red hot . . . shaman-artists used [eland] blood to infuse their paint with eland potency. . . as shamans danced, they turned to face the paintings when they wished to heighten the level of their potency. Paint [and the painted visions were] trance-inducing . . . a "good" person could place his or her hand on a painting of an eland and derive potency from it; a "bad" person would adhere to the rock and eventually waste away and die.[35]

Across tropical Africa, the spiritual activation of an altar is precisely marked by blood-moistened stone. Patricia Vinnicombe, a rock-art scholar, therefore argues that the shelters where the shamans painted with the blood and fat of elands mixed with ocher constituted a classic kind of sanctuary.[36] The rock shelter was thus an altar, charged with mystic force, and a point of moral judgment.

Thirdly, sub-Saharan altars, particularly those of the ancient Mande and the modern traditionalist Yoruba, are often caparisoned with images that directly reflect the postures and gestures of suppliants or ritual experts, seasoned voyagers into the realm of the spirit. Icons on such altars echo the stances and gestures of the worshipers. The same equivalence characterizes the figures on the rock faces, silhouetted miniatures of shamanistic postures, paraphernalia, and spiritual revelations. These mirrorings of devo-

Tree, Stone, Blood, and Fire: Dawn of the Black Atlantic Altar

PLATE 15: //XEGWI ROCK PAINTING, NORTHEASTERN CAPE PROVINCE, SOUTH AFRICA, EIGHTEENTH/EARLY NINETEENTH CENTURY. The mobile texture of the rock illustrates the shamanistic treatment of it as literally vital to the paintings—a living agent, collaborating with them. The painting shows a trance dance, with, at left, a shaman as a therianthropic figure—transformed as part antelope—shedding blood from the nose. Photo: T. A. Dowson, Rock Art Research Unit, University of Witwatersrand, Johannesburg.

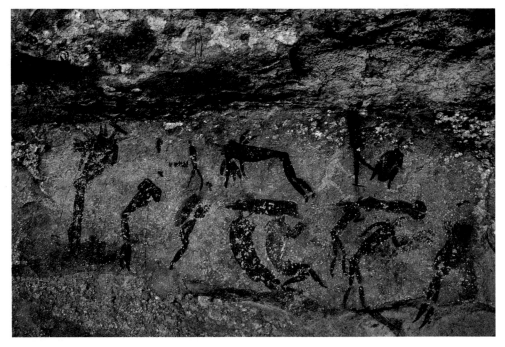

PLATE 16 : //XEGWI ROCK PAINTING, LESOTHO, EIGHTEENTH/EARLY NINETEENTH CENTURY. Two shamans stand transformed, and a fantastic serpent-like creature emerges from a step in the rock. Photo: T. A. Dowson, Rock Art Research Unit, University of Witwatersrand, Johannesburg.

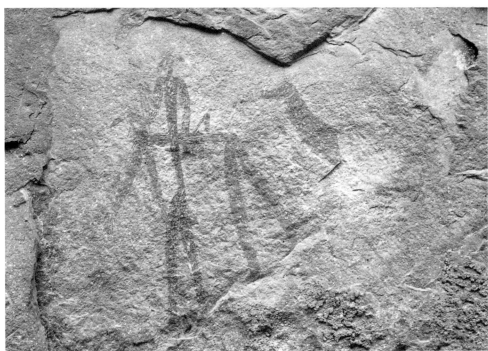

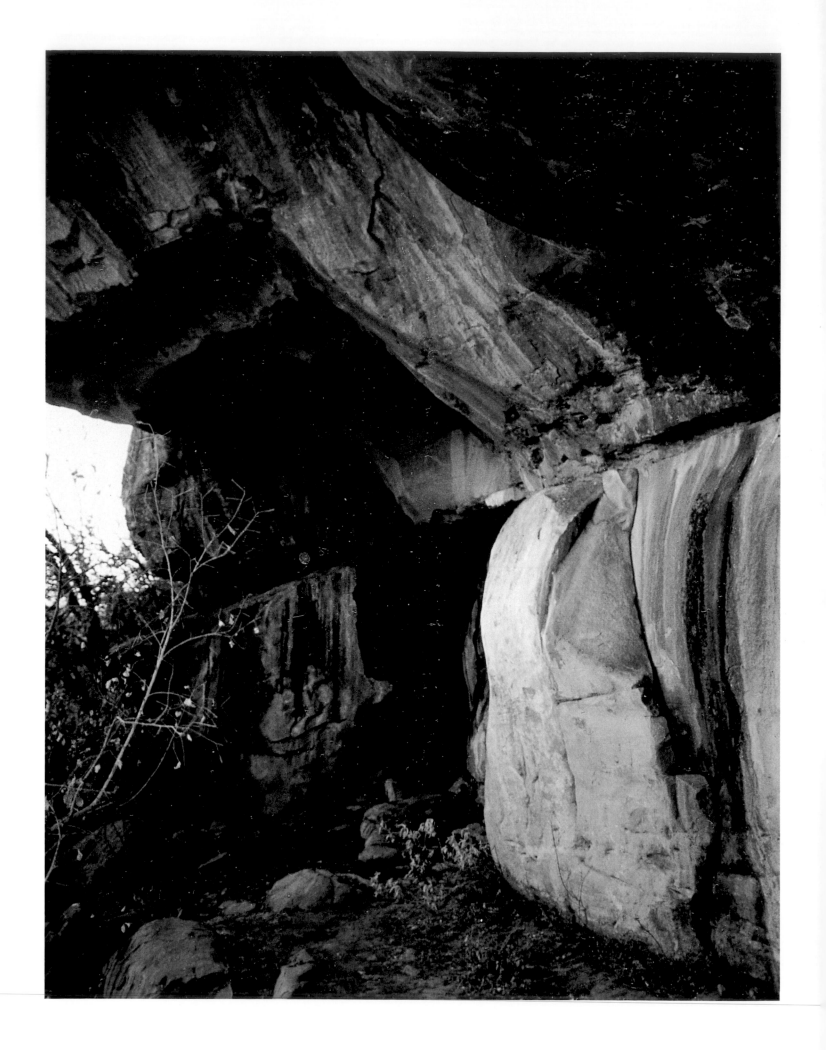

Tree, Stone, Blood, and Fire: Dawn of the Black Atlantic Altar

tions include kneeling figures with arms back, a position that the shamans sometimes adopt when falling into trance; trance-dancing figures bent over, often with dancing sticks and with red lines from the nose, documenting the nasal bleeding experienced by some entranced San healers; a legs-crossed stance—perhaps a "stagger step" used by an entranced shaman to mimic a dying eland, and to demonstrate that he, too, stands at the boundary of another world; painted figures with fly whisks, classic emblems of a dancing shaman; and images of ritually induced hallucination, including serpents bleeding from the nose (transformed shamans, perhaps).[37]

Finally, like the stones of the *orisha* on Yoruba Atlantic altars, the rock face itself held within its forms and undulations an existence of its own. It was not a neutral tabula rasa, like a sheet of white paper, but an undulating threshold of the spirit world, interacting with the shamanic imagery in ways wonderful and strange.[38] Just as staggering on crossed legs, or blood spilling from the nose, dramatized a threshold, a "break," in motion and identity, so shamanic artists carefully selected "breaks" in the rock surface to manifest a spiritual emergence or beginning. They clearly used small rupestrine openings, steps, irregularities in the rock, and other ruptures in the medium's flow to mark points of entrance or exit to the spirit world.[39] Just as *amati a oni ganza*, the twisted branches of the forest, mobilize for the Ituri Pygmies the pattern-breaking power of certain natural forms, so the San translate breaks in the walls of rock faces as spiritualized boundaries. For the shamanic mind the natural undulations of the rock, forever "boiling" like a frozen multitinted mist, would have seemed an attractive "paper" upon which to notate a hyperventilated vision.

The medium was the threshold. Spirit figures seemingly entered or exited from breaks within the rock (plates 15–16). Or they danced, posed, or gestured upon its crevices or ledges (plate 13). No wonder dancer healers turned to face these rock-face miniatures "when they wished to heighten the level of their potency."[40] The paintings were summaries of the entire religion. In that sense they were not unlike the windows of Chartres.

San and Pygmy "altars in motion," circling human bodies lit by sweat and fire, similarly fleshed out points of sacrifice involving body, sound, and movement. Among Pygmies, the point of sacrifice was "red" (fire) or "green": leaf, tree fork, forest floor, raffia-marked precinct. "Green" certainly was the answer of the spirits to this giving: the forest-authorized *molimo* sound in the Ituri, the moving green of raffia- or leaf-covered spirits farther west among the Pygmies of the Central African Republic.

Pure "red," by contrast, characterized sacrifice and spiritual response among the San. The color of the flames at the nucleus of the healing round was matched by the blood from the nose of shamans in the spirit. Then fire-ritualized ocher and the blood of elands continued the crimson theme in the reconstituting of healers' dancing, in miniature, on the painted rock.

Seen together, the green of the forest and the red of the fire and the blood writ on stone unite with the circle of inspired dancers at a locus of exaltation: the dawn of the Black Atlantic altar.

A Chart for the Soul:
The Kongo Atlantic Altar

Lutélama, lutélama, lusikímisa nzá
Keti yau yateka kala bonso yateka ba.

Stand up, stand up, and wake the world
So it again becomes what it formerly was.
 —Efraim Andersson, *Messianic Popular Movements in the Lower Congo*,
 1958

Kisimba, the quartz crystal that captures moonlight, essence of spirit.
 —Allen Roberts, "Social and Historical Contexts of Tabwa Art," 1986

Bu lukweenda ku mpyaata, nde: luzika bambuta zeno.

We go to a priest of divination, who says: place an offering to your ancestors
on their tomb.
 —Yvon Nsuka, *"Une Prière d'Invocation Kongo,"* 1970

Altars occur in Kongo where worlds start and end. The primary altar is the tomb—the place where one offers words, ritual hand-claps, crockery, food, and libations to the ancestors. Here tree or grove adds focus to the worship. Then come extensions of the tomb, the *minkisi*, portable sacred medicines of God. (In the U.S., *minkisi*—the Ki-Kongo plural of *nkisi*, meaning a medicated image or *pacquet*—are commonly known as "charms.") These unfailingly enclose a bit of graveyard earth to capture spirit.

PLATE 18 (OPPOSITE): KONGO COSMOGRAMS. Kongo cosmograms, documented in seventeenth-century collections of Kongo art now in Copenhagen and Rome, go back for centuries, very likely to the very rise of Kongo civilization. Top to bottom: the *dikenga* sign, its cross denoting the crossroads or boundary between this world and the world of the spirit, its circle portraying the soul's cosmic orbit: birth, life, death, and rebirth. A cross tipped with solar circles marks the same "four moments" of sun and soul. A figure's light-shedding head reflects the vision of soul as sun or star. A diamond, sometimes with an internal cross or with diamonds or triangles at its points, is a variant of the *dikenga* sign; the topmost diamond here springs soulfully away from the body. An amphibian reptile, again of diamonds, crosses the line between land and water, evoking the soul's traversal of the *dikenga* crossroad. A figure takes a cross, symbolizing soul, for a head. All from Wyatt McGaffey, *Religion and Society in Central Africa. The Bakongo of Lower Zaire*, 1986. The spiral is another symbol of the soul's endless journey—hence the import attached to seashells in Kongo burials. From an early-twentieth-century *niombo* reliquary figure (see plate 19).

The considerable social centralization represented by the ancient Kongo city of Loango is said to have related to the elaboration there of large and complicated *nkisi* altars fixed upon the earth. Farther east, in the interior, one still finds the *lu-saba*, a temporary shed or enclosure serving as a kind of private altar where an *nkisi* is guarded by its priest. Some *minkisi* are also kept in the house, in the rafters. When communal needs are urgent, the *nkisi* becomes portable: for a healing or other session the *nganga*, the officiant, will take it down from the rafters or out from the *lu-saba* to the village square, where clients and *nganga* honor the image or bundle with words and dance.

Unusual rock, root, or wood formations, or special pools, are believed manifestations of powerful spirits called *simbi*, and may serve as "natural" altars. Persons in ecstasy invoke before such presences. The river, the cave, and the forest grove also figure in the Kongo topology of the spirit, as initiatory places wherein to meditate and communicate with the dead.

It is difficult, then, to pinpoint the Kongo altar. There is constant oscillation—between village square and nature, healer's shed and forest pool, tomb and mountain outcrop, ordinary site and place of astonishment. It is when the *nganga*, dancing, trembles at the coming of the spirit that the altar becomes perceptible as a realm of grace. This ecstatic trembling of the shoulders, called *mayembo*, is our best measure of where to look for "altars" among Bakongo. (Recall the discovery of "altars" in the spiritual warmth of fire and dancing trancers among the San.) When the *nganga* trembles with the spirit before a *simbi* pool or an *nkisi* bundle, he *becomes* an altar. Shrine and pilgrim are blurred into a mutual idiom. It is the *nganga*'s trembling shoulders, like a shrine flag fluttering in the wind, that identify the working altar.

In the spirit or otherwise, *nganga* may create yet another kind of "altar": sacred points or blazons drawn upon the ground. Extending the chain of spiritual inspiration from tomb to *nkisi* to *nganga* to these mystic cruciform figures, Kongo ritual experts might chalk one circle (*dikongo*) on the earth and another near the eye: "When the

A Chart for the Soul: The Kongo Atlantic Altar

novice bends down to look at the ground, he will have a vision of his entire departed *kanda* [clan], adults as well as children, because the circle has turned into a mirror."[1] Similarly, when an initiate into the redoubtable Lemba society among northern Kongo stood upon a cross drawn or chalked on the earth, he stood upon an altar of ancestral worth. As bride and groom unite before the Western altar, so the Lemba person married into mystic richness, standing over an emblem of two worlds. For the thing that unites all these Kongo altars, built, found, natural, or fleeting, is that they indicate the turning point (*dikenga*) where the pure power of the dead brings its radiance to the present.

Dikenga: Star Map for the Soul

The *dikenga* marks the crossroads, the tomb, the parting of the ways. It flags the vanishing point where village meets forest, where river meets sea, where the limitations of ordinary vision become acute. The *dikenga*, when drawn, becomes a template of the Kongo altar: a cross within a circle. The vertical axis, the "power line," connects God above with the dead below. The horizontal axis, the "*kalunga* line," marks the water boundary between the living and the dead.

The *dikenga* circle charts the soul's timeless voyage. Soul cycles as a star in heaven. To the Bakongo it is a shining circle, a miniature of the sun. Hence they mark the sun's four moments—dawn, noon, sunset, and midnight (when it's shining in the other world)—by small circles at the end of each arm of the cross, mirroring the immortal progress of the soul: birth, full strength, fading, renaissance. The four corners of a diamond tell the same sequence.

The *dikenga*, sign of cosmic turning, shapes Kongo consciousness. As such it perdures across the centuries. The leading Mu-Kongo scholar K. Kia Bunseki Fu-Kiau explains how this cosmogram captures the progress of the soul as a miniature sun: "*Nzila ntangu yikóndolo nsuka kinzungídila ye nzá; zingu kia muntu i tangu yankaka kinzungídila ye yau*" (The path of the sun endlessly circles the world; the life of the person circles, as another sun, within the same compass).[2] Echoing this vision is an ideogram discovered in a cave in Bas-Zaire: the Kongo person, arms up, in ecstasy, head blazing solar streams of light (plate 18).

In sum, soul replicates the sun in miniature. Brilliantly, it moves within its circle. Sometimes the circle turns into a diamond, but the turning points remain the same—birth, florescence, decline, renaissance. Sometimes, also, certain reptiles, like pythons shedding skin, miraculously reborn; and felines, crossing forests (the dead) and villages (the living); and amphibians, traversing land and water, logically weave themselves into the calculus. Another sign, depicting a head become a cross, shows the soul in flight. Its arms indicate the divide between this world and the next, and lozenge-shaped legs describe the familiar diamond form. The river in which it stands is another marker of the boundary between two realms. Bakongo also read the journey of the soul in the spiral of a seashell, the name of which, *zinga*, is in Ki-Kongo a homonym for the word for a long life (plate 18).

The Bakongo geometry of spirit, circle, diamond, spiral, and crisscross portraying the soul in flight, rounding the four corners of the world as power superior to time, traces back for centuries. Witness, for example, a two-world emblem that repeats across a cap for a seventeenth-century Kongo chief (plate 20). This splendid *mpú*, which entered the

collection of the royal cabinet in Copenhagen in 1674, documents a language of revelation and avowal.

Warriors of the Soul: Kongo Impact on Central Africa

In Kongo belief, the soul (*ndunzi*) resides in the forehead (also *ndunzi*). As emblem of the soul, the diamond accordingly appears on the foreheads of certain northern-Kongo and Kongo-related statuary, for example among the Bembe (plate 19). A diamond-form device also adorns the foreheads of many masks of the Punu, just to the north of Kongo in Gabon (plates 21 and 22).

South of Kongo, the site of the soul is more usually marked with a cross on the forehead. Among Chokwe in northeastern Angola, a special cross motif (*cingelyengelye*) can deck the forehead of certain masks (plates 23 and 24). Some are carved in praise of the beauty of women; here they center the power of a man.

Recognizing this province of shared ideographic symbolism helps solve a problem that has long challenged Africanists. Fang-area *bieri* reliquary guardians and Kota/ Mbeti/Bamba/Tsayi–area "*mbulu ngulu*" ("not quite an accurate name") reliquary guardians (plate 25) share the same function; why, then, are they so dissimilar? *Bieri* are commanding in their muscularity, their full-bodied quasi-naturalism; *mbulu ngulu* address us abstractly, as flat, sectioned, silhouetted signs covered with brass leaf.

The answer is: reliquary guardian figures among Kota, Mbeti, Bamba, and neighboring groups generally reflect cultural cognation with Kongo cosmography. Liberated from an infelicitous restriction to a single "tribe," they may be restored to broad cultural currents transcending language and location. Many so-called *mbulu ngulu*—the brass-plated Kota guardian images in which an oval face encloses a cross and the neck surmounts an abstract rendering of arms akimbo, so that the arms enclose a diamond void—clearly relate to a group of Kongo signs for soul and cosmos (see, for example,

PLATE 19 (BELOW LEFT): BEMBE *NIOMBO* RELIQUARY FIGURE BY MAKOZA OF KINGOYI, ZAIRE, CA. 1900–1934. This northern-Kongo statue bears on its forehead (*ndunzi*) a diamond, symbol of the soul (also *ndunzi*). Other signs have similar cosmological significance, the column of diamonds suggesting the spirit's spiraling cycle through life and death, the seashell-like spiral around the nipple invoking transcendence. There is a crisscross emblem on the heart. A cross is a powerful emblem in Kongo—simply to mark one on the ground may constitute an altar. Collection of the Musée Royale de l'Afrique Centrale, Tervüren, Belgium.

PLATE 20 (BELOW RIGHT): KONGO *MPU* (CHIEF'S HAT), "ANGOLA," COLLECTED IN 1674. Below the bold zigzag interlacing pattern appear interlocking clusters emblemizing the two worlds, the present world and the all-encompassing spiritual world described in the Kongo religion. In Kongo symbology, circles, diamonds, spirals, and crosses all stand for movements of the soul in the dimension of the spirit. Photo: Robert Farris Thompson. Collection of the Etnografiska Museum, Copenhagen.

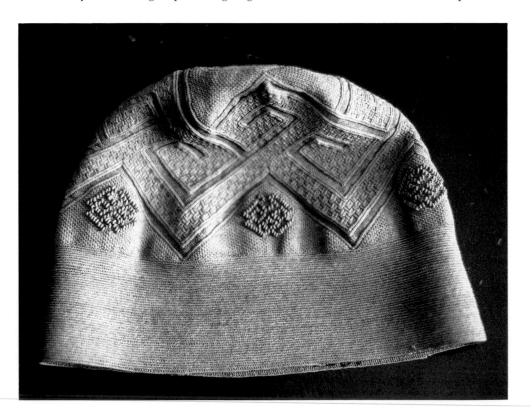

A Chart for the Soul: The Kongo Atlantic Altar

PLATES 21 AND 22 (RIGHT): PUNU MASK, GABON, MADE BEFORE 1949. PLATES 23 AND 24 (BELOW): CHOKWE MASK, ANGOLA, MADE BEFORE 1939. Diamonds and diamonds within diamonds adorn forehead and cheeks of the Punu mask. In the *cingelyengelye* motif on the Chokwe mask's forehead the points of a diamond are extended into crisscrosses and triangles, a variant of the cross tipped with circles (plate 18). Both collection of the Buffalo Museum of Science.

plates 18 and 27). As a Chinese ideogram reads across languages, as numerals like *1* and *2* can be read across Europe, so these images strike a powerful pan-"tribal" warning pose: "Our world lacks a sun, our world is empty, our world is death, moving by itself—step forward without communal authorization and fall immediately into something very serious."[3]

In northwestern Kongo there are Vili masks, associated with healing and divining, that cryptically embody the four-point boundaries of the soul's orbit. This they do through partitions of different colors, as in the sectioned face of the *mbulu ngulu*. But these are more than faces; they are charts of the spirit. Take as immediate example a mask representing a person from the world of the dead, a masterpiece of Vili art (plate 26). Vili call this styling of a countenance *ngobidi*, "grand mask of intimidation." The work, now in the Vatican Museo Missionario-Etnologico, dates from the first quarter of this century, and was collected before 1924.

A shieldlike pattern, in red and white, surrounds the eyes, and surmounts a totally black area beneath the nose. An appended leather goatee emblematizes wisdom. Down the nose streaks a line—*kala*, black—which indicates that this spirit has the power to close, or open, the viewing of the other world. The spirit wheels into the night, in the dark below the nose, and wheels back in the dawn, in the brilliance about the eyes. Ancestral knowledge, communicated in the colors and divisions of the design, underscores a power to heal. In 1887, for the Berlin Museum für Volkerkunde, William Joest collected a similar mask worn by an expert in curing the sick.

The same visual medicine, with the same three colors—red, white, black, preserving the completion of the soul's circle—passed into the twentieth-century world of messianic Kimbanguism in Bas-Zaire. Consider some Kimbanguist *nkanda nzila zulu* (identity papers for the road to heaven) dating from 1945–49 (plate 28). They blaze with cosmograms, strikingly recombined. Kimbanguist visionaries considered these illuminated papers sacred passports to the sky: "On the occasion of a burial they [were] placed in the hand of the deceased who [would] thus not . . . appear empty-handed at the gate to the other world."[4]

PLATE 25 (LEFT): KOTA "*MBULU NGULU*" RELIQUARY FIGURE, GABON, MADE BEFORE 1950. As with the Chokwe, Bembe, Punu, Vili, and other peoples, the Kota share elements of the Kongo cosmography. Their reliquary guardian figures, for example, simplify the human body into a pair of arms akimbo—that is, arms outlining a Kongo-like classic diamond. Collection of the Buffalo Museum of Science.

PLATE 26 (RIGHT): VILI *NGOBIDI* MASK (GRAND MASK OF INTIMIDATION), COLLECTED BEFORE 1924. Bright red-and-white patterning around the cheeks and brows of the *ngobidi* mask cedes to black in the lower half, qualifying the mask as a two-world emblem. It represents a person imbued with power from the dead. The black line down the nose is said to indicate this person's power to close or open the viewing of the other world. Collection of the Vatican Museo Missionario-Etnologico.

PLATE 27 (ABOVE): KONGO COSMOGRAM. A cross-over-diamond pattern (soul and its journey) links the characterization of face and limbs in both this Kongo cosmogram and the Kota reliquary figure (plate 25). From Wyatt McGaffey, *Religion and Society in Central Africa. The Bakongo of Lower Zaire*, 1986, cover illustration.

A Chart for the Soul: The Kongo Atlantic Altar

Nkanda nzila zulu transferred into the modern world of passports, borders, and identity papers the ancient signs of the voyaging soul. Once appliquéd or painted onto the chests of the famous *niombo* reliquary images of Kingoyi in northern Kongo (plate 19), these include the spiral of return, the python of transcendence, the rectangle of the cosmos split between the living and the dead, death and renaissance, and from navel to heart, and various mystic mats for travel across the two worlds. In the Kimbanguist passport, mystic mats become airplanes, or trucks with steering wheels shaped in the sign of the cosmogram. In the example illustrated, the Christian cross puns on an airplane to heaven, star propellers all awhirl. Souls flash as stars. One shines within a circle, radiating black and red, manifestly a sun in miniature.

A similar idiom of transcendence, also in red, white, and black, lights up a Kidumu-society mask of the Tsaaye (Teke) civilization in the republic of Congo (plate 29). M.-C. Dupré, the expert on these art forms, was told such masks did not represent a face.[5] Indeed they do not. They capture, abstractly, the soul in circling motion. This is true in terms not only of the mask's roundness but also of its scalloped edge, involving the eye in a carousel.

But this diagram of spirit is more than a circle: it divides into two worlds. The world of the living is rendered by the upper half, which is a fraction of an inch higher in relief than the lower section, the world of the dead. "Eyes" of the ancestors, totally white, may appear in the lower zone, together with a cosmogram inscribed in a tiny circle near the

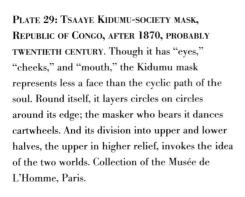

PLATE 28 (OPPOSITE, LOWER RIGHT): KONGO *NKANDA NZILA ZULU* (IDENTITY PAPERS FOR THE ROAD TO HEAVEN), BAS-ZAIRE, 1945–49. Kimbanguism is a messianic religion combining Kongo and Christian patterns of belief. Transforming the Western *carte d'identité*, Kimbanguists of the '40s drew up passports for the journey to the spirit world. The crosses within circles are *dikenga* signs; in the yard shows of black North America, such spinning crosses and circles are countered by pinwheels, tire planters, and, in at least one case, a literal propeller (plates 72, 78). From Efraim Andersson, *Messianic Popular Movements in the Lower Congo*, 1958.

PLATE 29: TSAAYE KIDUMU-SOCIETY MASK, REPUBLIC OF CONGO, AFTER 1870, PROBABLY TWENTIETH CENTURY. Though it has "eyes," "cheeks," and "mouth," the Kidumu mask represents less a face than the cyclic path of the soul. Round itself, it layers circles on circles around its edge; the masker who bears it dances cartwheels. And its division into upper and lower halves, the upper in higher relief, invokes the idea of the two worlds. Collection of the Musée de L'Homme, Paris.

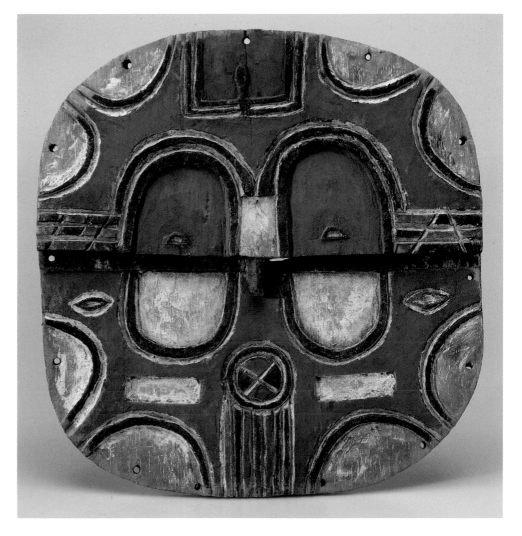

bottom. Rectangular areas carved in either "cheek" are filled with white clay, like tiny tombs (plate 30).

The cryptic telling of the world in motion continues in Kidumu-society choreography: the masker *cartwheels* before his audience. It is said this mask was "invented" around 1870, to go with the cartwheels. But the invention involved a reconstellation of a host of earlier, traditional concepts and symbolizations. In northern Kongo, for example, each time a cartwheeler touched the ground with the palms of his hands, he was "walking in the other world."

All of these examples—seventeenth-century Kongo, nineteenth-century Punu, Tsaaye, and Chokwe, twentieth-century Vili and Kimbanguist—portray the indelible presence of a widespread ideology. More evidence could be assembled, including the cruciform-body-in-a-frame designs of the Holo (plate 31), and even, through distant but powerful Bantu cognation, the four-point, all-seeing eyes of the cosmogram identifying the 'Alunga (cf. *kalunga*, "ocean, completion, God," in Ki-Kongo and other Central African languages) mask among the Bembe of Zaire (plate 32).

In Kongo and Angola, *dikenga* ideology perdured across the four centuries of the slave trade. It was from this place and span of time that such patterns traveled to the Americas.

PLATE 30: TSAAYE KIDUMU-SOCIETY MASK (DETAIL), REPUBLIC OF CONGO, AFTER 1870, PROBABLY TWENTIETH CENTURY. Bars filled with white clay (*mpemba*), ancient Kongo medium of the spirit (white is the color of the other world), mark the "cheeks" of the Kidumu mask in its lower half, which stands for the world of the dead. For "mouth," the mask has a *dikenga* sign. The "goatee" of striated lines may imply wisdom, like the beard of the Vili *ngobidi* (plate 26). Collection of the Musée de L'Homme, Paris.

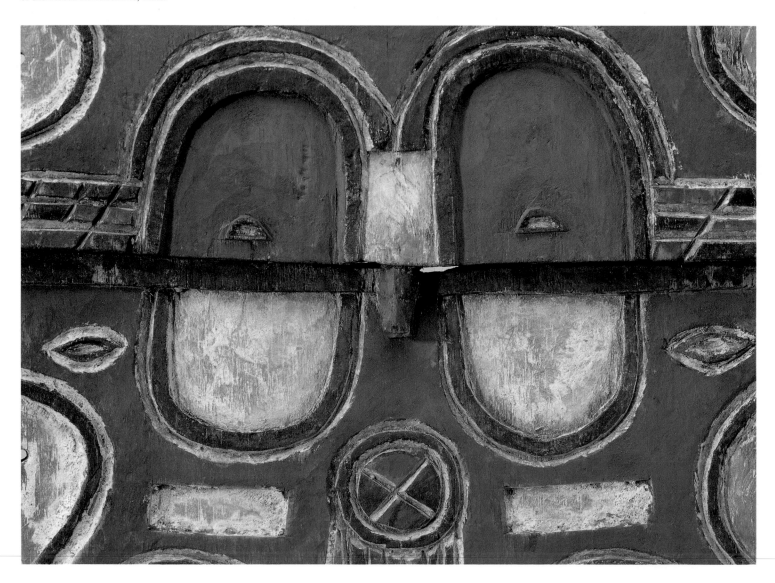

A Chart for the Soul: The Kongo Atlantic Altar

PLATE 31 (ABOVE): HOLO *NZAMBI* (ALMIGHTY GOD) FIGURE, WESTERN ZAIRE, TWENTIETH CENTURY. The very shape of this figure, incorporating its own frame, outlines a Kongo-like cross. Circled cosmograms appear to left and right at the bottom of the figure. Collection of the Musée Royale de l'Afrique Centrale, Tervüren, Belgium.

PLATE 32 (ABOVE): BEMBE 'ALUNGA MASK, ZAIRE, TWENTIETH CENTURY. The 'Alunga mask's enormous eyes are themselves *dikenga*-like signs— four-pointed diamondlike crosses within circles filled with the kaolin of the other world. And the mask's name apparently relates to the Ki-Kongo *kalunga*, "ocean, completion, God." The "*kalunga* line" is the boundary of the spirit world. Collection of the Musée Royale de l'Afrique Centrale, Tervüren, Belgium.

Kongo in the Atlantic Trade

Kongo and Angola accounted for approximately forty percent of the ten million or so African captives who landed in the Americas between 1500 and 1870. Kongo and Angola captives made up the majority culture among the slaves of New Orleans, South Carolina, Cuba, Haiti, and Brazil. Their influence was very strong.

As John Thornton writes, Kongo captives arriving in the Americas did not face as many barriers to cultural transmission as some scholars, overlooking the very aesthetic and spiritual principles that best survived the Atlantic Trade, have maintained.[6] Even the notion that slavery destroyed African social structure, an assertion about which materialists in particular are absolutely confident, can be challenged. Witness the appearance in the nineteenth century of miniature, idealized versions of the court of ancient Kongo in the *congadas* of Brazil, with their kings and queens, and in Cuba, where, at Sabanilla del Comendador, there was "a king who was king of all the Bakongo of Matanzas and once a year one would go there to pay him homage."[7] Witness also the intense and intricate codes of honorific greeting that characterize the elaborate protocols of the black Mardi gras "Indians" in contemporary New Orleans.

African kinship structures were replaced by adoptive kinship structures in myriad underground versions of the Kongo classical religion, led by visionary priests and priestesses. Proof of the power of these groupings, from Montevideo and Rio to Havana and New Orleans, is that women and men sharing Kongo beliefs and creativity, and getting together at festivals and funerals, shaped sounds and motions that would later define whole chapters of twentieth-century popular music: tango, samba, rumba, jazz. These Kongo influences are known and documented. They are matched by new evidence showing that a Suriname sparring dance, maroon *susa*, stems directly from the battle of footwork known as *nsunsa* among Bakongo; that the *riya/ra* ritual opening to Kongo tales was creolized into the *cric/crac* formula of the blacks of Haiti and Martinique; that the bumping of waists to end a dance, Kongo *bakana*, became Afro-Cuban *vacunao* and Afro-Brazilian *umbigada*; that Kongo *tiénga*, circulatory hip motions, became the Kongo grind in U.S. jazz dance and *gouyade* in Haitian choreography; and that the thigh-and-chest-slapping dances imparting confidence and self-spirit in Kongo *kamba* evolved into nineteenth-century North American patting juba, twentieth-century black-Brazilian *bate coxa* (literally "slap thigh" dancing), and twentieth-century hambone in the black United States.

Further expressions—the conga lines of Afro-Cuba and the ring shout of the Deep South Old Time Religion—brought back the circling "altars in motion" not only of Kongo play and worship but, before them, of San and Pygmy styles of reverence by the fires of God and the forest. As Sterling Stuckey notes, "The circle imported [to the Americas] by Africans from Kongo was so powerful in its elaboration of a religious vision that it contributed disproportionately to the centrality of the circle in slavery."[8] Alternative "altars in motion," circling and stamping and laced with Pygmy- and San-like yodelized shouts and ecstasy, broke out before the Judeo-Christian altar as before the many forms of altar that dot the Kongo landscape.

There are deep implications to these freewheeling forms. They take us back to Kongo, where it is believed that although we fade and die, we wheel back strong, new, and purified in the persons of our grandchildren, whose resemblance to our faces, voices, and

manners of walking will be duly noted by the spiritually endowed. Those who have lived an especially full and generous life wheel back in such indestructible forms as a piece of quartz, or a waterfall, or a bright distant star.

Above all, just as an old-time black spiritual tells us that we all have a right to the tree of life, so the Kongo religion teaches that we all have a right to the full round of existence, though our safety in that passage is not assured: "Now and in the past, people take it for granted that the successful functioning of the body, physical and social, depends on the integrity of its soul. The soul should be round, like the sun, but witchcraft attacks may cause it to crumble at the edges [*vézuka*, to break into pieces], rendering the body vulnerable."[9] Thus one of the first things a parent might do for a child in Kongo would be to fashion a small round disk from wood or a seed, perforate it, and attach it to a string to hang over his heart or tie around her neck, waist, or ankle. This would become a guide and charm to the child's soul, guarding its round boundaries, charting the child's safe circuit to maturity and old age. The Ki-Kongo phrase is precise: *Lunda lukóngolo lwa lunga*—keep the circle of the child complete.

Cut to the late-eighteenth-century Annapolis townhouse of one of the signers of the Declaration of Independence, Charles Carroll of Maryland. In a room where black persons worked, numerous ritual objects have been found in a cache clearly datable to 1790–1800: not only pieces of quartz, automatic emblems of spirit-flash (referring to the *simbi* spirits of the Kongo religion), but further Kongo-like charms, and a "found cosmogram" on a piece of pearlware (plate 33).

The meanings of quartz (*ngéngele*) in Kongo are various. Priests award it to certain elders as a sign of trust. They give it to those in whom the community has faith, and it figures in the making of important charms like *nkita nsumbu*. Another name for quartz in Ki-Kongo, *mpézomo*, recalls the flash (*vézima*) of lightning;[10] the brilliance of this icelike stone can arouse the spirit perennially. That light associates its crystals with *simbi* spirits, who are in turn aligned with exciting, inspired, charismatic leaders. Such persons serve as a conduit for knowledge from the other world: "They kept this 'simbi,' this quartz, 'this guardian star,' as a sign that the important spirits will guide and protect them, so that anything they brought to the community, from the ancestors, would be to its general benefit."[11]

There is another famous manifestation of *simbi* besides quartz—medicinally powerful, strangely shaped roots. The appearance of caches of quartz crystals in colonial black America, then, certainly implies the copresence of "root men" and "root women"—healers working with roots and herbs for the caring of their people.

The Annapolis cache also preserves a pearlware vessel, found, significantly, upside-down, as if in communication with the ancestors. It bears a handpainted asterisk design in its base. Kongo people would certainly have seen this found symbol as a cosmogram, channeling forces of the spirit. Intriguingly, the Carroll House cache also contains three flat disks, seemingly cut from bone, an inch and a half wide, and perforated for wearing. The apparent use of bone, which points to "the white," the other world, was probably meaningful.

The recurrence of perforated disks, quartz stones, and asterisk-centered crockery fragments in other North American colonial sites attributed to black habitation suggests a widespread ritual usage. To which can be compared, for a last example, the combination

PLATE 33 (RIGHT, ABOVE): CONTENTS OF A CACHE
FOUND IN THE CHARLES CARROLL TOWNHOUSE,
ANNAPOLIS, MARYLAND, 1790–1800. Among the
contents of the Carroll House cache are quartz
crystals, perforated disks apparently of bone, and a
crockery fragment bearing an asterisk. In Kongo,
quartz is used in important charms, and to honor
the spirits known as *simbi*. Its brightness is
treasured. Kongo people also sometimes wear
wooden disks, or round seeds, perforated and
strung on cord, to protect the circle of the soul.
Kongo captives in the Americas would surely have
read the pottery asterisk as a found cosmogram—a
star (*mbwétete*), a sun, a soul. Photo: Lynn Jones,
Archaeology in Annapolis, 1992.

PLATE 34 (RIGHT, BELOW): CONTENTS OF KONGO
NKISI MBENZA CHARM, NORTH KONGO, LATE
NINETEENTH/EARLY TWENTIETH CENTURY. Along
with twisted roots (like quartz, often manifestations
of *simbi*), this African charm included quartz
crystals, bones, and pierced round disks or seeds—
intriguingly similar to the Carroll House cache.
From Karl Edward Laman, *The Kongo*, Uppsala,
Sweden: Studio Ethnographica Upsaliensia, 1962.

of bones, twisted roots, a pierced round seed, and five pieces of quartz crystal that make up the old and important *mbenza* charm in Kongo (plate 34). *Mbenza* call on *simbi* "to open the womb for a rich progeny."[12]

Whatever the precise functions of the crystals, pierced disks, and cosmogram found in Maryland, almost assuredly they announce nothing less than the planting of Central African religious practices on the soil of North America. These traditions would fan out across the continent.

Cut to Mark Twain, *The Adventures of Huckleberry Finn*. Focus on the "charm" that Big Jim wears: "Jim always kept that five-center piece around his neck with a string and said it was the charm the devil [*sic*] give to him with his own hand and told him he cure anybody with it and fetch witches whenever he wanted to, just by saying something to it." "Jim was most ruined, for a servant, because he got so stuck up on account of having seen the devil and been rode by witches."[13]

This observation is filtered through the mind of a major novelist, writing for drama and effect. But, reflecting Twain's command of the black vernacular, brilliantly argued for recently by Shelley Fisher Fishkin, it rings true.[14] The nickel, made of silver, continues "the white" of the apparently bone disks of the eighteenth century; its flash and circularity protected Jim's spirit, and for him would almost certainly also have connoted power through money. And the self-confidence fostered by this secret source of power strengthened him, "ruining him for a servant." Similar objects backed the valor of persons leading slave revolts, like Gullah Jack in South Carolina.

Cut again, to a novelized eviction scene in twentieth-century Harlem. In a passage in *Invisible Man*, Ralph Ellison is annotating certain objects owned by back-home elders, sacred items they have brought with them to the northern city: "a dime pierced with a nail hole so as to be worn about the ankle on a string for luck."[15] Ellison, like Twain before him, was dipping into the well of black tradition. He was dramatizing a phenomenon reported on by N. N. Puckett: "Some Negroes openly say that [a silver] coin keeps off evil spirits. . . . Frank Dickerson says only a silver ball will do the work (he carries one himself)."[16]

Senegambians too wear copper coins about the heart for protection, but this is another tradition, another medium. The Kongo custom involves round seeds or round light wood for wear not only about the heart but also around the ankle, close to the foot, and to the unfolding of one's path.

In September 1991, in Virginia's Accomack County, Grey Gundaker, the leading anthropologist of traditional African-American writing and graphic signs, discovered an improvised African-American altar: out of the circle of a tire, in which red and white flowers grew together with a seashell, arose a found tree-trunk painted white, itself surmounted by a silver ball. Out of the ball emerged more flowers, again red and white. As a gardener's statement, universally communicating "decoration," the flowers offered camouflage, softening the seriousness of the complex: tire, shell, tree, silver sphere, the color red (means of communicating), the color white (the other world).[17]

An ancient insistence recrystallizes upon a lawn in North America. The tire puns on circling, a giant dime revolving. A seashell classically protects the journey of the soul. The climax is the silver ball, spirit and cosmos, all in flash and roundness. This tidewater lawn introduces a whole new chapter. But before we enter this marvelous world, we

briefly consider altars among Kongo creoles of Cuba and of Afro-Cuban New York City.

Masters of the Forest and the Sky:
Cuban Kongo Altars and the Art of José Bedia

*Tadeo got off the boat at Cárdenas. They put him to work on the Manacas
sugar plantation and from there [took him to] Santa Rosalía, but in his
thoughts he kept on living Kongo.*
 —Lydia Cabrera, *Reglas de Congo Palo Monte Mayombe*, 1979

The Kongo religion did not establish itself anonymously in nineteenth-century Cuban
slavery. Women and men like Lydia Cabrera's Tadeo, defiantly Kongo, spoke the sights
of the forest, spoke the powers of the crossroads, and covertly reestablished the authority
of their spirits and religious leaders. This they did in a creole Kongo way.

Havana they renamed Kuna Mbanza, "to town over there." Their worship, emerging,
took a creole name: *Regla de Mayombé*. Yombe is a northern-Kongo group, east of the
Vili. And *regla* means "rule." This means king, this means queen. This means rediscov-
ered royalty, as in one man's evocation of the nineteenth century: "The [Cuban] Cabildo
of [our] Royal Bakongo . . . was Kongo dia Ntótila *de verdad*, the very Kongo court with
King and Queen, and entourage and everything, all in order and respect . . . [in these
rooms] we were governed a la africana."[18] Kongo centenarians like Pachilanga (1803–
1928), Ta Antón of Cárdenas (ca. 1855–1955), and "Kongo del Kongo" (1846–1946)
tutored the creole nation within the nation and guarded its continuity.

Persons like Tadeo—assigned to the sugar-cane fields, assigned to the big house—
secretly made *minkisi* ("he was a mighty *nganga*," Cabrera writes) and kept the faith.
Tadeo tutored younger, Cuban-born, non-Bakongo blacks in Ki-Kongo language and
religion. He favored those who could take his rough humor.

When a child was born to Cuban Bakongo, seven *nganga* "baptized it in the style of
their tierra, protecting its head with vows to their charm, *nkisi malongo* [*nkisi
Malwangu*?], that death not come, nor evil harm its body. And they took the infant into
the forest, with a [votive] rooster and a [votive] rodent. There they made sacrifice [to the
ancestors] and came out in procession singing, with the infant in their arms, *ngángula
musi, ngángula musi* [the blacksmith, the blacksmith]."[19] Through the intelligence of
such worshipers the Kongo forms of altar reemerged: riverbank, forest, crossroads,
blazon on the earth, and, most dramatically, cemetery and *nkisi*.

Reading Fernando Ortiz on nineteenth-century Cuba, one gets the impression that
underground Kongo religious practice wired the entire island. Runaway slaves, *matiabos*,
headed for Cuba's mountainous interior. Here is one of their shrines: "an altar, made of
branches and sticks and on top of this was placed the skin of a goat . . . on this altar were
rooster spurs, cow horns, shells, and seed rosaries."[20] The militancy embedded in spurs is
obvious. Horns, shells, and rosaries may have referred to other powers, like medicine,
divination, and perdurance. Also in the *palenques*, the runaway-slave settlements, "were
discovered wooden images with chicken feathers, earthen stewing pans filled with a
resinous mass in which were nailed the teeth of bush rats . . . pieces of mirror, etc."[21]

A Chart for the Soul: The Kongo Atlantic Altar

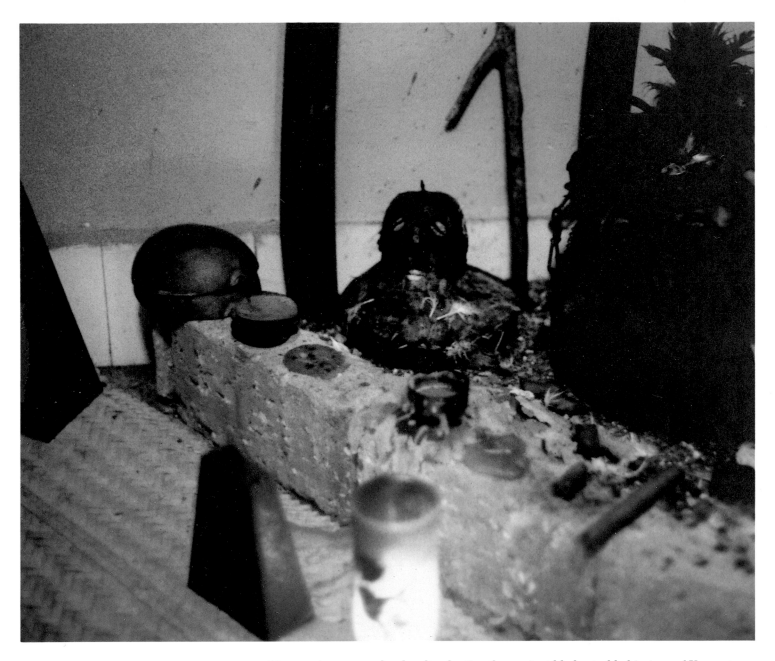

PLATE 35: JOSE BEDIA'S *MUNANSO* FOR *NKISI SARABANDA*, HAVANA, CUBA, NOVEMBER 1986. The *Regla de Mayombé* is the Cuban descendant of Kongo worship; the *munansó* translates the Kongo *lu-saba* shrine. This one, hidden in a closet in an urban apartment, included a red-brick enclosure (*luumbu*) with an *nkisi* or "charm" to the spirit Sarabanda (right): a cauldron filled with feathers, earths, sticks, stones, beads, and iron. There is also a mirror-stoppered cow's horn (*mpaka*, not visible), for divination; a hooked branch (*lungowa*), attracting positive spirit and repelling evil; and a cowrie-eyed figure, Lucero, guardian of the spiritual crossroads that such a shrine constitutes. Photo: Robert Farris Thompson, 1986.

Here we have a creole *nkondi*, adapting the ancient blade-studded images of Kongo to New World contingency, "nailed" in an earthen pan. The *nkondi* "hunts." In this case he hunts from a mystic point of aerial surveillance (the feathers), warning the Afro-Cuban *nganga* and his following of the approach of Spanish soldiers. His "bite" is as strong as the teeth of rodents. With medicated mirrors, he secures the *matiabos'* independence.

Throughout the nineteenth century Cuban police harassed the *mayomberos*, interrupting worship, confiscating *minkisi*, but the religion kept going. Not without changes, though. By the twentieth century the Kongo *lu-saba* had become the Cuban *munansó*, distinguished, barely, from other rural habitations by a red or white flag on the roof or door. A chaste simplicity defined its interior: wooden walls, earthen floor, charms in their vessels, and maybe a banner, plus accessories for healing and divination. Here the Kongo tradition of *nkisi* enclosure continued to flourish: "The siting of the *minkisi* requires special conditions. They must be in isolated rooms, closed-off and must always rest on earth, for which a special kind of [brick-lined] edge is constructed."[22] This applies also to the modern city: in a Havana apartment in 1986 I photographed a closet in which a

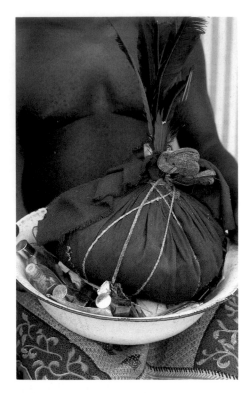

PLATE 36: SUKU *NKISI MBUKI*, KINSHASA, ZAIRE, EARLY 1970S. This Central African *nkisi* is tied in a bag within an enamel bowl, rather than enthroned in a cauldron like its Havana counterpart (plate 35). But it holds many of the same elements: sticks, feathers, earths. Both *nkisi* are modern, following separate lines of descent from common roots. Photo: Robert Farris Thompson, 1972.

priest had built a secret *munansó*, constructing the *luumbu* (enclosure) with a row of red bricks (plate 35). These held in place the specially brought-in earth on which rested his *nkisi*, the spirit Sarabanda, richly caparisoned with feathers, sticks, stones, beads, and irons.

This altar-in-a-closet also included a mirror-stoppered *mpaka*, a cow's horn, used for divination: when shaken, if nothing rattles, the horn says no; if material within audibly moves when jostled, it says yes. This mirror-in-a-horn is a Cuban version of the Kongo *nkisi lumweno*, mirror medicine. Its creole name, *vititi menso*, relates to ritual: when a novice is initiated into the preparation and care of *nkisi* and cows horn, the *nganga* may take leaves of the laurel, steep them in water, and wash the postulant's eyes in the mixture to make him clairvoyant. Hence *vititi menso*, literally "greens-about-the-eyes," or "leaves-in-the-eyes," describes this medicine of vision.

On creole Kongo altars there is also usually a crossroads guardian, with cowrie eyes and mouth, based on Echú but here called Lucero. Vessel, cow's horn, and Lucero form the essential triad of the Kongo-Cuban *nkisi* altar.[23] This Lucero replicates the shape and outline of the Yoruba-Cuban household deity of the crossroads (the African Yoruba Eshù-Elégba), but, like Exu and Pomba-Gira in black Rio, he is magnetized to Kongo concepts of *dikenga* down to his name—in Spanish, "morning star" or "evening star," a name redolent with images of things changing in the sky.

The *nkisi* itself is made according to Kongo recipes of earths and feathers and forest wood, modified by contingency. Bristling at top with the feathers of heaven and weighted at bottom with cemetery earths, it is a cauldron, continuing the form and function of Old World medicines of God. Indeed, inside an *nkisi mbuki* for psychological healing made in Kinshasa in the early '70s (plate 36) there are the same caparisons—feathers, the sticks of the forest, earths—we see studding the mouth of an *nkisi Sarabanda* in Cuba, linked around with heavy-duty Western iron and chains (plate 35). With his guardian clairvoyant, Lucero, Sarabanda towers over a changing world.

Many (not all) Cuban followers of Kongo-influenced religions fuse Yoruba *orisha* and Catholic saint with *minkisi*. In one shrine where David Brown has worked, multiple *minkisi* form a minipantheon: Sarabanda marching with Ogum and his irons, Siete Rayos fused with Changó/Santa Barbara, Madre de Agua with Yemanjá, Mama Chola with Ochún, Kobayende with San Lázaro/Obaluaiye, Tiembla Tierra with Obatalá.[24] Here, anthropomorphic personality is added to the Kongo *nkisi* complex of charm plus *bilongo* (medicines) plus chant plus taboos. At the core, however, nothing changes: as in Kongo, the charm is composed, filled with *bilongo*, and sung to, and it makes its taboos plain. The taboos suggest why Cubans call an *nkisi* a *prenda*, a pledge. One pledges not to eat such-and-such, not to do such-and-such, upon receiving the sacred medicine.

The creole lexicon of *nkisi* worship that took root in Cuba diverged only lightly from the parent structure. Meanings changed slightly, as well:

A Chart for the Soul: The Kongo Atlantic Altar

Cuba	Kongo	
fumbi	*mvumbi*, dead body	spirit in *nkisi*
kángila sila	*kanga nzila*	tie the road
kiyumba	*kinyumba*, ghost	skull in the charm
mambo	*mambu*, matters	song to the *nkisi*
matari	*matadi*, stones	stone
mpaka	*mpaka*, horn	horn for mystic vision
nfinda	*mfinda*, forest	forest, hill, cemetery
nkisi, *nkiso*	*nkisi*, charm	vessel with spirit
nsasi	*nzazi*, lightning	Changó/Santa Barbara
nso, *munansó*	*nzó*, house	temple, altar
ntóndele	*ntondele*, formal thanks	thanks
vititi menso	*vititi*, greens, and	a horn of mystic
	meeso, eyes	vision, stoppered
		with a mirror.

PLATES 37 AND 38 (BELOW): MURALS FRAMING A LATIN CATHOLIC–STYLE ALTAR IN A KONGO/ANGOLA *CANDOMBLÉ* TEMPLE, BAHIA, BRAZIL. Astral bodies—sun, moon, stars (see plate 106)—in Kongo and Kongo-derived imagery relate to the understanding of the soul as wheeling through day and night. Photos: Ian Churchill, 1985.

In Cuba as in Kongo, for example, one of the things the *nganga* does when setting up an *nkisi* is mystically secure the four corners of the room, square, or enclosure with acts and incantations. He does this chanting "*Kángila sila*," "Tie the road."[25] Creolization of the visual environment matches creolization of the ritual discourse.

As time went on, the *Regla de Mayombé* moved into larger areas of Havana. Space opened up. Thus, in Vedado, where large rooms and patios are available, the wall behind the *minkisi* is often painted blue, with stars indicating the cosmic wheeling of the soul. (A distinguished Kongo/Angola house in Bahia, Brazil, phrases matters similarly, framing a Latin Catholic altar with a painted setting sun at left and, at right, a rising moon above two trees; plates 37 and 38). Such astral depictions relate to the Kongo association of stars and meteors with souls in flight, peppering the sky with traces of the important dead.

Outwardly Yoruba, Lucero dovetails with the Kongo heritage. He is a *mbwétete*, a star of the spirit—a soul. This star rises, then fades before the sun, indicating the *nkisi*'s passage between the worlds of night and of morning. Lucero also protects the *nkisi* from outside perturbations, monitoring the protective palisade of bricks. There is, in fact, a Kongo invocation: *Mbwétete, mbwétete, tumba mikala* (Star, star, defend our boundary).

A hooked piece of forest branch (*lungowa*) in the Havana-closet *munansó* pulls spirit mystically into the vessel and pushes undesirable forces out. The *lungowa* opens roads and eliminates evil by mystically tying (*kanga*) or nailing (*koma*) matters into the *nkisi*. This in turn contributes to an even larger "hammering" of various coded pieces of forest wood, some with commanding or military names like *vira mundo* (turns the world) and *vence batalla* (wins the battle). All of which directly reflects the traditions of Kongo, where *nganga* hammer vows or admonitions into images with nails and blades and pegs (see plate 68) and sometimes even thorns, as magnificently exemplified by an example in Lisbon's Museu de Sociedada Geografia.

The cutting of these forest branches sometimes involves conversation with the moon. José Bedia, who is both a distinguished Cuban artist and an initiated priest of the *Regla de Mayombé*, illustrates this ritual in a painting of 1990 titled *Con licencia* (With [the moon's] permission, plate 39). A priest, ritually naked, kneels in the night before the

PLATE 39 (RIGHT): JOSE BEDIA, *CON LICENCIA* (WITH [THE MOON'S] PERMISSION), 1990, OIL ON CLOTH. A priest kneels to the moon, asking permission to cut a branch in ritual. At left is his *munansó*, the simple enclosure that protects the *nkisi*.

PLATE 40 (ABOVE): JOSE BEDIA, *CON LICENCIA* (WITH [THE MOON'S] PERMISSION; DETAIL), 1990. Bedia, himself a priest of the *Regla de Mayombé*, has concealed the *nkisi* within the *munansó* in *Con licencia* by fixing a cotton flap to the painting. Beneath the flap he has drawn the *nkisi* proper, hidden from everyday sight. Signed with a Kongo-like combination of crosses and solar circles (seal of the crossroads guardian spirit, Lucero), the cauldron contains a hooked branch or *lungowa*, an iron knife, and a skull. Photos: Robert Farris Thompson, 1990.

moon, whose permission he has asked before cutting a ritual branch of wood and leaves. This he will insert in his *nkisi* to multiply its power.

Behind him, shaped with natural branches, appears his rustic *munansó* (shrine). He protects his *nkisi* with a flap of cotton, which, uplifted, reveals an altar to Sarabanda (plate 40). It is signed with the seal of Lucero (*fimba lucero*): two crossed arrows, two suns, and two crosses. Lucero's signature orients the *nkisi* so that we know to which side to pray. The cardinal points code the spirit's omniscience.

The *lungowa* emerging from the *nkisi* again attracts the spirit. It is meant to represent the wood of the yaya tree (*Ozandra lanceolata*), one of the forest sticks offering spiritual deterrence. A skull completes the capture of the spirit. It is partially concealed, the artist punning on the half-curve of the rising sun. The knife is to cut ritual leaves. The tripod below harks back to the three primordial stones (*makukwa matatu malámbidi*) upon which the founding king of Kongo "cooked" the primordial medicines of the land and made the first *nkisi*. The flask is filled with whiskey; the priest takes a swig and spews it on the *prenda*, startling it into action. A candle is burning, to guide and to honor.

In Kongo the moon (*ngonda*) is seen as a source of well-being. To speak to the moon is to declare self-acceptance, *mu vova kwa ngonda i mu támbula ngeye kibeni* (because when you speak to the moon you are speaking as who you really are. You can't substract from nature unless you come meaning what you say and do). And the moon says yes, with countless streaming rays.

Part of the preparation of the *munansó* involves the ritual burying (*zika*) of the *nkisi* vessel beside a tree. Wyatt McGaffey shows that the Kongo person may tap the power of the dead by burying an *nkisi* in "strategic places"—at a tree or crossroads, or in a ceme-tery.[26] Burying is "nailing," arousing "the leopard" in the vessel for the glory of its owner. The tradition continues in Cuba, where the period of ritual interral is seven or twenty-one days. These seem to be not Ki-Kongo mystic numbers but more probably Yoruba ciphers associated with Ogún, the god of iron, and with Ifá divination. Ogún fits

the spiritual militancy of the Kongo religion, to the point where the Yoruba iron-and-war god and his Roman Catholic counterpart, Saint Peter (with the iron key to heaven), blend in the *nkisi Sarabanda*. Wood battles wood, *nkisi* fights *nkisi*, in an unending contest for protection of a person's soul. "The perpetual struggle with the unseen forces that cause illness and misfortune is called war in Kongo."[27] To bury the *nkisi* for seven days or twenty-one, iron's own numbers, drenches it with Ogún's militant edge.

Nkisi burial under a strong tree like the laurel adds time, growth, and power to the vessel's medicines. Bedia illustrates this ritual in a drawing that shows a naked man kneeling before a tree, his *nkisi* hidden in the earth before it (plate 41). *Nganga* sing a Kongo ritual song, a mambo, that explains the meaning of this act: *Debajo del laurel yo tengo mi confianza*—Beneath the laurel I keep my confidence.

PLATE 41 (ABOVE): JOSE BEDIA, *DEBAJO DEL LAUREL YO TENGO MI CONFIANZA* (BENEATH THE LAUREL I KEEP MY CONFIDENCE), CA. 1986, INK ON PAPER. Both Kongo and Cuban priests (both called *nganga*) may bury an *nkisi* for a certain number of days, to "nail" or awaken its power. In Bedia's drawing, the strategic site is beneath a laurel tree. Photo: Robert Farris Thompson, 1990.

PLATE 42 (RIGHT): JOSE BEDIA, *¿PA' QUE TU ME LLAMAS?* (WHAT ARE YOU CALLING ME FOR?), CA. 1986, INK ON PAPER. Singing and sacrificing before an *nkisi*, the priest may summon the spirit in the cauldron, and be possessed by it. This one, emerging, speaks: "*Yo soy Sarabanda*," "I am Sarabanda." Photo: Robert Farris Thompson, 1990.

65

PLATE 45 (OPPOSITE): JOSE BEDIA, DRAWING OF HIS OWN *NKISI SARABANDA,* summer 1991. Annotations identify the attributes of this most important spirit (see plate 44).

PLATE 43 (BELOW LEFT): CUBAN-CREOLE *NKONDI,* GUANABACOA CEMETERY, HAVANA, CUBA, LATE 1970S–EARLY 1980S. This cemetery *nkisi* includes a *lungowa,* the hooked stick of power; a cross honoring God Almighty, Nzambi Mpungu; and a seashell, for long life and the soul's eternal journey. Photo: Robert Farris Thompson, 1988.

PLATE 44 (BELOW RIGHT): JOSE BEDIA, *NKISI SARABANDA,* HAVANA, CUBA, 1988. What seems to be a laundry hamper in Bedia's apartment opens to reveal a shrine to Sarabanda, with sun, moon, and stars, cross for Nzambi Mpungu, iron implements, horn for divination, and other attributes. Many of these elements are charted in plate 45. Photo: Robert Farris Thompson, 1988.

Sometimes as the *nganga* sings this, he trembles, possessed by the spirit of an old black person from colonial days, hidden in the miniature cemetery that the *nkisi* constitutes. The ghost wafts out (plate 42), possesses the *nganga*'s body, and commands his voice. He now is singing in *bozal*, the creolized Spanish/Ki-Kongo of plantation days. Time melts. It could be Tadeo singing:

> *Yo entra finda*
> *Yo sale finda*
> I enter forest
> I exit forest

Afro-Cuban and Kongo history combine in the chanting of such language. Words from the past make tree and vessel, spirit and man, fuse into an altar.

The cemetery of Guanabacoa, across the harbor from Havana, yields an incredible example of this fusion—a local variant of an *nkisi nkondi*, with inserted ideograms of spiritual beginnings and protection (plate 43). The medicines are at work in the name of God (Nzambi Mpungu), Whose presence is "signed" in the small wooden crucifix. This remarkable creole *nkondi*, apparently dating from the late 1970s or early 1980s, includes a seashell for perdurance, for crossing water to the other world.

Bedia's masterpiece is his own Havana *nkisi Sarabanda*, completed in 1988 (plate 44). He constructed it in a corner, and disguised it: when covered with two wooden flaps,

A Chart for the Soul: The Kongo Atlantic Altar

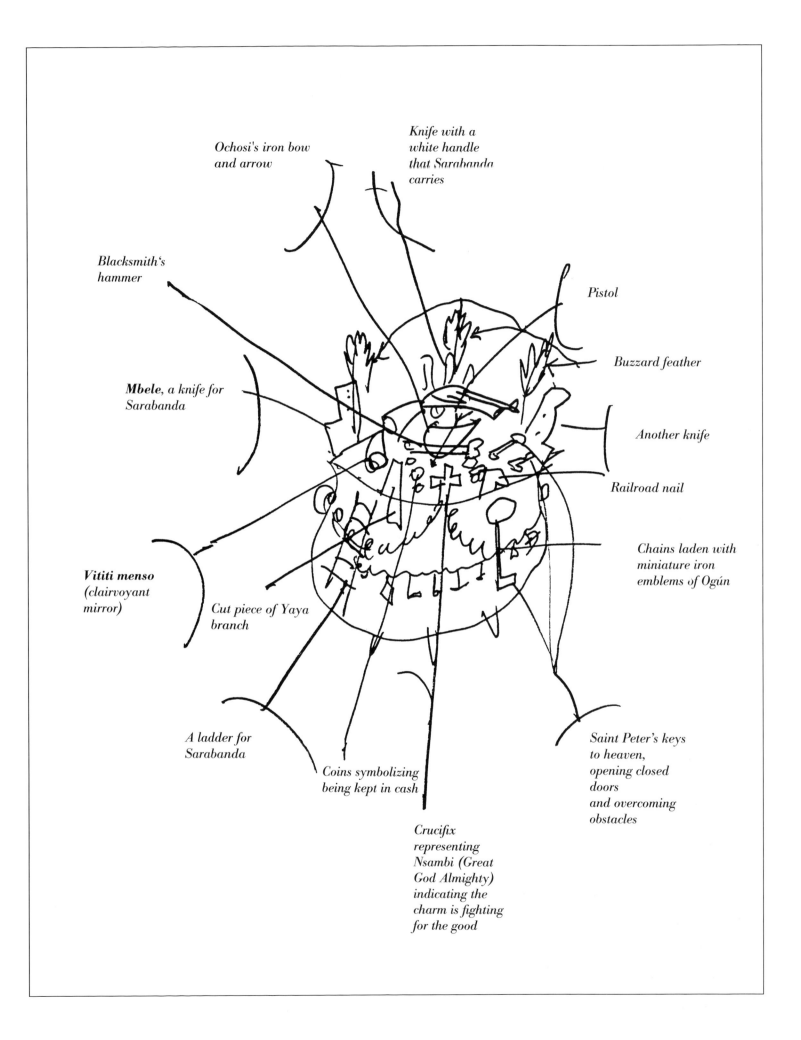

Ochosi's iron bow
and arrow

Knife with a
white handle
that Sarabanda
carries

Blacksmith's
hammer

Pistol

Buzzard feather

Mbele, a knife for
Sarabanda

Another knife

Railroad nail

Vititi menso
(clairvoyant
mirror)

Chains laden with
miniature iron
emblems of Ogún

Cut piece of Yaya
branch

A ladder for
Sarabanda

Saint Peter's keys
to heaven,
opening closed
doors
and overcoming
obstacles

Coins symbolizing
being kept in cash

Crucifix
representing
Nsambi (Great
God Almighty)
indicating the
charm is fighting
for the good

it immediately takes on the guise of a laundry hamper. Lifting the concealing wood we witness Bedia's brilliant version of the *nkisi*. He paints one side black, with moon and stars and comet, to represent "the carriage of the night." The opposing side is blue, punctuated by the sun, "starting and renewing things." The crucifix before the *nkisi* once again represents Nzambi Mpungu, Great God Almighty. This indicates, as usual, that the medicines are working for the good, that the *nganga* is positive in intent and action.

On both sides of the Atlantic the *nkisi* is considered a person—Bedia's *nkisi* is not an altar *to* Sarabanda, it *is* Sarabanda. Bedia dresses it accordingly, with a warrior's heavy-duty iron, with an athlete workman's instruments of prowess. For Sarabanda, the creole spirit of a powerful black man who worked on the railroad in the last century, is the John Henry of Cuba.

Bedia adds the traditional fighting woods, like yaya. He adds, as well, the *vititi menso*, horn with mirror, for vision and prediction, and the feathers of aerial ecstasy and surveillance. Signifying ascent to the powers hidden in the sky is a miniature ladder: "This you give to Sarabanda and also to Ogún and Eleguá." The richest dialogue is with iron, starting with the kettle container and ending with the objects bristling at the summit and along the side: a forge hammer; a protective iron bow and arrow for Ochosi; knives for Sarabanda, some with white handles; a pistol; *clavos de línea*, railroad nails, in reference to Sarabanda's past; coins ("so you are not out of money"); a chain with miniature iron implements of Ogún; and the "keys of Saint Peter that open the gates of paradise, symbolizing the possibility of liberation." The artist has sketched all these details, with their glosses (plate 45). Sarabanda arises in an ecumenical idiom, lightly Catholic, and Yoruba, but essentially Kongo.

The Kongo element of other altars to Sarabanda is deepened by the presence of a red *bandera*, the celebratory flag that often appears on the wall behind or beside the *nkisi*, allowing it to move through time and space: "*Prenda no camina si no hay bandera*" (Without a flag the *prenda* won't move).[28] The flag bears *gandó* (from the Ki-Kongo *nkandu*, magic lock), protective signs composed of battling arrows and other warning elements. Felipe García Villamil, a distinguished Cuban-born *mayombero* now living in the Bronx, keeps a *gandó*-emblazoned flag in his own *munansó*-in-a-closet to protect his *nkisi*, Sarabanda Rompe Monte. Its signs, in white on the red cloth, include symmetrically balanced, drumlike cartridges for gunpowder, which rest on a further emblem of spiritual deterrence: a circle bisected by a strong horizontal arrow, the point penetrating a triangle to the circle's right (plate 47). This is Kaworonda, a *policía* or spirit of ensnarement, marching with Ochosi. Signing protection of altar and home, *gandó* says Look out, be careful (*Cuidado*). And the *bandera* itself also evokes black Cuban history, for many *mambí*, the African-descended Cuban guerrillas who battled colonialist Spain in the late nineteenth century, were members of the *Regla de Mayombé* and fought under flags of red. Remembered here, their voices add to the air of spiritual valor.

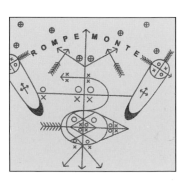

In its deepest Kongo usage, the flag over the *nkisi* celebrates victory over death—the victory of the spirit in the vessel. It "waves the words," recalling moments in black creole history. One of Cabrera's informants recalls, "I witnessed the funeral of a Kongo Society queen [in the nineteenth century]. In the street, at each crossroads, they performed a ceremony: they placed her body on the ground and various blacks saluted her by waving large Spanish flags."[29] Some would have seen patriotism here, but the celebrants themselves used street intersections as a chain of found cosmograms: waving flags, they voiced the "victory" of a life of distinction. At the death of Beny Moré, the great Cuban singer of mambo and *son*, and also a *mayombero*, his mourners waved a huge flag over *him*.

A Chart for the Soul: The Kongo Atlantic Altar

In Kongo itself as in the West, flags also fly where there is war or fighting. Silently secured on the wall above the *nkisi*, the *bandera* broadcasts the vessel's fight for its owner and his family.

A splendid example of the red *bandera* lies in the Casa de Africa museum in Havana (plate 48). At top appears the radiating sun, "the heart of the mpungu's power."[30] A sign with arrows at the points of the compass and points between, together with four suns or eyes, indicates the directions of the world, over which the *nkisi mpungu* has protective access. The arrows that compose these ideographic signatures wage war against the jealous and the envious. Logically, such signs appear also on the doors to one's house or *botánica*, including today those of New Jersey and Manhattan.

A square with three emblems at upper left includes a spiral (*luzingu*), sign of longevity and of the *nganga's* power to roll or unroll the path of life, to learn one's history, to find the source of problems; a vertical double arrow between two further double arrows, the latter displayed as opposed crescents, cryptically referring to life's diverse movements; and a vertical and angled crossing of two arrows, communicating matters high and low, *lwemba/nkala*, a marriage of two worlds. These signs, called *firmas*, are richly elaborated. A sampling of further *firmas* appears in plates 46, 49, and 50, some of them signatures of the spirit, or maps for it, some of them warnings. *Firmas* often arm themselves with the allusive militancy of the arrow. Their power is expressed, almost always, under the controlling concept of the four winds, or of the crossroads. They are chalked on initiates "as a variant of the signature of *nkisi*," and also on the *nkisi* vessel itself.[31] They are worn embroidered or chalked upon red handkerchiefs over the chests of the wearer. They mark points of emphasis on an altar. Sometimes they even serve as altars, focusing sacrifice and prayer.

All of which emphasizes the interchangeability of *nkisi*, flag, cosmogram, and person.

Tempo dya Nganga: Dressing the Wind and Dressing the Tree

The presence of ladders and flags around Cuban *nkisi* relates to the flag-ladder-and-tree combinations associated with the Brazilian spirit Tempo, or Tempu. The name derives from the Ki-Kongo word *tembo*, "a violent wind, a storm, a hurricane,"[32] and also an *nkisi* focused on the nsanda tree (*Ficus dusenii*), tall with roots enclosing wide nichelike spaces, or on the nsinda tree. In Kongo, *nkisi Tembo* also bring children. Hence the Ki-Kongo phrase *Tembo kia ngiakísila nkento vumu*: "It is the storm that impregnates a woman."

Brought to Brazil, Bakongo honored Tempo in the gameleira branca (*Ficus doliaria Martius*), a tree not far, in tallness and spreading roots, from the nsanda of the Old World. Yoruba in Brazil, arriving later, probably built on this creole solution, worshiping at the feet of gameleira when they renewed the service of their own tree *orisha*, Iroko. (The Nigerian iroko tree, *Chlorophora excelsa*, is a different species from the South American.)

The forward motion of this tradition relates to a body of cognate material in Central Africa. Take, for example, the Eastern Pende *mbundjuka* (place of the phenomenon), a hunters' altar built around a mubo tree, which represents a chief. *Miheta*, cut branches of a scrub tree used for firewood, are lashed around the bottom of the mubo trunk with a rope of cactus fiber. This represents both the cloth of the chief and the people circled

round him. The cactus of which the rope is made is very long-lived. It becomes an ideogram of the band of followers about the chief.

Zoë Strother, who photographed Chief Kutshia's *mbundjuka* near Ndjindji, Zaire, in November 1987, says that the manioc stalks visible to the right of the altar add a prayer for good crops (plate 51). But the basic desire voiced before the mubo is success in hunting:

As we remember you, may you remember us
Work [oh ancestors] that many animals die,
That we have luck in hunting,
That women give birth, that plants grow in abundance in
 our fields. [Help us] trap the animals and the birds.

[call] Are we going to be able to kill?
[thunderous response] Yes![33]

The sap of the mubo is deep red. It runs like blood. At the end of the ritual, Pende strike the tree eight times with their machetes. It bleeds at once. This is the blood of the animals they will kill.

When Bahian followers of Tempo offer leaves (*atim*, derived from the Ki-Kongo *nti*, tree) gathered in his name, dress gameleira with a white flag, and set pottery vessels filled with liquid or food between its roots, they make signs of allegiance not unlike those of Africa.

When wind shakes the flag flown by the *nkisi Tempo*, the spirit is present. Wind caught in cloth brings strength. By analogy with the life span of the gameleira, this *nkisi* also delivers longevity. The altar includes a ladder, like Sarabanda's in Cuba, "to indicate a system of progressive elevation." Seven iron lances, often upright in a circle around the altar base, allude to "seven ritual sacrifices over seven ritual years."[34] There is also a grill, referring, on the Kongo side, to roast-goat, chicken, and *churrasco* (barbecued-beef) offerings to the spirit. On the Catholic side it associates Tempo with San Lorenzo, whose famous attribute is the grill upon which he was martyred.[35]

In addition, some Brazilian songs associate Tempo with Lemba, "a major historic [North Kongo society] of healing, trade, and marriage relations."[36] In the Kongo/Angola houses of Brazil, Lemba fuses with the image of the Yoruba creator god Oxala, with Jesus, and, sometimes, with Tempo. This extraordinary mix may reinforce the symbology of lances and ladder, its probable sources being Catholic chromolithographs of Christ on the Cross, ladder and two lances leaning inward.

For all the blending, Kongo is the basic origin. When Tempo possesses one of his followers, those around him shout with excitement a phrase that takes us back to Central Africa: "*Tempu dya nganga!*" (The priest's own Tempu!). This praise name, said "so one knows who he is,"[37] appears embossed on an honorific copper flag made by the local master Clodomir Menezes da Silva in 1985, and in a design done by an artist/priest named Gutenberg in 1988, where "Tempo" is abbreviated to a single *T* (plate 52). When Tempo is sung to in Rio and Bahia, some texts are entirely in Ki-Kongo:

A Chart for the Soul: The Kongo Atlantic Altar

PLATE 52: GUTENBERG, SHRINE TO THE SPIRIT TEMPO, *CANDOMBLÉ* ODE BUALEJI, SALVADOR, BRAZIL, 1980S. At left, a painting of Tempo dressed in the raffia of forest power, with his attributes of ladder and lances. At right, another attribute of Tempo, a grill, is surmounted by a tiny metal flag bearing his initial, *T*. White paint evokes the other world; a flagstaff elevates a banner high above the frame of the photograph. Photo: Robert Farris Thompson, 1989.

PLATE 53: KONGO/ANGOLA TREE ALTAR TO THE SPIRIT TEMPO, *CANDOMBLÉ* BATE FOLHA, BAHIA, BRAZIL, TWENTIETH CENTURY. Arrived in Brazil, Bakongo refocused the honoring of Tempo (the Kongo spirit Tembo) from the African nsanda tree to the gameleira. Here they set *quartinha* and two-handled *talha* vessels, and a shallow bowl of food, as votive offerings among the tree's roots. Photo: Robert Farris Thompson, 1989.

PLATE 54: AN NSANDA TREE MARKING A GRAVE, NORTHERN KONGO, EARLY TWENTIETH CENTURY. The Kongo practice of marking a grave with a tree has continued among many African-Americans in the United States (see plate 61). Photo: Svenska Missions Forbundet, Stockholm.

Tempo e, erere
Oya Tempo, pelula
Kongo, manzila, Lemba e
Nge, Tempo, ae.

O Tempo [moving in the wind]
Lord Tempo, make us jump
Lord Kongo, going on the path, O Lemba
You, Tempo, ae.[38]

Consider a famous altar to Tempo at Bate Folha, Bahia, which I photographed in 1987 (plate 53). The tree's prestige is immediately signaled by the enlivening of the crevices between its roots with light-blue votive *quartinha* water vessels. Pottery similarly clusters at the feet of Dahomean and Anago iroko trees, and below a turn-of-the-century nsanda tree in Kongo that marked an important grave (plate 54).

Consider, for contrast, an altar to the Dahomey/Yoruba tree spirit Iroko, photographed in 1986 by Ian Churchill at a *candomblé nago* in the city of Salvador (plate 55). A narrow, sashlike white cloth, like the trailing banner recorded on the Surimombo plantation, Suriname, in 1707 (plates 129, 133), identifies this powerful tree as an enclosing spirit. Before the tree, forked roots and branches—visually assertive, like forked *lungowa* in Kongo-Cuban shrines—enclose a stumplike altar, its top bearing traces of sacrifice. The feeling of this altar is removed from most Iroko and Loko altars in Bahia, or across the water in Benin and Nigeria. For here we have "Iroko" seen from a Kongo-influenced point of view.

At Bate Folha, though, ironically a Kongo/Angola house, canonical Dahomey/Yoruba influences swing into place. Each *quartinha* at the Bate Folha altar represents the offering of a follower of the spirit. They dot the roots with a landscape of devotion. The large double-handled *talha* jars emphasize the community's responsibility to keep the *nkisi Tempu* in water and assuaged. Finally, one devotee has laid a shallow earthen bowl filled with sacrificial food, to ask for a special blessing.

The Kongo/Angola Tempo shrine at Bualeji, on the opposite side of Bahia (plate 52), exerts a different fascination. The canon of grill, flag, and ladder is in place, but at the gateway to the shrine there are also *quartinhas* that flash in silver paint, "representing spirit." The inner court recalls a *luumbu* enclosure, open to the sky. The mural at left depicts Tempo as a person dressed in forest raffia. He moves under a flag, a ladder, and lances, scattered in the wind.

The painting is preamble. Then comes a jump into white, as if with *mpemba* clay, signifying the purity of the other world. Raffia fronds too announce the precinct's sanctity. Gutenberg designed this jewellike space in the 1970s, composing the work in tacit lines that marry realms: the metal flag-ladder-and-grill combination is supported by an hourglass-shaped pedestal, mirroring two worlds; the grill is on an axis with a silver-painted he-goat skull, shining upon the wall—grill and bone, cause and effect.

Meanwhile an actual flag, high above (its staff is visible in the photograph), flutters in the breeze. Tempo is present. In Kongo such fluttering (*vévila*) is associated with *nganga* in ecstasy, trembling and jumping. Spirit, moving in cloth, pinpoints in space a Kongo

A Chart for the Soul: The Kongo Atlantic Altar

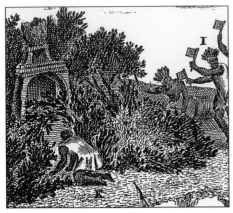

PLATES 56, 57, 58 (TOP TO BOTTOM): OLFERT
DAPPER, DRAWINGS OF LOANGO, 1668. Working
from sailors' accounts, Dapper drew
reconstructions of a Kongo *nkisi Mymi* altar,
featuring an uplifted vessel (plate 56), and of
servitors of *nkisi Bumba* dancing in plumed
bonnets in relation to an apparently cosmographic
arch (plate 57). Bearing in mind the fanciful
nature of the illustration, he also seems to have
recorded the narrow domestic architecture of
northern Kongo (plate 58), one putative prototype
for the similarly narrow shotgun houses of the
black United States. From Olfert Dapper,
Description de l'Afrique, 1668.

altar. Perhaps this is why the servitors in Bahia beg Tempo to make them jump, as they
witness his presence in the wind.

From Ancient Loango to Twentieth-Century North America: Roots of the Yard Show

Whether concretized in a square piece of cloth fluttering in the breeze or rendered as a
simple tracing on the ground, *dikenga* thinking embodies world motion. Its central prin-
ciple, that the circle of the soul must roll to completion, has generated a cosmogram
culture, wheeling through colors, circles, crosses, diamonds, and spirals. Secret liberty of
worship among blacks in North America, plus their adaptive intelligence, kept the core
of this tradition alive. Circular seeds turned into dimes. Circular earth-drawings turned
into tires. Spinning crosses turned into pinwheels. But the basic soul principle behind
them remained, unquestioned and fluent.

In 1668, apparently working from sailors' reports, Olfert Dapper described Kongo's
northern metropolis of Loango as already rich in what we now know were the roots of
this transatlantic engine for the circling of the soul.[39] The Loango matrix included the
concept of the large enclosure, drenched with associations of protection. Via Bantu
migration, this concept echoed far afield, for example at Khami (plate 59), where a circu-
lar enclosure spectacularly surrounds and glorifies an inner stone presence, radiating the
immortal power of the ancestors. We have already noted what Stuckey calls "the central-
ity of the circle in slavery," and the ring shout indelibly encircling spirit among the
blacks of North America.

Dapper also found that important Kongo men wore cat-skin kilts, announcing their
power to cross boundaries like a feline. In the nineteenth century these would be worn
in Kongo Montevideo. And Dapper heard of raffia garments bearing roseate patterns in
parrot feathers, standing for powers of speech, spirit-flash, and flight, and intuiting the
soul as a traveling sun. The same pattern illumines Cuban *banderas*. Loango servitors of
nkisi Bumba, dancing in plumed bonnets to proclaim the plenitude of heaven, likewise
predict the feather headgear of certain Cuban *nganga*.

In 1668, the people of Loango were driving nails into *nkisi Kikokoo*, a wooden statue
of a seated man — one of our earliest references to the *nkisi nkondi* concept, and a fore-
runner to the conceptual nailing of *nkisi* in Cuba. For *nkisi Mymi* they built a shrine of
leaves on a road shaded by trees. Inside was a kind of chair: "a seat lifted up like a kind
of trunk supporting a vessel full of trifles like a chaplet of small pebbles such as found by
the sea."[40] This altar not only resembles the medicines upheld in metal kettles in Cuba,
but seems a root of the rule of enthronement defining so many *nkisi*-like arrangements
of objects and figuration in African-American yard shows of the Deep South.

Dapper's drawing of Loango suggests the breadth of the seventeenth-century city
(plate 58). Row on row of narrow houses stand tightly packed. We are looking at a city of
proto-shotguns, the famously narrow domestic black architecture of the United States
and the Caribbean. Such narrow houses, still built among the Bembe in north Kongo, are
spatially analogous to structures built and lived in to this day in New Orleans, Houston,
Louisville, and other U.S. towns.

PLATE 59 (PREVIOUS PAGE): THE STONE ENCLOSURE AROUND THE MONOLITH PLATFORM AT KHAMI, ZIMBABWE, CA. 1400–1600. Conga lines in black Cuba, the ring shouts of the Old Time Religion in the American South, the circling "altars in motion" of Kongo (and also of San and Pygmy worship)—all take the form of the circle, the crucial symbol of Kongo cosmology. Through Bantu migration, the circle and cognate rephrasings of its protective meaning emerged far afield in the stone circle at Khami. Photo: Christopher Munnelly, 1992.

What is more, *nkisi* altars appear in the drawing's foreground. One is a shrine rather like that described for *nkisi Mymi*—a basket of powers, supported by a structure describing an empty half-circle and an empty rectangle, both clear signs of the other world (plate 56). This altar is surrounded by its own private forest, like the lavish bunches of freshly cut foliage that cluster around *nkisi Sarabanda* during certain rituals in Matanzas, New York, New Jersey, and other places.

The other *nkisi* is a leaf-made arch (*lukote*) describing a half-circle (*ndambu a lukóngolo*) through which warriors had to pass (plate 57). Negotiation of this arch related mystically to the protection of the inner circle of their souls. They also had to pass through the legs of a female leader; if her thighs grazed them while so doing, they had to stay home, for this was a sign of certain death in battle.

The men by the arch are wearing feather bonnets (*nsala*), a metaphoric way of saying, "Our power is flying; nothing can stop us" (*Ka tuside diaka mu nitu ko; tuneni mena nsala ye ba vena ma kilenda kakídila dio ko*). The *nsala* is a standard costume for warriors. They also wave flags, a tradition said to have been borrowed from the forest-Pygmy custom of waving leaves to send or summon protective forest "radiations" (*fila minienie*), messages between two worlds. Bakongo adapted this custom to flags of white cloth, which they waved to signal the ancestral world. Our faith in Dapper's pictorial rendering of feathered bonnets and related art is based on the repetition of such detail in his text.[41]

The whole idea of wheeling under an arch of cosmos, calling the ancestors with flags, and wearing feathers that trumpet connections with plenitude and war is this: We will be made complete; once we are complete, we can move from place to place, from time to time, without being blocked or tied. This circling machinery of assertion and continuity was later phrased in the placement of whitewashed tires, propellers, pinwheels, and other motion emblems upon lawns in black America. Here it is, nascent, in 1668.

Rise of the Yard Show

Like all *minkisi*, yard shows in black America carry a double edge: power to give and to take back, to greet and to defend. They actually involve more space than that embraced between street and habitation, their name being vernacular shorthand for a totalizing tradition involving spiritual mediation of the whole yard-porch-house-backyard-vehicle continuum. And complex as it is, that continuum represents only half of the equation, half of the *dikenga* wheel. The other half is the cemetery. As Bedia's Havana altar to Sarabanda wheels from sunrise to midnight and back, so the cemetery inspires the house, which in turn inspires the cemetery again. Sometimes the vehicle in the driveway carries particles of this dense spiritual message into the streets, like a slow-motion meteor.

In earlier texts I have described eight recurrent elements linking Kongo graves to black graves in North America. The list grows larger, and applies to house and yard as well as to tomb: (1) the planted tree and cactus in Kongo, planted tree in U.S. black tombs, and living fences of cactus and other plants in Haiti and sometimes in the U.S.; (2) iron pipes—"next to broken china, the most ubiquitous type of grave marker in the African American tradition";[42] (3) white stones, gravel, and crystals; (4) pottery markers, in Kongo incised with ideographs, in the U.S. sometimes encrusted with small objects,

PLATE 60 (OPPOSITE): AFRICAN-AMERICAN "RADIO TOMB," FORT PIERCE, FLORIDA, 2 OCTOBER 1945. A common theme in Kongo-inflected black tombs in the United States is communication with the dead—through Mothers' Day cards left on the grave, for example, or by embedding a radio in a tomb, allowing the dead to keep in touch. Photo: Onajide Shabaka, 1989.

like the bottles called "memory jars"; (5) bottles, once glass, now increasingly made of plastic; (6) enclosures; (7) seashells; (8) mirrors, glass, bonfires, headlights, and lamps; (9) the last-used objects of the dead; (10) the theme of the white chicken, *nsusu mpembe*, a frequent expiatory sacrifice in Kongo burials; (11) modern emblems of mobility—miniature airplanes, taxis, trucks, and bicycles, or their parts, like a crankcase or a hubcap or a handlebar; and (12) Western markers in granite and other media, which, on black lawns, experience a recoding of their original Western meanings.

To this add further graveyard elements discovered by Angelika Kruger-Kahloula on the American side of the Atlantic: century plants and evergreens, cinder blocks, gifts and messages, Masonic emblems and photographs, home-made markers.[43] Century plants and evergreens are medicines of perdurance, in this sense related to seashells. Cinder blocks are time-resistant abstractions of the house, which, again like the seashell, protects the soul. Gifts and messages are part of an ongoing Kongo tradition of conversation with the dead, be they *nkisi* spirits or ancestors implored in their tombs at times of crisis. Such conversations creolize into Mothers' Day cards set up on tombs, or miniature Christmas trees placed at the appropriate time beside headstones, or "tree-stones." Another, beautiful example: a "radio tomb" dated October 2, 1945, in a black cemetery in Fort Pierce, Florida, a modern promise of eternal communication (plate 60). The Masonic preoccupation with grades of light is instantly exciting to persons raised in Kongo-tinged traditions; in Haiti the Kongo love of Masonic secrecy gave rise to a tradition called Kongo-Mazonne. Finally, the home-made grave marker may reflect the reluctance of some traditionalists to let a stranger carve their loved one's name. As often, it has to do with saving money.

These cemetery elements also turn up in yard shows, as in the potted century plant above the door to the Houston home of Cleveland Turner, and in the written messages, to the living and to God, that festoon the lawn of Joe Light in Memphis. Such "decorations" are segments from the patterned whole, the circling journey of the soul. They are auxiliary rockets to keep the grand wheel safe and moving. The match between the "dress" of the tomb and the "dress" of the house and the "dress" of the vehicle activates and protects the soul with recurrent verbs of mystic action. This is in the purest *nkisi* tradition: spiritual admonishment via objects that pun on verbs.

Here are some verbs planted in tomb, yard, and vehicle to command the spirit on both sides of the Atlantic. Be contained: within the tomb, within a vessel on the porch, within gleaming glass vessels impaled on a tree or filled with colored water and set in a window, within a whitewashed rock boundary, within a line of quartz pebbles. Be blessed or driven back, according to your character, by figuration: the person-repelling Fang *bieri* and south-and-central-Gabon *mbulu ngulu*, linked with the cognate gesturing tomb sculpture of Kongo and with the "monkey jugs" on Western graves and in homes, where they further creolize into dolls, toys, and animals. Be healed—or stung—by lightning-related cacti or witch-resistant plants around graves and houses in Kongo, transmuted into century plants (be healed of mortality) and evergreens (same message) planted on North American lawn or tomb. Be healed of loss by association with an immortal tree, such as shelters the tombs of Kongo, or as towers over the grave of a black woman buried in a cemetery near Winston-Salem, North Carolina, in 1843 (plate 61). Be attracted, to the spiritual flash of mirrors or of beetle wings or of kaolin, in Kongo, and

PLATE 61 (ABOVE): GRAVE OF A BLACK WOMAN, NEAR WINSTON-SALEM, NORTH CAROLINA, 1843. To mark a grave with a tree echoes a Kongo cemetery practice (plate 54), as well as the African tradition of the tree altar. Photo: Robert Farris Thompson, 1990.

PLATE 62 (RIGHT): AFRICAN-AMERICAN GRAVE, MCDONOUGHVILLE CEMETERY, NEAR NEW ORLEANS, LOUISIANA, TWENTIETH CENTURY. Many New Orleans people, black and white, elevate their graves above the earth. But the addition of Kongo-like blue diamonds to this structure reveals an Afro-Louisiana tradition. Photo: Christopher Munnelly, 1992.

of mirrors, tinfoil, light bulbs, silver balls, and chrome hubcaps in America; be warned or exalted by their spirit-repelling and spirit-attracting flash. Be enthroned in glory, from the trunklike seat for a spirit on the outskirts of seventeenth-century Loango, to the uplifted tombs of New Orleans (plate 62), to the chairs, benches, and even porcelain toilet seats that cryptically stud cemeteries and yards across black North America, to James Hampton's climactic tinfoil-covered Throne of the Third Heaven, a room-size installation now in the Smithsonian Institution in Washington, D.C. Complete your circle, travel your life protected by a perforated disk, proof to the witches; say the same thing with a dime on a string, or with a tractor-tire planter in a yard (but tell strangers the rubber is just to keep weeds or water out); stud lawn and yard with automobile tires, white-washed and serrated, like a sun streaming rays; wheel variously, in your car, on your lawn, in your tomb, with radio dials, telephone dials, and clock faces without hands.

How did this massive eternity-machine arrive and flourish in relative obscurity? The answer is easy: slaves weren't supposed to have a culture, so no white person looked. And if they had, slave cabins and quarters, as archaeology now reveals, kept their treasures well concealed.

Thankfully, archaeologists are now at work. In the words of Mark Leone, "We know where to look and how to count."[44] In the house of a free black of Annapolis, Leone recently discovered, and dated to 1847, a cache of pierced coins and seashells, adorning the dwelling with medicines for continuity and the guarding of the soul. This was, perhaps, one of our earliest yard or house *nkisi*.

In the city of New York in 1626, when it was still New Amsterdam, there were around eleven blacks, including, notably for our discussion of the Kongo influence in North America, one called Simon Kongo and one Paul d'Angola.[45] Eighty-six years later, in 1712, a Reverend John Sharpe complained that in New York even Christian slaves were "buried in the Common by those of their country and complexion" according to African rites.[46] Unsurprisingly, recent excavation of the old black burial ground discovered in downtown Manhattan in 1992 has uncovered a skeleton in company with a seashell, one of the earliest American attestations of the basic Kongo concept that burial with a shell protects the soul within this carapace, and carries it on to glory. Certain New York priests of African traditional religions, visiting this burial site in 1992, became possessed by spirits—in effect, the entire site became an altar.[47]

With the discovery of these early beachheads of Kongo sacred culture upon our soil, we no longer have to ask when and where cosmogram phrasings took root here, as we have long known they did, in countless ways. In the nineteenth century, for example, religiously inspired African-Americans were mobilizing their thoughts and dreams in terms of the geometrized cosmos of their ancestors: "God has connected up the line between my soul and heaven. . . . I heard the Lord and He spoke to me and I saw Him take a sun out of a sun and he said to me, 'Behold, my little one, I am God Almighty. I freed your soul from death.'"[48] The sun-out-of-sun notion restates the classical Kongo dogma that we are miniatures of the sun, moving in orbit. Association of the soul with something round, something moving in the sky, something brilliant, continues today.

The monotheistic Kongo concept of Nzambi Mpungu, Great God Almighty, fused with the God of the Christians. And though laymen and scholars alike may have demoted the

medicinal part of the religion, the *minkisi*, to "superstition," creole space for this Kongo heritage was made from at least the early eighteenth century on. The making of *minkisi* returned in "conjuring"; Gullah Jack was surely not the only person "who combined membership in the African Methodist Church with the practice of conjure."[49] Behind Paul Radin's famous phrase, "The Negro was not converted to God. He converted God to himself," lay unsuspected Kongo/Angola implications.[50]

As Theodore Ford observes, the crossing of a body of water was an ever-recurrent theme of the black spiritual.[51] What is that theme but a recoding of the *kalunga* line, boundary between the worlds of the living and of the dead? Blacks even altered the architecture of worship, as a notice from 1856 records: "Having furnished the prayer-house with seats having a back-rail, Negroes petitioned him to remove it, because it did not leave them room enough to pray."[52] By "pray," of course, they meant space for moving and shouting with the spirit.

Blacks reexpressed the cosmogram in pottery, incising ideographic signs, *dikenga* and related patterns (plate 63), inside hand-crafted bowls. These "colono ware" vessels date from about 1725–1820.[53] Bowls with such marks—crosses and other signs—have been dredged up from river bottoms in the Carolina low country. Fu-Kiau interprets them: "The cross is the wheel of the world, a 'living wheel' [*lulu yavuumuna*], a wheel that turns. The spirit of an enemy is put in this turning world."[54] Immersed in the river, the spirit would presumably be swept out to sea.

Cross-marked pottery could heal as well as trap and banish: "If someone were sick he went to a healer who put an X in the bottom of a vessel to protect his soul."[55] This X, scratched on pottery in the eighteenth and early nineteenth centuries, and the protectively turning concept behind it, may well have influenced the placement of myriad protective pinwheels in the lawns and gardens of later generations of African-Americans. Another of these African-American symbols was a distinctive Z-like cross, its arms leading one up, one down, and lacking solar disks at their tips. Symbolizing an "empty world" (*nza dyampamba mpamba*), this *dimbu* (sign) points to a double darkness, and was probably drawn to counteract a dangerous element within the community: "Once put in a vessel with this sign, you are gone; there is nothing in the sky, nothing in the world, to save you."[56]

Mystic embottlement, as a tactic against the antisocial, also crossed the water. In this century it reappears in one of the masterpieces of Thornton Dial, a black artist of Bessemer, Alabama. And it guides the rise and formulation of a famous cultural expression, the U.S. "bottle tree" tradition.

Bakongo consider trees sentinels of the spirit. An offshoot of this belief diffused through the black United States, constellating around New World trees, where in Central Africa it had involved the fig and other species. Here is the recollection of an exslave: "I usually prayed behind a big beech-tree, a little distance from the house, and often during the night when I would feel to pray, I would get out of bed and go to this tree."[57] This was an improvised tree-altar, served in the night. There were grove altars as well: "I went to the peach orchard and prayed. . . . a voice spoke to me, saying 'go tell the world I have freed your soul.'"[58]

Little did the planters know: right on their property Africans had covertly transformed trees into sites of religion. These were the "kneel-away stations" sung about in gospel music to this day. Albert Raboteau documents another name for altars hidden in

the thickets: "hush harbors."[59]

The plantation owners were also kept in the dark about tree-marked graves, "lost" in the woods. How could they have known that before one such grave, a mere stump, a union of human reverence and ancestral inspiration gave rise to a memorable enfoldment:

> The graveyard was in the woods. . . . My spirit was overawed by the solemnity of the scene. For more than ten years I had frequented this spot, but never had it seemed to me so sacred as now. A black stump at the head of my mother's grave was all that remained of a tree my father had planted. . . . I knelt down and kissed [the grave markers] and poured forth a prayer to God for guidance and support in the perilous step I was about to take. I seemed to hear my father's voice come from it, bidding me not to tarry till I reached freedom.[60]

In this cemetery, a platform for black liberation, rested the parents of Harriet Jacobs, author of the famous *Incidents in the Life of a Slave Girl*, from 1861. Jacobs's sequence of worship mirrored that of Kongo: entering a spiritually charged *mfinda* (forest), finding the *nti* (tree) that located her ancestors, and kneeling (*fukama*) before them to seek their blessing at a critical moment. Their spirit gave her the courage to begin her famous trek to freedom. Who knows what analogous aspirations were voiced before the tree tomb near Winston-Salem? Or before other tree-altars/tombs, from the Atlantic to the Mississippi and beyond?

Cut back to Kongo: The elder goes to the cemetery with his people. They bring five plates and five calabashes of palm wine, drawn from the flowers of palm trees. When the elder has arrived at the grave of his own predecessor, he kneels down and addresses all the ancestors as follows:

> We go to the diviner.
> He says: attend the grave of the ancestors.
> This is the reason we have come. . . .
>
> Today I bring you five plates
> Eat these *matondo* [mushrooms] standing for love
> [Grant us] procreation and human wealth
> I bring you five calabashes of rich palm wine,
> *nsamba*
> Favor procreation and human wealth.
>
> All you ancestors at the water boundary
> [Be positive in your actions] that we may remain to
> see joy.[61]

In North America the ritual was elided. Leaving plates and other objects atop the mound on the occasion of the actual burial was one thing, but taking plates and liquor from the big house for secondary rituals and requests would have aroused dangerous

A Chart for the Soul: The Kongo Atlantic Altar

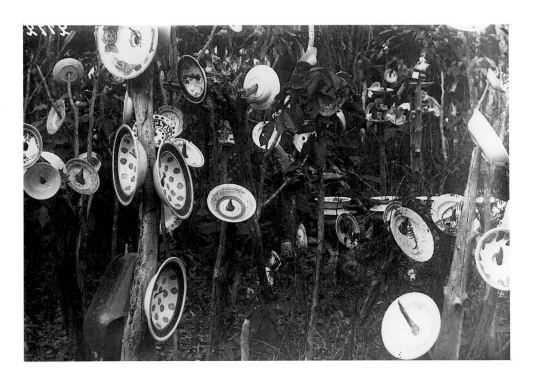

curiosity. Harriet Jacobs slipped away for her final rite with nothing to offer but a kiss, words of affection, and the transatlantic gesture, kneeling before the tomb.

In Kongo, while the elder was pouring palm wine over the grave, the clan members would jam the sharpened ends of cut and bare tree branches and saplings, fixed in the earth around the graves, through holes pierced in the center of plates. R. P. Gerard photographed this rite at a cemetery near Mbanza Ngungu (then Thysville) in 1909–10 (plate 64). Suspended, the plates look like nothing so much as giant white mushrooms. The resemblance was probably intentional, an ideograph of affection, for the noun *matondo*, mushrooms, puns on the verb *tonda*, to love.

Cut to the U.S. South again, this time to a story by Shirley Ann Grau:

> The dead gifts on the top . . . every grave had them. Cups and glasses turned purple by the sun and china animals—dogs and cats and a broody hen or two [the sacrificial chicken, *nsusu mpembe*]. And plates. Lots of plates. Most of these stood on two-inch-high spires of sandy mud, jutting out like mushrooms from the grave. The rain had given them this form.[62]

The characterization of these African-American grave plates as mushroomlike provides an interesting coincidence, even if knowledge of the *matondo/tonda* pun had long since faded.

To place a dead branch upright in one's yard, leaves sheared off, endings stubbed, glassware jammed on, fits the paradigm documented at Mbanza Ngungu. A dead branch bearing shining glass bottles, and set up by the house, constitutes a presence from the graveyard. This the culturally prepared would have determined at a glance.

The received wisdom about bottle trees, usually mediated by Americans of European descent, is that the gleam of the glass is intended to attract negative spirits who are then trapped in the bottles. This is essentially correct, though doubtless elided in the passage from blacks to whites to print. More likely the original message was richer,

rooted in a larger context, and went more or less like this: The cemetery and the yard are one. The dead watch over us. If you come to do us harm, here are dead trees and dead branches from their woods and glass from their scintillation. Join them! But if you come in good faith may your soul be strengthened in the strength of their flash.

The original Mississippi bottle tree—lean, bottles starkly hoist on sharpened branches—was structurally little changed from the plate-and-branch traditions of the Kongo graveyard. This style distinguishes it from the fatter, more symmetrical bottle trees of later blacks and whites (plate 65), which show, in evident protective coloration, the influence of the Christmas tree. Some bottle trees have vessels tied on with string (plate 67). One source for these would be Kongo-Caribbean traditions of guarding fruit trees by tying medicines to the branches; in Suriname such charms are still called *kandu*, from the Ki-Kongo *nkandu*. Others would be European Christmas trees and German Easter egg trees, such as a string-tied Easter egg tree in Dresden, Germany, dated 1993 (plate 66). The Dresden setting is manicured throughout: tree, eggs, chairs, walls. But a string-tied bottle tree seen in in a yard in tidewater Virginia in 1987 (plate 67) exhibits pattern-breaking (one window of the house has shutters, two do not), shifting colors, and a spontaneous up-down arrangement of the bottles, reflecting the African-American love of improvisation and surprise.

PLATE 65: BOTTLE TREE, NORTHERN MISSISSIPPI, 1970S. Earlier bottle trees were lean and asymmetrical (plate 73); later examples, like this one, may resemble Christmas trees, in cultural camouflage. Photo: Robert Farris Thompson, 1980.

On close inspection the term "bottle tree" may be a verbalism that jams the frequency of a fuller message, just as Kongo "nail fetishes" (*zinkondi*) neither are fetishes—they are medicines of God—nor are worked only with nails; blades are often used as well (plate 68). Similarly, Eudora Welty's famous 1931 photograph of a half-dozen bottle-laden trees in Mississippi's Simpson County, southeast of Jackson, includes, between the three trees to the left, a "bottle shelf" supporting a vertical flask and another object. There was a comparable "image shelf" in Mbanza Ngungu in 1909–10, showing a Toby jug suspended on a plate. Behind him was a china doll surmounting a gnarled and knobby trunk. And there are image shelves outside many doors in the black Americas, from the house of Anna Campbell on Bohicket Road, Johns Island, South Carolina, to the Woodford section of Port of Spain, Trinidad.[63]

In short, bottle trees are part of a larger perspective involving not only yards, houses, and gardens but images set up on shelves or other elevations. In this way traditionalist African-American homes are mystically "dressed" with signs of simultaneous aesthetic welcome and arrest. In the Caribbean, for example, brooms are fixed over doors, and sometimes to trees, to sweep away evil.[64] Surfacing in North America, the same process gives rise to a memorable "broom tree" made by Rachel Presha of Suffolk, Virginia, in around 1987 (plate 69). If a whisk broom on a door can make the same gesture as a bottle tree, the difficulty in locating bottle trees before the twentieth century by no means indicates that the tradition was absent. It was simply coded in less conspicuous, even covert ways—like secretly trapping a spirit in a cross-marked colono vessel and hurling it into the river.

Attempting to trace the yard-show complex in full caparison, we cannot isolate here a tree, there a "face jug" (a vessel or cup made into a Toby-like face through the addition of white clay). Bottle trees are dramatic, and have tended to obscure equally important impulses, like image shelves, which have roots no less intricate. Dapper, for example, describes two shell-covered calabashes set atop a tablelike construction to protect a house in seventeenth-century Loango, predicting image shelves not only in contemporary Kongo cemeteries but outside North American back doors. In addition, the Loango calabashes, covered with shells, sound like distant relatives of porcelain-fragment-

A Chart for the Soul: The Kongo Atlantic Altar

PLATE 66 (ABOVE LEFT): EASTER EGG TREE, DRESDEN, GERMANY, 1993. Photo: Christopher Munnelly.

PLATE 67 (ABOVE RIGHT): BOTTLE TREE, TIDEWATER VIRGINIA, 1980S. PHOTO: BEVERLY McGAW, 1988. German Easter egg trees, like European/American Christmas trees, may nourish the bottle tree tradition. But note how manicured the Dresden tree is, whereas the bottles on the Virginia tree are asymetrically syncopated, a pattern-breaking exercise in the African-American aesthetic tradition.

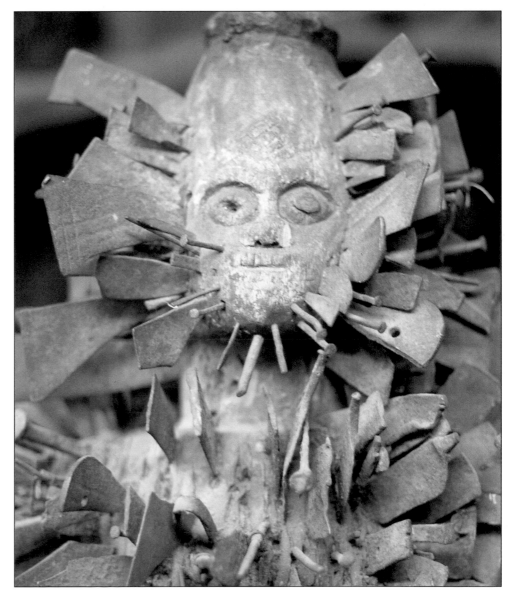

PLATE 68 (RIGHT): KONGO *NKONDI* (OATH-TAKING BLADE IMAGE), MANIANGA, NORTHERN KONGO, NINETEENTH CENTURY. The material tying of spiritually coded issues seems to link the *nkondi* to the bottle-tree traditions of the Americas. Photo: Robert Farris Thompson, 1977.

PLATE 69 (ABOVE): RACHEL PRESHA, BROOM TREE, SUFFOLK, VIRGINIA, CA. 1987. The affixture of brooms to trees and houses, to sweep away evil, appears in the Caribbean as well as in the U.S. Photo: Tom Meredith Crockett, 1987.

PLATES 70 AND 71 (TOP TO BOTTOM): YARD SHOWS, AUSTIN, TEXAS, BOTH EARLY 1990S. The yard shows of the American South and the bottle tree tradition are all part of the same Kongo continuum. In the Austin garden in plate 71, Clorox bottles filled with different-colored waters, it is said, keep out "dogs," but fit a larger pattern of aesthetic assertion and spiritual protection. Photos: plate 70, Robert Farris Thompson, 1992; plate 71, Christopher Munnelly, 1992.

PLATE 72 (LEFT): YARD SHOW, CAIRO, ILLINOIS, EARLY 1990S. The pinwheel shape in this and other gardens relates to control of the wind, spiritual protection, and aesthetic fancy. Some pinwheels would also appear to relate to the protective wheeling of the *dikenga* sign (see plates 18 and 28, for example). For some, they are installed to keep out "birds." Photo: John Nunley, 1992.

A Chart for the Soul: The Kongo Atlantic Altar

covered jars and slabs used in black burials in the U.S. today.

In nineteenth-century Kongo, baskets were placed all around the doors of the house to trap evil. Which compares with New Orleans, where blacks were urged to "hide [roots and herbs and medicated bottles] in the four corners of your house to keep things in your favor . . . plant gourd vines around the house to keep snakes away."[65] Winslow Homer's *Near Andersonville*, 1865–66, shows a woman of color standing in a doorway. To the left of the portal are gourd vines, to the right an open basket. In North Carolina, according to the African-American painter John Biggers, mystic traps, coded as decorative pottery, are still to be found on porches here and there. They palisade the house. They hold and capture evil at the threshold.

African-American yard art emerges from the totality of these traditions in creative collision with the West. The clusters of objects, for instance, around the house of a woman of color in Austin, Texas, in 1993, are clearly for catching things: they are receptacles, urns, porcelain commodes, a bird cage (plate 70). Their focus is a tree and a shrub. Some are enthroned on pedestals or tables—like the image shelves of the black Caribbean, or the elevated calabashes and containers of seventeenth-century Loango. All fit into a pattern of protection, in which Clorox bottles, for example, ostensibly keep out "dogs" (plate 71), and pinwheels, like those in a spectacular pinwheel garden at Cairo, Illinois (plate 72), keep out "birds."

Flash and light are equally effective weapons in the war against spiritual loss or misadventure. Hence note light bulbs for spiritual illumination in one of the trees that Welty saw in '30s Mississippi (plate 73). These in turn relate to a northwestern-Louisiana custom, documented near Mooringsport in the fall of 1992. From field notes about the porch of a black farmer:

> I [noted] not only a kind of improvised throne way out beyond the house, built [by] a tree, but also a container by the door. It was filled with [used] light bulbs. I stared. The owner cut my gaze in two: "They don't work." Not in this world, they don't. Not by currents materialists would understand. Like lamps and bulbs on graves . . . they light up when a person dies and goes to glory.

Spent light, for the dead, exerts deterrence when re-sited on a porch, just as mirrors do, whether caught in the image of a hand in a Georgia graveyard or flashing by an Alabama or Mississippi doorway. This may explain why light bulbs, or so it is locally reported, once studded the grave of the famous blues person Leadbelly, in a cemetery in the same part of Louisiana.

The frequency of such impulses among African-Americans makes it almost inevitable that in modern Kongo we find some chieftains wearing *mpu*—royal hats—sewn with Christmas tree lights and electrical wiring. Ramona Austin saw this among the Bakongo ba Boma, and one chief explained, "The bulbs bring me force and the shape reminds me of beautiful women, pregnant."[66] Metal thread on a head, as a pun on mystic sources of ecstasy and spiritual communication, recalls the Ki-Kongo for telegraph wire—*nsinga a mayembo*, ecstasy on a wire. It also suggests the headgear of George Boddison, the traditionally minded black man who lived in and governed "Tin City," a '30s settlement, "born of the Depression," east of Savannah: "A copper wire was bound around his head

PLATE 73: EUDORA WELTY, BLACK AND WHITE
PHOTOGRAPH OF BOTTLE TREES IN SIMPSON
COUNTY, MISSISSIPPI (DETAIL), 1931. Welty
recorded the early shape of the Mississippi bottle
tree. Note the creative reconstellation of many
elements we have reviewed: broom, wheel, bottles,
and also light bulbs. The latter reflect the Kongo
theme of spiritual light—in Kongo, after all, the
soul is likened to the sun. It is said that on the day
of a person's death the bulbs light up to lead her to
the other world. Outside the frame of this detail of
Welty's photograph are three more bottle trees and
a "bottle shelf." Photo: Eudora Welty.

and attached to this wire were two broken bits of mirror which, lying flat against his temples with the reflecting side out, flashed and glittered when he moved his head." The mirror and wires distinctly imparted personal protection: "Evil can't dwell on me. It have to pass on."[67] George Boddison, in other words, was wearing his yard show.

The "Philadelphia Wire Man," an unknown genius of a northern city, seems to have shared Boddison's convictions, only he chose to miniaturize wire and wrapping to the scale of the human hand. To him are attributed a body of neo-*minkisi*, fabulously wired-and-tied charms (plate 74) resembling Kongo bound-stone charms for *simbi* (plate 75), the Kongo spirits whose emergence in North America through secret usages of crystals, unusually shaped roots as charms, and further lore we have already observed. The souls of *simbi* are especially seen in the flash of a shooting star.

Certain yard-show artists conceive automobiles, motorcycles, and bicycles with a similar richness of light and motion. In the 1970s, Cortor Black of Houston multiplied the power of his soul with a "light chariot" fashioned by affixing myriad "bullet lights" of chrome and red glass to the hood and sides of his Pontiac (plate 77). Alvia Wardlaw reports that Black also papered the walls of his home with tinfoil, in poetic evocation of spirit.[68] The photograph shows his vehicle circa 1972. According to his fellow Houston yard-artist Cleveland Turner, later additions included flashing mirrors rhythmically applied to the vehicle's surface. This car summoned light. So doing, it guarded and directed the soul of its maker. Recall the light bulbs on the grave of Leadbelly. Recall their climactic fusion with tinfoil (Cortor Black's "wallpaper") in Hampton's Throne of the Third Heaven, which he made in rented garage space.

Black's vehicle, a yard show on wheels, relates to a spiritualized car by Country Cummins of Washington, D.C., here illustrated as it was in November 1987 (plate 76). It is told that Cummins's daughter was kidnapped, and that he designed the car hoping to become notorious, so that spreading his name would result in finding her. It is also told that the campaign worked—that he found and was reunited with her.

In this practical machine for protection, power and astonishment occur in essentially the same way as in yard art for the guarding of garden and home. In an idiom of time and deterrence, clocks, animal horns, figures, and wheels make a cairn. Radiating lines painted above the tires recover and renew the flaring triangles cut into African-American tire planters (plate 78). Cummins's strongly achieved clash of media recalls a quality once remarked by Miles Davis in the jazz solos of John Coltrane: "It's like hearing an argument from all sides."[69]

The protagonist of Ellison's *Invisible Man*, battling a sense of formlessness, wires together a kind of *nkisi* of "vital aliveness" to cover his basement ceiling, "every inch of it," with 1,369 expensive light bulbs. In the late 1970s, Charles Chisolm of Baltimore surrounded himself with even more light: a motorcycle caparisoned with 1,450 bullet-shaped lights and 3,500 rhinestones and sequins (plate 79). Chrome and glass set this bike in motion long before the ignition key is turned. With this work Chisolm, like his spiritual brothers Cummins and Black, radiates himself, true second to the sun. He commands the spirit to light his way to glory, and also to wealth, for the chrome and the sequins are distinctly currency. Indeed the artist, when he designed his own belt buckle, covered it with a sparkle of polished dimes and quarters (plate 80).

A Chart for the Soul: The Kongo Atlantic Altar

PLATE 74 (RIGHT): ARTIST UNKNOWN ("PHILADELPHIA WIRE MAN"), OBJECT OF BOUND WIRE AND TAPE, PHILADELPHIA, PENNSYLVANIA, TWENTIETH CENTURY, BEFORE 1986. Photo: Janet Fleisher, 1987. PLATE 75 (BELOW): KONGO BOUND-STONE CHARM FOR *SIMBI*, COLLECTED IN NORTHERN KONGO IN THE 1910S. From Wyatt McGaffey, *Art and Healing of the Bakongo Commented by Themselves: Minkisi from the Laman Collection*, 1991. In the 1970s, an artist known to us only as the "Philadelphia Wire Man" was using modern materials to create *minkisi*-like objects resembling, for example, bound stone charms dedicated to *simbi* spirits in Kongo.

PLATE 76 (NEAR RIGHT): COUNTRY CUMMINS AND HIS CAR, WASHINGTON, D.C., 1980S., 1987. PLATE 77 (FAR RIGHT): CORTOR BLACK AND HIS CAR, HOUSTON, TEXAS, 1970S. , ca. 1972. Combining light and wheeling motion, these cars pick up classic creole-Kongo ideas. Photos: Collection of Robert Farris Thompson

PLATE 78 (ABOVE): TIRE-AND-HUBCAP PLANTER
WITH HORNS AND FAN BLADES, LOUISIANA, 1991.
Tires and other found forms of the wheeling
Kongo circle, like fan blades and hubcaps, appear
frequently in African-American yard shows. Photo:
Grey Gundaker, 1991.

PLATE 79 (ABOVE): CHARLES CHISOLM, MOTORCYCLE,
BALTIMORE, MARYLAND, LATE 1970S. Chisolm's
motorcycle concentrates light: it is equipped with
1,450 light bulbs and 3,500 rhinestones and sequins.
Photo courtesy of the Charles Chisolm family, ca.
1980.

PLATES 81 AND 82 (BELOW LEFT AND RIGHT): SEALS
ON THE ONE-DOLLAR BILL. Charles Chisolm's
motorcycle (plate 79) builds on a triangle shape and
includes an eagle figure. He himself is a Freemason.
The triangular pyramid with illuminated eye on the
dollar bill derives from the Freemasonry tradition.
Masonic concern with light is easily accessible to
Kongo people. Indeed, in Haiti there is a tradition
known as "Kongo-Mazonne."

PLATE 80 (ABOVE): CHARLES CHISOLM, BELT
BUCKLE, BALTIMORE, MARYLAND, CA. 1979–80.
Polished silver lights the way to luck and wealth,
and also apparently reflects the artist's status as a
Mason. Photo: Robert Farris Thompson, 1984.

A Chart for the Soul: The Kongo Atlantic Altar

Three major themes combine in the Chisolm 'cycle: light, at incredible wavelengths; a powerful triangle; and, invisible in the photograph, an American eagle, its image recessed in that triangle. With a belt buckle that mystically attracts coin to prompt us, we consider the possibility that Chisolm recombined his pyramid of light and eagle from the back of the U.S. one-dollar bill (plates 81 and 82). It was likely a medicine of wealth and motion. Questioned about his obsessive handling of lights and facets in June 1984, the artist responded, "I am a Mason and light is a major portion of that world."

Mending Materialism and Declaring Independence

Ku nsi a gani, nata nongo kunatandi baku kibakanga ko.
A Kongo saying: Needles mend, blades destroy.

Yard shows and auxiliary gestures open up worlds and keep things in motion from Savannah to Seattle. Summarizing an intricate example near Killen, Alabama, Gundaker writes, "[Edward] Houston's yard registers values through configurations of objects and plants that also recur with striking consistency in domestic yards and also many graveyards across the U.S."[70] She goes on to note repeated themes in these yards: borders and circles of objects made of silvery, reflecting materials; motion emblems; high-contrast colors; iron and bottles in trees; porcelain and other white vessels; roots and unusual wood formations, a pure *simbi* preoccupation; and seats and chairs, for commemorative and honorific ends. Gundaker also points out recurrent organizational patterns: "encirclement; a pointed contrast between wilder areas of the yard and those that are more settled and carefully groomed; and attention to crossroads and thresholds."[71]

At work on placing all this in a temporal perspective, Gundaker has discovered a fictional account, published by a novelist, Effie Graham, in 1912, that provides a bridge from the late nineteenth century to the present time. This interesting document spotlights an African-American woman whose garden includes two baby carriages, filled with earth and flowers, to commemorate two dead children. She has rolled their names to glory.[72]

In the same way, the yard show wheels a people's soul across our nation. Some have supposed it mere idiosyncrasy, unrooted in larger social facts or value systems, but the voluble, endless parlance of the tradition, from coast to coast, confronts our world with a lexicon of memory and purpose. No one piece of this intricate mosaic—bottle trees, face jugs, memory jars, rock piles in the yard—bears alone the burden of proof of heritage or meaning. It is the combination of all these elements together, in full and proper context, that announces this new art history, vernacular and American.

Consider a pair of tombs in McDonoughville Cemetery, across the Mississippi from New Orleans, and in New Orleans itself. In material and shape they seem European, and they are; but they are also marked with diamond-shaped blue tiles, restoring the Kongo cosmogram. And they are part of a larger context that includes brilliant pieces of broken glass and porcelain, deliberately embedded in the earth before one tomb (plate 83) and in a vertical slab above another (plate 84).

Now compare two tombs in the da Santana cemetery in Luanda, capital of Angola. Christopher Munnelly photographed them in July 1992. As in New Orleans, the outward

PLATE 83: AFRICAN-AMERICAN TOMB, NEW ORLEANS, LOUISIANA, LATE NINETEENTH CENTURY. A diamond-shaped tile centers the stone, as in the graves in plates 62 and 84. And pieces of broken pottery and glass are embedded at the stone's foot. Broken pottery was used as a spiritual barrier to protect houses in the Kongo city of Loango at least as far back as the seventeenth century. Photo: Grey Gundaker, 1991.

PLATE 84 (ABOVE): AFRICAN-AMERICAN TOMBS, McDONOUGHVILLE CEMETERY, ALGIERS, LOUISIANA, TWENTIETH CENTURY. The grave to the right is marked by resurgent Kongo diamonds. Above the grave to the left is a small, headstonelike vertical slab, with embedded broken porcelain. Photo: Christopher Munnelly, 1992.

PLATES 85 AND 86 (BELOW LEFT AND RIGHT): KONGO GRAVES, DA SANTANA CEMETERY, LUANDA, ANGOLA, MID TWENTIETH CENTURY. Though provided with Western architectural accoutrements and texts in Portuguese, these graves are also protected by cactus, traditional guard against witchcraft, and, as in contemporary Louisiana (plates 83 and 84), by broken pottery. Photos: Christopher Munnelly, 1992.

form and impetus are Western, particularly in the miniature cathedral crowning one grave (plate 85) and in the tablets in Portuguese on another (plate 86). Then we notice cactus, an ancient guard against witchcraft in traditional Kongo tombs,[73] as well as reinstatements of the four-point emblem of the cosmogram. But what really links these graves to New Orleans is the fact that they too are guarded by a base of deliberately broken and scattered tiles.

For all their modernism, Luanda and New Orleans share an ancient Kongo expression: broken pottery, sign of death, wards off evil and creates boundaries. Broken pottery guarded houses in Loango as far back as the seventeenth century. Meanwhile, the cross-and-diamond idiom, as Gundaker has documented, protects a home in New Orleans (plate 87) and lights up the stained-glass windows of a church in eastern Virginia (plate 89).[74] The late Charles Logan (1890–1985), an African-American visionary who lived in Alton, Illinois, protected his back with a self-made "diamond coat" (plate 88). He set a diamond-form seal of spirit in a field as luminous as a stained-glass window. Literally dressing himself in the lexicon of black church and cemetery, Logan lived and shared a faith and a joyousness that may help explain his longevity.

A custom related to the broken pottery on the tombs in Luanda and New Orleans appears in the piling up of stones, shells, and glass with a cairnlike insistence in certain yard shows (plate 91). These in turn relate to rock piles on graves, notably in the black cemeteries around Jacksonville, Florida. And the memory jars of black burials (plate 90) allusively crosscut not only rock piles but also the tradition of breaking porcelain or pottery at tombs to guard against evil and the roaming of the spirits enclosed therein. That the memory-jar tradition is not, as some believe, a thing of the past is attested by a twentieth-century tombstone in Austin, Texas, a stone clearly enlivened with the same formal logic of fragmented embellishment (plate 92).

Yard shows not only express spiritual concerns, they are conversations with the surround of neighbors and strangers. Thus a black woman in Austin surrounds her house with plastic bottles filled with colored water, protecting her premises, she says, from roaming dogs (plate 71). As disguise, she keys her colors to major American holidays—

A Chart for the Soul: The Kongo Atlantic Altar

TOP TO BOTTOM, LEFT TO RIGHT: PLATE 87: AFRICAN-AMERICAN HOME, NEW ORLEANS. The crosses alone might be Christian emblems, but their combination with diamonds suggests African content. Photo: Grey Gundaker, 1991. PLATE 88: CHARLES LOGAN, DIAMOND COAT (DETAIL), ALTON, ILLINOIS, 1970S/1980S. Photo: Ken and Kate Anderson, early 1980s. PLATE 89: CHURCH WINDOW, PAINTER, VIRGINIA. The window repeats the cosmogram three times. Photo: Grey Gundaker, 1991. PLATE 90: AFRICAN-AMERICAN MEMORY JAR, U.S. SOUTH. The memory jar is an offering made at a black graveside. This example is studded with shells (see plate 18), crosses, a pinwheel- or *dikenga*-like disk, pottery shards, and other objects. Photograph collection Robert Farris Thompson. PLATE 91: YARD-SHOW CAIRN, TIDEWATER VIRGINIA, 1988. Note the shells on the cairn (as in the memory jar), and the existence of rock piles as cemetery sculpture in, for example, Jacksonville, Florida. The cairn's crowning red light reflectors are protective. Photo: Beverly McGaw, 1988. PLATE 92: AFRICAN-AMERICAN HEADSTONE WITH EMBEDDED GLASS AND PORCELAIN, AUSTIN, TEXAS, TWENTIETH CENTURY. The yard-show cairn, the memory jar, graveside broken pottery (plates 83–86), and porcelain-embedded headstones are clearly linked traditions. Photo: Robert Farris Thompson, 1992.

green and red at Christmas, red, white, and blue on the Fourth of July. Similarly, just as Mother's Day cards on tombs are a tradition of the black cemetery, so yard shows may formulate material conversations with the ancestors. The same woman in Austin keeps on her porch an iron pot her mother cooked hominy in, as well as a stone her late husband collected on a trip: "We used to argue about it and now it's all I have of him." She explains the bottles on her lawn and in a tree—"They make a noise against evil in the wind"—as "obstacles." People come, she says, people look around, and suddenly they feel that someone is watching over things. Glossing further this idiom of spiritual deterrence, she adds that pinwheels in her yard "keep those birds away; they see the colors and try to light on them and then it moves and frightens them away. . . . my tire planters protect my flowers from outside dirt and water. Paint them white. Paint them all colors. Cut them in two and place them like arches all around the lawn."

What makes these yard shows altars? They are visual prayers, with saints masked as scarecrows asking protection of inner life and soul (plates 93 and 94). Outwardly simple, they are inwardly rich with meditation. Witness the sequence leading to a Virginia African-American's door: two whitened tire planters with inserted red reflectors, two circles of red bricks, two white trunks tied with red ribbon, a red propeller and a maroon-and-white lighthouse, two open vessels at the steps, two vessels at the door (plate 95). In a careful orchestration, outward decoration is cast in inner symmetries of spiritual admonishment.

PLATE 93: YARD-SHOW "SCARECROW," U.S. SOUTH, 1991. The recurrent appearance of scarecrows in yard shows suggests a role as guardian figures. Wheels and hubcaps—there are several in this apparently random accumulation—lend motion to protection. Photo: Grey Gundaker, 1991.

The confidence and fluency of the tradition have led to arresting works of art. Of a pair of house-protective "dolls" in southwestern Mississippi, for example, one has ribbons for legs, as if part of her body were crimson smoke; the other surmounts the head of an animal, is long of leg and commanding of gesture, and wears a pistol as a necklace (plate 96). The mixture of charm and militancy is in perfect balance, exquisite evocation. These are dolls that preach.

Yard shows constitute a declaration of architectural independence. Not only do they free us from imagining that the gardens of America stem from a single (read: European) heritage, but their mixture of toughness, memory, and camaraderie liberates us from the assorted nihilisms and apocalypticisms of so-called postmodernism, and from other movements that have lost their way. Spirit does not date. Neither does it fear the garish world of commerce and technology.

With one or two handsomely selective gestures, Gyp Packnett, a master yard-artist of southwestern Mississippi, has harvested ancient truths from outward detritus and debris. Building himself a meditation garden (plate 97), he has caparisoned it with a fence of wheels and icons, like fugitives from a Kongo passport to the other world. The garden leads to a commanding, thick-trunked tree, where chairs cluster and combine. This precinct within a precinct is announced by a gate emblazoned with a wheel: behold, Packnett explains, an entrance to the other world (plate 98). A cow skull over a wheel travels with death. It travels, too, with life rediscovered, bone dressed with paint, chains, machinery, and glass (plate 99). This intricately-arrived-at spirit guards the circle of our life, the ideal motion of our turning spirit.

A Chart for the Soul: The Kongo Atlantic Altar

African-Americans are justly famous for what they say and do in blues and spirituals, gospel and rap. But they have also preached *visually*. Soul art turns, soul art wheels. In the process, the yards, houses, and sometimes cars, too, of visionary black and black-influenced women and men adhere to ancestral truths. Theirs is a force and a work that drive us all toward possibility and return.

PLATE 97 (BELOW): GYP PACKNETT'S GARDEN, SOUTHWESTERN MISSISSIPPI, BEGUN CA. EARLY 1970S. Drawing: Grey Gundaker, 1991.

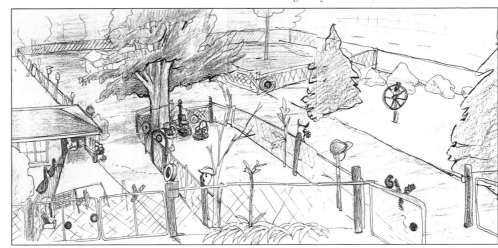

PLATE 94 (ABOVE, TOP): YARD SHOW WITH "SCARECROWS" AND DOLLS, RENFREW STREET, PITTSBURGH, 1980. Photo: Renee Stout, 1980.

PLATE 95 (ABOVE, CENTER): AFRICAN-AMERICAN GARDEN, TIDEWATER VIRGINIA, 1980S. Emblems of motion and containment are carefully sited. Photo: Beverly McGaw, 1988.

PLATE 96 (ABOVE, BOTTOM): DOLLS PROTECTING THE DOOR OF GYP PACKNETT, SOUTHWESTERN MISSISSIPPI, EARLY 1990S. Queried as to the doll on the right, he said, "She tells the world she can take care of things." Photo: Grey Gundaker, 1991.

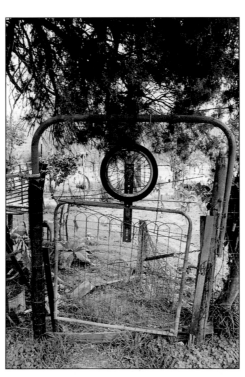

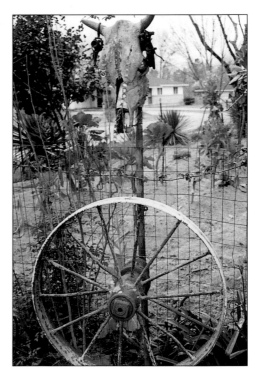

.PLATES 98 AND 99 (ABOVE LEFT AND RIGHT): GYP PACKNETT'S GARDEN. Packnett has built a garden within a garden, focused on a cedar tree—an emblem of family—with arrangements of enthroning chairs. Its gate is "a bed frame topped with sunrise/sunset." A cow skull with one of the garden's many further wheels offers powerful protection. Photos: Grey Gundaker, 1991.

The Chalk and the Rosary: The African Voice in Umbanda

North American blacks of Kongo heritage redirected the Christian image of God toward their own monotheist recognition of Nzambi Mpungu, whose medicines they kept alive in covert ways, in their herb gardens and in the lexicons of their yard shows and cemetery art. In Brazil the mix was different, compounded not only of Nzambi Mpungu and his myriad medicines but of Yoruba saints and deities, and of Amerindian allusions. Still and all, the major black urban religion of Brazil today bears a Kongo/Angola name: Umbanda. And Kongo influences appear in critical elements of Umbanda ritual and altar-making.

This famous fusion-faith of Rio/Niteroi represents a decisive moment in African influence on the sacred art of our hemisphere. Spreading first across Brazil, then into Uruguay and Argentina, it has latterly attained a wide geographic range that includes New York City. The women and men of Umbanda have elaborated an exquisite network of spiritual interactions. They show us means by which religions can come together to make not bloodshed but peace and sense. In Umbanda, persons in the spirit focus on charity, advising the troubled in mind or soul for minimal compensation.

Outwardly, Umbanda seems quite Western, with its Roman Catholic–looking altars and its songs almost entirely in Portuguese. Some houses even lack African drumming, furnishing percussion solely by hand-clapping. But on closer inspection one learns that each saint is an analogue for a Yoruba *orisha* or power, and that the spirits that come down are essentially *caboclos*, Kongoized Native Americans of the interior, and *pretos velhos*, black elders whose names—Pai Joaquim de Angola and Maria Konga and Maria Kabinda—communicate generic Kongo and Angola origins. The drawing of blazons on the ground with white chalk called by its Ki-Kongo name, *pemba*, and the use of gunpowder art, as in Kongo and in the Kongo religions of Cuba, redress Umbanda's balance of influences toward Central Africa. This faith must be understood as a coordination of incoming influences to a core element: the Kongo cosmogram, map for the preservation of the soul and the safeguarding of the people. Indicating Umbanda's true sources of authority and inspiration are the dramatic moments that propel it toward its accomplishments of charity and mental healing: gunpowder art; finger-snapping by the priest under possession, to wash the supplicants of evil; and the bowing down to Kongo-influenced cosmograms at the corners of the dancing/healing court.

Scholars have been mesmerized by the Yoruba impact on Brazil, but given the predominance of Ki-Kongo in the African element of Rio slang, and the worship of the tree-*nkisi* Tempo with lyrics in creolized Ki-Kongo, a richer vein of sources must remain to be tapped. As early as 1912, in fact, in a religious house called the candomblé das Cambindas, worship comprised spirit possession accompanied by songs in Portuguese—traits already predictive of Umbanda. And one such song is sung in the voice of a Kongo woman, Maria Musange. Washing clothes for the whites of Rio, she expresses resentment at her servitude.

The first Umbanda center arose in the middle 1920s in a rented backyard on the outskirts of Niteroi, across Guanabara Bay from Rio. The history of this inception reads like a creole retelling of a Central African "drum of affliction" legend: in his early twenties, the founder, Zelio de Moraes, is suddenly paralyzed. Western medicine cannot cure him. He consults a spiritist federation in Rio, where the shade of a Jesuit priest tells him

that his illness is the sign of a sacred mission: "He was to be the founder of a new religion, a true Brazilian religion dedicated to the worship and propitiation of Brazilian spirits: *caboclos* and *pretos velhos*."[75] The new religion will restore these powers to the positions of respect denied them by Kardecists, adherents of a spiritualist movement begun in France. The spirit also reveals that his *own* spiritual mentor, *O caboclo das Sete Encruzilhadas*, will visit Zelio shortly to give him further instructions. Zelio returns home. Contact with the spirits cures him. He then receives the prophesied visit from the *caboclo* of the Seven Crossroads, who confirms Zelio's mission: found a religion and call it Umbanda.

Note the sequence: Zelio is afflicted; in founding a faith he is cured. The religion is dictated in the spirit, first by the spirit of a Jesuit priest, representing the Catholic and European part of Umbanda, then by a "native American," the primary mentor, who represents not only Umbanda's *caboclo* element but also its Kongo constituent. Indeed, the spirit's very name shows a Kongo-like preoccupation with the crossroads as a theater of spiritual enactment. In addition, this *caboclo* knows Ki-Kongo or Kimbundu: Umbanda, the name he gives Zelio to start off the religion, is close to the Ki-Kongo word *banda*, to start, to begin the work, and to the Angola Kimbundu word *umbanda*, essentially meaning "to work positively with medicines."

Then the first Umbanda center was named the Spiritist Center of Our Lady of Piety. It and indeed the entire enterprise were hidden behind a Catholic mask.

The surest way of concretizing this Brazilian history of combining the dynamics of Roman Catholicism, Kardecist spiritualism, the Yoruba religion, the Kongo religion, and the Amerindian presence is to study the play of the great symbols of these different forces in interaction upon the altar. Diana de G. Brown makes this clear: "In Umbanda Pura, [the Yoruba *orixa*] . . . are represented in the statuary on Umbanda altars, in either their African or their Catholic persona, according to the preference of the particular centro for emphasizing the Catholic or the African presence."[76] The Kardecist element remains in the glasses of water set on the altar for capture of the spirit—a practice dovetailing nicely with the Kongo concept of spirit mediation through and across the river or the ocean—and in the placement there also of images of deceased persons who once lived in Brazil.

The Yoruba element, like the Roman Catholic, is honorific. In the "astral hierarchy" of Umbanda we start at the summit with Oxala, Yoruba god of creativity and purity of mind and spirit, syncretized with God Almighty in the Christian pantheon. Immediately under Oxala/God or Oxala/Jesus come six *orixa*, associated with their traditional Yoruba spiritual domains (Xango with lightning, Yemanjá with the Atlantic Ocean, Oxossi with the hunt, and so on), and the evidently creolized-Kongo spirit Yorima. Each *orixa* is the lord or captain of a line (*linha*) of seven subspirits, who in turn captain sub-subdivisions called kingdoms (*reinos*) or phalanxes (*falanges*).

These are the working sections of the religion, made up mainly of *caboclos* and *pretos velhos*. That the *caboclos*' lines fall under three major *orixa* indicates the glory of their ancient wisdom: some serve in Oxala's army; under Yemanjá, Amerinds from the interior blend in name and spirit with important Yoruba goddesses like Nana Bukúu, Oxum, and Oya Yansan; and Oxossi, linked to Oxala through his cryptic mountain (*oke*), creative promptitude (*ji lo da*), and whiteness, takes the *caboclos*, his fellow users of the bow and arrow, under his special aegis. And it is under Yorima that the *pretos velhos* come, their names clearly indicating knowledge of their sub-Saharan origins, principally Kongo/

PLATE 100: W. WILSON DA MATTA E SILVA, DIAGRAM OF THE UMBANDA SAINTS AND THEIR ARMIES, CA. 1985. This striking diagram compares the major *orixa* and their followers to a convocation of stars streaming light. From Helena Theodora Lopes, "Umbanda and Other Religions of Bantu Origin in Rio de Janeiro," 1985.

Angola: Pai Kongo de Arunda, Maria Konga, Pai Joaquim de Angola.

Umbanda knows many other powers besides these principal groups. The Yoruba worship of twins explodes here into a general honoring of the spirits of dead children, *crianças*, in which we see fragments of both Yoruba twin appellations (Afro-Brazilian *doum* equals Yoruba *idowu*, the next child born after a pair of twins) and the Roman Catholic twin saints Damiao and Cosme. Then there are the *exus*, Yoruba-derived trickster spirits, one of them magnificently creole—the dandy Ze Pilintra, dressed in the Brazilian equivalent of a '30s zoot suit (white silk, red cravat, handkerchief), and barefoot and ready to run. Exu and his creole wife, Pomba Gira (apparently from the Ki-Kongo *mpambu nzila*, crossing of the roads), are miniature walking "drums of affliction," suffering from their sins of crime, prevarication, and prostitution but coming back wiser and tougher. They speak from a position of total authority, then, when they possess the troubled to advise them on precisely what hard times comprise, how evil is so often bad planning, and how to survive without abasement of the self. In the process the crossroads emblem of Exu and Ze dovetails with the cosmogram of Kongo, the two forces blending inextricably into a single pattern or design.

Helena Theodoro Lopes, in a classic article, "Umbanda and Other Religions of Bantu Origin in Rio de Janeiro," helps us to determine what Umbanda's Kongo roots might be.[77] She notes three religions of Kongo bearing emergent in Rio: Candomblé Angola, Candomblé Congo, and, later, Umbanda. (In Candomblé Angola, *minkisi* worship and

ancestor worship again surface together, and the priest communicates with the deceased by means of *pemba*, white chalk or clay, the ancient Kongo medium of spiritual presence and surveillance.) In this study I have focused on the ideology and symbolism of the Umbanda of the *favelas* (*umbanda do morro*), which now increasingly influences and re-Africanizes the formerly white-oriented Umbanda practiced below the hills in town (*umbanda de asfalto*). In the process, Kongo language, cosmogrammatic structure, and ritual are pervading Umbanda more and more.

Recall that in Kongo the soul in flight is symbolized by a star (*mbwétete*), then look at the way a believer imagines the Umbanda universe of mixed Amerind, Yoruba, Kongo, and Roman Catholic forces (plate 100). This diagram charts nothing less than a new constellation in the firmament of world religions. A triangle of the law is the still point of a turning world of saints, *minkisi*, and *orixa*, recalling the three stones upon which the original medicines of Kongo once were placed and "cooked." Then come the inner circle of six honorific *orixa* and their attributes (as creolized in Umbanda thought), each a blazing star of the first magnitude: Orixala, "light of Lord God"; Xango, "lord of the ethereal fire" (the fire of lightning); Yemanjá, "the generating principle" (of the sea); Ogum, who "concerns himself with conflicts"; Yori (Yoruba *orí*?), "manifest divine power"; and Oxossi, "the soul hunter, doctrine, instruction."

The seventh member of this circle is Yorima (perhaps ultimately taken from the Ki-Kongo *yodima*, to prosper, to flourish, to shine), who leads the *pretos velhos*, the souls of dead Kongo/Angola slaves. Significantly, this is the spirit who presides over the imparting of Umbanda's essence.

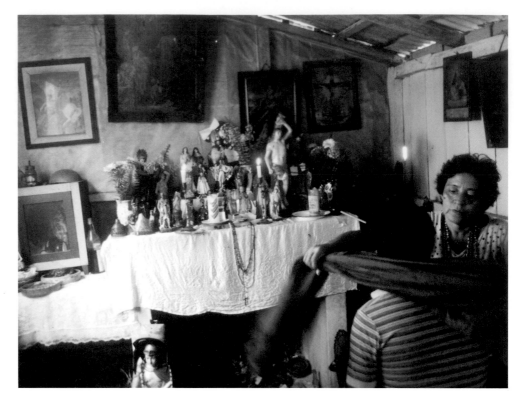

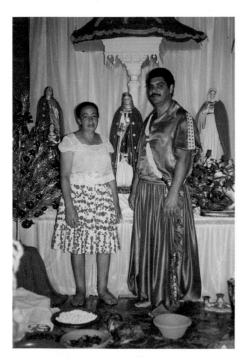

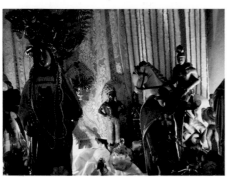

Five Umbanda Altars

Charity is essential to Umbanda. Thus the first Umbanda altar we visit, in the river city of Manaus, is given over to charitable healing (plate 101). An officiant carefully assuages a person's mental anguish and worry by rubbing his neck with a green sash consecrated by color to the spirit of war, Ogum. In this small *centro*, visited in the summer of 1990, the officiant, lips pursed with quiet concentration, is "making a peace" (*ela esta fazendo uma paz*). She restores a torn life to a sense of being cared for. Ogum and his legions have been activated, and they guard and caress now the nape of the neck, where one is most vulnerable. On the wall, icons of Catholic/Yoruba saints witness and extend the power of this healing. A white wall meets a beige wall, accentuating this domestic, interior crossroads, where one world is summoned for the protection of another.

Built up over an immaculate white cloth symbolizing the vestment of Jesus/Oxala, who presides over all the sacraments, the altar ecumenically incorporates, from left, images of Buddha, African calabashes, Roman Catholic candles, and "works done with honey" (contained in hivelike vessels). The multitude of saints/*orixa*, mixed with an occasional *preto velho* or *caboclo*, asserts the marching of Umbanda's spirit legions. The powers in this corner make something happen in the spirit. And that power, in this case, is a peace that surpasses understanding.

An Umbanda altar in the Centro Espirita Africano Reino dos Xangos (founded on May 10, 1967) in Rio Grande, Brazil's southernmost city, enthrones the guiding stars, the *orixa*/saints, and the *caboclos*. Our detail was taken on January 3, 1990 (plate 103). Its comparison with a photograph of the same altar as it was in January 1974 elicits a clear expansion of creative vision (plate 102): the few spirits on the table in 1974 have grown to an army in 1990. What is more, during those sixteen years the presiding priest and priestess, through restless refinement and elaboration, have achieved a rich staging of icons and light. With concealed sources of illumination, they orchestrate darks and lights

PLATE 104 (RIGHT): CENTRO REINO SAO LAZARO, RIO GRANDE, BRAZIL, LATE 1980S. The altar is framed in a shell-like alcove. Bands of color bring down the different *orixa* and their power. Oxala/Jesus stands on the topmost pedestal, with Omo-Olu/Sao Lazaro, patron of this Umbanda *centro*, directly below him. Other deities are arrayed in support of them. Hidden beneath the altar are recesses for the trickster spirits. Photo: Robert Farris Thompson, 1990.

PLATE 105 (RIGHT): CENTRO REINO SAO LAZARO, RIO GRANDE, BRAZIL, LATE 1980S. On a side wall in this centro is a shrine to Pai Manuel, *rei Congo* (king of Kongo). Photo: Robert Farris Thompson, 1990.

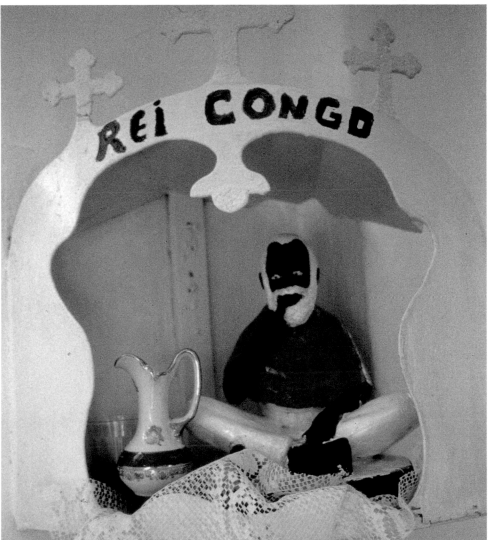

101

PLATE 106: DONA JULIA, UMBANDA ALTAR, RIO DE JANEIRO, BRAZIL, 1984. Blue-and-white crepe on the ceiling translates the domain of the ocean into the sky, and honors the *orixa* Yemanjá, who appears on the wall above the altar as a mermaid. Oxala/Jesus is central among the *orixa*/saints. The bearded and mustachioed face below him is that of a local eye-ear-nose-and-throat specialist who, now deceased, acts as a supporting spirit. The figures below the altar include, at right, a doll addressing linked *ibeji* or twin emblems. Bowls holding stones and marbles immersed in water honor the *orixa* Yansan and Oxum, *ibeji* spirits, as well as the spirits of dead children. Photo: Robert Farris Thompson, 1984.

to ring the saints with apparitional brilliance, strongly silhouetting them. Bathed in soft shadow, the image of Yansan/Santa Barbara, at left, assimilates her subtle lighting to the pensive quality of her countenance. She is honored with garlands—beaded strands for Xango (red and white), Yemanjá (blue and white), and Oxala (pure white)—and guarded behind by a mounted image of Ogum.

The parade of the spirits is rich and various: dead twins, given under a Ki-Kongo name, *mabasa*, to the left of Yansan/Santa Barbara; the *caboclo* Ubirajara, arms feistily akimbo; the *caboclo* de Lua; and Ogum/Sao Jorge, as well as Xango in red cape and sword. In their ecumenical fusion these icons bring together three races and three faiths. The red-and-white back cloth picks up the colors of the saint of the house, Xango/Saint Jerome, then breaks into the contrasting transparent white lace of Oxala/Jesus Christ.

In another Rio Grande *centro*, Reino Sao Lazaro, the colors of the seven major spirits of Umbanda—the red of Xango, the green of Ogum, the gold of Oxum, and so forth— stream down from heaven and paint the shrine with the promise of benediction (plate

A Chart for the Soul: The Kongo Atlantic Altar

104). The priestess who designed the altar creates a shell of color and outlines it with a lacy meander in light blue and white. Descending in color, the spirits reemerge as icons: at summit, Oxala/Lord Jesus, and under him, also empedestaled, the patron of the house, Omo-Olu/Sao Lazaro. Nana/Saint Anne, mother of Mary, appears above Yemanjá, goddess of the Atlantic, in blue. Then follow the chalice of Oxala, Yansan/Santa Barbara, and Yemanjá again. A mirror, marking the vanity of Oxum, sparkles at Nana's feet.

Beneath the altar closed compartments hide nether spirits, negative counterparts for the positive forces displayed above. In these secret spaces stand images of the tricksters Pomba Gira/Salome, dancing with a tambourine, and Exu. Drums to the side of the altar emphasize that its procedures aim at Africa. A photograph of a familiar spirit, set above a door, betrays connections with Umbanda's originating spiritualist impulse. High upon a wall to one side is an exquisite addition, a miniature shrine for Pai Manuel, king of Kongo (plate 105). Like an *ntadi* or funerary guardian monument, he sits in the classically Kongo cross-legged way, smoking his pipe, and meditating, no doubt, on the guidance of his followers. In a wonderfully cut-out space the artist seats him on a cloud of lace. Aware of the history of relationship between Kongo and the Church of Rome, she accentuates the purity of his spirit in Christian terms, with three crosses. A long-handled vessel defines his palace as his tomb; here his followers, when they come to ask his blessing, maintain the Kongo protocols of sacrificial meat and liquid. The vessel is a sign of service. And the apotheosis of a historical king of Kongo emphasizes the basic lines of thought and visitation upon which Umbanda is built.

Toward the end of December 1984, a priestess named Dona Julia prepared an Umbanda altar for a ceremony in the Cobertura section of Rio de Janeiro. The house, on the building's third story, was guarded at the stairs by the trickster Ze Pilintra, his Kongo signature/cosmogram (*ponto riscado*) being written there in Kongo's sacred white chalk. Inside the apartment, guarded with two further *pontos*—one appliquéd as a kind of wall hanging, the other on the floor of the dancing area—were three altars. Two were private, built on bureau tops in a bedroom. But the main altar was public, and stood at the end of a long rectangular room serving as a space for dance and prayer (plate 106).

This altar regathers superbly Umbanda hierarchies of thought and vision. At the same time that she brings together the diverse origins of her faith, Dona Julia reconciles heaven and the ocean: the ghost raffia effect of the shimmering rows of shredded blue-and-white crepe paper at the top gives the effect of rippling oceanic water reflected in a mirror in the sky, an extension of the realm of the mermaid Yemanjá, whose image presides upon the altar wall. This wall is pale blue, with stars, bringing heaven down as witness. The altar cloth is also light blue, but the phrasing of its color is ambiguous, standing for sky but equally for ocean. It makes a canopy for the under-altar portion, where "working spirits," clusters of *pretos velhos*, share space with *ibeji*, *crianças*, and other powers.

The canonical crowning figure, Oxala/Lord Jesus, extends His arms in benediction. *Orixa*/saints march with *caboclos* Cazaro, in feather bonnets, and Estrela (star), shown in loincloth under an actual star. Kardecist touches reemerge: the photograph of a familiar spirit is on the wall, and on the altar, amidst *caboclos*, *orixa*, and *pretos velhos*, appears the bearded bust of one Doctor Velerio de Menezes, a departed eye-ear-nose-and-throat specialist. Serving to cure or heal, he is an appropriate icon for this altar, where, as in all

PLATE 107: FRATERNIDAD PAI JOAQUIM, BUENOS AIRES, ARGENTINA, LATE 1980S. Two kinds of Umbanda altar appear here: the material, iconic altar, of which there are several at the Fraternidad Pai Joaquim, arranged in tiers on the wall; and the *ponto riscado*, the "drawn" altar, a chalk or clay (*pemba*) circle on the floor containing spirit signatures or seals that recall the *firmas* of the *Regla de Mayombé* (plates 46, 48–50). Photo: Robert Farris Thompson, March 1990.

Umbanda, distraught clients come to have their problems analyzed and weighed by persons in the spirit.

The altar once again makes tangible Umbanda's armies within armies, marching toward charity and grace. A speaker, indicating modern means of transmitting song and prayer, is built into it at left. Below at left are *pretos velhos*, *crianças* and twins, and a sailor, Marujo, a maritime *caboclo* "who drinks a lot and is rowdy but entertaining."[78] He is of the phalanx of Yemanjá. On the floor, in direct citation of Yoruba *ikoko* filled with river water and the stones of Yemoja or Eyinle, are two porcelain bowls, one, at left, filled with the *ota* (stones) of Yansan, the other with those of Oxum, goddess of sweet water, mixed with marbles in which reside *crianças* and dead twins. A celluloid doll leans forward, hands stretched out, as if to play with three linked twin images to her right. A matching doll at left helps frame the altar. She and the other children bring laughter, play, and tiny voices into this gathering of stars and phalanxes from another world.

Umbanda has expanded south in recent years, crossing the borders of Uruguay and Argentina. It has spread in particular throughout Buenos Aires, where, according to Alejandro Frígerio, one of the leading Afro-Americanists of Argentina, the first Umbanda *centro* emerged in 1966. Now there are hundreds, suggesting the appeal of Umbanda's therapeutic charity.

One of the principal Umbanda altars in Buenos Aires is found at the Fraternidad Pai Joaquim, in the Floresta section of the city (plate 107). The phrasing is formal: Catholic-looking *orixa*/saints float on miniature altars—cloudlike, decked in white—while the spirit signatures of the Kongo cosmogram are sealed in chalk circles upon the floor. Circles also embrace the icons on the tiny altars, thus making *pontos*, spirit-summoning ideograms, of them all. Such summoning transmutes into flesh and blood, for multiple spirit possessions occurred the night I visited this altar, in March 1990.

Under the pressure of the coming of the spirits, the definition of this space as single altar dissolves. There are really three altars to Umbanda. First is the formal, iconic altar, establishing the dignity and seriousness of the religion in universal terms. Then come "drawn altars," the *pontos riscados*, written, like *firmas* in Kongo Cuba, in sacred *pemba*. Identifying, calling, and anchoring the spirits at a point of worship or concern, these emblems are so strongly drenched with breath and spirit that devotees salute them, kneeling, often, before the four points or four corners where they are frequently drawn—crossroads within crossroads, gates within gates. Then come the third and most dramatic altars, persons possessed by *caboclos*, *pretos velhos*, or other spirits. These resolve tiered icons on the wall and chalked signatures on the floor into flesh and blood and act, making them yield, again and again, to the higher, Africanizing synthesis of possession by the spirit.

On that night in March 1990 came down Exu Sete Encruzilhadas, Trickster of the Seven Crossroads. He identified himself with a signed *ponto riscado*, making horns with his fingers. Another *exu*, hearty and athletic, made his presence known in a wise and ironical laugh. Then came the female *exu* Pomba-Gira, dancing with her tambourine.

After whirling and dancing before the Latin altar the spirits sat down to listen to the problems voiced by clients, and to offer advice in the spirit. In a roped-off area, persons with problems knelt in multiple units of consultation, one per *preto velho* or *caboclo* or *exu*. As in Manaus, "the work" included blessing by honey: a foreign visitor was anointed

by Exu Tranca Rua with honey to his forehead (to have good thoughts), to his chest (to have good feelings), to his nape (that his enemies would not harm him), to his hands (not to seek justice with his own bare hands), and to his feet (that he would always find an open road).

The seated spirits, barefoot and serious, are living extensions of the altar. Before these altars-in-the-flesh come persons with their many problems, kneeling or sitting cross-legged on the floor in consultation. The circling dances of Umbanda possession spirits recall the ring shouts of the Old Time Religion in North America. And with their finger-snapping passes about the bodies of their troubled clients, drawing off bad luck and negation, Umbanda spirits recall finger-snapping episodes and the laying on of hands among the San shamans of Namibia and Angola. Indeed, the visionary situations of Umbanda spirit possession strongly recall San and Pygmy "altars in motion," the latter's shouts of the spirit approximating the former's wordless idiom of ecstasy and exaltation.

For all their outward signs of Western blazonry, the *pontos*, at the level of deep structure, align with Kongo. Thus the area upon which they are drawn must be carefully swept and consecrated, establishing cosmographic space as in the Old World originating custom: "*Nganga*, being summoned, has his assistant sweep a patch of ground, upon which he then describes a figure like a checquer board, which he uses for divination."[79] In such an area the solution of the client's problem can be set out by *nganga* and *nkisi*, and can be achieved. Which is precisely the point and action of the *pontos* in Umbanda. In Kongo, *nganga* tremble with the spirit and carry the insights of the *nkisi* into words and recipes. In Umbanda, *pretos velhos* and *caboclos* arising from the *pontos*, and inspiring living persons with their voice and vision, grant the poor and the troubled a chance to bring their problems to icons made of flesh and blood. As altars that give voice, the possession priests reveal antidotes and resolutions, composing a collective medicine of concern.

PLATE 108: ROBERT HARPER, YARD SHOW, HOUSTON, TEXAS, BEGUN 1980S. Found objects have been selected for crisscross, diamond, and arching motion patterns, with wheels and fan blades lifted on high. Photo: courtesy of Suzanne Theis. The Orange Show Foundation, Houston, Texas.

Envoi: The Feather and the Circle

In both quality and visionary impact, the Kongo Atlantic altar stands as an important contribution to art history. Persons in Kongo, Cuban *mayomberos*, Brazilian Umbandistas, and African-Americans in the northern continent jointly address, through all their differences, the central issue of the safety and perdurance of the soul. This generates a characteristic rapport between sculptural and rapt arts, between ideographic cosmograms chalked on myriad surfaces and spirit possession. *Nkisi* guard the soul, cosmograms guide it, and officiants bring it forward in the trembling of their shoulders and the momentary obliteration of their personality by higher force.

Such art has its roots and its rationale in the cosmogram, the means to glory and the ground of inspiration. As we have seen, this vital core element took root variously—in designs scratched in the bottoms of eighteenth-century North American colono ware, in the bottoms of *nkisi* kettles in Havana, in ground blazons (*veve simbi*, *veve kalfour*) on the Petro/Kongo side of Vodun in Haiti, and in the theory and enactment of the Umbanda *ponto riscado*. As we survey this shared vocabulary of ideographic forms, unsuspected concordances linking the far-flung provinces begin to suggest themselves, especially where Kongo/Angola demographic majorities and depths of tradition have left their impact. Thus the wheels of soul and continuity that stud the yard shows of the black United States, for example, are North American *pontos* to attract God's presence and protection. As shields, they also resemble the wheeling patterns that Afro-Cubans chalk as guardians on doors.

Look, by the same token, at the tremendous feather-idioms in Kongo sacred art, a complicated lexicon of plumes and powers that remains to be fully explored. But inspection of a magnificent Vili feathered-costume-and-mask combination now in the Berlin Museum für Volkerkunde in Dahlem (plate 8) already shows how "the feathers from many species were put together to generate tremendous energy and to symbolize all worlds of flying beings."[80] Focusing the face with sources of power and inspiration, in a radiance that sends one flying, this mask of cosmos obliterates fear and hesitation. The feathered ambiance imparts a message: our power is soaring, we are no longer physical, nothing can stop us.

We find feather emblems also upon the altars of Kongo-influenced Haiti. And the *caboclo* possession spirits of Brazil may don feather bonnets similar to the headgear of the Kongo *nganga*. The impulse is stronger still in Cuba, where feathered *nkisi Sarabanda* and other *prenda* vessels link up with plumed images, and with priests who wear spiritual feathers (*nsala za peve*) radiating from their heads.

A feathered idiom of transcendence survives also in the nomenclature of certain traditionalist black doctors of the spirit in North America: Doctor Buzzard, Doctor Hawk. And in New Orleans, city of Kongo Square, which received African influences direct from the Old World and also from the Caribbean, feathered bonnets from the iconography of the Plains Indians were powerfully attractive to blacks. (In the same way, visionary African-Americans love the books of Revelation and of Ezekiel; wheels in the sky excite a mind primed by the cosmogram.) In Mardigridean festivalizing, however, the blacks rephrased the siting of the plumes, spreading them over the entire body, as in the Vili tradition, rather than concentrating mainly on the head, as the Indians had (plate 9). Thus they were able to express pictures of transcendence, already in their minds, in several

languages. The precise dovetailing of the feathered beings of Loango with the feathered marchers of New Orleans remains to be tested and assayed, but in certain ways the message seems the same. Both are moving altars of the spirit. Both are shouts worn as dress: *We are persons exalted by God's plumes*—no one can stop us.

The ring shout of the Old Time Religion relates to the circle of the cosmogram as a prayer: God grant all dancers the completion of their lives. Think of the honorific circle of stones around the monolith at Khami, in Zimbabwe (plate 59). Move from there to the arch of completion, and the elevated fans and hubcaps wheeling soul and spirit through the sky, that studded the Houston yard show of Robert Harper in 1990 (plate 108). Harper's text is both different and unchanging. The blue of his bread boxes endows a wall with Matissean azures, direct from heaven; intervening passages in white, many tracing diamonds and crosses in openwork, enhance the richness of the blue. Discovering essential signs—diamond, arch, wheels—in modern forms, Harper pares away the mute and inessential in technology in favor of the parlance of the soul.

Belief in the superiority of an ambiance of the spirit similarly inspired an Umbanda priest/architect working in the '80s in the Brazilian state of Maranhao (plate 109). Within a circular amphitheater, a vast, heroic *ponto* writ in three dimensions, he peopled space with spirit chairs encircling an elevated table of the visionary. Each guided to cosmos by surmounting plaster stars with *nkisi*-like mirrors embedded in them, these chairs gather as spirits in themselves, waiting to enthrone a visionary audience. Persons meditating at the table for the dignitaries form perfect diamonds with their fingers on its surface. Angels, and icons of war (Ogum) and peace (Oxala/Lord Jesus), back the table in a symmetry of contribution. Above, at the top of a commanding wall, the leaders of the legions of Umbanda gather under the wings of the dove of the Holy Spirit. This is a primary monument in the history of Umbanda, a ring shout in art and architecture.

These far-flung programs—the monolith at Khami, the wall in Third Ward Houston, the sanctuary of the spirits in Maranhao—are nonetheless continuous in their ring-shout impetus, in the idiom of their wheeling. The richest search, for the perfect realization of the circle of the soul, motivates them all.

PLATE 109: BABALAO ORIXA SEBASTIAO DE JESUS, HOLY SANCTUARY OF THE TENDA ESPIRITA SAO SEBASTIAO, MARANHAO, BRAZIL, BEGUN 1960. The roundness of the Maranhao Umbanda temple recalls the circle symbol of countless *pontos riscados*, as well as African circle forms dating back to the stone enclosure at Khami (plate 59) and, earlier still, to the circling "altars in motion" of Pygmy and San peoples. Here, outer rings of chairs are arranged in semicircles and marked with mirrored stars. Seven steps lead to a table surrounded by eleven thrones, each surmounted by an *orixa* or guardian angel; and a framing wall is topped by standing figures of the *orixa* and Umbanda leaders, gathered under the sign of the Holy Spirit. Photo: Robert Farris Thompson, 1989.

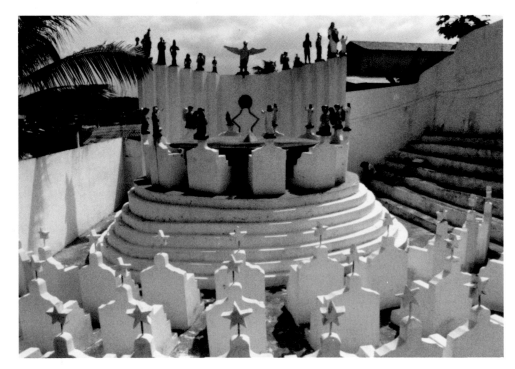

The Face of the Past:
Staff Shrines and Flag Altars

The function of the artist is to make actual the spiritual, so that it is there to be possessed.

–Robert Motherwell, "The Modern Painter's World," 1944

A signal contribution of traditional sub-Saharan religions to world civilization is a strongly spiritualized ecology. Here, religious respect for the natural world and its spirits was not bulldozed into oblivion by the advent of urban life. Like the Greeks, West Africans have lived in cities for millennia. Yet they have always worshiped in groves, and have regarded certain tall trees as loci of spiritual presence. Not only among Yoruba and Kongo but also among Mande, Akan, Fon, and the maroon (runaway-slave) civilizations of Suriname, in South America, traditionalists view the forest as found cathedral, and certain towering species of tree as altars of the spirit.

Here we document ancient forest and other altar traditions among the Mande and Mande-related Akan and Fon/Ewe. It is a story that begins with the city of Djenné-jeno.

The Altars of Djenné-jeno

Djenné-jeno ("ancient Djenné") is the oldest known city in Africa south of the Sahara. Susan and Roderick McIntosh, archaeologists, have established that this ancient municipality, located on an island in the Bani River in modern Mali, grew from a village in the third century B.C. into a cosmopolitan center of approximately 10,000 people by A.D. 800.[1]

Reflecting the sophistication of Djenné-jeno's urban way of life, powerfully executed terra-cotta icons, destined for shrines, have emerged in this area. Gestures portrayed by the altar icons of Djenné-jeno and neighboring areas, Bernard de Grunne argues, were repeated by the supplicant worshiping before the altar. The servitor mimed the stance of the icon.[2] This suggests that Djenné altar statuary reflects ancient Mande modes of worship.

The link between servitor and altar image, one mirroring the gesture of the other, provides a key to understanding the forked-branch and clay-pillar altars that remain important throughout the Mande area. Maroons reestablished these basic altar modes in South America, specifically in Suriname.

Forked-branch and pillar altars mime the verticality of the tree. Their basic upholding gesture, supporting a vessel of medicine or power, is mimed in turn by both Akan and Suriname possession priests. As the worshiper in ancient Djenné *became* the gesture represented on the altar, so these priests take on the supportive strength and majesty of certain trees: they take the vessel from the top of the surrogate tree and balance it on their own heads. At this moment the spirit in the vessel possesses the head upon which it rests.

We find these traditions equally in Ghana, Côte d'Ivoire, and coastal-creole and inland-maroon Suriname. In these areas, linked by the Atlantic Trade, the possession priestess or priest dances as a living pillar, supporting a sacred vessel on his or her head.

With these lines of spiritual descent came further Sudanisms to Suriname, such as women studding the walls of their habitations with crockery or calabashes, a tendency toward openwork arabesques in wood-carving and other decorative media, and even one apparent instance of a West Sudanic Koranic reading-stool inspiring an identically constructed Suriname maroon folding-stool. We are not, in other words, talking of one or two traits, isolated and arbitrarily compared, but of elements within a larger current of black culture, the Mande diaspora.

It becomes imperative to start at the beginning, in Djenné-jeno, and to learn what is known about art and altars in that remote time. This knowledge we will use as a springboard for understanding the relationship linking possession priests and priestesses to forked-branch and clay-pillar altars in Suriname.

Altars and Altar Statuary of Ancient Djenné

The first inhabitants of Djenné-jeno were herders and fishermen, their mode of life not far removed from hunting and gathering. The people of ancient Djenné lived in domical, circular houses, built of bent poles and woven-reed mats waterproofed with wet clay, formally cognate with the leaf-shingled houses of forest peoples. And other links relate the ancient settlements of the Sudan to the forest.

The Muslim scholar Al-Bekri wrote in 1067–68 of the city of Ghana, north of Djenné-jeno. His description, one of the most detailed accounts available of a medieval urban center in the western Sudan, brings out a separation of the city into traditional and Muslim halves, a division that continues today among, for example, the Dagomba of northern Ghana. Al-Bekri talks of the cultural contrast between the twelve mosques of the Muslim town and the "sacred grove" (al-ghaba in Arabic) that was an extension of the royal town, where lived the followers of the traditional gods and spirits of the land: "Around the king's town are domed huts and groves where live the [priests and officiants of the ancient traditional religion]. In [the groves] are also the idols and the tombs of their kings. These groves are guarded, no one can enter them nor discover their contents."[3]

We do not know precisely what the altars looked like in the groves of the ancient city of Ghana. But we do have a considerable amount of altar statuary, plus a smattering of its architectural coordinates, in Djenné-jeno. The McIntoshes excavated an entire round-house foundation in that city. There they found a male and female pair of terracotta statuettes, set in a niche within the curve of the house wall: "Their shrine-like positioning cast light on three similar statuettes we had discovered in 1977. All were in a kneeling posture, with short skirts or loincloths; all had been set into a wall or placed under the floor. Why had the people thought it important to incorporate them in their house structures?"[4]

The culture of a people who still inhabit the area today, the Bamana, provides an answer. In 1903, Charles Monteil published a richly documented book on the contemporary city of Djenné in which he noted, among Bamana,

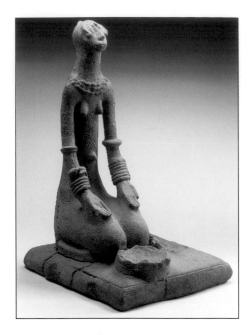

PLATE 110 (ABOVE): SOROGO TERRA-COTTA ALTAR
STATUE, DJENNÉ-JENO, MALI, CA. 1396–1546. In
over half the surviving altar statues from ancient
Djenné (believed to have been populated largely
by Sorogo, a Mande people), the figure kneels,
prescribing a pose still used to initiate worship in
the Sudan today. The low, dishlike element before
this late-medieval officiant, who dresses herself
richly for the occasion, is also not unlike the flat,
circular women's altars of presentday Sudan
(plates 111, 112). Among the Mande, to lay one's
palms open and upward denotes generosity and
honesty of intent. Collection of the Musée Dapper,
Paris.

in the entry-habitation, a sort of vestibule which, in important houses,
separates the first court from the street and which is called *blo*. Here one
ordinarily finds the altar to the ancestors and familial gods. The altar to the
ancestors consists, sometimes, of a small wooden plank with a human mask,
called *kara*, sometimes an unfired clay figurine. The spirits are believed to
come into these objects which receive, for this reason, the blood of [animal]
victims and the liquid of libations.[5]

Among the Bamana of turn-of-the-century Djenné, therefore, the gateway became a
household altar. Such altars were built as a kind of spiritual drawbridge: they were fash-
ioned to guard and command the point of access and transition, a concept met equally in
threshold altars to Eshù, Oshóòsi, and Ogún in Nigeria, Cuba, Bahia, and New York.

The modern city of Djenné boasts the quintessence of the Sudanese architectural
style. Matching this level of artistic quality, the nearby city of Djenné-jeno and neighbor-
ing areas produced, as de Grunne illustrates, "ancient terra-cotta statuary made in sixty-
six different sacred postures, making it the single richest source on religious gestures in
Africa."[6] De Grunne argues that the makers of the altar statues of Djenné-jeno were
Mande Sorogo: "great hunters, fishermen, architects and masons, mixed with Nono
farmers . . . a mix of early Bozo with different waves of Soninke/Nono coming from the
northeast."[7]

Mama Kontao, one of de Grunne's informants, explains the protocols governing the
relation of the worshiper to altar statuary today: "The person who wanted to sacrifice to
the statues had first to retire in a secret place, take off his clothes, and sacrifice the animal
intended for the altar. The animal's blood was carefully stored in a vessel and taken into
[the shrine]."[8] In his state of ritual nakedness, the person offering the sacrifice would
pour the blood on the statue and adopt the statue's attitude.

There are two main gestures among the surviving examples of Djenné-jeno altar stat-
uary: kneeling (52 percent) and enthronement (30 percent). A Sorogo terra-cotta figure
may depict, say, a kneeling woman, magnificent in her balance and poise, her open-palmed
hands resting on her thighs (plate 110). This primary pose of the ancient Upper Niger
Delta icons still provides a prologue to worship: "According to Mama Kwanta the kneeling
gesture with hands on knees is taken before making a sacrifice to the statue."[9]

A low form resembling a flat, circular altar still used by Sudanic women today appears
before this ancient figure on the same base. Compare Labelle Prussin: "In the foreground
to the [altars of the Tallensi of northern Ghana] are the male and female ancestral shrines
of the lineage, similar to those illustrated for the Kassena" (plate 111) or, for that matter,
for the Bobo at Dissankey, Upper Volta (plate 112).[10] The male altar in these later altars
is conical and phallic, the female low to the earth, and round.

Formally, the flat quadrangle forming the sculpture's base is twice contradicted, once
by the uplifted circle of the miniature altar, and again by the kneeling woman's rightly
curving thighs. Curves and circle pull altar and woman into a single text.

Rich jewelry—beads about her neck, strongly rendered arm bands, and bracelets at her
wrists—ennoble the woman in an idiom of status and command. Her literal openhanded-
ness emphasizes generosity of mind and spirit, and demonstrates Mande openness of
intent, devoid of covert action or witchcraft. Her massive neck lifts up her head, there-

The Face of the Past: Staff Shrines and Flag Altars

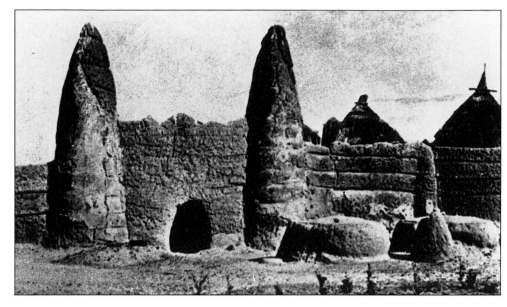

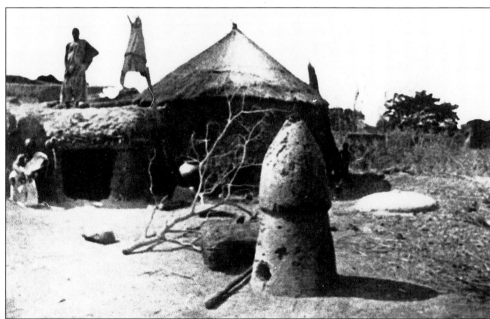

fore her thoughts, in an opulently stabilizing manner. This compares, in turn, with the anchoring effect of her powerful thighs below the vertical of her body. Fashioned more than five hundred years ago (probably between 1396 and 1546) in what de Grunne calls "the longilinear style of Bankoni," this image gives a clear sense of the excellence of medieval West Sudanic altar terra-cotta statuary.[11]

Our second Delta altar image (plate 113), fleshed out in a seated pose, codes permanence of speech. Mande believe that important, binding discourse must be said sitting down, whereas simple speech, the fleeting manifestation of language, is rendered standing up.[12] This symbolically seated image is older than the Bankoni image; it dates from perhaps 939–1299.

Hands drape powerfully over knees. Backs of the palms are showing, as opposed to open palms. Eyes burst with spirit. They protrude like blades, with two sharp facets, and surmount shelflike frozen lips, seals of composure and discretion. The style of this countenance probably bears too much resemblance to ancient Ogboni facial imagery in Yoruba art to be coincidence. It suggests artistic contacts between these two cultures

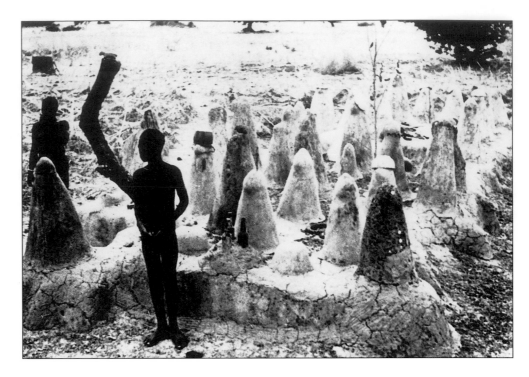

going back at least to medieval times, linking these high points of classical accomplishment in the history of West African art.

In addition, in other ancient Nigerian cultures, notably Edo, diminutive masks were worn on the body to demarcate royal and spiritual patrimony. Here twinned miniature heads flank the seated figure's heart. These deepen, perhaps, his bodily shield, his chest, by invocation of the spirits.

This particular style of altar statuary, native to the inner Delta, did not travel to the Americas, except perhaps by Yoruba reflection. But the basic idea communicated by the gesture—that being seated binds the speaker to his word—is a fundament of religious initiation in the black Atlantic world. And other powerful Mande ideas of altars and worship did come to the coast of Ghana and Senegambia, and traveled from there across the seas.

Of Trees and Sacred Groves

Since the day of Al-Bekri and before, the Mande sacred grove has testified to a view of trees as symbolic embodiments of the spirit, as natural altars. Often such tree altars appear deep within the ritual woods of the Mande linguistic area, and of the Mande-influenced Akans.

Two important West Sudanic altar types, the vessel-in-forked-branch altar and the vessel-holding clay pillar, extend tree altars by logical extrapolation from their supportive height and verticality. (In these traditions, altar and supported sacred vessel often become a single entity.) Such idioms traveled south to Côte d'Ivoire and Ghana in a current of culture too multiple, too complex, too faith-oriented, to be broken by the temporary disruptions of the nobility of the people effected by African wars or transatlantic slaving.

The sacred groves of the Mande exert a subtle fascination. Each grove, special to a particular religious group or society, brings together sacred trees and altars in indelibly philosophic constellations. A rich source of information on Mande groves and altars is

The Face of the Past: Staff Shrines and Flag Altars

Dominique Zahan's *Sociétés d'Initiation Bambara*, which tells, for example, that at the center of the Kore-society initiatory grove among the Bamana, one meets a special clearing, deliberately swept, carefully cut back. A sacred tree presides here, and at its base generally rest two stones, one white, of granitic consistency, the other lateritic red, marking this spot as an altar of certain spirits.[13]

The forest setting of such shrines represents "mystery" – "that which is impenetrable, that which cannot be entered except with the greatest of difficulty."[14] If the forest is the image of initiatory knowledge, then the clearing within it is "the end of the quest for that knowledge."[15] This rendering of the forest as a veil, to be pierced only by initiation, dates from the time, surely, of the earliest hunters and gatherers.

It is important to stress that these are all outdoor altars, open to the elements, as are forked-branch and clay-pillar shrines aligning to the same traditions. Their being outdoors is an element of their capture of energy and illumination from natural sources under God.

Mande and Akan Tree Altars

According to Zahan, Bamana members of the Ndomo society consider a certain species of tree an altar even if, in extreme age, it topples over and rests upon the ground. A tree becomes an altar in part because it is an automatic ideogram of time and permanence. Tree altars also communicate incarnations of ascendancy or strength, as in the case of the towering ficus or the great baobab. Zahan writes,

> As an altar, a tree becomes the witness of the consecration of a human being
> and of his accession to the level of religious values. This is emphatically not
> to be confused with a contingent divinization of man, nor even less with any
> divinization of the tree. [A tree altar] is an evocative presence of a durable and
> important human quality. The blood that is "given" [to the tree] indicates
> simply the faith of the society in the immortality of its attributes.[16]

In other words, where Western outsiders find idolatry, the actual worship involves a complex reading of the tree as a spiritual ideogram. A tree deepens honor of unseen presences with concrete signs of majesty. As African altars, trees are signs of standing grace and power, even as stained-glass windows instruct Christians in the name and nature of Jesus, and signify the incarnation of His spirit in the passage of light through glass.

At the bases of some Bamana Ndomo-society tree altars lie stones that receive offerings of blood sacrifice. This mixes one sign of permanence with another, for stones, impervious to the organic process as we know it, are appropriate foci for offerings to immortal spirits.

The same blend, of faith and ideography, characterizes tree altars among the Akan. Early in this century, R. S. Rattray documented such a shrine at Nkoranza among the northern Asante.[17] The tree was the shrine of a god whose spirit dwelt in its roots. Material writing extended the understanding of the god's worship: inverted pots at the tree's foot, symbolically deposited upside-down, empowered the spirit dwelling here to throw illness back upon its source. There was yet another sign, a string tied round the trunk. This meant, "The donor wished the god to bear him upon his back as a mother carries her child,"[18] an element of faith recalling the "rock of ages" metaphor

of Judaism and Christianity.

Rattray also tells us that chiefs, upon enthronement, take oaths before tree altars to rule wisely and guard the people. All are dressed in white, appropriate to an august moment when chiefs swear to represent good government before the moral witness of the spirit in the tree. Thank offerings, doubling as material script, hang on the sacred trees of other Akan spirits: "bead necklaces, bracelets, rags, pieces of cloth worn by the donor, or the whole cloth. Small replicas of fetters tie the soul of the [spirit] to his or her tree. Strips of white cloth usually represent pledges of attachment" of the worshiper to the spirit honored by the altar.[19]

Tree shrines dot the axes of the Mande cultural diaspora, to say nothing of the breadth of the Kwa language group, which stretches from Nigeria to Liberia, and of other language and cultural groups as well. Among Gur-speakers living between the Akan and the nuclear Mande, Senufo consider the iroko tree (*Chlorophora regia, Chlorophora excelsa,* and *Anatiaris africana*) sacred to their ancestors. To disturb such trees is taboo; "its roots serve as an altar for offerings of cultivated food when it grows within the precincts of a farm."[20] The same tree is sacred among the Ewe, Fon, and Yoruba.

This means that where Mande, Gur, and Kwa (Ewe, Fon, and Yoruba) influences come together in the western hemisphere we should expect strong reemergence of such outdoor worship, even if different but analogous tree species were substituted in the new terrain. And this is precisely what happened in Suriname. But before we examine this remarkable extension, let us take note, in the Western Sudan and regions further south, of tree-surrogate forms of altar.

Outdoor Vessel-in-Forked-Branch Altars

In a classic text, *Hatumere*, Prussin talks about such shrines:

> Just as the planting and placation of a cosmic tree is the physical manifesta-
> tion of ritual associated with the establishment of place in the universe, and
> just as the ancestral earthen pillar is the expression of ancestral center among
> sedentary agriculturalists, so the carved forked post of the Fulbe, the *do ba,*
> surrogate for the tree, symbolizes the first act of settling. The term *do ba*
> literally means "place of the fathers" and the three carved prongs support a
> bowl or calabash containing sacrificial offerings to the ancestors.
>
> The forked post, marking the center of a settlement, is found equally and
> ultimately in the same location as its counterpart, an ancestral earthen pillar—
> in the center of newly founded and settled nomadic communities, at the
> entrances to compounds . . . and in the inner courtyards of the aristocracy.[21]

Such structures are widely present in West Africa, from the courtyards of Oualata, in Mauritania, to the settlements of the Fulani of Mali and beyond. They also appear among Akans in Ghana and Côte d'Ivoire, as a function of long-present cultural influences flowing down from the north: "At one time the courtyard of every Asante compound contained an altar, a *gyase dua,* either a tree or a branch set in the ground between whose forks a calabash or brass pan was wedged and in which sacrificial offer-ings were deposited. . . . This same altar can be found in the courtyard of every extant

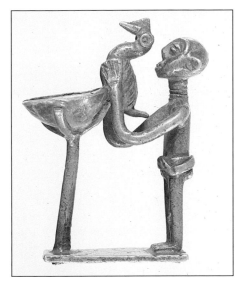

Akan 'shrine house,' though in some cases all that remains is the tree stump. It is the
focal point of every interior courtyard." Prussin continues, "When viewed in the broader
cultural context, the use of a forked post as a symbol for the *nyame dua* implies a tradi-
tion to a new place or settlement site. Its presence in the Asante spatial realm seems to
reinforce the [Akan] migration myths of founding ancestors coming from the north."[22]

Mande-to-Akan channels of transmission for the forked-branch shrine link up, ulti-
mately, with hunting-and-gathering styles of worship: Pygmies use the fork of a tree as a
place for offerings to the god of the forest.

Among the Asante, to return to the southward distribution, altars in forks become the
classic shrine to God (*nyame dua*). Thus M. D. McLeod: "formerly shrines to God were
set up inside most houses. A brass bowl, clay pot, or calabash was placed in the forks of a
branch of the Alstonia gongensis tree set vertically in the ground" (plate 5).[23] Such altars,
in fact, are fundaments in Akan culture. They figure in the lexicon of *adinkra* stamped-
cloth ideograms (plate 115); Akan figural goldweights also include depictions of a priest
sacrificing an egg or chicken into a vessel supported by a classic forked-branch altar
(plate 116). We will find the same sacrifice—eggs—on the same kind of altar among
Suriname maroons.

Outdoor Clay-Pillar Altars

The forked-branch altar provisionally relates to the "found altar" of the forest. But the
outdoor clay-pillar altar, sometimes supporting an offertory vessel at the summit and
sometimes not (in latter instances receiving blood or other offerings directly), apparently
emerged in the time of the earliest West Sudanic settlements. Thus de Grunne:

> A team of French archaeologists [Saliège et al., 1980] excavated the mega-
> lithic site of Tondiarou. Tondiarou is the Karnak of West Africa. It is made
> of long rows of large upright cylindrical stone pillars. These stone pillars may
> be the origin of the earthen ancestral [altar] pillars found in Mali, Burkina
> Faso, northern Ghana and Ivory Coast.[24]

Like all classical forms, the pillar altar embodies the essential convictions of a civiliza-
tion. In Mande-kan it is called *lo*, a word for which Maurice Delafosse, in his dictionary
of this language, reports a cluster of meanings: "vertical position; that which is vertical;
raised stone; truncated earthen altar in the form of a cone which supports an offertory
vessel; knowledge; to know."[25] This semantic range offers useful nuances, suggesting a
link between megalithic stone pillars and ancestral altars made of cones of clay, with or
without offertory vessels balanced at their summits. In addition, it relates the whole
tradition to manifestations of ancestral wisdom.

The heaviest concentration of clay-pillar altars lies in the heart of the Mande- and
Gur-speaking civilizations of West Africa, essentially the Upper Niger Delta and the
Upper Volta Basin: "These earthen pillars are associated, in all instances, with some
aspect of the traditional systems of value and the cosmology of the peoples who shape
and mold them. They can be found singly, in clusters, sometimes integral with the
entrances to patrilineal homesteads, sometimes applied as altars to granary walls or other

PLATE 117 (TOP): DYULA (MANDE TRADER) MOSQUE, KAWARA, COTE D'IVOIRE. The arrayed cones that constitute the Dyula mosque, architecturally dramatic as they are, were designed with more than aesthetic effect in mind: they reproduce the conical form of many clay-pillar altars of the Upper Niger Delta and Upper Volta Basin (see, for example plates 111, 112, 114). Photo: Labelle Prussin, 1970.

PLATE 118 (BOTTOM): FRIDAY MOSQUE, DJENNÉ, MALI, RECONSTRUCTED IN 1907. The engaged pillars built into the walls of the Friday Mosque—note their summits—are further transmutations of the clay-pillar altar. Photo: Labelle Prussin, 1970.

sacred building forms."[26] So powerfully pervasive is this basic tradition that it influenced the distinctive styling of the famous mosques of Djenné and other cities in the inland Delta. Prussin documents the association of conical earthen altars with founding ancestors in northern Côte d'Ivoire and northern Ghana, where clustered clay pillars "symbolize the genealogy in depth"[27] (plate 114). This arresting vision of massed spiritual beings echoes in the cluster of white cones making up the Dyula (Mande trader) mosque at Kawara in Côte d'Ivoire (plate 117). Such standing avatars of spirit and lineage are also woven into the fabric of the famous Muslim architecture of Djenné, where they herald the entrances into the 1907 Friday Mosque (plate 118). The clay-pillar altar tradition is ingeniously transmuted in the engaged earthen pillars of this most important religious building of the inland Delta. When Prussin asked the master mason of Djenné, M. Be Sao, to give reasons for the beauty of the Friday Mosque, he answered, "Because [the clay pillars] are tall and straight, like a man."[28]

The Friday Mosque represents one climax in the history of this form. The second climax took place in Suriname.

Altars of the Suriname Maroons

Mande/Akan tree and tree-surrogate altars, transformed by contact with traditions deriving from other African civilizations, reappear among the blacks of Suriname. The reinstatement is part of a larger creative synthesis: in Suriname, three great currents of culture and belief—Mande/Akan, Ewe/Fon/Yoruba, and Kongo/Angola—arrived and came together. In contact on the plantations of the English, Portuguese Jewish, and Netherlandish colonists, they deepened essential shared beliefs.

These early fusions emerged in the eighteenth-century shrines made by men and women fleeing slavery for the African-like rain forest that beckoned beyond the plantations. The result was a new and complex New World form, the flag altar. Saamaka maroons call these shrines *faáka páu*. Ndjuká and Aluku, the major maroons of the east, call them *faaka tiki*.

Among Ndjuká a town without a mortuary (*kee osu*) and a flag altar to the ancestors has no clear political status. Flag altars embody history and heritage, and link their servitors to the founding moments of their civilization. They also symbolize the spiritual strengths of the six black civilizations in the Suriname forests and in southwestern French Guiana. These six maroon civilizations are: the Saamaka on the Suriname River and its tributaries, the Gaánlío and the Pikílío; the Ndjuká on the Cottica, Marowijne, and Tapanahoni rivers; the Aluku on the Lawa River along the French Guiana/Suriname border; the Matawai on the Saramacca River; the Kwinti on the Coppename; and the Paamaka, between two groups of Ndjuká on the Marowijne.

More than a decade before North Americans broke from British rule, ancestors of these peoples, through successful guerrilla warfare, had forced Dutch colonial authorities to grant them autonomy. The Ndjuká treaty was signed on October 10, 1760; the Saamaka in 1762; the Matawai in 1769. Relatively secure in their inner-forest settlements, these African-descended groups then crafted a new life. Freedom among them was associated with "things African." They designed a new world of art and architecture, creatively complicating remembered fragments of a sub-Saharan past by absorption of additional techniques gleaned from plantation experiences and contact with Amerindians.

The most important of the maroon civilizations are the Ndjuká, Saamaka, and Aluku. Once they were established there was no stopping their cultural drive and confidence. When, for example, a late-eighteenth-century Moravian missionary attempted to proselytize a traditional Saamaka priestess, telling her that by serving the deities of Africa she had become the Devil's slave, she shut him up at once: "I already know," she replied, "all about that slavery business!"[29]

The New World black religion in which this woman placed her faith had emerged from some of the most culturally powerful areas of tropical Africa, the Mande/Akan complex, dramatically heightened in the last century or so of the Suriname slave trade through the presence of Ewe/Fon/Yoruba peoples, arriving in that land between 1640 and 1735; and of Kongo/Angola captives, who numbered a constant third in the numbers of Suriname slaves between the 1640s and 1735, dropping to a still significant 24 percent between 1736 and 1795. (The slave trade continued well after the signing of the various treaties with the maroons, and slavery itself was not abolished on the coast until 1863.) A full rendering of this history has been published by Richard Price.[30]

Price's "Windward Coast" refers more to Cape Lahou, in Côte d'Ivoire, than to anywhere else in that region. A sample of fifty-six Dutch slaving ships suggests that perhaps 50 percent of "Windward" slaves were shipped from this point. "Gold Coast" refers, as it does today, to the shore between the mouth of the River Tano, modern boundary between Ghana and Côte d'Ivoire, to about the mouth of the River Volta in the east. "Slave Coast" embraces the Ewe/Fon/Western-Yoruba area, and Loango/Angola refers to the coast of Central Africa from northern Kongo to the Bakongo of northern Angola plus culturally related ethnicities north, east, and south.

The late—and relatively heavy (49 percent)—arrival of captives from Cape Lahou was probably decisive in the formation of early Saamaka and Ndjuká altars. Cape Lahou would have included northwestern Akan, but more probably, according to Philip Curtin,[31] captives from wars to the north of the Baoulé, particularly those involved in the formation of the Mande Kingdom of Kong, as Price notes.[32] Cape Lahou channeled remembered images from the heartland of the clay-pillar and vessel-in-forked-branch altar-making traditions. This incoming influence could only have reinforced traditions remembered by descendants of earlier captives from the periphery of Akan territory, for such altars were also found among Lobi in northern Ghana, among the Bono of the Akan northwest, and among Fon/Ewe, east of the Akans. All formed variants of a tradition extending back to ancient Mande.

The Suriname planters, ignorant of cross-ethnic intellectual ties of shared heritage, assumed a divide-and-conquer strategy, separating members of the "same tribe" to block the formation of potentially dangerous unions among captives: "not . . . daring to trust 'em together, lest Rage and Courage should put 'em upon contriving some great Action to the detriment of the Colony."[33] True, Mande, Gur, Akan, and Fon spoke different languages and came from highly distinctive cultures. But this masked what they shared, at the level of altars and religion, as a result of the great Mande (Dyula) diaspora of artistic and religious ideas and objects, from the region of Djenné to the coast of modern Ghana. (Here, at El Mina, Portuguese met Mande traders in the fifteenth century.) And what they shared, such as respect for and practice of divination, became an automatic weapon of confidence and liberation.

Time and again in the annals of maroon history, references appear to African-derived diviners warning the runaways of the approach of the whites. Traditions also record exhortation of the early runaways by persons in the spirit, as the rebels fought their way to freedom. The first altars were clearly linked to this informing, liberating spirit. These altars symbolized communion with the gods, the ancestors, and the grand medicines (*gaán obia*). They and the rituals performed before them contributed distinctly to the establishment of viable civilizations in the rain forests; they were, in fact, centers of cultural resistance. We can sense this in the action of a certain Sergeant Dorig, who, in 1758, led a military expedition against a runaway settlement in Para and deliberately destroyed a shrine.[34]

Levels of shared religious convictions, not to mention linguistic cognition, were even stronger among blacks from Loango and northern Angola. They might be known to their masters as "Loango" or "Pumbu" or "Yombe," but these were simply provinces of the Kongo culture. Captives from further afield in Central Africa shared fundaments of religion and belief with their Kongo brothers and sisters.

For example, in Kongo and neighboring areas people widely believed in the sacredness of white clay (*mpemba*) as a sign of dawn, and as a seal of the other world. The term *pemba*, lightly creolized but with Central African associative values of purity and spiritual presence intact, flowed right into the formation of the coastal-black and Ndjuká religions. There it took strength from analogous Gold Coast memories of *hyire*, white clay "applied to the body to show innocence and purity" in the religion of the Akan.[35] Combined, these influences echo in the rich coatings of sacred porcelain clay that announce the presence of the spirit in the embellishment of many Ndjuká shrine images.

Unknowingly, the Dutch slavers had tapped into the traditions of two of the great migratory cultures of Africa, Mande and Bantu, plus that of one of the most culturally aggressive kingdoms, Dahomey. The first and third currents brought tree and tree-surrogate altar traditions to Suriname. The second, Kongo, sparked the emergence of a new configuration, the flag altar.

In addition, just as the captives were not as culturally divided as the plantation authorities had hoped, neither were the forest runaways sealed off from plantation blacks. Silvia de Groot shows that after the 1760 treaty granting independence to the Ndjuká, authorities on the coast had to exert ceaseless pressure to block unauthorized Ndjuká travel among coastal blacks—including, even, travel in the city of Paramaribo: "Until about 1845 every effort was made to keep them out of the plantation areas, where they came to trade timber and otherwise in search of a livelihood."[36] By the time of abolition, the Ndjuká "were still travelling to and fro along the river between their tribal areas on the Tapanahoni and the plantation area and Paramaribo as in the old days."[37] Oral testimony about further nineteenth-century contacts among coastal blacks and maroons, gathered by H. U. E. Thoden van Velzen and Wilhelmina van Wetering, is equally rich.[38]

Saamaka probes of the coast trace back to the wars of liberation. Thus Price: "My reading of [Saamaka-related] archival materials discloses an absolutely staggering amount of maroon-slave contact during the relevant period."[39] Price also argues that as late as 1800, one third of the blacks on the plantations were removed from Africa by less than five years. This meant that strong memories of African culture, as well as Western materials like machetes and guns, must have leaked constantly from the plantations to the maroons during the nineteenth century. Price adds, "I suspect that African ethnicity remained a stronger organizational principle among slaves in coastal Suriname, for a

much longer time, than it did in the interior—largely because new slaves, fresh from Africa, continued to arrive in great numbers on coastal plantations until the late eighteenth century."[40]

Thus as we talk about "African influence" on maroon altar-making, we seek our truths in creole fusions. In Matanzas, Cuba, or in Bahia, Brazil, Dahomean and Yoruba and Kongo peoples had relatively separate impact. But in Suriname we are talking about transtribal traditions from a wide array of sources, Mande to Akan and Dahomey, creatively regathered on South American soil. Comparing an African tree altar to one in Suriname, then, involves knowledge of an overlapping, full tradition. There are sacred iroko-tree altars from the lands of the Yoruba to those of the Senufo and farther afield in western Africa. Baobab altars appear from the Fon territory of Dahomey to Mande country in Mali, and silk cotton tree altars are comparably widespread. Correspondingly, among Ndjuká in Suriname, silk cotton tree (Ndjuká: *kankantii*) altars appear in virtually every village. There are several in the capital town of Dii Tabiki.

Up River and Down

The comparatist mode engaged in this chapter is clearly a shorthand for massive, overlapping, cross-ethnic phenomena of belief and practice. Equal sense is made if we view blacks downriver on the coast and blacks upriver in the rain forest as a cultural continuum, not hermetically sealed-off units. The fact that Sranan, the coastal-black language, and Ndjuká, the eastern-maroon language, are largely mutually intelligible has long challenged scholars to look for similar relationships in the visual languages of blacks of the interior and of the coast.

Indeed, both Paramaribo traditional healers and Ndjuká Kumanti healers embed mirrors in sculpture as instruments of mystic surveillance (plate 121). The practice is also pursued in Kongo, and even among Afro-Suriname migrants now living in Bijlmermeer, a black ghetto of Amsterdam. Further apparent coast-to-upriver links appear between the octagonally shaped heads of figural carved-wood grave-markers in old plantation cemeteries (plates 119 and 120) and the identically octagonal heads of the images guarding certain Kumanti shrines on the Tapanahoni River (plate 121).

There are further town/forest material connections. Perhaps the most powerful example is an altar constructed out of a bench, collected by Moravians from coastal creole blacks in Paramaribo in the nineteenth century (plate 123). It is now in the Herrnhut Volkerkunde-museum in the former East Germany. In many African religions the altar image invokes enthronement. Here the idea is literal: a bench has been perforated with two holes into which are fitted pottery containers filled with sacred white clay. They flank a strongly African-influenced image, its coiffure worked into a crownlike crest, and holding its hands against its chest. This town altar is not only a concrete manifestation of the idea of the enthronement of the spirit, but a manifestation also of what appears to be Dahomey/Yoruba sculpture, a rare appearance of very pure African art in an African-American altar.

Transformation of bench into altar continues among the twentieth-century Saamaka, as instanced by a Kumanti *obia bangi*—a bench for a Kumanti spirit—collected in 1929 by Melville J. Herskovits for the Hamburg Museum für Volkerkunde (plate 122). Raffia, a clay serpent, and a guardian figurine appear instead of the creoles' porcelain clay in

PLATES 119 AND 120: GRAVE MARKERS, SURINAME, EIGHTEENTH?/EARLY NINETEENTH CENTURY. The markers come from a cemetery on the former Joden Savannah plantation. Photos: Christopher Healey, ca. 1980.

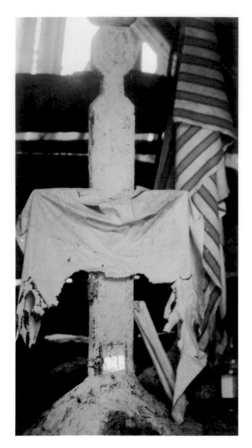

pots and standing human figure. But the idea that a stool or a bench can become an altar is an essential African idea that links these two altar pieces together. And the more "African-looking" of the two was actually fashioned among the coastal blacks.

Many more examples could be marshaled to make the point that Saamaka and Ndjuká, far from being isolated, were involved, from the outset, in material dialogue with blacks and Westerners on the coast, in parallel with their creative absorption of cassava, hammocks, and fishing techniques from the Amerinds upriver from their settlements. Establishing African and plantation-black influences in the rise of the altars of the maroons leads to the recognition of such altars as foci of cultural and political independence. Beyond their purely spiritual inherencies, maroon altars symbolize, some of them, successful armed resistance against the coastal slave plantocracy. Aggressive objects—sharp iron blades, scissors, heavy clubs, and so forth—identify Kumanti altars up and down the Tapanahoni. This feisty vision relates directly to abiding legends: "Kumanti [priests] were in the vanguard of the fight against both the forces of the plantation colony (until 1760) and against their erstwhile friends, the Aluku."[41] To this day many Kumanti shrines, as will be seen shortly, visually orchestrate ideas of freedom, discipline, and invincibility.

PLATE 121: NDJUKA ALTAR TO THE KUMANTI SPIRITS, GODO OLO, SURINAME, TWENTIETH CENTURY. Formally, this abstractly figural post, with its octagonal head (the surmounting dish is for *obia*, or medicine), on the upper Tapanahoni River recalls the shape of earlier, eighteenth?/nineteenth-century grave markers in an old plantation cemetery nearer the coast (plates 119, 120). This suggests material links between the culture of the plantation slaves and that of the maroon runaways. Embedded in the pyramidal clay base of the Kumanti shrine is a pair of scissors, to sever the servitor from trouble. Photo: Robert Farris Thompson, 1981.

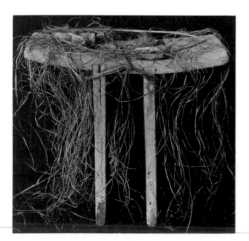

The Face of the Past: Staff Shrines and Flag Altars

Sacred Groves and Sacred Trees

In 1794, as part of the Rousseau-ian iconography of the "noble savage," Freret executed three engravings illustrating idealized fragments from black Caribbean life. One of these engravings, *Le Culte des Nègres* (The cult of the blacks), portrays a never-never version of the Africanized tree altar: "The turf is the altar," according to the caption, and "the hollow of a tree is the temple" (plate 124).

The handling of details was largely imaginary; according to Marcel Chatillon, an expert on the iconography of Caribbean blacks in the eighteenth century, Freret meant to show that blacks share a universal, redeeming respect for the Creator.[42] Nevertheless, the use of earth between tree roots as an altar, and the view of the tree itself as a kind of church, were almost certainly based on actual witness. Discountenancing the "idol" Colinet inserted, and his Western "framing" of that image within a rectangular recess in the tree, the placement of an offering on the earth before the tree ultimately reflects ritual reality, as do the kneeling postures of the servitors.

We turn from this problematic reflection of eighteenth-century black worship involving trees to the real thing in nineteenth- and twentieth-century Suriname. Saamaka have sacred groves, one of the most important of which shelters a shrine to the ancestors at Dangogo on the Pikílío, near the Saamaka capital of Asindoopo. The tradition of the sacred grove continues, as well, among the Ndjuká, where several are hidden in the vicinity of the civilization's ancient capital, Puketi. And throughout the territory of both Saamaka and Ndjuká, outdoor tree-altars appear. Their presence has been documented since the late eighteenth century.

The silk cotton tree, often towering over 100 feet high, offers perhaps the most impressive of maroon tree-altars. John Gabriel Stedman made note of it in 1776: "They bring their offerings to the Wild Cotton tree which they adore with high reverence."[43] Melville and Frances Herskovits encountered it among Saamaka at Sei, on the upper Suriname River, in the late 1920s: "At the entrance to the village of Sei a gigantic silk-cotton tree stood. Its trunk was massive and the roots, which projected outwards like so many buttresses, made of it a great somber cathedral."[44] This forest equivalent to a Gothic spire harbored the worship of three Saamaka spirits: Gedeonsu, a male god; Tinne, his wife; and their child, Dyombie.

Liquid sacrifice at this natural altar, as among Akan, Fon, and Anago, was poured between the roots. Here the worshipers also positioned bottles used in libations. Here they set out, as well, a calabash filled with sacred white clay (*keeti*) for ritual purification. When the time came to dance in honor of the spirits associated with this lordly sentinel, the followers dressed the tree, placing a tunic of cotton around its trunk, the way devotees honor iroko among the Ketu Yoruba of both Benin (plate 127) and Bahia (plate 128).

A similar sash honors one of several *kankantii* altars at Dii Tabiki that I photographed in December 1981 (plate 126). Special armatures (*kifunga*) for the hanging of spiritually protective raffia screens (*musoko*) separate the altar from ordinary happening. The railings also add focus to the *kankantii*'s soaring accents. Ba Bono, a local traditional priest, remarked of this altar, "Our ancestors 'work with' [*wooko anga*] this silk cotton tree." He meant that his forefathers "shared responsibility for the proper execution of its rites," and for the keeping of the altar for the good of the people.[45] Compare this shrine with a stunted silk cotton tree altar found in the courtyard of the king's sleeping room in

Kumasi, Asante, in 1817 (see plates 4 and 5).

There are other forest emblems in maroon culture, and one of them probably relates to Bantu roots, mediated to South America via Kongo and Angola. Recall the staffs of twisted wood that are used by both Mbuti and Bakongo to indicate spiritual presence, and consider the following report from Suriname: "We may also see various krom-tiki [*koon tiki*], sticks or pieces of bush vines which have grown in a peculiar zig-zag fashion. These, too, are supposed (amongst the maroons) to have protective powers. . . ."[46]

Vessel-in-Fork Altars

On the upper Suriname River, in the Saamaka village of Toledo, in April 1885, K. Martin carefully documented an impromptu calabash-in-fork altar set up by the door of a habitation (plate 125).[47] The Herskovitses came across the same kind of rough-and-ready shrine in another Saamaka village, Sei, in 1928–29, and noted its association with healing and assuagement: "a low forked stick sunk into the ground, holding a pot with water and [collected herbs] in it for the curing powers of its obia [positive medicine]."[48] As to the late twentieth century, Sally Price writes, "One of the most frequent ritual uses of calabashes is for ablutions, and in many instances the site of the washing is converted into a small shrine by installing the calabash bowl in a forked stick set into the ground."[49]

Richard Price extends this information: "Three [or more] pronged forked sticks supporting a vessel are . . . one common form of temporary or permanent Saramaka offering. This form is used in a number of different obias. In some recipes, eggs are put in, especially if an egg-loving god, like a watawenu or vodu, is involved."[50]

Vessel-in-fork altars not only mark the sites of rituals among Saamaka, then, but in some instances absorb the same egg sacrifices that Akans offer to God, that the Gá offer to thunder spirits, and that the Fon of Dahomey yield to their famous serpent spirits, to cite but three overlapping West African usages, all also using fork altars. The continuity is simple and direct. Note the abiding focus on ablution, and the honoring of egg-loving spirits. Still to be demonstrated is whether or not the fork altar additionally aligns with notions of migration, as among the Fulani.

PLATE 125 (ABOVE): K. MARTIN, DRAWING OF A SAAMAKA VESSEL-IN-FORK ALTAR (DETAIL), TOLEDO, SURINAME, 1885. This altar on the upper Suriname River recalls a whole class of West African equivalents—for example, the altar represented in the Akan goldweight shown in plate 116. From Martin, *Bijdragen Tot de Taal-Land-en Volkenkunde van Nederlandsch-Indie,* 1886.

PLATE 126 (RIGHT): NDJUKA *KANKANTII* (SILK COTTON TREE) ALTAR, DII TABIKI, SURINAME, TWENTIETH CENTURY OR EARLIER. The wood rails around the tree's trunk are armatures on which to hang protective raffia screens (*musoko*). Photo: Robert Farris Thompson, 1981.

PLATE 127 (OPPOSITE): KETU YORUBA IROKO-TREE ALTAR TO IROKO, NEAR KETU, BENIN, TWENTIETH CENTURY. Photo: Robert Farris Thompson, 1972.

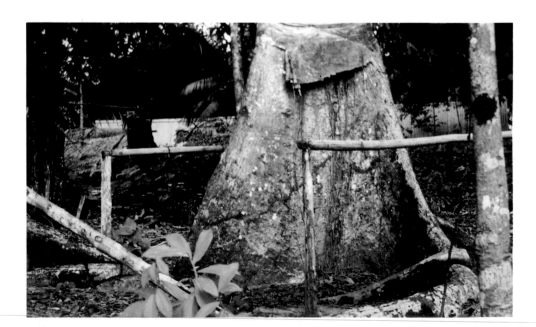

The Face of the Past: Staff Shrines and Flag Altars

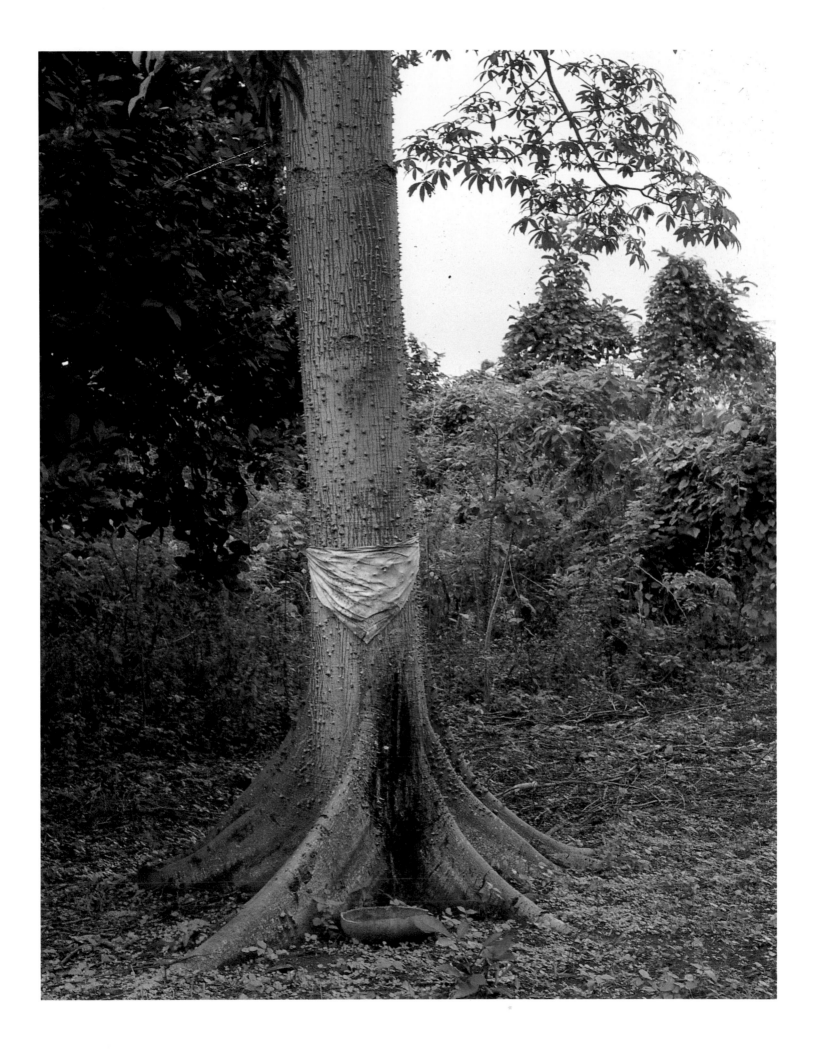

PLATE 128: KETU YORUBA TREE ALTAR TO IROKO,
COSME DE FARIAS, BAHIA, TWENTIETH CENTURY.
Photo: Robert Farris Thompson, 1982.

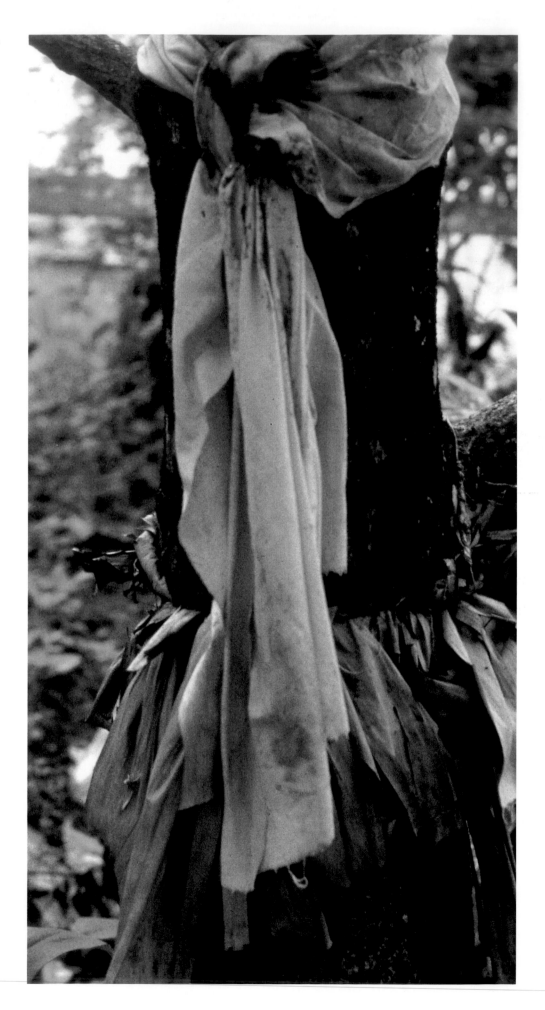

The Face of the Past: Staff Shrines and Flag Altars

Wood- or Clay-Pillar Altars Supporting a Vessel

Dennis Warren, an authority on Akan culture and societies, has photographed the transformation of vessel-on-pedestal-altar into vessel-on-possessed-person at an Afra shrine among the Bono of northwestern Akan territory. Here the spirit of the river Afram, which merges with the Volta near Peki, is worshiped in a given sequence: the shrine in place, mounted on a pedestal in the shrine room; the shrine dressed up and brought outside in ritual finery; the shrine carried on the head of its priest, Kofi Owusu, the spirit within it possessing him (plate 131).

The same spiritual sequence reappears in Suriname, not only among the river villages of the Saamaka and Ndjuká but also among the coastal blacks. The Herskovitses record a Saamaka instance:

PLATE 129: DIRK VALKENBURG, *SLAVE "PLAY" ON THE DOMBI PLANTATION*, 1707, OIL ON CANVAS. Valkenburg's picture, of a black festival at the Palmeneribo-Surimombo plantation on the Suriname River, is of great historical interest. Many of the people he shows celebrating here escaped upriver to freedom a few years later, and are ancestors of some of today's Saamaka. Collection of the Danish Royal Museum of Fine Arts, Copenhagen.

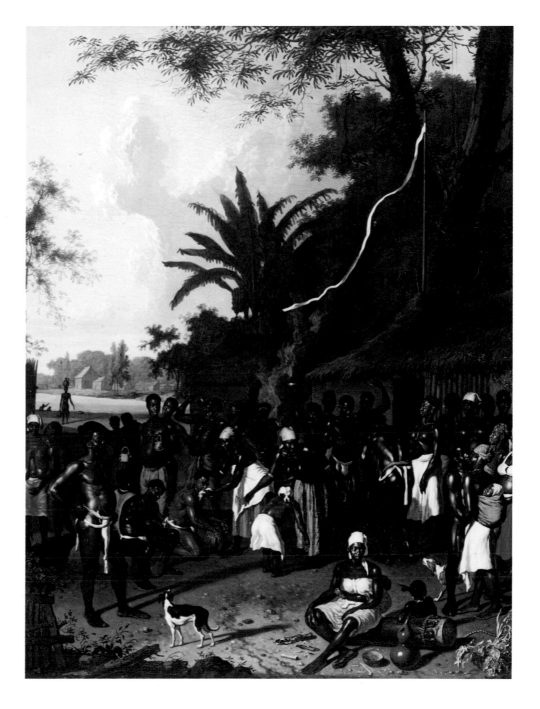

PLATE 130: K. MARTIN, DRAWING OF A SAAMAKA VESSEL-ON-COLUMN ALTAR, SURINAME, 1885. The sashlike flag evokes the *nsungwa*, the tall staff with cloth banner that Kongo people may shake in the air at a funeral, and the narrow strip of cloth flying over the "slave play" at the Surimombo plantation in 1707 (plate 133). And the vessel-on-column altar itself recalls Mande/Akan principles of sacred design. From Martin, *Bijdragen Tot de Taal-Land-en Volkenkunde van Nederlandsch-Indie*, 1886.

PLATE 131: KOFI OWOSU, PRIEST OF THE AFRAM RIVER, GHANA. The spirit is contained in a vessel that usually rests on a pedestal. Here, the altar pedestal takes on human flesh. Photo: Dennis Warren, 1970s.

I talk to my god. If I have something to beg of him for myself, or for someone else, then I put the pot [from an altar pedestal] which belongs to him on my head and the drum calls him. When my body begins to shake, then it is the god. He has come, and when I speak it is not I but the god speaking.[51]

During his voyage among the Saamaka in April 1885, Martin drew a vessel-on-column altar (plate 130), adding brief remarks: "vessel with medicine, under a table-like construction providing protection against the rain. The height of the table is approximately four feet."[52] Next to the altar appears a wisplike white banner on a pole. More sash than flag, it recalls a similarly structured banner unfurled to mark the "play" of plantation blacks in a painting by Dirk Valkenburg, from 1707 (plates 129, 133), at the Suriname River adjoining the plantations of Palmeneribo-Surimombo.

Finally, C. H. de Goeje, recounting an expedition to the Toemoekhoemak mountains in the early century, describes a similar Ndjuká shrine: "Under a roof a wooden pole painted with clay on top [of which] was positioned a pot filled with herbs for healing."[53]

We can match these early notices in the literature to an actual Saamaka vessel-on-column altar now in the Hamburg Museum für Volkerkunde (plate 152). Melville Herskovits collected it in 1929, at the Saamaka village of Ganiakonde (now submerged in the lake behind the Suralco dam). This shrine embodies the spirit of a "fighting *obia*," Djanfoso, who stood in Ganiakonde guarding the village from all evil. An *obia patu*, a plate filled with protective medicine, was balanced on its head, not unlike the protective bundle balanced on the head of a Bono River priest in Ghana (plate 151). In addition, the structure roughly mirrors the Birifor vessel-on-head figural column marking an ancestral altar in Mali that was photographed by the late Katherine Coryton White (plate 2).

Fésitén: Ndjuká and Saamaka Flag Altars to the Past

Even if everyone in the whole village died, it would be up to you to carry on,
to tend to the ancestor shrine.

—Grandmother Kandamma, quoted in Richard and Sally Price, *Two*
Evenings in Saramaka, 1991

The Saamaka have a most important phrase for "history," *fésitén*, literally the "first time," meaning the distant past. Pikílío Saamaka associate this phrase with an altar in a sacred grove near the village of Dangogo. It is an altar to the "old-time people" (*awonenge*), the ancestors who "heard the guns of war"—who witnessed the wars of liberation from slavery.

Here a flag-emblazoned altar receives libations of sugar-cane beer, poured on the earth beneath newly raised banners. Here "the Old-Time People are one by one invoked—their names spoken [or played on the *apinti* drum], their deeds recounted, their foibles recalled, and the drums/dances/songs that they once loved performed to give them special pleasure."[54] This is spirit-designed art and architecture.

The design of the altar—*faáka páu*, "staff with a flag"—was first given by the spirit of Fankía, great ancestress, who witnessed the wars of liberation:

> Fankía heard the guns of war. When they brought her down from the Upper River [in the great migration of the 1770s] she was still a "large-apron-girl" [teenager].
>
> Well, she lived until she died [in ca. the mid 1840s] and they raised up her coffin [in divination]. She told them that the Old-Time People had a message for the living about how they should henceforth speak with them. They should build a shrine according to the specific instructions she would give. And whenever they wanted to talk to the Old-Time People, they should pour libations at its base. And until today, the first name invoked at the shrine of Awónênge must always be Fankía, who heard the guns of war.[55]

I honor Richard Price's research on Fankía and her contemporaries by reassembling visual influences—African, plantation creole, European—that come together in her architecture of the spirit.

By the time of Fankía, Kongo slaves in Suriname had bequeathed at least 10 to 15 percent of the total lexical range of the Saamaka language. And Kongo culture likewise filtered, through the slave ports and the plantations, into Saamaka culture. Witness these direct attestations: Kongo *kandu*, "spiritual locks" against thieves, including one called among Saamaka "Mother Kongo"; and *nsunsa*, the Kongo game of footwork, seen by Stedman in Suriname in the 1770s and continuing to this day under the creole rubric *susa*.[56] Valkenburg painted two blacks playing *nsunsa* in 1707 on the Dombi plantation. They are clearly squared off, sparring, one-on-one, with the player to the right cocking his foot back in combat and the player to the left reading his opponent's footwork carefully for the next move (plate 132).

PLATE 132: DIRK VALKENBURG, *SLAVE "PLAY" ON THE DOMBI PLANTATION* (DETAIL), 1707. Valkenburg provides a fascinating glimpse of black life on an early-eighteenth-century Suriname plantation. Here, for example, he seems to have documented two Suriname blacks sparring, one on one, in a game of footwork that derives from the Kongo *nsunsa* dance. Collection of the Danish Royal Museum of Fine Arts, Copenhagen.

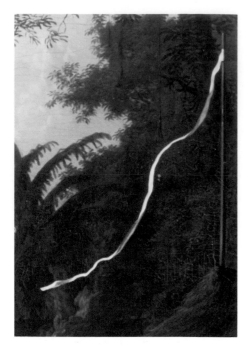

PLATE 133: DIRK VALKENBURG, *SLAVE "PLAY" ON THE DOMBI PLANTATION* (DETAIL), 1707. Valkenburg also noticed a narrow banner flying from a pole in a thatched roof, though he was probably unaware that it may have marked a shrine (see plates 130, 135, 150). Collection of the Danish Royal Museum of Fine Arts, Copenhagen.

A banner in the form of a long, trailing strip of cloth unfurls high above these slaves (plate 133). The flag recalls a particular kind of Kongo long-pole banner, the *nsungwa*, that constitutes one likely root—but only one—of the *faáka páu/faaka tiki* complex. In addition, two men are playing wedge-tuned drums, and another such drum lies on the ground. In morphology and in style of play, these drums reflect influences from the Kongo coast. Drums, *nsunsa* sport, and the ritual importance of a flag flowed directly from Kongo and from this plantation into the world of Saamaka runaway blacks. As Richard Price remarks, "Valkenburg's plantation painting, of a slave 'play' in 1707, almost certainly depicts some of the very people who just a few years later became the original Dombi maroons."[57] The Dómbi, a Saamaka clan, settled upriver in the villages of Pikiseei, Futuna, Botopasi, and Daume.

Midway between these villages and Palmeneribo-Surimombo, on the same Suriname River, Martin documented in 1885 a long, narrow, sashlike altar banner, like a miniature version of the one unfurled in Valkenburg's view of the early-eighteenth-century plantation. Here the banner honored a spirit whose uplifted medicine was set on a pillar altar protected by a simple shelter (plate 130). Can there have been a similar altar, hidden from the eyes of Valkenburg, under or near the banner at Palmeneribo-Surimombo?

Note how, in that painting, the long trailing banner, like a streak of slow-motion lightning, flutters from a pole emerging from a swelling mound of thatch at the end of a building roof (plate 133). In April 1885, Martin documented the same element of Afro-Suriname architecture—roof bulge pierced by rising staff (plate 135)—at Watjibasu, a Nyafai-clan Saamaka village on the Suriname River:

> Watjibasu is famous up and down the river for possession of a main god of the region. In the middle of an open clearing . . . stands a square, low idol-house. Out of its middle projects a tall post. At the summit of this post is a square board, which serves as a table for beverages, devoted to the god. [Above this platform] is attached a white flag, intended to fight off the evil spirit. A ladder leads up [to this level] and only one person may bring something to drink to the god. . . . Next to the large pole for the god stands a small staff for the ancestors, to which one also prays.[58]

PLATE 134: MUSLIM MARABOUT CEMETERY, SOUTHERN LIBYA. The Muslim custom of adorning graves with flags and pottery may have influenced the emergence of flags on certain Akan altars (see plates 4 and 5)—one possible line of descent for the Suriname flag altar. From Christoph Krüger et al., eds., *Sahara*, 1969.

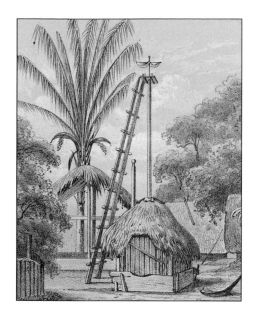

PLATE 135: K. MARTIN, DRAWING OF A SAAMAKA FLAG ALTAR, WATJIBASU, SURINAME, 1885. Nearly two hundred years before Martin visited Watjibasu, the painter Valkenburg saw Suriname blacks flying a banner from the highest point of a thatched roof (plate 133). Here that banner on a post emerging from similarly peaked thatch has become a carefully designed shrine, complete with ladder for sacrifice on high to heaven. From Martin, *Bijdragen Tot de Taal-Land-en Volkenkunde van Nederlandsch-Indie*, 1886.

PLATE 136: *LA FIESTA DEL DIA DE REYES A LA HABANA DEL SIGLO PASADO* (FESTIVAL OF EPIPHANY IN NINETEENTH-CENTURY HAVANA; DETAIL), LATE NINETEENTH CENTURY, ENGRAVING. Mid- to late-nineteenth-century processioneers in black Cuba might carry a staff with fluttering cloth in perpetuation of the Kongo *nsungwa* tradition. From Lydia Cabrera, *La Sociedad Secreta Abakuá*, 1959.

Martin also witnessed narrow-sash banners not unlike *nsungwa*, and very close in style to the banner at early-eighteenth-century Palmeneribo-Surimombo. But here, at Watjibasu, he saw something new: an elaborate flag altar on a platform in the air. The Saamaka makers of this shrine had arranged cloth on a crosslike frame, shaping a figure that resembled a bird with outspread wings.

A flag has become an altar, unfurled on high in a manner theatrical and unique. Further influences have to be marshaled to explain this complex blend. We begin with those cultural marvels of the Sahara, the graves of Muslim marabouts, marked with pottery, stones, and flags (plate 134). Given the Islamic influence on metallurgy, leather-working, and other arts among the Akan of the coast, it is not surprising that we also find flags associated with the spirit in the same area.

Cape Lahou, as already seen, was a conduit of Mande and Mande-influenced culture, including the Akan periphery, into the New World. Consider the courtyard of the Asante king's sleeping-room in Kumasi in 1817. Here appears a full panoply of Mande/Akan tree and tree-surrogate altars: two copper-vessel-in-fork shrines and two tree shrines, stunted silk cotton and manchineel. But right next to the trees and uplifted vessels there was also a flag shrine, or, more accurately, a flag tree—sacred white and red banners at the top of a trunk taken directly from natures (plates 4 and 5). With fork-and-vessel and tree altars reemergent in Suriname, it is reasonable that memories of such banners should have surfaced there too.

In addition, Northern Akan tie cloths to a tree to honor an indwelling spirit, as at Nkoranza. This is more or less in agreement with the wish of Fankía, that cloths should be unfurled, on high, to honor the unseen ancestors.

The Kongo contribution to the flag altar, the *nsungwa*, held by a processioneer at a funeral, is a towering staff onto which a narrow strip or strips of cloth are tied at the very top. To honor the dead, processioneers shake and elevate *nsungwa* in the air. The cloth strips atop these staffs encode *mambu* (words, matters, problems) that the living seek to communicate to the dead; one activates the attention of the other world by "waving the words" (*minika mambu*), a basic Kongo metaphor for spiritually activated admonitions. This ritual act "vibrates" (*dikítisa*) cloth-coded prayer, so that the ancestors cannot fail to comprehend.[59]

There are visual reflections of the *nsungwa* tradition in mid- or late-nineteenth-century Havana (plate 136), early-nineteenth-century Rio de Janeiro (plate 137), and, possibly, nineteenth-century Martinique. The New World *nsungwa* banner staffs appear, logically enough, in contexts of further Kongo influence: *ngoma* festival drumming in Cuba; or the Rio funeral of the son of a royal Kongo person, carried Kongo-style in a hammock, a *kipooyi*, to the other world.

Thus memories of *nsungwa*, Akan flag altars, and sash-decorated iroko trees, all to communicate with the spirit world, explain, via multiple reinforcement, what happened in the rise of Suriname altar art.

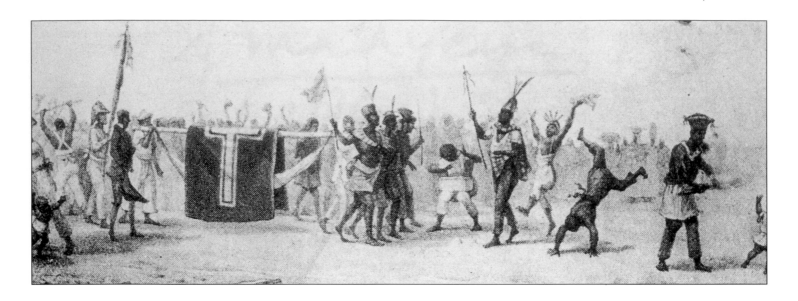

ankía heard the guns of war. This means she and her people must have seen Western military banners, leaving an indelible impression—perhaps the European element of the *faáka páu*. Yet the runaways had flags of their own. A renowned maroon commander, Baron, and his men fought Stedman's troops near a settlement called Boukou on February 28, 1773; the moment Baron saw Stedman's men advancing, he "planted a white flag within their view, which he meant as a token of defiance and independence."[60]

PLATE 137: JEAN BAPTISTE DEBRET, FUNERAL OF THE SON OF A BLACK KING, BETWEEN 1816 AND 1831, ENGRAVING. In black Rio de Janeiro, a funeral procession with nsungwa-like staffs. As in Kongo, the body, of the son of a royal person, is carried in a hammock or *kipooyi*. And here as in Havana (plate 136), the context—there festival, here funeral—reproduces the situations in which *nsungwa* would be borne in Kongo. From Jean Baptiste Debret, *Voyage Pittoresque et Historique au Brésil*, vol. II, 1834–39.

At the same time, the rebel leader may well have been calling on God (Masa Gadu), via the color of the cloth he used, to help him vanquish the Europeans and their hired black mercenaries. In 1885 Johannes King, a Matawai maroon, published an account based on oral history of early maroon guerrilla warfare. This text illustrates "how our forefathers honored God and their early ancestors . . . when they returned to their villages": by setting up special flag altars. "In the morning, they took a piece of white cloth and they raised a white flag to Gran Gado [the supreme deity] in the heavens. Then they all [knelt] and gave [God] thanks for [having] given them strength in the forest to fight and win a major war against the whites."[61] Then they erected a flag-altar to the ancestors: "They raised another flag with a black cloth. This they did to honor the former warriors, those who had fought and won against the whites."[62]

The concept of honoring the dead under flags of the spirit dovetails with another element of Kongo ritual culture, flag-decked graves and banner-guarded domestic shrines. Flags are put on Kongo graves, but only at the time of burial—the survivors do not replenish them. They are called *mpeeve* or *mpévula*, and are considered "glory symbols" (*sinsu kya nzítusu*), unfurled as signs of "victory" (*ndúgunu*) of spirit over death.

Rectangular cloth flags appeared in Kongo in the sixteenth century. "We see traces of Western influence in that development," says the Kongo scholar K. Kia Bunseki Fu-Kiau.[63] Before European flags entered the kingdom as items of trade, Kongo people celebrated military victories by waving cut branches from trees. They also used animal-skin "flags," often civet, as mediation symbols on tombs of chiefs. As the civet cat roamed from bush to village, so the spirit honored by these flags had crossed the line. Cat skins and, later, Western rectangular flags were used like *nsungwa* as communications to the dead—words waved as banners like semaphores flashing to the other world. Finally, for

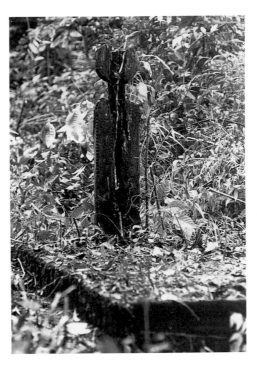 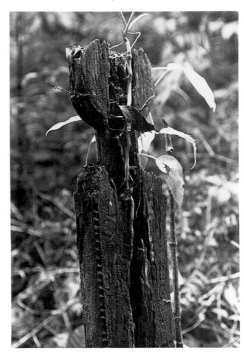

Kongo, motion imparted by wind to flags directly demonstrated ancestral presence.
Banganga (ritual experts) phrased this belief in the following way: "The wind on the flag
is a vibration shared by the two communities, the living and the dead."[64]

Such flags as might have been unfurled on graves of important blacks on Suriname
plantations have long since vanished. But at an old plantation burial place of whites at
Joden Savannah, on the lower Suriname River, a powerful flat-board image with an
octagonal head rises out of a miniature enclosure of four carpentered planks around a
tomb (plates 138, 139). The style of this enclosure, reminiscent of Kongo cemetery
luumbu (fenced-in precincts for the spirit), probably inspired, at least in part, the making
of similar plank enclosures around the bottom of Saamaka *faáka páu* and eastern-
maroon *faaka tiki* altars to the dead. Whether we are dealing with a Kongo influence
mediated by African plantation workers who insinuated a bit of their own design in the
making of a European's grave, or with some other European source, is not the main
point here, however. The point is that this style is *old*, going back at least to the early
nineteenth and possibly even the late eighteenth century. For *faáka páu* are acts of
honorific memory, visually gathering things that brought pleasure (*pizíi*) to the ancestors.

The *faáka páu*, then, is a form of celebratory archaism, bringing back old wood-
carving styles (note the "early" look of wood openwork in most of the fences around
such enclosures in the Pikílío area), cloth preferences, and old-time pottery (plate 143).
These are acts of deliberate classicism, mirrored by similarly old styles of singing and
dance performed before the flag altar, and by gifts of striped cloth in the old prized
pattern. Note even such a detail as the finials that embellish the fence around the
ancestral shrine at Asindoopo (plate 143). Its decoration is a simple openwork of straight
lines and circles, roughly matching the earliest known "owl eye" style, as opposed to the
complex interlacing (*páu a páu déndu*) of later Saamaka styles. It also roughly matches
the openwork of the oldest surviving nineteenth-century house in Dii Tabiki, among the
Ndjuká (plate 140). This conservatism extends to the kind of pottery (*djogu*) placed
before this altar—clearly an old type of ware.

PLATE 141 (RIGHT): P. J. BENOIT, ENGRAVING OF FUNERAL PROCESSION, PROBABLY 1831. At a funeral procession in nineteenth-century coastal Suriname, the black mourners, at right, wear white caps or white headbands, an observance linked to the surviving inland maroon custom of winding the head of the dead, and, among Saamaka, of ancestor altar statuary, with white cloth (see plates 143, 153). From P. J. Benoit, *Journey through Suriname*, 1839.

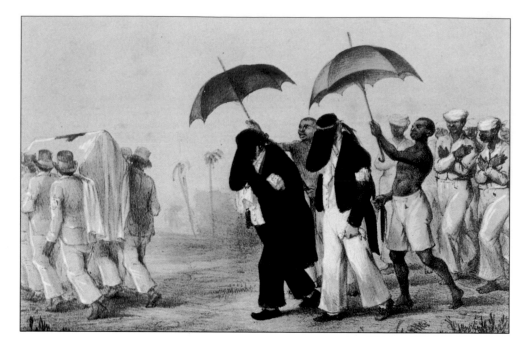

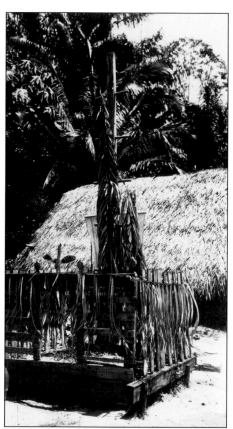

PLATE 142 (ABOVE): ANCESTOR ALTAR, SAAMAKA COUNTRY, SURINAME, probably early twentieth century. Rungs in the sides of the central flagstaff transform it into a ladder, enabling the servitor to pour a libation from closer to heaven. The concept recalls the shrine that Martin documented in Watjibasu in 1885 (plate 135). Photo: Melville J. Herskovits, 1929.

Respect for heritage also defines the use of figural sculpture as a guard or presence before the shrine. We now know, thanks to Moravian-collected works dating after the reopening of the Saamaka mission in the mid nineteenth century, that a vigorous tradition of African-influenced figural altar-statuary flourished among the Saamaka before the twentieth century (plate 144). The cuts and proportions of such sculpture were simultaneously restated radically in flattened abstract figures (plate 145); this old-time altar sculpture, also collected by Moravians in the nineteenth century, hints at an internal, highly sophisticated veering toward the simplified and abstract in the history of Saamaka altar art.

In any event, today the images that guard Saamaka ancestor shrines in the area where the Gaánlío and Pikílío rivers merge are simplified but strong and visually compelling. Such images often have white headbands (plates 143, 153); local informants suggest that this refers to the custom of wrapping the dead person's head with white cloth before burial, a tradition that matches city and plantation-funeral custom, where mourners wear white cloth or white caps about their heads (plate 141). A screen of striped cloth is set up before the guardian image. Here the patterns match the kinds of cloth traded on the coast of what is now Ghana in the mid nineteenth century.

In April 1885, Martin saw a flag shrine soaring some fifteen feet in the air, with vessels offered to the spirit of God or to the ancestors so high up that a ladder was necessary to reach the platform (plate 135). Both John Womack Vandercook[65] and the Herskovitses have seen similar altars suspended in the air. The Herskovitses add, "One year when the time for the new rains came, the rain did not fall. In the villages the priests climbed the ladders within the sacred enclosures and from on high poured out libations to the ancestors, beseeching them to intercede in behalf of the living."[66] Melville Herskovits photographed such an altar in 1929 (plate 142), in which the central flagstaff has been transformed into a ladder by insertion of pegs or rungs into its sides. A similar ladder to heaven defines the high altar to the ancestors at Asindoopo (plate 143). Note also the continuity of the style of enclosure and the old type of pottery for pouring water while praying (*bégi*) to the ancestors.

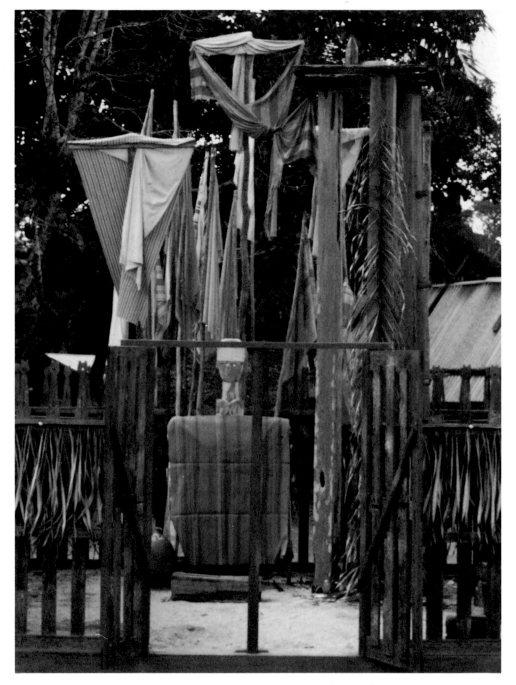

PLATE 144 (ABOVE LEFT): SAAMAKA ALTAR STATUE, NINETEENTH CENTURY. PLATE 145 (ABOVE RIGHT): SAAMAKA ALTAR STATUE, NINETEENTH CENTURY. These two examples of nineteenth-century Saamaka statuary, both collected by members of the Moravian mission to the Saamaka, are formally linked, the abstract work restating and flattening the lines, cuts, and proportions of the more obviously figural one. Their coexistence suggests both contrast and continuity in the history of Saamaka altar art. Both collection of the Volkerkundemuseum, Herrnhut. Photos: Christopher Munnelly, 1992.

PLATE 143 (ABOVE): SAAMAKA ALTAR TO THE ANCESTORS, ASINDOOPO, SURINAME, TWENTIETH CENTURY. Saamaka altars preserve old styles of woodwork. The old-style ornamentation of the surrounding fence is a deliberate, celebratory archaism reflecting the desire to please the ancestors with their kind of art. Photo: Robert Farris Thompson, 1978.

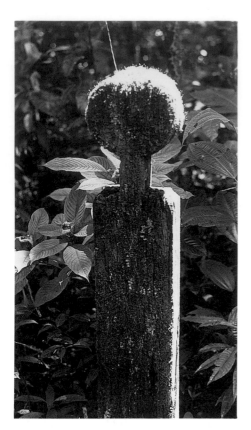

Flat-Sided Altar Sculpture in Suriname: A Brief Excursus

There are flat-sculpture images, virtual silhouettes cut in wood, going back to slave-plantation grave-markers (plate 146), and flat-sided images were seen on the shrines of priests and priestesses on the Suriname coast in the early nineteenth century. P. J. Benoit illustrates a priestess of "water-mama" in her shrine (plate 147); on a wall, beside her identifying badge of snake-mediumship, is a shelf supporting flat-sided carpentered images.[67] These images, dating from before 1831, lead logically to a flat-sided image for the Akan-derived (water?) spirit Aflamu, who wears an amulet around the neck not unlike those worn by possession priests of water deities among Akan (plates 148, 151).

The tradition leads on to a masterpiece of maroon shrine sculpture (now submerged by a lake), an image with a disklike head, recalling Gá, Fanti, and Bono antecedents in West Africa. It was photographed before 1977 at the Saamaka shrine for the goddess of the river at Pati Island, below Duwata and above Adawai. This image, meant to protect boatmen over various perilous cataracts, stands purposefully within a frame of wood.

Another style flourished in the shrines of the Saa Kiiki River Ndjuká and apparently neighboring Saamaka villages in the last quarter of the nineteenth century. This style involves a bifaceted heart-shaped face over an unadorned, cylindrical body. Compare Martin's drawing, from 1885 (plate 150), with spirit images that I would date to the same period because of the closeness of their style to this image (plate 152), as well as to a remarkable little Ndjuká "god image" collected by A. Kinkowstrom at Kofi Kampu on the Saa Kiiki in 1890 (plate 149).

Thus as part of the density and vitality of altar art and ritual in maroon Suriname, we can attest to the existence of various modes and styles, from the full-bodied, intensely Africanizing image collected in Paramaribo and mid-nineteenth-century Saamaka by the Moravians, to flat-sided abstract images from perhaps the same period, leading through bifaceted facial styles to the normative "guardian image" style now definitive on the Pikílío and Gaánlío main open-air altars to the ancestors.

PLATE 147 (RIGHT): P. J. BENOIT, ENGRAVING OF SHRINE OF "WATER-MAMA," PROBABLY 1831. The shrine's priestess, living on the Suriname coast, had three flat-sided sculptures on a shelf on the wall of her shrine. From P. J. Benoit, *Journey through Suriname*, 1839.

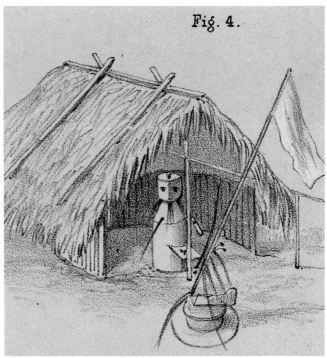

PLATE 148 (ABOVE): ALTAR STATUE TO THE SPIRIT AFLAMU, SURINAME, BEFORE 1929. Aflamu, perhaps a water spirit, wears an amulet not unlike those worn by Akan water-deity priests in Africa (plate 151). This flat-sided sculpture honoring Aflamu seems a descendant of the genre of carpentered flat altar statuary that Benoit saw in a shelf-top shrine, probably in 1831 (plate 147). Collection of the American Museum of Natural History, New York.

PLATE 149 (TOP LEFT): NDJUKA ALTAR STATUE, KOFI KAMPU, SURINAME, COLLECTED IN 1890. The bare cylinders of the pillar altars in plates 150 and 152 here become a cone, small, delicate, and ornamented with a dot pattern. Collection of the Etnografiska Museet, Stockholm. Photo: Robert Farris Thompson, 1975.

PLATE 150 (TOP RIGHT): K. MARTIN, DRAWING OF A SAAMAKA PILLAR ALTAR, SAAMAKA COUNTRY, SURINAME, 1885. The rectangular flag marking this shrine reflects Western contact, but the altar image itself, with bifaceted face, is set strongly within one of the late-nineteenth-century maroon altar styles. From Martin, *Bijdragen Tot de Taal-Land-en Volkenkunde van Nederlandsch-Indie*, 1886.

PLATE 151 (BOTTOM LEFT): AKAN WATER-DEITY PRIEST WITH AMULET AND ALTAR BUNDLE. Photo: Dennis Warren, 1970s.

PLATE 152 (BOTTOM RIGHT): SAAMAKA PILLAR ALTAR TO THE SPIRIT DJANFOSO (RIGHT), GANIAKONDE, SURINAME, COLLECTED IN 1929, WITH *AGIDU* DRUM FROM THE SAME PERIOD. With its bifaceted face, conical neck, and cylindrical body, this altar figure to a "fighting *obia*" is very similar to one of those Martin saw in 1885 (plate 150). Collection of the Hamburg Museum für Volkerkunde.

The continuity of such traditions, from Africa and through plantation carpentry, endorses the sureness of line and the life within the forms that characterize *faáka páu* sculpture of today among the Saamaka of the villages of Gódo (plate 153) and Soolán (plate 154). When we stand before such images, confronted by West Africanized cowrie eyes, crisp relation of ears and nose to facial panel, and spectral, funereal head-winding, and then regard their context, we witness in full the imperatives of Fankía: old-time carved figures, old-time striped cloths, old-time flags of the spirit, old-time jugs and sacrifice, to exalt with pleasure those who heard the guns of war (plate 155).

PLATES 153 AND 154 (LEFT TO RIGHT): SAAMAKA *PINDI* ALTAR STATUE, GODO VILLAGE, SURINAME, PROBABLY 1970S. SAAMAKA *PINDI* ALTAR STATUE, SOOLAN VILLAGE, SURINAME, PROBABLY 1970S. Like the figure in the great Asindoopo altar (plate 143), the Gódo figure wears a white headband. Saamaka maroons may similarly wrap a dead person's head with white cloth before burial (see also plate 141). The sophisticated stylistic means in the *pindi* tradition, as evidenced here, is impressive. Photos: Christopher Healey, 1970s.

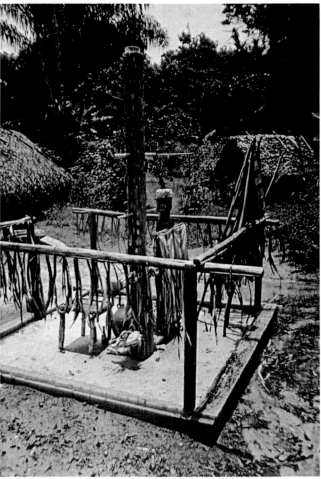

PLATE 155 (RIGHT): SAAMAKA ALTAR TO THE ANCESTORS, PIKILIO AREA, SURINAME, TWENTIETH CENTURY. Here we see the characteristic Saamaka orchestration of elevated altar, enclosure, and pindi image. Photo: Christopher Healey, 1970s.

Conclusion: Ndjuká *Faaka Tiki*

Two ancestor shrines play a pivotal role in funerary rites and therefore in the ritual life of the Ndjukás: the mortuary and the ancestor pole. Without these two shrines no settlement will be granted village status. A village is therefore clearly distinguished from a settlement irrespective of the number of its inhabitants.

> —Thoden van Velzen and van Wetering, *The Great Father and the Danger*, 1991

There are four different kinds of Ndjuká flag altar: the large community flag altar to the grand ancestors (*faaka tiki fu den gaan yooka*), where elders worship on behalf of the group, collectively, making libations and speeches not for themselves but for the whole community, reflecting an egalitarian impulse built into Ndjuká culture; the family altar (*a famii faaka*), a smaller, more intimate affair, often tended by chiefs or important men; the altars of mediums who work with spirits, like the Dahomey-derived Papa Gadu serpent deity, or avenging spirits (*kunu*)—these altars can incorporate elaborate flag decorations; and altars to the important warrior Kumanti spirits (*Kumanti posu*), which are figural posts, not necessarily decked with flags.

The Altar to the Grand Ancestors

The structure of the large *faaka tiki fu den gaan yooka* (plate 156) is in many respects analogous to the Saamaka *faáka páu*. A T-form cross (*koloisi*) suspends a single long sheet of white cloth (*a weti koosi*) within a carpentered enclosure (*djali*) in which is usually sited an antique piece of pottery (*kaniki*) for pouring libations of liquor (*sopi*) onto stones (*siton fu faaka*) as the point of prayer (*begi peesi*).

Saamaka *faáka páu* include a shield of striped cloth before the staff and a standing image. The altar to the Ndjuká ancestors goes without this image. The Ndjuká elders, when making serious requests of the ancestors, tie "ex-voto" cloths to the flagstaff beneath the flag, after long supplications and making a libation. This spectral length of fabric, fluttering in an intensity of white, calls on God and the ancestors with an emblem of perfect reputation that is deepened by its length: according to an informant, Ba Kodjo Kanape, "In order to have the full strength of this altar to the ancestors you have to have the full length of a tree." This special soaring kind of shrine, then, honors the collective ancestors as a treelike standing sentinel. The linking of the color white with coastal funereal headbands is deepened by the fact that in Ndjuká cemeteries reported by Thoden van Velzen, headstones are T-form crosses, not Christian crosses, as if a miniature version of the frame that holds the cloth in *faaka tiki*. The view of the flag as a shrouded heroic headstone, rising from a simulated grave enclosure, makes sense also when Kumanti figural *posu* (shrine posts) with octagonal heads are compared to old plantation headstones at Joden Savannah, the latter all strongly silhouetted with eight sharp facets.

The *Famii Faaka*

I illustrate the family-style *famii faaka* altar by a detail of a small altar that stood on the

PLATE 156: NDJUKA ALTAR TO THE GRAND ANCESTORS, DII TABIKI, SURINAME, TWENTIETH CENTURY. The Ndjuká altar to the grand ancestors (*faaka tiki fu den gaan yooka*) comprises a long sheet of white cloth hanging from a T-form cross. It stands within an enclosure that also contains a pottery vessel, from which the town elders pour libations on behalf of the entire community. Photo: Robert Farris Thompson, 1981.

porch of the residence of the paramount chief of the Ndjuká, *Gaanman* Gazon Matoja, in December 1981 (plate 157). One flag made of flowered print stands in honor of the ancestors (*gaan sama*), the other, garlanded with a special red-and-black braided-cloth necklace, honors the spirit Sweli Gadu, a major Ndjuká deity. Numerous requests to the ancestors are registered with several cloths tied to the middle of the staff.

Papa Gadu and *Kunu* Altars

Mediums' altars for Papa Gadu and *kunu*, both in Godo Olo, upriver from Dii Tabiki, show the interplay between the ancestral clay-pillar altar with vessel and a creolized profusion of honorific striped banners (plates 158 and 159). The pillar altar for Papa Gadu is said to date from before the time of the paramount chief Oseisei, that is, before 1884. As to the white pillar with balanced vessel in an altar to the avenging spirits, photographed in January 1978, it was said that only those deeply initiated in *obia* work would know how to make this mound of kaolin, and that "no one should touch it out of fear. Crack it, you'll perhaps die. The first offering given to *kunu* is a 'contract' and we take this, the first present, and put it underground and put a mound of porcelain clay over it. This is the beginning of the pillar of white clay you see before you."[68] Herbal washings for ill clients of this altar are given from material uplifted in the large "cup"

PLATE 157 (ABOVE): NDJUKA FAMILY ALTAR, DII TABIKI, SURINAME, TWENTIETH CENTURY. The paramount chief of the Ndjuká, *Gaanman* Gazon Matoja, tends this *famii faaka*, which stands on his own porch. The taller flag honors the ancestors; the smaller one, with its necklace of braid, is dedicated to the spirit Sweli Gadu. The *famii faaka* is an intimate, local altar, but not every home contains one; it is usually found in the care of chiefs and other important men. Photo: Robert Farris Thompson, 1981.

PLATE 158 (RIGHT, TOP): NDJUKA ALTAR TO *KUNU* (AVENGING SPIRITS), GODO OLO, SURINAME, TWENTIETH CENTURY OR EARLIER. Photo: Robert Farris Thompson, 1978. PLATE 159 (RIGHT, BOTTOM): NDJUKA ALTAR TO THE SPIRIT PAPA GADU, GODO OLO, SURINAME, BEFORE 1884. Photo: Robert Farris Thompson, 1981. These two clay-pillar altars are clearly cognate. The *kunu* are spirits, of humans or gods, eager to avenge some moral wrong in the past.

The Face of the Past: Staff Shrines and Flag Altars

PLATE 160: NDJUKA ALTAR STATUE TO PAPA GADU, GAAN BOLI, SURINAME, TWENTIETH CENTURY OR EARLIER. The resemblance of the face of this Papa Gadu figure to that of the Saamaka river goddess at Pati Island (not illustrated) suggests links between the two maroon cultures. At the same time, both faces appear Africanized, relating to disk-faced figures found along the coast of eastern Ghana. Photo: Robert Farris Thompson, 1981.

(*komiki*) at the apex of the mound. Respect for the dreaded *kunu* spirit honored here is such that he has been given his own table for drinking a generous range of beverages—Coca-Cola, orange soda, whisky, and beer.

Papa Gadu statuary is imposing. Essentially a massive post relieved with a stylized ovaloid face, rising from a massive, athletic neck, the Papa Gadu image recalls various disklike stylizations of the head among a variety of Cape Lahou and Gold Coast civilizations, especially Bono, Asante, Fanti, and Gá. One monument of Ndjuká Papa Gadu shrine art, at Gaan Boli, is swathed in red cloth around the body below the neck (plate 160). In facial stylization it matches the correspondingly important piece of figural sculpture that presides over the entrance to the shrine of the goddess of the river at Pati Island. The similarity hints at a fusion style involving Saamaka and Ndjuká, and containing vaguely intimated memories of Gold Coast disk-faced carving styles, brought together with worship of river and snake gods from areas farther afield in West Africa, notably Dahomey, and reconsidered in terms of plantation-learned styles of carpentry.

Altars of the Kumanti Spirits

Kumanti is one of the nobler of the African-derived religions of Suriname, but, like Haitian Vodun, it is strongly misunderstood:

> Some of the more spectacular feats of Kumanti mediums have fascinated ethnographers. . . . they have seen Kumanti mediums jump into a blazing fire, touch the red hot blades of machetes, jump into piles of bottles to trample these into pieces with their bare feet. They climb tree trunks covered with thorns and escape without a scratch.
>
> The Kumanti follower seeks to conquer fear. . . through fasting and other techniques inducing dissociation. [The] rewards will be immunity to wounds, even invincibility in combat. Regular meditation on the eternal verities of Kumanti lore will lead to the coveted state of equanimity of self-confidence.
>
> Kumanti are considered to be the best of all traditional healers, but they are also believed to manufacture the best weapons. During the eighteenth century, Kumanti mediums were in the vanguard of the fight against the forces of the plantation colony.
>
> Kumanti spirits bring no evil; they communicate that humans may control their world. Of all emotions, fear is considered the great enemy.[69]

The Kumanti altar image is usually kaolin-coated and the flag carried by its arms is white, "bringing peace." The image is a text displaying Kumanti valor. In a shrine in Godo Olo (plate 121), the head supports a dish and "in this dish they make the grand *obia*. At the Kumanti ceremony they will give you *obia* from this dish then they will cut you and it will not hurt."[70] When a person is troubled by a polluted relationship, rather than wasting vital energy about it he can come to this image, and the pair of scissors (*sesei*) embedded in the mound of sacred porcelain clay at its base will be used to "cut you apart from the trouble" (*koti singaafu paati*). And with meditation and initiation, the initiate will become as a Kumanti medium, dancing with a mirror around his neck, even

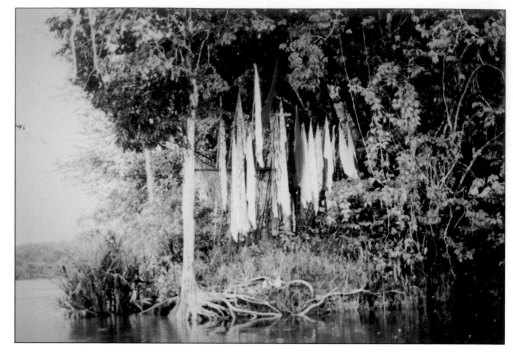

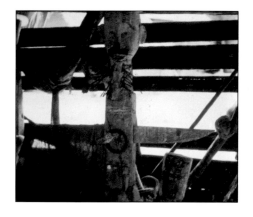

as a mirror blazes at the foot of this anthropomorphic shaft of wood. Kumanti "gives words to the mirror," meaning that the Kumanti adherent, toughened by fasting and deepened by initiation, fears not the evil someone might work against him: "Like mirrors, Kumanti can see you, however, whenever, you might come."[71]

An image in another Godo Olo shrine preaches Kumanti invincibility with its body and its attitude. Protectively, it spreads out its arms, blocking all evil (plate 162). A dish with *obia*, for protection from pain, surmounts the head. And a blade inserted in the body assures devotees that with proper ritual preparation they can be protected from all kinds of tearings of the flesh. The message of this blade-embedded image, its mustache and beard strongly humanizing it and drawing it closer to its devotees, is strong and clear: nobody can kill you, whether by knife or anything else made of iron (*a á mu poi fu kii yu anga nefi—ná wan sani di meke anga izii*). Complements of strangely twisted *kokoti* walking sticks and inverted objects add to the concentration of forces aimed at restoration of confidence and the utter annihilation of all fear. We stand in the presence of one of the secrets of the maroon's successful war of liberation, a machine for bravery and confidence under God.

The last altar considered stands at the confluence of the Jai Kiiki and the Tapanahoni rivers, upstream from Dii Tabiki going toward Gaan Boli (plate 161). With this altar we have come full cycle from Djenné-jeno. There, the ancient Mande altar guarded the entrance to a compound. This altar guards another threshold, another crossroads. Voyagers on the river pray, at this point, to Papa Gadu, who is honored with red flags, and to various other spirits, that all will go well as they swing to the right, up the Jai Kiiki, or continue on the broad Tapanahoni.

For the maroons, this altar civilized a rain-forest river, dressing a promontory with a multitude of flags. Gazon Asidonoopo Matoja, paramount chief of the Ndjuká, told me as we talked of this shrine: "When we came to this river, nothing was here. We added cloth, we added ideas of dress." The richness of those ideas, synthesized in *faaka tiki*, flowed in from sources we have seen, and from sources yet to be fully examined—like the tomb-

PLATE 163: FESTIVALIZING CREOLES BEARING
MARCHING FLAGS, PARAMARIBO, SURINAME, 1929.
Photo: Melville J. Herskovits.

flag tradition of the Muslim marabouts of the Sahara (plate 134), which may well have influenced the formation of Asante flag-shrines, for the Akan were always open to northern influences from Islamic Africa. Akan and Kongo flag traditions both ancient and strong, in collision with Western flags of armies and nations, haunt the vibrant marching flags that Melville Herskovits photographed among black creoles at Paramaribo in 1929 (plate 163). And these, in turn, inform the upriver flag altars of the Ndjuká, punctuating the rain forests with images from the "first time," when the guns of war were silenced, when the blacks raised flags, to celebrate their freedom and the renewal of their souls.

With the Assurance of Infinity: Yoruba Atlantic Altars

Love killed no one. Rather it made them beautiful and happy [and able to go]
forth with the assurance of infinity.
 —Zora Neale Hurston, *Tell My Horse*, 1938

Ìwà [character, moral behavior] is the essence of being.
 —Wande Abimbola, *Yoruba Oral Tradition*, 1975

In ancient towns and villages from southwestern Nigeria to Benin and Togo, Yoruba priestesses and priests encode in their altars the work of the spirit. This they do in several ways.

First, they emphasize the rank and secrecy of the gods with space. In towns, communal shrines include a first court open to the public, an inner court for the initiates, and a compact innermost chamber, *ita orun*, "the space of heaven," where essential stones and other emblems rest upon an elevated dais. In the inner court, with sacred dance and music, persons turn into gods, as space is filled by those in the spirit. When this happens, the aura of the *ita orun* takes charge of the compound.

The Yoruba, urban since the Middle Ages, imprint the same tripartite design upon their rural sacred groves. Western Pygmies, it will be recalled, consider the forest a point of reverence and prayer. The Yoruba combine like notions, of the woods as found cathedral, with their own, intricately urban way of being, inscribing in undifferentiated trees and undergrowth the familiar three-part sectioning: a large public clearing, followed by an initiates' clearing, climaxed by an inmost area where a tree, or a stone, or a small clay habitation conceals important emblems, marking a point of communication with the spirit.

The altar itself, ascendantly designed, indicates grandeur and transcendence by enthronement. In Yoruba antiquity there were no chairs in the Western sense. A square or semicircular clay dais (*erupa*), carefully smoothed and shaped, served this function. Thought to emulate the structure of the world, this dais continues to afford symbolic elevation (*gbega*, carriage on high) of essential altar objects. Officiants intensify that elevation by placement of the most important objects on a further cylindrical stand (*apere*), which in turn may support a calabash in which other calabashes are stacked, in a layered system of symbolic support.

The dais embodies immediacy of communication: quick absorption of spilled votive liquid into its clay is taken as a sign of prayer instantly taken into the consciousness of the spirit. "Whatever we say [before an altar]," the late Aràbà Ekó once explained, "let it penetrate into the earth, so that whatever is said will be [at once] accepted by God Almighty."[1] There are often pottery and calabash vessels on the altar; as he prays, the devotee pours cool water from these vessels to assuage and greet the spirits. Pottery and calabashes are tangible instruments of sacrifice and devotion to higher force. They are signs of propitiation, of the officiant's morality or gentleness of character (*iwà pèlé*), and of the enhancement of her inner head (*orî*) or destiny.

A proverb helps us understand this: *Awo onipele kì i faya; igba onipele kì ifo.* The plate of a gentle person never breaks; the calabash of a person gently conducting her affairs will never smash.[2] In other words, not only do pottery and calabashes on the altar

cool or please the spirits with the pouring of their contents, in their very fragility they seal a code of conduct.

The Yoruba, like many traditional Africans, also worship before "found altars"—dramatic rocky outcrops, deep pools, forcefully flowing rivers, the ocean, strong and salient trees. Trees become emblems of the gods, altars to their spirit, as in, for example, the relationship binding the boundary-marking akoko tree to Ogún, the road-slashing god of iron. (Yoruba notions of trees as altars carry over strongly into Haitian Vodun.) In their town altars Yoruba often miniaturize such sources of perdurance and inspiration, for example by concealing river stones and river liquid for Oshun, the goddess of sweet water and love, within a vessel. Special priests collect the meteorites that the thunder god Shangó hurls in storms and exalt them by enthronement upon the dais. Or officiants place upon the altar the objects that embody the gods' enabling grace (àse, the power to make things happen), so that a single piece of iron, for example, metonymically summons Ogún and the whole of the spirit of blacksmithing. With proper song and dance and incantation, each àse-drenched material or object becomes an inspiring source for possession of priestess and priest by the spirit. When this happens, devotees become icons in the flesh. The altar is doubled.

The altar is a school of being, designed to attract and deepen the powers of inspiration. By spatial and iconic means it instructs the devotee in the proper arts of ìwà pèlé. Dwarf doors force the postulant to bow deeply upon entrance to the inner shrine;[3] altar icons mime proper act and gesture in proximity to the divine—kneeling, double presentations of the hands, dancing for the spirit with head tie wrapped respectfully around the waist. These images are not passive pieces of shrine "furniture," then: they essentialize "the work," showing the proper way to stand and kneel before the gods.[4]

Finally, the altar's maker often invokes the goddess or the god with culminating points, and with centering accents that frame or emphasize the icon or object—subsidiary figures and other flanking or framing elements, like caryatid posts or a proscenium. This is the "place where the world comes to a point" (ibi sónsó).[5] This is the place of glory, compared to the soaring gables (kòbi) under which a king might sit, or to the pointed cone of his royal headgear (adé ibile), as well as to other sharp points, like the tip of the war god's cutlass, or the tip of the python's tail—all pure expressions of the inner power of character and destiny (orí), all pure expressions of the inner potentiality of the gods (àse).

Once the world-famous Yoruba singer Sunny Adé was seriously ill. Thinking he was dying, he composed a song to the altar of his head—in Yoruba belief, the source of his personal destiny and luck. Here his own embodiments of orí, àse, and ìwà pèlé came dramatically to a point. He begged his head, his inner spark of inspiration, his messenger of God, to save him:

> Orí mi yé o,
> Jà
> Jà fún mi
>
> Èdá mi yé o,
> Jà

PLATE 164: YORUBA *AIYE ORUN* (WORLD FROM HEAVEN) MONUMENT (DETAIL), ATTRIBUTED TO BABA OLOJA, ISARE, NIGERIA, CA. 1930S. The *aiye orun* stood outside the palace of Isare until 1964. Itself a giant crown, it shows on the right a king wearing royal headgear that bears the face of a spirit presence. A servant shades the king's head with an umbrella, offering ritual assuagement. Yoruba consider the head, *orí*, the source of one's destiny and luck. Photo: Robert Farris Thompson, 1965. Collection of the Nigerian Museum, Lagos.

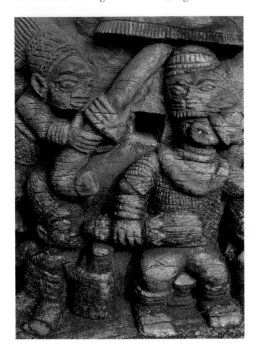

Jà fún mi.

Altar to my head [my destiny], please
Fight
Fight for me

Creator please
Fight
Fight for me.[6]

The fevers subsided. The song became a world-beat hit in the winter of 1982–83. But few dancers realized they were moving to a song about an altar to one's head, improvised on a hospital bed.[7] Heir to a shrine-making culture, Sunny Adé was no stranger to the language of destiny, and to the use of its idiom at a point of crisis.

When the traits of the Yoruba altar converge in sacred usage, the truths of the faith fall splendidly into place. For the altar provides a rising point, a crowned potentiality with which to orient and focus ritual acts of sacrifice and devotion—a "face." The Yoruba have another proverb: *Ojú ni òrò wa.* When two see eye to eye, face to face, that is communication and spiritual attainment.[8] Babatunde Lawal expands this point: "To tame or pacify is to 'cool the face' [*tù l'ojú*]. Thus, providing the nonfigurative symbol of an *orisha* with sculptured face facilitates the pacification of that *orisha*, for what has a face is controllable."[9]

That such control and communication could be realized with the self-altar of one's head, in an anonymous hospital ward, plants an important clue as to how the Yoruba classical faith became a world religion.

As the "countenance of the divine," the Yoruba altar relates to the region's monarchical tradition and the cultural complexity associated with it, which have protected this people from any serious sense of cultural diminishment in contact with the outside world.[10] Thus points about the altar may be illustrated by the *aiye orun* (world from heaven), a monument of Yoruba art—a giant wooden crown or helmet, serving as a kind of altar to the head and to the power of the kings, that until 1964 stood in front of the palace of Isare, Nigeria, to mark and announce the ruler's authority (plate 164). Locally attributed to the master carver Baba Oloja, and perhaps carved in the early 1930s, this richly realized work distills a sense of a civilization.

PLATE 166 (OPPOSITE PAGE, BOTTOM): ALTAR COURTYARD, ANCIENT IFE, 1000-1200 A.D. A pottery-and-stone pavement, perhaps designed and made by women, is laid in irregular herringbone patterns and concentric rings to frame a libation vessel. The pattern is spontaneous, oscillating, often broken—a common African aesthetic, suggesting the power of the spirit to break with the ordinary. Cf., for example, the Bira *amati a oni ganza* (plate 11) and the African-American yard show (plate 67). Drawing after Garlake, 1974.

Carved in powerful three-quarter relief, a king in royal headgear appears before us. His crown confronts us with another face—perhaps that of his inner destiny, or perhaps of Oduduwa, the first Yoruba king, or some other spirit. The ruler himself looks off to the right. His role as living altar, second only to the gods, is communicated by the intense spirituality of his crown. A courtier enacts *itutu*, ritual assuagement—keeping the ruler and his crowned, all-important head carefully shaded under an umbrella. Matching this discretion is the king's fly-whisk (*irùkèrè*), which he holds in his right hand. Moving this whisk he can acknowledge greetings without using speech, or can softly speak behind it. This frame of quiet is a summons to seriousness: it distances the king from minor perturbations.

Elevation on an *apere*, and accentuation of his head with areas of shadowed dark, transform the ruler into a virtual altar within an altar. He is in himself *ibi sónsó*, the

With the Assurance of Infinity: Yoruba Atlantic Altars

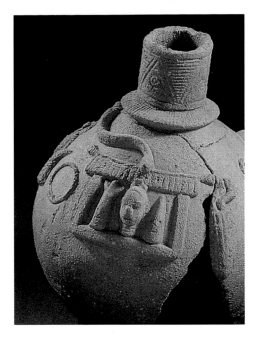

PLATE 165 (ABOVE): YORUBA RITUAL POT, ILE-IFE,
NIGERIA, CA. 1200–1400 A.D. In relief, the pot
shows a head raised on an altar flanked by conical
clay-pillar altars—spiritual heads (orí inú). A celestial
serpent descends centrally and lightninglike. The
altar's elevation and framing, the respect for the
head, the sharp points (for the Yoruba, the ibi sónsó,
the "place where the world comes to a point,"
manifests presence and power)—all these remain on
Yoruba altars today. The pot was made to be
embedded in a pavement, like that in plate 166.
Collection of the University Art Museum, Obafemi
Awolowo University.

place where the world comes to a point; he is orí, the head, the zenith from which to
dispense justice and impart tranquillity to the land.

The spiritual order on which this scene is built can be traced back to antiquity. A
ritual pot from the Yoruba holy city of Ilé-Ifè, Nigeria, dated to the thirteenth or four-
teenth century A.D., shows an important head on an altar, flanked by sharp-pointed
representations of a person's spiritual head (orí inú) (plate 165). Elevation, flanking clay
pillars to the left and right, and, above all, spirit resolved in things coming to a point—all
these qualities of the modern Yoruba altar are present here. The àse of this ruler or
important spirit, apparently flanked by cone-shaped altars to one's destiny, calls upon the
grace of the ministers of God. And heaven answers: as in the sixteenth-century iconogra-
phy of Benin, directly above the ruler or spirit a serpent comes down like lightning from
the sky and discharges a sense of power in the connection of two worlds. A poem of grace
descends, and leaves a curving, centered trace.

Implicit in the altars of today is the belief that the head and other avatars of àse and
iwà can summon spirit to an altar, to be fleshed out by possession devotees. Here that
belief wondrously becomes explicit.

The Yoruba of modern Ilé-Ifè uphold other traditions that have come down from the
past, and that illumine the way a "face of the gods" is set up and envisioned. These traits
include important ritual seats, rectilinear courtyards with a vessel for libations in the
center and a semicircular dais-altar at one end, threshold altars at the gates to a city or
the door to a habitation, and a concept of the gods as founding giants on the earth,
resulting in monumental staffs and other implements connected with their altars and
their names. The concept of god as giant is linked with a certain broad and hyperbolic
gaze, which has traveled the oceans and characterizes certain Yoruba sculpture in Cuba
and Brazil.

Elaborate stone seats have emerged archaeologically in Ilé-Ifè, marking an early
phase of the Yoruba concept of initiatory enthronement on the altar. As Henry Drewall
observes, "These intriguing enigmatic images relate to the import of ijókó (seats) in
Yoruba thought. Seats are literally, as well as metaphorically, understood as seats of
power. Initiates and priests to the gods sit on them when preparing to go into possession
trance."[11] This belief provides historical sanction for the magnificent tronos (altars of
enthronement and initiation) that are monuments of Yoruba worship in the New York
City area today.

At the center of an altar courtyard in ancient Ifè, dated to ca. 1000–1200 A.D., was a
vessel for libations, its position emphasized by concentric circles of pottery shards and
stones (plate 166). A shard-and-stone pavement, vividly designed, covered the earth of
the entire courtyard: "a series of rows of shards set on edge, often in a herringbone
pattern, alternating with rows of stones."[12] One assumes such pavements were laid down
and designed by women, whom the Yoruba customarily associate with the making of
pottery, a traditionally female practice. In addition, the wavy, spontaneous oscillation of
the pattern recalls the freedom of line in earth drawings still executed by Ilé-Ifè women
for Orisha Olurogbo, plus possible, distant cognation with the inner-bark-painting
designs made by Ejagham women in Nigeria, to the east.

As persons danced or shuffled barefoot across these changeling patterns, the tactile
sensations they received, deepened by changes in drumming, may have formed part of a

PLATES 167 AND 168 (ABOVE, LEFT TO RIGHT):
IDENA GATE, KETU, BENIN. Like the crossroads for
Kongo people, the threshold is a spiritually
important site for the Yoruba. In Ketu, a gate to the
city is itself an altar, honoring Èshù-Elégba and
Shangó, whose axes stand out against the sky.
Photos: Robert Farris Thompson, 1965.

PLATE 169 (BELOW): HAMMER OF OGUN, OGUN
LAADIN SHRINE, ILE-IFE, NIGERIA, PROBABLY
BEFORE 1000 A.D. Ogún is the Yoruba god of iron.
His hammer takes the form of a pointed wrought-
iron mound rising from the earth in the Laadin
shrine. See also plate 201. Photo: Phyllis Galembo,
1989.

totalizing invocation of the spirit. Indeed, in Central Africa today, and also in Haiti,
break-pattern art like that of this ancient Yoruba courtyard is still associated with the
shattering of ordinary happening in spirit possession. And the pot in the center of the
court provides a precedent for the altar-with-post (*poteau mitan*) that centers the Vodun
dancing-court in Haiti. The siting of semicircular dais-altars within courtyards likewise
continues in the city of Benin, where the shape is said to communicate "the totality of
[earth's] powers in its roundness."[13]

Threshold altars clustered about crossroads, gates, and portals in ancient Ifè. As
Drewal points out, the Yemoo crossroads site alone has yielded a rich cache of terra-
cottas, castings, and ritual pavements. Altars at thresholds and important intersections are
found everywhere in the Yoruba Atlantic world. Few are as dramatic as the Idena Gate in
the ancient city of Ketu, a point of entrance associated not only with Èshù-Elégba, the
messenger of the gods, but also with Shangó, whose axes, etched against the sky at the
gate's summit, bless incoming friends while warning strangers that his dangerous spirit
guards the town (plate 168). Cascading over gate and adjoining walls, rich thatching
imparts a masklike awesomeness to the famous altar-portal (plate 167).

Following the belief that the gods moved as giants when the world began, several of
the altars of Ifè include objects designed for persons of superhuman stature, like the
massive hammer of the iron god at his shrine at Laadin (plates 169, 201), or the tall
stone that designates his penis in the shrine at Oke Mogun (plate 200). Oranmiyan,
"valiant hero of heaven" (*akin orun*) and the youngest son of the Yoruba founding king
Oduduwa, left a measure of his enormous height in the soaring war-staff of stone, stud-
ded with iron insertions, that stands today as one of the most famous of the monuments
of Ifè (plate 170). Today the primary sign of the gods' fabled stature is their exorbitant
gaze, "looking broadly across the world, like giants."[14] That gaze is miniaturized in the
wide-open stare of persons in a state of spirit possession, when the devotee literally
becomes the face of the god. This extraordinary quality echoes in sculpture, from the

With the Assurance of Infinity: Yoruba Atlantic Altars

bulging eyes seen in many Yoruba art-forms in Nigeria to one of the monuments of Yoruba altar art in the New World, dating, apparently, from the last quarter of the nineteenth century: a seat for the thunder god, found in the northeast of Brazil, and there redesignated by the creoles a "throne of Yemanjá" (plate 171). The pressure of inner vision, registered in the eyes of a Mahi-Yoruba drum mask from nineteenth-century Cuba (plate 173), is matched in the face of a woman possessed by a Yoruba spirit in Brazil in 1990 (plate 172).

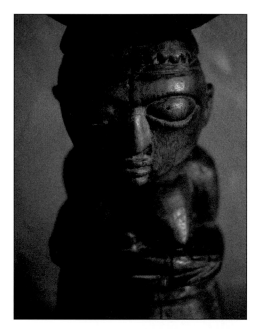

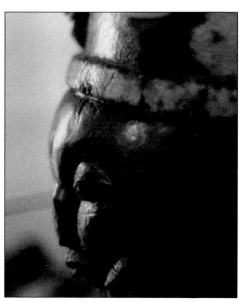

151

The Yoruba in the Atlantic Trade

Yoruba, forever diasporic, given to traffic and to travel long before the Atlantic Trade, stabilized themselves by the backdrop of their religion and their monarchical tradition, as splendidly realized by the *aiye orun* at Isare. In this way, like the Chinese and the Jews, no matter where they went or what happened to them they knew who they were, and how to maintain their self-sufficiency.

We do not have to rehearse in these pages how the Yoruba civilization has flourished across nine centuries. Neither do we detail again how they, with the Mande and the Bakongo, are one of the continuously urban civilizations of black Africa, and heir to one of the great art traditions of the planet. They needed every ounce of this self-confidence, for in the nineteenth century they were pitted against one of the most horrible episodes in history, the Atlantic slave trade. In spite of this horror they established their classical religion overseas.

To build their altars in the United States, Cuba, Puerto Rico, Brazil, and many other places in the Western hemisphere was not, however, a simple matter of diffusion in the Atlantic Trade. Invention too must be invoked to explain the continuity. Creative adjustment resulted in various new languages of Yoruba worship in the Americas: Afro-Cuban Santería, Afro-Brazilian *candomblé nago*, and the Rada side of *sévi lwa* or Vodun, the national religion of Haiti.

The monuments of Ifè rooted Yorubaland in a realm and atmosphere of ideal divine kingship, offering a focus and a center that reverberated through the kinship networks down to the individual. Conceptually, these monuments translated everyone into a daughter or son of the founding rulers. Similarly, the Yoruba religion and its altars, in its familiar structure of mother of the devotees and father of the devotees (*iyalorisa*, *babalorisa*), has offered a sense of rootedness highly appealing to overseas migrants of yesterday and today.[15]

More than one voyage was involved in the Yoruba transition to the Americas. The history of their Atlantic altars is really a matter of three passages. The first, etched in horror, was the Atlantic Trade, bringing Yoruba captives in chains from Lagos, Badagry, and other slave ports to the plantations of Cuba and Brazil. The second has involved a constant process of transience, including the coming of Dahomean-Yoruba Legba worshipers to New Orleans in 1803, the emigration of Afro-Cubans to New York roughly 140 years later, from the 1940s on, and a dramatic moment in 1980, the Mariel boat-lift. Such "rediasporization" (John Szwed's term[16]) has also involved the voyaging of Cubans to Caracas in recent years, and of Brazilians to the cities of Uruguay and Argentina.

The third voyage ran parallel to the other two, but in reverse. Even under slavery, and under postslavery persecution in the late nineteenth century, the Yoruba of Cuba and Brazil managed to maintain sporadic but precious contact with Africa through networks of friends and traders. They sought the sacred cowries, seeds, and beads of Africa for their religion. And certain freed blacks made pilgrimages to West Africa, receiving instruction in divination and the niceties of ritual, and bringing back sacred sculpture.

Yoruba slaving is linked in part with the Haitian revolution of 1794–1803, which forced a shift of sugar cultivation, crown jewel of the French plantocracy in Haiti, to western Cuba and northeastern Brazil. Here demand for slaves was great. At the same time, as Philip Curtin remarks, "Slaving among the Yoruba was an effective feature in

With the Assurance of Infinity: Yoruba Atlantic Altars

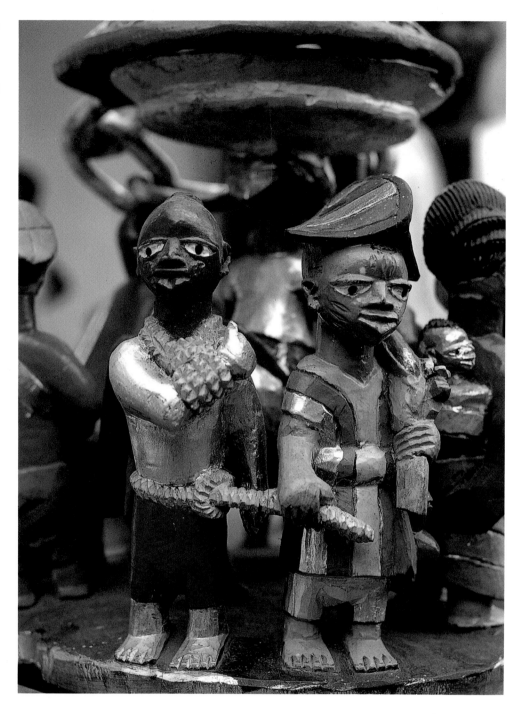

Yoruba politics because of the political disintegration [of the Oyo Empire] rather than [American] demand being a cause of that disintegration."[17] The ancient city of Oyo-Ilé had been so powerful that it had kept the peace throughout the land. When it collapsed, in the early nineteenth century, civil wars broke out and ravaged the Yoruba landscape. Egba attacked Ijebu and sold them into slavery, Ibadan battled Ekiti and dealt with captives similarly.

A nineteenth-century Ketu Yoruba sculpture documents this hapless moment: a member of the Egba Yoruba army from Abeokuta, in the southwest of modern Nigeria, leads into captivity an Ijebu soldier, from the cultural group immediately to the southeast of the Egba metropolis (plate 174). They have immobilized the Ijebu's right or fighting arm, tying it tightly to rope about his neck. They have also shaved his head "to show that he is no longer free, that he can no longer wear a cap." This is also the reason why he is

dressed only in a pair of shorts. So stated the Olubara of Abeokuta, the owner of this piece, in the summer of 1965. The victorious warrior wields a rifle with his left hand and forces his captive forward with rope tied to the latter's waist. He wears an elegant "dog-ear" cap (*fìlà abetí ajá*) and the striped smock of a warrior. These sartorial privileges set the Egba in contrast to the condition of the slave. A Ketu-area artist carved this generic warrior-and-prisoner theme, which stands as an internal artistic document of a terrible period in Yoruba history.

During the period 1823–65, the "golden age" of sugar cultivation, over 400,000 blacks were brought illegally from Africa to Cuba. Over a third of these captives were from the kingdoms of the Yoruba. We get a sense of Yoruba importations in northeastern Brazil from inventories dating from roughly the same period.[18] This advent corresponded primarily to the fourth and last cycle of slaving from West Africa to Brazil—that from 1770 to 1850, including clandestine slaving after 1815. As in Cuba, then, Yoruba featured heavily among the most recent arrivals of enslaved African peoples. Pierre Verger argues that the predominance of Yoruba culture in Brazil was explained by "their recent and massive venue and resistance to the cultural influences of their masters on the part of . . . priests [and priestesses of the traditional religion] conscious of the value of their institutions and strongly attached to the principles of their religion."[19]

This is a large-scale explanation. At a microanalytic level, culture was transmitted by specific and local means. The persistence of Yoruba cooking in both Cuba and Brazil, for example, kept up morale and continuity in many undetected ways. African women, Yoruba in particular, dominated the culinary arts of colonial Bahia and enriched the cuisine of the entire nation with the introduction of palm oil (*epo pupa*) and *malagueta* pepper (*ataare*). Keeping alive their wholesome taste for fresh greens—as opposed to the meat and bread of the Portuguese—helped keep the Yoruba themselves alive.[20]

But these were more than foods: they were writings in code. African systems of logic and belief flowed unsuspected from the kitchen, giving the gods the dishes they craved. A food made from yam flour (*àmàlà*) heavily seasoned with alligator peppers brought the fire of Shangó's lightning to one's palate in Cuba and in Brazil. Obatálá, sovereign associated with the white cloth of perfection of reputation, was honored with white foods like *èko*, fermented corn wrapped in plantain leaves. Red foods, creolized to apples and pomegranates, brought back the image of the thunder god; yellow or amber foods, particularly honey, activated the image of Oshun, the Yoruba goddess of love.[21] Unbeknownst to the slave masters, when the Yoruba of Cuba and Brazil ate black-eyed peas brought on ships from the motherland they were absorbing material ideographs of mystic continuity: the word *èwà*, black-eyed peas, puns on *ewa* or *wa*, essence of existence. "In the worship of twins," says the Yoruba linguist Dejo Afolayan, "*ibéjì* [twin children] represent a power of existence manifested in their ritual consumption of black-eyed peas."[22] The role of Yoruba women in preparing such foods in Cuba and Brazil, and in covertly keeping alive the sacred lore connected with them, was of extreme importance. Whites tasted these foods, and learned to love them, but had no idea that they embodied secret writings.

Yoruba kept continuity through other channels of graphic or ideographic writing as well, as if in a Gospel or Torah noted by none but they: beads, seeds, cowrie shells, sacred soaps, and other materials used in religious practice. Yoruba could hide one of

With the Assurance of Infinity: Yoruba Atlantic Altars

these emblems, symbolic beads, under protective Catholic cover. Thus the explorer Richard Burton, who had been on the coast of Dahomey and Yorubaland, remarked perceptively in Brazil in 1869 that rosary beads seemed "to awaken the Negro's sense of home."[23] Burton explained that *popó* beads, from the coast immediately to the west of the Yoruba, "comprise his finest finery and his riches."[24] Beads took New World Yoruba home and back again, with a strand of red and white beads not only reactivating the beads of Shangó the thunder lord, but embodying in the alternating white bead a trace of his legendary connection with the deity of creativity, Obatálá, whose color (and foods, as we have seen) are white.

How was this object-mediated continuity kept alive? Lydia Cabrera shows that "contact was not entirely lost between the Yoruba in Cuba and the land of their ancestors . . . thanks to Canary Islander traders, like the famous Bernabé, who imported regularly the precious African seeds and nuts . . . cowrie shells, stones, parrot feathers, sculpture, stones, brass bracelets for Ochún or water-smoothed river stones [for her worship]."[25] In the twentieth century this trade was renewed. Meanwhile in Brazil, certain Yoruba freedmen also "went to the trouble of importing religious objects and articles for personal use: kola nuts, cauries, cloth and soap from the coast, and oil of the dende palm."[26] In Recife, in the early twentieth century, Pai Adao "though born in Brazil studied religion in [Yorubaland]."[27] In Bahia in the same period a Yoruba religious leader, Martiniano do Bomfim, played an influential role after a pilgrimage to Africa; he came back bearing sculptures, herbal recipes, and divination verses, resuming with greater intensity his serving of the gods.

The most dramatic and important channel of literary continuity was the Yoruba divination system called Ifá, which, brought over the sea in the memories of captive priests, was reestablished in Brazil and particularly in Cuba. Ifá is both a discipline and an *orisha*, another name of Orunmila, the god of divination. The moral teachings of Ifá, a core element of the classical Yoruba culture, are contained in a body of recitals called *odù*. These verses of oral literature are powerfully sanctioned, for "the Yoruba people believe that Orunmila [the god of divination] was present when . . . Almighty God [Olodumare] created heaven and earth. Ifá therefore knows the history of earth and heaven and mastered the moral and physical laws with which Olodumare governs the universe."[28]

Each *odù* has its own name, character, and ideographic sign to be written on the plate that is used in divination. And each *odù* divides into three sections: a saying communicated in a verse; a story, the gist of the diviner's recital, in which one hears tales of the goddesses and the gods in situations similar to one's own; and the practical application of the story to one's problems.[29] "We use common sense," the late Alaperu of Iperu, a superb priest of divination, stated in 1962. "If," he added, "the story is about a god at war, and how he won a victory, we translate the parables of determination and steadfastness in terms that make sense for a young university student who is probably worried about passing his examinations."[30]

The main thing is that the stories included in *odù* often sanction the diviner's advice by reference to the history of the *orisha*, the deities of the Yoruba. Thus Yoruba-Cuban and Yoruba-Brazilian diviners, retelling *odù*, transmitted meanings and nuances of the religion of ancient Yorubaland to the New World. So the *orisha* arrived in the Americas, utterly recognizable, even when, as often happened, their names changed slightly in the journey and over time. Joseph M. Murphy summarizes: "Santería was generated from . . .

odù and the *babalawo* priesthood assumed authority in a condensed system of [worship]. It is upon Ifá, then, that the ceremonial structure of Santería rests."[31] And David Hilary Brown, also discussing Yoruba Cuba, adds to this argument on creole creativity: "Ifá tradition is not merely a direct and static African survival but has grown with the experience of Afro-Cuban Ifá sages. The histories of the *odù* are saturated with Cuban experience."[32]

Oja, Atabaques, Tronos, Mazos, and *Batá*:
Afro-Cuban and Afro-Brazilian Idioms of Worship

Time and circumstance creolized Latin into the five major Romance languages, French, Spanish, Portuguese, Italian, and Rumanian. Similarly, creole Yoruba in Cuba and Brazil manifested their adaptive genius in creative remappings of the altar. And this resulted in the rise of different visual idioms of reverence and worship.

In Cuba, the Yoruba sequence of outer court, inner court, and altar chamber was variously modified. An early Yoruba-Cuban shrine, at Placetas in the late 1870s, kept close to the African template: an outdoor court for drum dances, an inner court in the living room (which, in a departure from Yorubaland practice, could be visited by uninitiated guests), and in the bedroom the sacred chamber, called *igbodu*. The founder, Antonica Fines, painted her three-room house with red doors in honor of the thunder god. For him she planted a royal palm, for Eleguá (the Cuban Eshù-Elégba) a romerillo tree, for Obatalá a mango, and for Oya a purple caimito tree, decking these tree altars with appropriately colored beads and cloths. The sacred ecology of the Yoruba had been regained.[33]

Devotees installed all their *orichas* upon a single dais in the *igbodu*. As this practice developed, priestesses and priests reinvented the idea of the *apere*, the exaltation by elevation, in a many-shelved cabinet called the *canastillero*, now one of the basic forms of Yoruba-Cuban altar (plate 175). The cabinet could be closed if strangers were in the house, keeping the religion's visual core hidden in the days when it was persecuted by police, in the nineteenth and early twentieth centuries. In March 1992, the priest of the well-known Nilo Nillé house in the city of Matanzas, Eugenio Lamar, allowed me to

PLATE 175: *CANASTILLERO* IN THE HOUSE OF AN AFRO-CUBAN PRIESTESS, LUYANO, CUBA, 1980s. The *canastillero* is a cabinet that both elevates and, if necessary, conceals the vessels dedicated to the *oricha* of the Yoruba faith in Cuba. Photo: Ivor Miller, 1991.

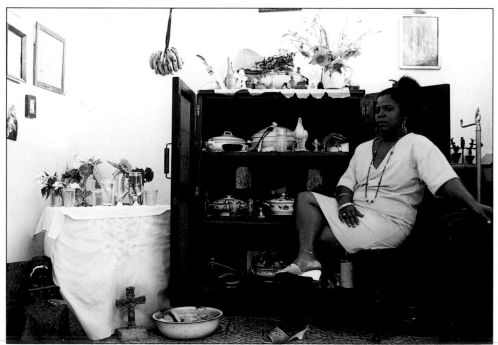

With the Assurance of Infinity: Yoruba Atlantic Altars

PLATE 176 (RIGHT): INTERIOR OF THE *CANISTILLERO* OF EUGENIO LAMAR, PRIEST OF THE NILO NILLÉ HOUSE, MATANZAS, CUBA, TWENTIETH CENTURY. The bottom shelf of Eugenio Lamar's *canastillero* contains a tureen (*sopera*) and other wooden and pottery vessels honoring, from left to right, the *oricha* Ochún, Agayú, Changó, Inle, and Yemayá. Other shelves are given over to other deities: Yewa and Oya Yansá, both female spirits; Oricha Oko, Ocha Guiña, and Obatalá, all "white" or gentle *oricha*; and an array of trickster spirits. Photo: Robert Farris Thompson, March 1992.

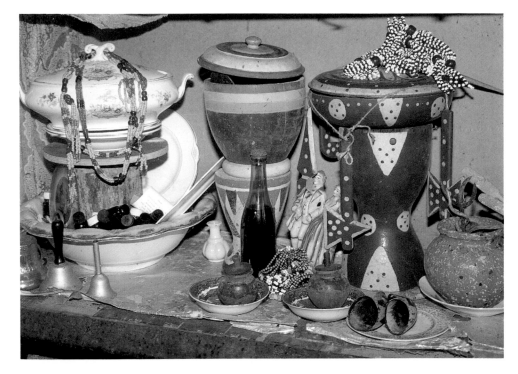

PLATE 177 (RIGHT): YORUBA *ISAASUN*, EGBADO COUNTRY, NIGERIA, 1920S. In Yorubaland, a person may fill a soup pot or *isaasun* with river rocks and water to promote longevity. This one is dedicated to the hunter river deity Eyinle. The Cuban arrangements of tureens or *soperas* (see, for example, plates 176, 183), holding stones and other sacred elements in honor of the *oricha*, elaborate this and related Yoruba modes of spiritual observance. Brazilian altars do likewise (see, e.g., plates 234, 243). Floor mats also have been richly developed in Cuba, in the art of the *trono*, the ritual throne of the *oricha* (see, for example, plates 270–272). Photo: Robert Farris Thompson, 1966.

photograph the interior of his *canastillero*. The insides of the doors are covered with gold foil. They gleam like gates to paradise. The top shelf is given over, at left, to redoubtable women *oricha*—Yewa and Oya Yansá—and at right to a series of three, mostly gentle, "white" *oricha*: Oricha Oko, Ocha Guiña, and Obatalá. Tricksters and other spirits dominate the second shelf. At the bottom, from left to right, we see Ochún, Agayú, Changó, Inle, and Yemayá (plate 176).

Another thing that changed in the Americas was pottery. On Yoruba altars a soup pot (*isaasun*) had served to contain river rocks and water, in effect making broth, a medicine imparting longevity by association with rock's time-resistant qualities (plate 177). In Cuba, women devotees, attuned to the nuances of pottery and cooking, kept the *isaasun*

concept alive with porcelain soup tureens (*soperas*) containing stones and other sacred essentials of the faith. Likewise, enamel and tin cups replaced African calabashes on the Cuban altars. Thus the whole assuaging dimension of the Yoruba altar returned in new flesh.

In Brazil, a new world of sacred pottery emerged in the fundamental concept of enthroning the *orixa* through placement of their emblems upon the altar:

> The god of divination can reveal that the *orisa* of the would-be initiate wants to receive personal offerings. The priest is then obliged to proceed to the *assentamento* [ritual enthronement] of that *orisa*. *Assentar* in Portuguese means to sit and also to base, to strengthen or consolidate. It is in actuality a base for the establishment of the *orisa*; a material base, a tangible support, a base that will receive the offering, that will become impregnated with the blood of the sacrificed animal. Properly sacralized, it will mark the union between the person and his divinity. This base, called *assento*, is the sacred pottery form.[34]

Brazilians creolized the Yoruba clay dais into a wrap-around cement structure supporting

> the sacred pottery vessels of the different *orisa*. In the background, elevated by stools, one finds the sacred pottery vessels of the priest. At the foot of the cement dais are placed numerous pottery jars filled with water. All the sacred vessels are covered with full dress cloths on which are posed the emblems of the *orisa* and their rich headdresses.[35]

The oldest and most important vessels for stones and other emblems were not only enthroned upon stools but specially dressed and crowned. Once again, things came to a point, though in a different way, creating a creole *ibi sónsó*.

Pottery returns to the Yoruba-Brazilian altar with a vengeance: for each initiate an *assento* vessel marks the union between person and *orixa*.[36] With symbolic colors and coverings these pots address the distinction of one *orixa* and her attributes from another. Besides containing *axe* (the Yoruba-Brazilian *àse*), pottery offers praise to the colors and characteristics of the different *orixa*: "The pottery forms include *alguidar*, bell-shaped earthenware pans and porcelain tureens [cf. Cuba]. The *alguidar* are for masculine *orixa*, except for the thunder god Xango, who receives a plate of wood. [The Yoruba of Nigeria pound wooden mortars with wooden pestles as lightning metaphors—tempestuous Shangó is evidently too hot for fragile pottery.] Oxala has a porcelain tureen like women *orixa*."[37] Stones in a wooden tray are for Xango. Stones in tureens are for Omo-Olu, Oxala, and the female *orixa* Oya Yansan, Oxum (Oshun in Africa), Yemanjá (Yemoja), and Nana; the stones of Yansan are maroon, those of Oxum yellowish, Yemanjá's are white, and Nana's, gray. In the different-colored stones of the *orixa* we find their irreducible essence, from which the "color" of their particular quality of salvation diffuses through other media, notably beads and cloth. Exu, Osanyin, and Oxumare take metal emblems inserted in cement poured into an earthen vessel. The iron emblems for

PLATE 178: BRAZILIAN POTTERY TYPES PUT TO SACRED USE. In Brazil as in Cuba, the Yoruba gods are honored by pottery vessels containing their sacred attributes. Clockwise from top left: the *alguidar*, a flat bowl, usually dedicated to masculine *orixa*; the *quartinha*, a small jar used to store water as an offering on the altar (see its similar use in Kongo/Angola Brazilian worship in plate 53); and the large *pote* and *talha*, used similarly. From Gisèle Binon Cossard, "*Contribution à l'Étude des Candomblés au Brésil: Le Candomblé Angola*," 1970.

With the Assurance of Infinity: Yoruba Atlantic Altars

Ogum, Oxossi, and Logunede are simply placed within the pottery.

Finally there are small jars (*moringas* and *quartinhas*) and large pots (*talhas* and *potes*) for water storage on the altar. These complete the Brazilianization of the Yoruba altar through regional pottery types. They are made locally, in the state of Bahia (plate 178).

All this takes place in a thoroughly creole situation. Wedge-tuned and peg-tuned drums are collectively called *atabaques*, a term stemming from Portugal, but wedge-tuned drums derive from the coast of Calabar or Kongo, peg-tuned drums are from Dahomey and Yorubaland, and individual drums bear Dahomean names like *run* and *runpi* (perhaps reflecting the earlier arrival of Dahomeans in the slave trade). Mixed in origin, they are nonetheless all used today strictly to provide the sacred African time signatures that call the gods of Yorubaland and Dahomey from across the seas. Drum names and drum actions seethe as signs of creative shapings of a multiethnic past.

In addition, even famous guardians of Yoruba purity, like the Gantois and Agonjú *candomblés* in Bahia, do not slight the Kongo/Native American *caboclo* spirits, keeping their shrines. In the middle of another *candomblé* noted for its Yoruba allegiance, Alto da Vila Praiana in Lauro de Freitas, there is a fully decorated tree altar to the Kongo-Brazilian spirit Tempo. The priest, Pai Balbino de Paula, whose Yoruba is magnificent in its ritual fluency, is also proud of his mastery of *caboclo* and Ki-Kongo songs. This reminds us that the Yoruba in Brazil, arriving after the earlier Kongo influx, built their Iroko worship on the Kongo usage of the fig tree as an abode of spirits and the dead.

Yoruba also built upon a most important Kongo concept, *kanga nitu*: to tie the body protectively against evil. This concept pervades the world of the *candomblés*,[38] where devotees dance with a protective *patuá* or charm tied at a vulnerable point, the nape of the neck (plate 180), and with a raffia charm at their backs. *Kanga nitu* is also a controlling concept in *capoeira angola*, the famous martial art of Bahia, where it is named *fechar corpo*, to close off the body from intrusion. There is even a song about it:

> *Do no escondo a ponta*
> *paraná*
> *ninguem sabe desatar*
> *paraná.*
>
> In the knot I hide the point
> *paraná*
> that no one can untie
> *paraná.*[39]

In Bahia, the Yoruba tradition of tying a woman's body ornamentally with a sash (*òjá*) apparently expanded exponentially through contact with Kongo ideas of spiritual tying. In this city, where women dominate the Yoruba *candomblés*, one now sees trees and the *assentos* of both male and female *orixa* tied with ornamental bow-tied *òjá*. In Dahomey and western Yorubaland an iroko-tree spirit might be honored with a single length of white cloth around the trunk (plate 127). But the painter Carybé, in a magnificent watercolor published in 1981, documents a Brazilian salutation to "Roko" (Iroko) in which a tree receives no less than three impressive white-bow-tied sashes (plate 182). Its special

PLATE 179 (ABOVE LEFT): HOUSE POST (*OPOILE*), KETU YORUBA COUNTRY, TWENTIETH CENTURY. The Yoruba *òjá* is a sash used both for ornament and to honor the gods. This figure tugs on an *òjá*, tying it in a bow. (The right half of the bow is broken off.) Photo: Larry Dupont, 1970. Collection of the University of California, Los Angeles, Museum of Ethnic Arts. PLATE 180 (ABOVE RIGHT): A WOMAN WEARING A *PATUA*, RIO DE JANEIRO, BRAZIL, 1972. Kongo and Yoruba cultures combine in many ways in Brazil. To "tie the body protectively against evil"—*kanga nitu*—is a Kongo practice, but here a woman in a Yoruba *candomblé* has tied a protective charm or *patuá* at a point of spiritual vulnerability. Photo: Elsbeth Selver.

spirit is "tied," then, as is that of a votive male goat, about to be sacrificed, and bearing two bow-tied sashes about its body. Men are drumming for Roko but women are in charge, kneeling, praying, standing, chanting praises, activating the air with a calabash rattle. Simply but indelibly, it is women with their sashes who establish this whole stance of festival and worship.

It is a remarkable fusion statement, combining not only vague overtones of Kongo *kanga nitu* but also an ancient Yoruba image of women honoring the gods. When a woman dances before the *orisha* in Yorubaland, she takes off her head tie (*gèlè*) and ties it as an *òjá* around her waist as a mark of honor (plate 179). *Òjá* on Brazilian drums, altars, and trees therefore festivalize entire settings with an aura of sacred dance and motion. In a more basic meaning, the *òjá* around the waist of a Yorubaland woman may be used to suspend a child against her body.[40] It is thus also a sign of nurturing, care, and life.

With the Assurance of Infinity: Yoruba Atlantic Altars

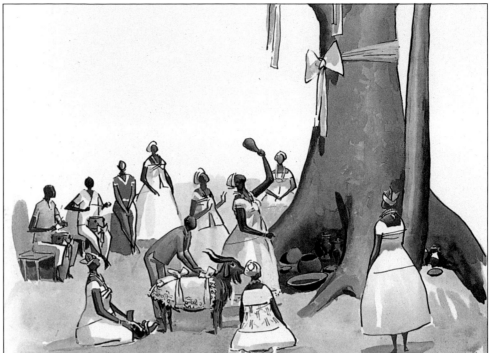

Women prepare and design most of the altars of Bahia, tying them and leaving their mark. The women who control the famous Maraketu house, for example, have prepared an altar to Oxossi, the rugged god of the hunt, setting his iron bow and arrow in a dish to center his powers (plate 181). Once establishing this essential point of union, they have bow-tied the whole *assento* with a cloth in forest green, the color appropriate to Oxossi's name. Out of the Kongo-like bundle emerge animal horns, signs of his prey and prowess, but the swelling packet also automatically conjures visions of children being carried, of generation and transmission. The Afro-Brazilian Yoruba altar, in short, ties and carries power from one realm to the next.

Orthography of the Major Yoruba Deities in Atlantic Perspective

The restlessly creative idiom in which the goddesses and gods of the Yoruba are served from Nigeria to the Americas is handsomely apparent in the proliferation of their names and spellings in various portions of the Yoruba religious world. The very term for "deity" is spelled *orisha* in Nigeria, *orixa* in Brazil, and *oricha* in Cuba. A table of these names may help readers verify at a glance where they are in this complex universe by word structure and orthography.

Deity	Nigeria/Benin	Brazil	Cuba
commitment, contingency	Eshù-Elégba	Exu	Echú, Eleguá
war, iron	Ogún	Ogum	Ogún
hunting	Oshóòsi	Oxossi	Ochosi
ocean	Yemoja	Yemanjá	Yemayá
sweet water, love	Oshun	Oxum	Ochún
whirlwind	Oya	Oya Yansan	Oya Yansá
healing	Osanyìn	Osanyin	Osaìn
thunder, lightning	Shangó	Xango	Changó
sister to Shangó	Dàda-Bàyònnì	Dada-Bayonni	Dadá Obañeñe
twins	*ibéjì*	*ibeji, mabasa*	*ibeyi*
mother of smallpox	Nana Bukúu	Nana	Nana Buruku

Deity	Nigeria/Benin	Brazil	Cuba
epidemic, smallpox	Obaluaiye,	Omo-Olu	Babalu Ayé, Omo-Olú
rainbow	Oshumare	Oxumare	Ochumare
gods of creativity and justice	Oshanlá	Oxala	Ochanlá
	Oshagiyan	Oxaguiam	Ocha Guiña
	Oshalufon	Oxalufom	Ocha Lufón
	Orisha Oko	Orixa Oko	Oricha Oko
moral inquisition	Egúngún	Egun	Egún
divination	Orunmila	Orunmila	Orula
creativity	Obatálá	Obatala	Obatalá
supreme god	Olodumare	Olodumare	Olodumare
god of the sea	Olókùn	Olokun	Olokun
deity of drums	Anyàn	Anyàn	
command, potentiality power to make things happen	àse	axe	aché

There are further variants in Trinidad Shangó worship, Haitian Vodun, nineteenth-century New Orleans Vodun, and South Carolina Oyotunji.

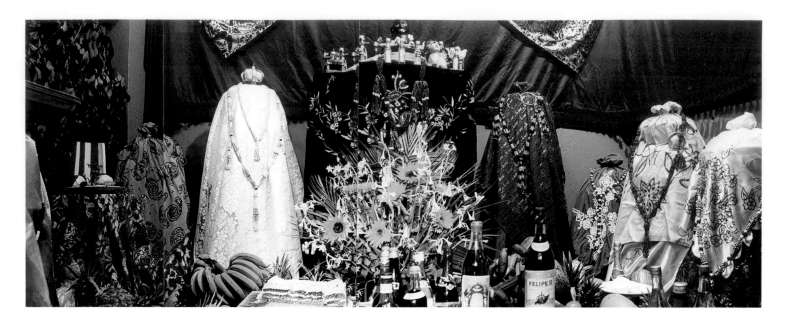

We have surveyed the mystic tying, with the *òjá* sash, of altars and musical instruments in Bahia. Now we come to a different style of draping: Afro-Cuban. Some Afro-Cubans keep their tureens containing the sacred stones of the *oricha* in the masking kind of furniture called the *canastillero*, in which, in days of persecution, *soperas* could pass as porcelain collections or quickly be concealed with doors slammed shut. But when the *soperas* are arranged in the open there is space and occasion for rich draping. A spectacular instance: an anniversary altar for Eleguá prepared by the famous *santero* "Ramoncito," of Guanabacoa, Cuba, in 1991 (plate 183).

PLATE 181 (PREVIOUS PAGE, LEFT): *ASSENTO* FOR OXOSSI (DETAIL), MARAKETU *CANDOMBLÉ*, BAHIA, BRAZIL, AS IT WAS IN 1984. The *assento* is an offering to the Brazilian *orixa*, a material base or foundation for their presence in the world. This one, made by Bahian women for the hunting god Oxossi, is a pottery dish containing the deity's iron bow and arrow (not visible), and a startling emergence of animal horns, goal and reward of the hunt. The whole is lavishly tied with a Yoruba *òjá*, in green, color of the forest. Photo: Robert Farris Thompson.

PLATE 182 (PREVIOUS PAGE, RIGHT): WATERCOLOR BY CARYBÉ SHOWING REVERENCES TO THE SPIRIT ROKO, BRAZIL, TWENTIETH CENTURY. "Roko" is, of course, the iroko tree, here honored by the tying of *òjá*-like white sashes around its trunk. From *Iconografia dos Deuses Africanos no Candomblé da Bahia*, 1981.

As we prepare to compare this master work to Nigeria, we should note that the comparable richness, elaborated in canopies and backdrops, of another Afro-Cuban altar tradition, that of the *trono* (the initiatory ritual throne), has been compared to royal canopies and draped Catholic altars in Iberia. But Spain has no copyright on canopies, nor on opulently draped altar images. Katherine Coryton White's superb photograph of an Ibadan altar to Orisha Oko, dated 1964 (plate 184), makes this clear immediately.

Here, images for Oko—carved in wood and darkened with royal indigo, eyes sparkling with nailed-on tin—stand in the midst of emblems of great cowrie wealth. Since Oko is an *orisha fúnfún*, a white spirit, the accents of white are intentional. Orisha Oko is an ally of an Obatálá-related deity, Oke, lord of the hill, whose altar, a mound of yam paste, rises in a vessel to the left. But the main interest here is the cloth draping, refined to state spiritual command. The images for Oko are turbaned with cloth strips, and garlanded with them, too, around their chins, from which depends more cloth linked in whiteness to the moral flash of Obatálá. Not only that, but several layers of trade and "up-country" textiles have been draped on their heads, cascading down, forming a kind of honorific tent, doubled by canopies above. Tent, canopy, turban, sash, wrap—at least five modes of dress or shelter combine to express Oko's preeminence.

Now cut back to Guanabacoa 1991 (plate 183). Several things have happened. Laterite walling vanishes and is replaced by cement walls painted green. The white and blue and indigo and beige of the Oko/Oke images have been replaced by a blaze of colors, which correspond to nine *oricha* honored in a line. In addition, the wall is a vision in red cloth, with a device (cropped in the photograph) in gold and black to honor the central spirit here, Echú.

With the Assurance of Infinity: Yoruba Atlantic Altars

PLATE 183: (OPPOSITE): YORUBA-CUBAN
ANNIVERSARY ALTAR FOR ELEGUA, PREPARED BY THE
LOCALLY RENOWNED PRIEST "RAMONCITO,"
GUANABACOA, CUBA, 1991. The *oricha* gather on the
anniversary or feast day of Eleguá in the guise of
richly draped *soperas*, tureens containing their
attributes. From left: Agayú, Oko, Oya, Obatalá-
Ajáguna, Eleguá, Yemayá, Olokun, Ochún, and
Changó. The cloths that conceal the *soperas*, which
are elevated on chairs, render the *oricha* their
appropriate colors. And each god also receives a
mazo, an elaborate, symbolically coded necklace of
beads (see plate 186). Photo: Ivor Miller, 1991.

PLATE 184: (BELOW): YORUBA ALTAR TO OKO,
IBADAN, NIGERIA, TWENTIETH CENTURY. Wooden
figures of this *orisha*—tin eyed, their skin colored
with indigo—receive complex treatments of cloth,
prefiguring the *trono* tradition of black Cuba and
New York. To the left, a mound of yam paste honors
Orisha Oke. Photo: Katherine Coryton White, 1964.

From left we see some of the nine colors of Agayú, father of Changó; the striped red-and-white tile of Oko; the orange-red print of Oya. White flecked with blood-red beads identifies the presence of Obatalá-Ayáguna. Exalted at the top, in a festive ambience of childlike figures, is Eleguá, for whom the *oricha* have gathered on his feast day. Continuing to the right appear Yemayá, her azure depths signified in blue; and Olokun, a sea god, also dressed in blue but with beads of indigo, white, and red. The gold of the goddess of love, Ochún, appears next, with her orange beads, and finally the red and white of the thunder god.

One senses creole recombinations and rephrasings. The sound of water on stone is implicit in the bracelets chiming on the images of the water goddesses Oya Yansá, Yemayá, and Ochún. And most of the *oricha* flaunt the multistranded bead device called the *mazo*, a hallmark of the Afro-Cuban style. The actual faces of the goddesses and gods have disappeared. They are sensed but not seen. They vanish into the masked tureens, containing the stones, containing the power. At once haunting, abstract, and opulent, their splendor is immense.

But for all this richness we have not exhausted the range of the Afro-Cuban *oricha* altar. Remaining for discussion are *tronos*, even more elaborate *mazos*, and the complement of sacred *batá* drums.

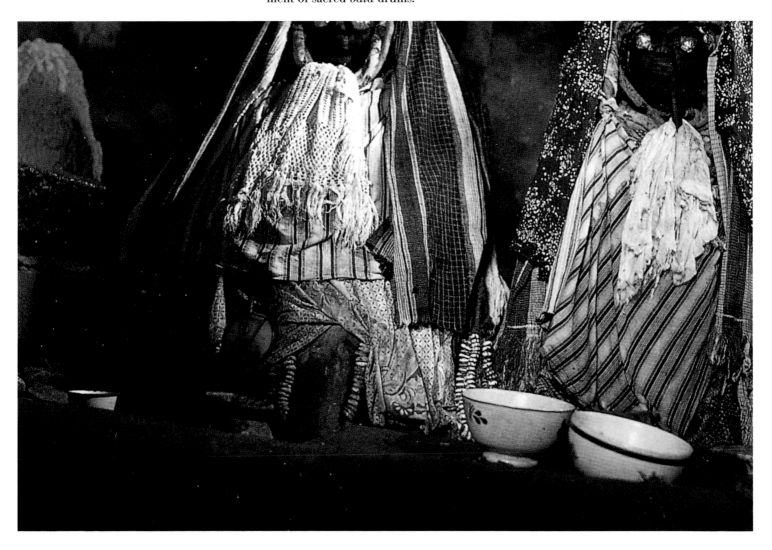

Tronos: Draping Deities with Heaven's Glamor

Oshun takes opulent cloths against the walls of altars. Shangó sits in the midst of mystic entourage, all set against cloths of crimson or walls painted in red and white. Yemoja stands in her famous Ibadan altar, cloth draped like a tent across her noble body. In the richness of these shrine elaborations, in the draping of these images, Yoruba experience a sense of heaven's glamour.

That vision has left its spiritual stamp in Cuba. Under creole pressure the tradition has taken on new shapes, new points of accentuated consciousness: draping the tureens holding the stones of the *oricha* upon the altar, building honorific *tronos* (thrones) to honor the grandeur of the gods.

In colonial times, in the nineteenth century, Yoruba draped-cloth shrines in Cuba were simple: "As to the ornamentation of the *trono* [some persons] have told us that the throne as such was set upon a mat and a white sheet was suspended on the wall and nothing else. Nothing luxurious! Curtains with ribboned [ties], embroidered cushions— that came later."[41] Even then, however, a few black women with rich patrons managed to recapture the sumptuousness of the imagined courts of Shangó and the *orisha*.[42] To judge from more recent, twentieth-century styles, they enriched the vision with elegant touches deriving from the West—canopies (*dosel*) and prosceniumlike manners of display. By the 1950s in the Havana area the following vision was representative: on the second day of initiation "one seated the initiate on [an inverted] mortar [the *trono*] . . . on a wooden platform covered with a mat, or simply on a mat. In the background draped cloth hung on the wall—*kélé*—formed a canopy."[43]

Mats appear in association with altar objects in some parts of Yorubaland (see plate 177). There, too, inverted mortars are connected with Shangó, thunder god and fourth king of the Oyo Yoruba. But the cloths of heaven become canopies in Cuba. This sounds like a creative remembering of the Yoruba royal umbrellas and *kòbì*—the bays projecting from the Oyo palace, with conical roofs sheltering kings and courtiers. And in a creole context, Western influences flow in too. Brown, for example, suggests adapted Roman Catholic and royal Spanish sources.[44]

One of the earliest centers of Yoruba worship in Cuba was the nineteenth-century self-help society Changó Tedún.[45] Here, perhaps, Western-tinged royal trappings, canopies, drawn curtains with ribbons, and so forth, recapturing the aura of Shangó's kingship in Africa, came to influence the making of *tronos* for all the *oricha*. Two elements suggest this: the use of the thunder god's inverted mortar, and the name of the draped cloth, *kélé*, a term of the Lucumí people of Cuba referring to the deity's red-and-white beads. In combining the cloths of heaven and the canopies of the palace in a proscenium manner, creole artists added new shape and color to Yoruba altar art.

The Yoruba of New York follow Afro-Cuban custom in the building of their *tronos*. They too elaborate hanging cloth canopies, cloth-draped mortars, and floor mats. But the manner by which they recombine these elements to construct a sacred space differs from house to house. Brown observes, "The construction of a throne, entailing the unfurling of rich cloth, signals dramatically the manifestation of *orisha* before the people."[46] *Tronos* arise in richness to underscore the importance of three Yoruba-Cuban rituals in particular: initiation (*trono del asiento*), celebration of the saint's anniversary (*trono del compleaños*), and presentation of the devotee to the *batá* drums (*trono del tambor*).

Two master *trono*-makers of the 1980s in the United States were the late Ramón Esquivel of Union City, New Jersey, and the late Juan Bauzo of Brooklyn, the latter honored with a special exhibition at the Caribbean Cultural Center in 1986. In 1989, in his Brooklyn apartment, Bauzo constructed a *trono* to celebrate the anniversary of his saint, Yemayá, goddess of the Atlantic Ocean. There he summoned her towering presence (plate 185). Rich white cloth trimmed with blue—her foam, her depths of azure—crowned and upheld the intelligence of the goddess.

PLATE 185: ANNIVERSARY *TRONO* ALTAR TO YEMAYA BY THE LATE JUAN BAUZO, BROOKLYN, NEW YORK, 1989. Juan Bauzo, a master Cuban-American *trono* maker, composed this altar for Yemayá, goddess of the Atlantic ocean, on her feast day, in her colors of white and blue. The altar is guarded by canes embodying warrior avatars of Obatalá, Ajáguna—the staff to the left, white with red—and Obamoro. Photo: Ivor Miller, 1989.

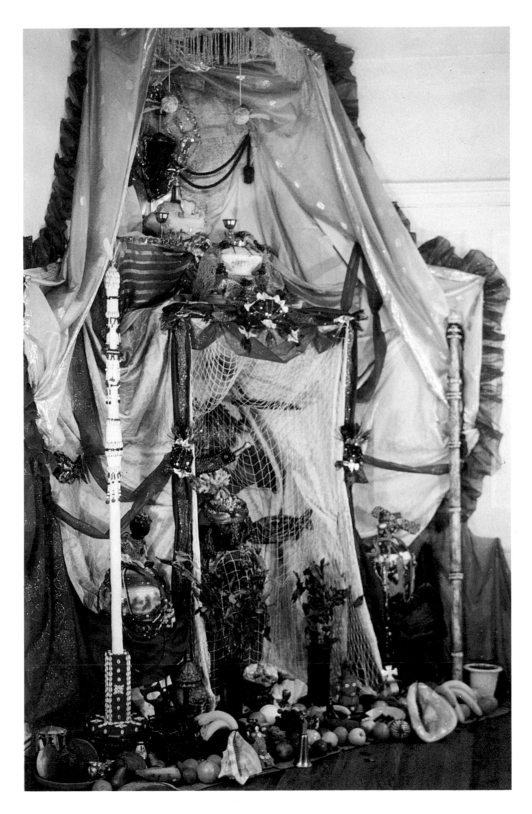

Mazos: Crowns Drawn in Dotted Lines

At the core of Yoruba divination is the divining chain, the *òpèlè*: eight seed-shell halves joined together by short sections of chain,[47] or sometimes by a beaded cord. The cord—chain or beads—is not as important as the seeds, however. Their falling when thrown, either concave or convex side up, creates a pattern that predicts the future.

Bernard Maupoil, in plate IIIb of *La Géomancie à l'ancienne Côte des Esclaves*, his classic text on Yoruba divination in Dahomey, illustrates a garland of beads marking the prestige of a particular diviner. Multiple cords of small beads join larger, white, punctuating beads. Like a coaxial cable filled with a buzz of images, they communicate in their symbolic number (sixteen), and in their richness, the power and glory of Orunmila, the god of divination. These multiple strands and their prestigious fastening beads are visual praise-poems to the power of divination, raising the priest "to a paroxysm of exaltation which lifts him to his highest value and calls him to his most authentic self."[48]

Multistranded bead necklaces, turning up among the Yoruba-influenced *candomblés* of Brazil, have drifted somewhat from their association with divination. They are generally worn to communicate the power and protection of a particular *orixa*, symbolized by the color of the strands and refined by the larger connecting beads, called "signatures" (*firmas*). In the *òpèlè* the seeds were the talking part of the instrument, predicting the future. Here the *firmas*, which, as Gisèle Binon Cossard points out, are not necessarily the signatures of the particular *orixa* honored by the necklace, predict with whom the *orixa* will move or march. "For example, on a necklace for Oshun, one puts 'signatures' of Oxossi or Obaluaiye or Xango."[49] Deoscoredes dos Santos makes similar points:

> The "*firma*" is . . . distinguished from the rest of the sacred necklace and
> threaded on the same string. As the name indicates, the "*firma*" affirm[s] the
> identity and [particular avatar] of the *orisha* of the initiate. . . . the "*firma*"
> also serves to establish the relationship with certain other *orisha* which
> accompany the *orisha* of the initiate. [For example,] on the string of
> [maroon] beads of Oya [there may be] a "*firma*" in which are found some
> [red and white] beads of Sango.[50]

Here the *firma* remembers that Oya marched with her husband, Xango, with whom she shares the tempest and the lightning. The *firma* is like an *òpèlè* seed frozen in time and space. It predicts just one thing: you will march forever with this spirit, who in turn will march forever with certain other spirits.

The multiple strands between the *firmas*—the biggest or most important *firma* goes at the back of the neck, which is considered vulnerable, and needs special mystic protection—symbolize the age and rank of the senior priestesses and priests who wear them. As the priestess Aildés Batista Lopes of Jacarepaguá, on the outskirts of Rio, notes, "*Com tempo agregam mais contas*": As time goes on, they add more beads.[51]

With the Assurance of Infinity: Yoruba Atlantic Altars

In Cuba, the tradition of honorific bead-making that apparently emerged from the basic *òpèlè* design has charged the Yoruba altar with an air of destiny and grandeur. Yoruba divination is perhaps stronger in Cuba than anywhere else in the Americas, a pendant to the island's unique reinstatement of Changó's *batá* drums. Presumably the first persons to improvise new creole manners of garlanding Yoruba altars with multiple strands of beads were priests of divination, versed in the traditions of Ifá. Because what seems to have happened is: the beads of the diviners of Nigeria and Dahomey were, as it were, lifted up, off the ground or off their bodies, and draped over the tureens containing the stones of *àse*—or rather *aché*, that power's Cuban name. For the stones within the vessels, faces from the past, were faces to be crowned, faces to be properly veiled with beads.

The finest description of the Afro-Cuban *mazo* is Brown's:

> *Collar de mazo* means literally "necklace cluster" or "bunch of bead-strands." All have a basic structure: a circle of multiple bead-strands . . . from which project . . . a number of multi-strand, tassel-like emanations, spaced equidistantly from one another. The emanations are called *moñas*, meaning "knots" or "ties." The *mazo* is constructed to have one *moña* which is thicker and more elaborate than the others, called the *moña principal* ("main knot"). At the junction of each *moña* and the main circle of strands is at least one large fastening bead, called a *gloria*. The *gloria* derives in name and form from the large, prominent, punctuating beads of the rosary.[52]

In tune with the cultural openness that often marks the Afro-Atlantic altar, the *mazo* dovetailing of Roman Catholic structure into Yoruba is powerfully ecumenical, adding a special power to its usage on the altar.

In an altar to various *oricha* photographed by Ivor Miller in 1991 in Guanabacoa (plate 183), the *moñas principales* are like anchors, stabilizing the draping of each *mazo* over spirits condensed in stones and contained in water-filled tureens. The ghost of a crucifix seems to weigh and organize the pendant *moñas principales*. Stronger, however, is the Yoruba element: *mazos* crown and veil the face of the gods (in contrast to the *òjá* of Bahia, which tie and sash the powers). In Miller's photograph the crowning of the *soperas* is done with rich cloths over which the *mazos* depend like necklaces for a band of giants, looming up in bodies made of pottery and chairs and enfolding cloth.

The most spectacular *collares de mazo*, as in the work of Melba Carillo of Latino New York City (plate 186), can include more than twelve thousand beads and weigh over five pounds. The richest are made in Latino New York City and Miami, where devotees spend vast amounts of money in the elaboration of *mazos*, as *ebo* (tribute) to the *oricha*, even as the Catholic towns of medieval France competed in the size and scale of their cathedrals. In recent years certain New York devotees have added tiny ivory elephants to the *moñas principales* of *mazos* for Obatalá, and special wooden beads to *mazos* for Changó. The Cuban *mayombero* Felipe García Villamil explains why these marvels of creole beadwork *must* be draped upon the tureens enclosing the stones of the *oricha*: to proclaim the gods' presence as *alagba*, as the oldest and greatest of the saints. The number of strands, he adds, announce the *camino*, the particular avatar with whom the devotee is linked: twelve strands for Dadá, sixteen for Orula (the Cuban Orunmila). The *glorias*, García Villamil says, wrap the face of the god "with a felicity that can resolve all problems."[53] So even as the *mazo*, in creole ingenuity, expands a Yoruba tradition to make an ecumenical

connection with the Roman Catholic rosary, it yet circles back, in García Villamil's defin-
ition, to an ancient tradition wherein seeds joined by strands of beads had the power to
outline and resolve all problems.

These are some of the reasons why devotees wear *mazos* on the second day of initia-
tion into the Yoruba religion in Cuba and New York, and on the day of their presentation
to the *batá* drums, thereafter to be draped over the *soperas* of their patron *oricha*, *moña*
principal anchored carefully in front, for as long as they live. The currents flowing from
gloria to *gloria* constitute one single act of divination: henceforth they are kings and
queens, henceforth their nobility is assured, so long as they morally honor the sovereign
hidden within the vessel beneath these beads.

Batá Drums: Thunder in the Circle and Lightning on the Edge

Batá drums—four of them in Nigeria, three in Cuba—form a family of voices. The gods
and goddesses sound within them and come down right beside them. *Batá*, in short,
unlock the wisdom of the ages.

These are hourglass-shaped drums with a membrane at each end. They are said to
have emerged first in the kingdom of Oyo-Ilé. There they were drenched with the aura

of Shangó Alado the thunder god (and also the fourth king of the Yoruba), and, to a lesser extent, with that of other *orisha*, like Yemoja, and of the immortal ancestors.

Tradition says that it was Shangó who made the first set of *batá*. Playing with fire and brass, he made them melt before our eyes to touch the other senses. His tongue turned to fire. His ax balanced meteorites. Similarly, his *batá* drums resonated with the secrets of turning clear skies into tempest.

Shangó performed lightning magic on his drums. Through close study, he stole intensity and phrasing from the noise of the rising storm. He stole lightning in the flash of his royal drums' shining accoutrements of brass. Then he put the flash and roar together, in his drumplay, and called down rain and lightning from the sky.

That rumbling of hand on skin, with accompanying metal sound of bells, is constant from Oyo to Matanzas to the Bronx. It is acoustical warning and inspiration. It is sound as antiquity. For if Oyo-Ilé was founded circa 1388–1431, and Shangó reigned in the 1400s, then the sound of *batá* goes back at least five centuries.[54]

Batá drums arrived in Cuba with Yoruba slaves in the early nineteenth century. They came to the United States later, via Afro-Cuban migration in the mid 1950s. Now they adorn the ritual life of several of our largest cities, including New York, Los Angeles, San Francisco, Oakland, and Miami.

Shangó may have made the first *batá* (another story says his mother brought them to Oyo-Ilé from the land of the Nupe, across the Niger), but it is the *orisha* Anyàn, deity of drums, who presides over their actual playing. Anyàn's praises teach us that objects of brass are clues to the meaning of the *batá* voice:

> *Agalú asórò igi*
> *Amúni mo ona ti a kò de ri*
> *Igi gogoro ti i so owó*
> *Aridegbe sòhúngòbi àyàn gbè mi.*
> *A kì i tele ó k'ebi o tun pa mi.*

> Ruler of the speech released from trees
> Who takes you on a road you never saw before
> Tall tree who grows [brass leaves of] money
> The one who finds brass and carries it to complete his
> speech, deliver me.
> To follow you is never to be hungry.[55]

Music made from sounding wood, "speech released from trees," meets Shangó's nobility in myriad accoutrements of brass. To play a drum bearing such emblems is to move, in miniature, the flash of Shangó's lightning. To play *batá* is to activate not only Shangó's fire but Anyàn's creative greatness, and thus to be doubly propelled to destiny.

The grandeur of *batá* can involve conquering enemies, where one returns to oneself after the jealousy or malice of others has blocked the way. In fact the brasses that decorate the Nigerian senior or "mother" *batá* drum, the *iyá*, memorialize actual military victories in Oyo history: to communicate success in a certain battle, brass plates were affixed to an *iyá* drum, adorning it "with a variety of figures and faces sculptured in

PLATE 187: "MOTHER" *BATÁ* DRUM (*IYÁ*), WESTERN OYO, NIGERIA, NINETEENTH CENTURY. The thunder god Shangó is said to have played *batá* drums to summon the storm; to play them is to associate with his power. They also invoke the *orisha* Anyàn, deity of drums. In Yorubaland *batá* come in groups of four, of which the *iyá* is the senior and the largest. Brass plates on the body of the drum memorialize Yoruba military victories. This example is consecrated to Yemoja; a rectangular brass plate shows the zigzags of Shangó's lightning. Photo: Robert Farris Thompson, 1964. Private collection.

relief; beaded necklaces also were hung on the drum."[56] I saw the same marks of achievement on an *iyá* in western Oyo in January 1964 (plate 187). The drum was consecrated to Yemoja. According to tradition, it had come from Oyo-Ilé four generations before. Brass masks adorned it, as well as a miniature animal. The masks stood for the heads of persons vanquished by the Yoruba in the wars of the early nineteenth century. Through zigzags on a rectangular leaf of brass, Shangó's lightning explicitly accompanied the storm music. On other drums I saw, bells of brass were tied to the senior drum.

Cuba has the honor of being the only American nation with a full-fledged, continuous *batá*-drum tradition. As in Nigeria, the Cuban *batá* set is led by *iyá*, the mother. The middle-sized drum is *itótele*, "the next in line." The third, *okónkolo*, might be translated "the repeating cadet," and clearly replicates a pattern in drum speech.

According to Fernando Ortiz, the first legitimate group of *batá* drums in the Havana area was made by two "salt water" Yoruba, Yoruba born in Africa—Àyànbí and Atandá—in around 1830. It was consecrated with the name of one of these Africans, Àyànbí—an appropriate christening, for it means "God of drums is born."[57] The founding *batá* trio multiplied and multiplied; by 1950 there were some fifteen recognized sets in Cuba. Julito Collazo and Francisco Aguabella brought *batá* to the United States in 1955. In New York today this vanguard has been joined by a richness of Cuban masters, led by García Villamil and Orlando "Puntilla" Ríos.

Brass masks have disappeared from Cuban *batá*. Metal bells remain, however, strung around the mouths of the drums in circles of constantly activated, jingling sound. In addition, the Nigerian practice of hanging beaded necklaces on *batá* drums, as marks of honor and spiritual presence, explodes in Cuba into a full-dress tradition of beaded aprons for the mother drum. Consider a trio of *batá* apparently dating from the turn of the century, each dressed with a beaded apron—the *bante* or *bandel*, the latter term a creolization of the former, which means "loincloth" in classical Yoruba (plate 188).

These beaded garments festivalize the instruments "like a flag for a fiesta."[58] In that sense they recall the ornamental *òjá* sashes tied on *atabaque* in Bahia, or on senior drums in Dahomey and in Dahomean religious centers in the Americas. They also emblematize the reverberating worlds of Changó and the other *oricha*, and their vision. The beaded strands of the *bandel* create a scintillating pattern of concentric rings around a circular mirror at the center (plate 189). Thus García Villamil: "Each circle is a symbol of an *oricha* and their world."[59] It is a way of signifying a victory, over time and space, as the drums call down the *oricha* one by one from heaven to the dancing floor. Concentric

With the Assurance of Infinity: Yoruba Atlantic Altars

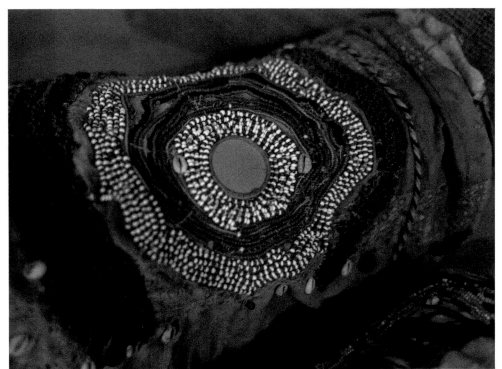

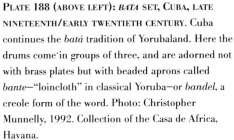

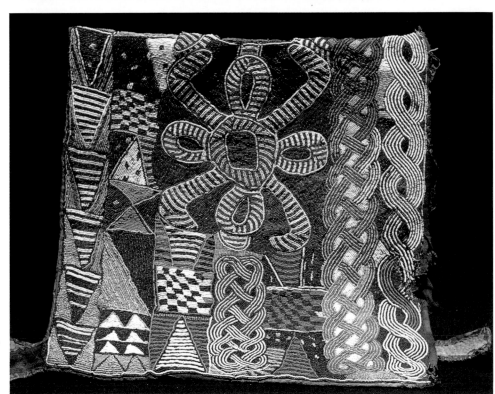

PLATE 188 (ABOVE LEFT): *BATÁ* SET, CUBA, LATE NINETEENTH/EARLY TWENTIETH CENTURY. Cuba continues the *batá* tradition of Yorubaland. Here the drums come in groups of three, and are adorned not with brass plates but with beaded aprons called *bante*—"loincloth" in classical Yoruba—or *bandel*, a creole form of the word. Photo: Christopher Munnelly, 1992. Collection of the Casa de Africa, Havana.

PLATE 189 (ABOVE RIGHT): BEAD *BANTE*, CUBA, LATE NINETEENTH/EARLY TWENTIETH CENTURY. A *bante* design of concentric circles around a mirror honors the *oricha*; it is as if the mirror were an eye through which the gods in the drum might watch the dancing and possession. Similar circles, in the colors of the oricha, are painted on the heads of Yoruba religious initiates in Cuba. But there is no standard pattern for the *bante*. Photo: Christopher Munnelly, 1992. Collection of the Casa de Africa, Havana.

PLATE 190 (ABOVE): A SHANGO PRIEST'S BEADED TUNIC (*EWU SHANGO*), OYO COUNTRY, NIGERIA, LATE NINETEENTH CENTURY. The thunder god Shangó is strongly connected with beading (see, for example, plate 251). Cuba's beaded coat for the drums he invented compares and may be linked with the beaded tunics of his priests in Yorubaland. Shangó dances in the storm at the center of this garment. Photo: Wilson Perkins Foss, 1960s. Collection of the Nigerian Museum, Lagos.

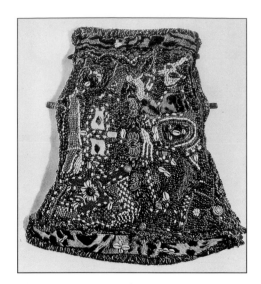

PLATE 191: BEAD BANTE, CUBA, LATE NINETEENTH CENTURY. This *bante* clearly suggests a connection with *ewu shangó* like that in plate 190. But the thunder god appears only through the presence of his axes; other *oricha* referred to include Ochún, Olokun, Echú, and Yemayá. Photo: Argeliers León, 1960.

PLATE 192 : *EGUN* MASKER (EGUN BABA ERIN), LAURO DE FREITAS, BRAZIL, SUMMER 1982. *Egun—egúngún* in Yorubaland—are the ancestral spirits honored by masked dancers in both Africa and the Americas. The name also refers to an *orixa*, Egun, the ancestor inquisitor, personification of the probing moral demands of the gods. There are no *egun* maskers in Cuba, where the role of moral inquisitor is most nearly matched by the role of the sacred *batá* drums. It may be significant, then, that Brazilian *egun* maskers wear mirror-studded garments similar to the *bante* robe for the *batá*, and called by the same name. Photo: Robert Farris Thompson.

circles in the colors of the *oricha* are also painted on the heads of initiates into the Yoruba religion in Cuba, a practice that qualifies the drums as sounding instruments of spiritual renaissance.

According to García Villamil, the mirror in the center of the *bandel* "is an eye within the garment for the drum. It reflects what will be attracted by the drum, the coming of the *oricha* in spirit possession, and what [the drum] has within, the powers of Anyàn and Changó." The mirror captures and transmits "images to Anyàn, like a telephone, saying, There is someone who is about to become possessed by Changó, go out and take him."[60] Through intensified sounding, complete the process of possession. These recitations by no means exhaust the resonances concealed here.

There is no standard pattern to *bante*; many *batá* drummers (*olubatá*) design their own, using rich cloths, with or without beads and mirrors. Moreover, divination occurs at every phase of the making of these sacred drums. We assume some of the *bandel* patterns are connected with *odù*.

At their finest, the beaded *bandeles* of Cuban *iyá* drums compare with the glories of the beaded tunics (*ewu shangó*) of Shangó priests in Oyo country in Nigeria (plate 190). On the back of an *ewu shangó* apparently from the late nineteenth century, Shangó whirls as an ancestor/inquisitor, lappets flaring in the wind, dervish in striped strips of country cloth. From a description of this masterpiece in my *Flash of the Spirit*:

> This spectacularly allusive tradition, the Yoruba beaded royal tunic, was renewed in Cuba in new form. It reached a peak of decorative quintessence in the making, perhaps in the last quarter of the nineteenth century, of a sumptuously beaded garment (*bandel*), for the mother-drum of a set of three Cuban-Yoruba *batá* drums [plate 191]. Striking changes are apparent. Instead of Shangó in a field of fiery . . . forces, there is a . . . creole fusion of distinct goddesses and gods. Olókùn, god of the sea, . . . appears at the summit of the composition, eyes fashioned out of flashing mirror shards. The ax of the thunder-god reappears at left, here centered with a shell-studded jewel of copper color, symbolizing Oshun and her world of wealth. The ancient eyes of Eshù-Elégbara, cowrie shells, stare forward from an implicit cross-roads at the bottom of the tunic. Left, there appears a bird of Yemayá, intuiting her powers; right, another thunder ax; and handsome segments of leopard pelt allude to *orisha* of the forest. And there is a segment of green and yellow beads for the deity of divination.[61]

Beaded *bandeles* in Cuba are intricate signs of the role of percussion in aesthetic reincarnation. This is appropriate to the role of *batá* as surrogates of Egún (from the African Egúngún), the ancestral inquisitor of Afro-Cuban religion. Brazilian Egun maskers in Itaparica, Lauro de Freitas, Jacarepaguá, and Vila America wear costumes with panels (plate 192) embellished similarly to the garments of the Cuban *batá* drums, and identically named: *bante*.

When the six heads of the three *batá* sound in unison they create a net of percussion, an acoustical *mazo* thrown over the hearing and over the consciousness of the pilgrim or novitiate, and pulling him or her into glory. Thunder resounds in the center of the drum. Lightning flashes in the *saworo*, the brilliant metal bells around the edge.

With the Assurance of Infinity: Yoruba Atlantic Altars

PLATE 193: DANCING COURT (*BARRACAO*) IN THE RELIGIOUS *CENTRO* OF AILDES BATISTA LOPES, JACAREPAGUA, BRAZIL, JANUARY 1990. There are no *batá* in Brazil, and no *mazos*; instead, *atabaque* drums are tied with celebratory crimson sashes relating to the *òjá* tradition (see plates 179, 181, 182). An *òjá* also ornaments the room's central column, which is dedicated to Agonjú, father of Xango. Photo: Robert Farris Thompson.

The *Barracão* of Aildés of Jacarepaguá

To reinforce a sense of the differences between the Yoruba altars of Cuba and of Brazil, let us consider the dancing court of a religious *centro* (plate 193). There are no *batá*, there are no *mazos*, even if a central column, richly decked and tied, resonates slightly like a *trono*. Clearly we are not in Cuba, nor in an Afro-Cuban *barrio* of Miami or New York. We are in the dancing court (*barracão*) of Aildés of Jacarepaguá, Brazil, in January 1990.

In the distance, *atabaques* are being played. They are sashed and tied in crimson to symbolize a celebration. The central column, dedicated to Agonjú, father of Xango, is tied similarly. *Òjá*, the band for tying around the waist of a Yoruba woman, in combination with the wedge-tuned *atabaques*, pinpoint us to black Brazil. Here a woman's artistic influence is pronounced.

Mazos veil and crown the gods in royal glory. *Òjá* tie and drape the *orixa* in exaltation. The confrontation of the idioms prepares us for immense creativity, at every level, as we now survey the different *orisha* and their altar traditions in Nigeria, Brazil, Cuba, and the United States.

Pillar at the Crossroads: Eshù-Elégba

Okunrin de, de, de, bi orun eba ona.

He's close, close, as close as the shoulder of the road.
 —Pierre Verger, *Notes sur le Culte des Orisa et Vodun à Bahia, la Baie de*
 Tous les Saints au Brésil, et à l'Ancienne Côte des Esclaves en Afrique,
 1957

Some thirty-two years ago an Afro-Brazilian priest of the Yoruba religion, Pai Balbino de Paula, founded an important *candomblé*, Ile Axe Opo Agonjú, at Alto da Vila Praiana, in Lauro de Freitas, north of Salvador. At that very moment, in a sentry-box-like structure to the right of the entrance, he began an altar to Legba, the Dahomean avatar of Elégba (plate 194). He did this in the conviction of his ancestors: ignored, Legba will make a man lose his way.[62]

A cement cylinder, seasoned with medicines and indigo (*waji*), became Legba's throne. Pai Balbino shaped the deity as an amorphous mass of clay, bristling with the inserted horns of a ram, "the power of Legba," evidence of an animal sacrifice.

A powerful wooden phallus, imported from Anagó in Africa, sexes the sculpture with a telltale raking accent. Inserted in the clay around the phallus, four-cowrie motifs form Ifá *irosun* patterns that predict good fortune and attract fine things. A beige *quartinha* jar filled with fresh water stands nearby, for pouring libation as kola nuts are offered upon the altar: "to cool as you ask." Moist white sand from the nearby ocean, scattered on the floor, completes an aura of ritual purity and coolness.

Pai Balbino explains that the cylinder altar is intended to recall the circular cone-on-cylinder ("rondavel") shrines of Dahomey. (Compare a rondavel shrine for Elégba, with penis finial, at Ishagba, Ohòrì-Ije, Benin, photographed in the summer of 1965; plate 195.) For Dahomey interrupts the rain forest between Lagos and Accra with savannalike anomalies of cactus, wells, rondavels, and other features normally associated with the arid north. Thus a triple geography of architecture, worship, and divination has dovetailed in the making of this shrine. Pai Balbino chose a Dahomean avatar of the trickster god to honor that side of his heritage. But certain elements of his shrine trace back, straight through Dahomey, to the cities of the Yoruba: clay pillar, phallus, cowries.

Pointed clay mounds for Legba and Exu recall clay-pillar altars erected by Mande and Mande-related Gur-speaking peoples to honor the spirits of departed men (plate 114).[63] Whatever the historical significance behind this powerful resemblance, for Yoruba themselves the laterite pillar (*yangi*) to Eshù is the "father" of all Eshù images, older than old.[64] This is because it commemorates a primordial struggle between two gods:

Eshù became a pillar of laterite to avoid the poisons of [the smallpox god] Obaluaiye. This dates from a time when the two of them were locked in mortal combat. Obaluaiye severely marked Eshù with smallpox, scarring his entire body. All of this happened because Eshù mocked the lameness of Obaluaiye.

PLATE 194 (RIGHT): YORUBA-BRAZILIAN ALTAR TO
LEGBA, MADE BY PAI BALBINO DE PAULA, ILE AXE
OPO AGONJU *CANDOMBLE*, LAURO DE FREITAS,
BRAZIL, 1961.
Legba is the Dahomean avatar of the
Yoruba *orisha* Èshù-Elégba, trickster god of
communication and contingency, who is alert to
lapses of generosity. Here he is personified as an
amorphous clay mass on a cylindrical cement
throne, crowned with the horns of a ram,
ornamented with cowries patterned to predict good
fortune, and powerfully phallused. Photo: Robert
Farris Thompson, 1985.

PLATE 195 (RIGHT): OHORI-YORUBA RONDAVEL
SHRINE FOR ELEGBA, ISHAGBA, BENIN, AS IT WAS IN
1965.
Pai Balbino is conversant with Dahomean
heritage as well as Yoruba, and he intended his
cylinder altar to Legba, topped by its roughly
conical clay mound with projecting phallus (plate
194), to echo the rondavel shrines of that region—
round, cone-roofed, and, here, with a phallic finial.
Photo: Robert Farris Thompson.

Obaluaiye, enraged, made a journey to the land of the Bariba. Ritual
experts there steeped him in the medicines of earth-made-hot [i.e., in the
arcana of throwing smallpox on a person]. Obaluaiye returned. He immedi-
ately tried out his skills on Eshù's body. It worked. That is why Eshù fled
into the *yangi*—to hide a disease-ruined body.[65]

Note how Obaluaiye retires to a northern land, there to perfect his sophisticated revenge.[66]

An altar to Eshù and Obasin on Ifeware Road in Ifè represents Eshù as a messenger to
Obasin, a deity associated with terrifying disturbances in the sky.[67] Here a small piece of
granite miniaturizes the concept of the *yangi*. Devotees of Eshù cool his mound with

sacrificial liquid lest matters flare or darken with misfortune. I saw the same practice followed in 1972 at Whévié, Benin (plate 196), where multiple Legba figures allowed each devotee to tend his or her own Legba image.

But in a Kongo/Angola *candomblé* in Bahia, as photographed in November 1989, things change radically. Here, instead of being "cooled" with food and liquid alone, images for various avatars of Exu are doused with alcohol and lit afire (plate 197). This is said to alert the various avatars or *caminhos* of Exu to awaken, listen to the client's problems, and set off on missions to ameliorate his fortune.

Arousal by fire, in addition to food and liquid sacrifice, reflects a collision of Kongo spiritual militance (*mvita*) with the spiritual protocols of the Yoruba-Brazilian way of worship. In addition, the various phrasings and rephrasings of crossroads imagery in the iron staffs for the avatars represent a rewriting in metal of the chalked designs called *pontos riscados* that summon the spirits in Brazilian Umbanda. This represents another creolized form of worship, the ultimate root of which is Kongo.

The pillar is a phallus, quintessence of maleness. In Dahomey shrines along the road from Allada to Agbomey as in Pai Balbino's shrine in Bahia, Legba's protruding penis lends visual overstatement to instructive shock. Ifá explains this, too: "Eshù is a lover on an heroic scale. We praise him in this manner: strongest-of-erections, hardest-of-all-hard-ons."[68] Absolute virility is a gift. The supreme god Olodumare so rewarded Eshù-Elégba because, at a critical moment in the history of the world, he alone was wise enough to sacrifice to higher force.[69]

A positive aspect to the riddle of Eshù is revealed in the story of why the crossroads became his classic point of sacrifice, and why he threw stones at the rich on the day that he was born:

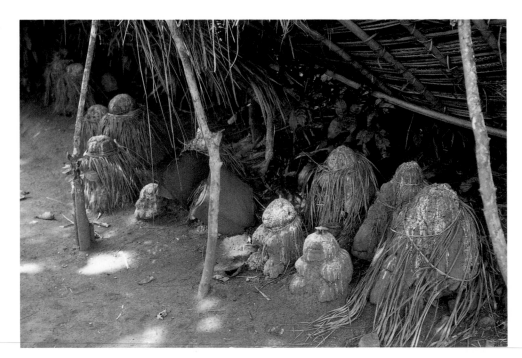

With the Assurance of Infinity: Yoruba Atlantic Altars

Where the roughly mounded, amorphous, loosely figural earthen altars of Legba at Whevié (plate 196) are cooled with offerings of water, these sharp, definite, pointedly forked metal avatars take offerings of flammable alcohol and fire. Apparently the product of militant Kongo spiritual practice applied in creole Brazil to Yoruba belief, they are related in their calligraphy to the *pontos riscados* of Umbanda (see plate 300). Photo: Robert Farris Thompson, 1989.

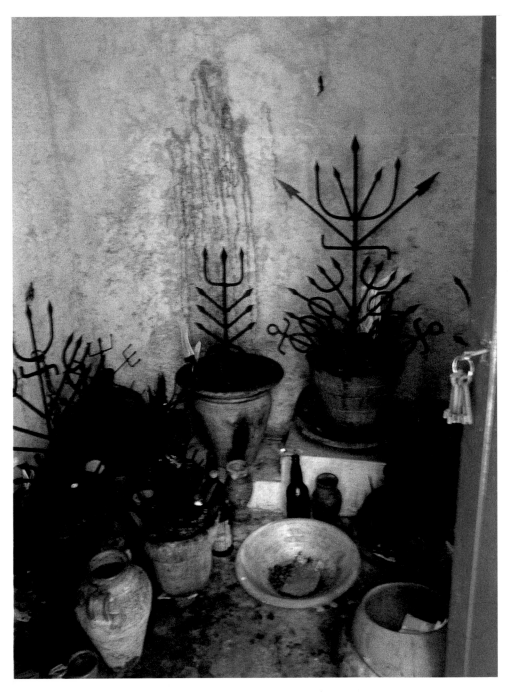

When Eshù arrived on earth he was already walking as a full-grown child. He carried stones in a calabash before the houses of the rich. He asked them: "bring whatever food you have, bring it to the cross-roads, that those less fortunate can eat."

To prompt the stingy, Eshù threw magically incandescent stones in their direction. This caused their houses all to burst in flames. . . . People started bringing food in generous quantities to the cross-roads. Soon all were eating. Dogs ate. Pigs ate. Even chickens ate. Aje Shàlúgà, god of money, offered cowrie coins, the small white shells that look like *kokoro* insects. He brought his cowries to the cross-roads. Everyone was staring at him, calling him, admiringly, "Money!"

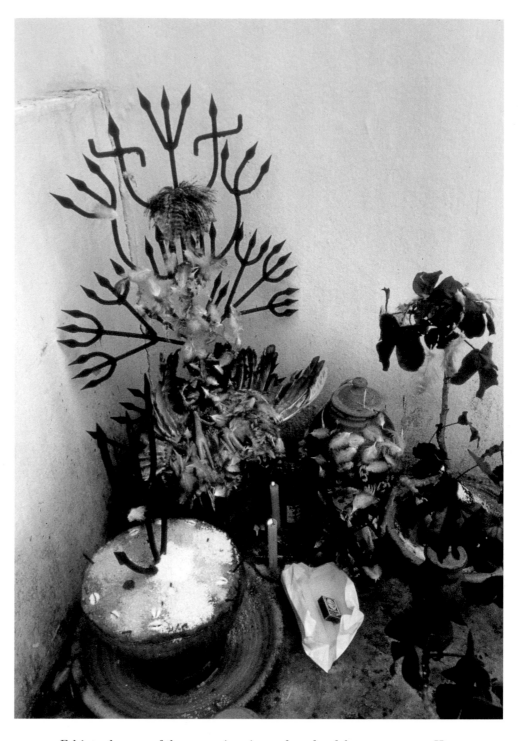

PLATE 198 (RIGHT): ALTAR TO EXU ABRE-CANCELAS (EXU WHO OPENS THE GATES), WITH STAFF BY JOSE ADARIO DOS SANTOS, BAHIA, BRAZIL, EARLY 1980S. An avatar of Exu guards the gate to a *candomblé* in Surburbana, Bahia. The priest, Pai de Santo, told me, "This particular *caminho* [avatar] has an affinity with alertness, taking note of everything coming in and going out." Here, the altar has just received food and animal sacrifice. See also plate 303. Photo: Robert Farris Thompson, November 1989.

PLATE 199 (OPPOSITE): ALTAR TO POMBA-GIRA, RIO DE JANEIRO, NEAR MIDNIGHT, 30 DECEMBER 1986. Pomba-Gira is a female, specifically Rio avatar of Exu. In one of Brazil's many combinations of Kongo and Yoruba belief, her name derives from the Ki-Kongo word for "crossroads," *mpambu nzila*. At a T-form crossroads on Avenida Atlántica, close to the beach of Copacabana, a devotee has left for her a red rose, *cachaça* liquor, and cigarettes. Photo: Robert Farris Thompson.

Eshù took some of these cowrie coins and made of them a garment. He put this cowrie-stranded cape around his shoulders. Immediately people praised him as Lord of Riches, King of Coin.[70]

The cowrie money-cape, draped on a thousand altar icons for Eshù, bears a special name: *obara owó eyo*, rain-of-money, torrent-of-coin (punning on *agbara ojo*, the torrent that flows after a strong rain).[71] The strands of cowries flood down Eshù's shoulders and cross his chest with purpose: monies gained from trade or privilege, crisscrossing time and space, can unleash untold showers of sudden and dynamic wealth when circulated by generosity and sacrifice. Moral argument and moral promise, as well as more famous qualities of provocation and surprise, haunt the Eshù crossroads altar.

With the Assurance of Infinity: Yoruba Atlantic Altars

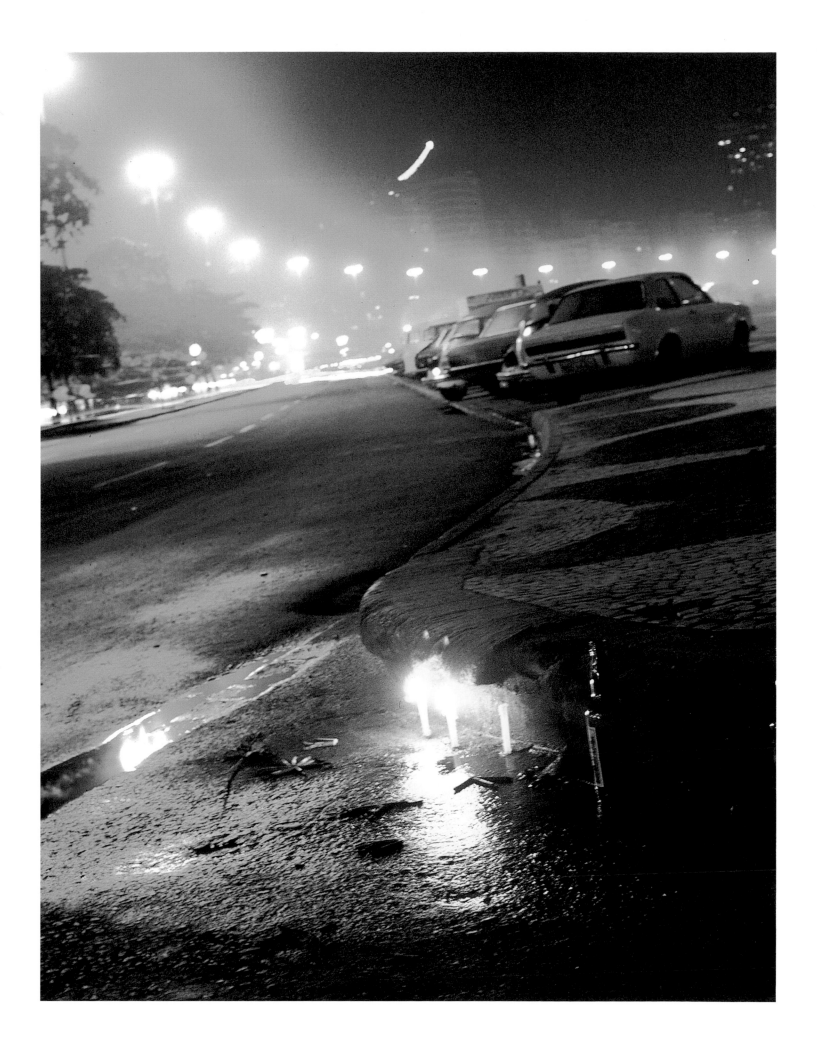

The phrasings of contingency, powerfully evocative of Eshù in Nigeria, undergo sea change after sea change in black Brazil. The main gate to a prominent *candomblé* in Suburbana, Bahia, is guarded by Exu Abre-Cancelas (Exu Who Opens the Gates). "This particular *caminho*," Pai de Santo told me in November 1989, "has an affinity with alertness, taking note of everything coming in and going out." His iron staff—richly branched, like a tree of signs—combines allusion to the winding roads of life (curved sections), crossroads (tridents), and continuations of one's journey (*sequimentos*, triple vertical arrows) (plate 198).

In Rio de Janeiro, a wonderfully vibrant, creole avatar of Exu has emerged: Pomba-Gira, a woman Exu. She takes her name from the Ki-Kongo term for crossroads (*mpambu nzila*). Near midnight at the end of 1986, on the evening of December 30, a devotee laid out a sacrifice to Pomba-Gira at a point where a road met Avenida Atlántica at the south end of Copacabana beach in Rio (plate 199). The *T*-form crossroads and the gift of a red rose identify the spirit as perhaps Pomba-Gira Cigana (Gypsy Pomba-Gira).[72] Additional gifts of liquor (*cachaça*) and cigarettes, arranged as material miniature crossroads below the curb, suggest that the supplicant was seeking the opening up of a situation in which he or she had been blocked in business or in love.[73]

Some would interpret the rum and cigarettes as purely masculine gifts, for a male avatar. But the floral offering feminizes this midnight altar, made by a person in search of love and continuity. It compares with the roses given to Yemanjá, Yoruba goddess of the sea, each New Year's Eve on Copacabana beach "so that in the same way, your life may flower."[74]

The Razor's Edge Becomes a Person: Ogún

Oloju ekun.

Ogún of the cold, unblinking, leopard stare.

—John Mason, *Orin Orisa*, 1992

Lord of smiths, warrior among warriors, bloodthirsty, fearless, Ogún rules in the cutting edge of iron. His prowess and ferocity are legendary. Today he invades precision technology, too, inspiring—and protecting—persons who weld or solder, who handle oil rigs, drive taxis, or shoulder modern arms.[75]

This warrior only fears being vanquished. According to Ifá, his famous altar on the hill at Oke Mogun, in Ilé-Ifè, marks the moment when he was finally defeated:

Ogún turned to stone at this very place, when shame overcame his spirit.
Once Ogún waged war against the divination spirit. But Orunmila defeated him. Shame came upon Ogún and he turned to stone.[76]

This is one version of the stones at Oke Mogun. Emese Oloriidoko, a keeper of the Ogún Laadin shrine in the palace of the Ooni, Ilé-Ifè, told another:

PLATE 200: SHRINE OF OGUN, OKE MOGUN, ILE-IFE, NIGERIA, PERHAPS BEFORE 1000 A.D. Ogún, *orisha* of iron, is said to have turned to stone at Oke Mogun, ashamed of defeat in battle—or else he himself carved these stones in a demonstration of art and skill. The two smaller stones are bladelike, befitting the god of metal; the larger is read as the god's penis. Photo: Phyllis Galembo, 1989.

With the Assurance of Infinity: Yoruba Atlantic Altars

Ogún came down. And immediately displayed his powers and his prowess by carving images right out of stone. We cannot do this. His strength exceeds our understanding.[77]

Ogún carved himself at Oke Mogun. The long lines of the shrine's three stones go up in space, rising from the ground (plate 200). The carving and erecting of the stones may date to the first millennium A.D.[78]

Two of the liths read like blades. Augmenting rhythms enliven their arrangement: the small stone at left abuts a slightly taller stone; then comes an incredible jump in scale to one huge standing force, the phallus of Ogún. It is said that the stones' insistent verticality renders spiritual uprightness (idurogangan), like the staffs of Òsanyìn, the healing orisha, that flesh out certain other altars to Ogún.[79] The "blades" and phallus embody danger and intimidation.

Other altar objects reveal the conviction that Ogún's spirit can be reached by sacrifice and honor. By the lesser stones keepers may place an oru, a small vessel for pouring cool water when invoking the name of Ogún. Both "blades" bear weathered traces of red palm oil. Oil on stone pours soothing incantation—itutu l'ojú—upon a fiery point, conferring harmony, establishing protection. Roland Abiodun reminds us: we dare not see his face too nakedly—we see only stones and membrum.[80]

Ogún's primordial altar—"the elder shrine, oldest of old"—is Ogún Laadin, in the palace of the Ooni. It, too, probably dates to the first millennium A.D. Here we meet Ogún's own hammer, a virtuoso piece of fused wrought iron, rising like a miniature volcano from the ground (plate 201). We also discover Ogún's anvil and his body, developed in a visionary sea of fish and crocodile, all turned to stone. Oloriidoko, a keeper of the Laadin shrine, explains:

> Once the people of Ifè wanted to kill Ogún Laadin. He asked them to show him the palms of their hands. He asked them: "Who is the artist connected with the cutting of these lines upon your palms?" They had no answer. So he asked them to sleep. While they slept he went into the ground, and all his emblems and his body turned to stone. He then asked them to regain consciousness. Immediately they tried to shoot at him, but to no avail. Traces of their bullets mark to this day the sides of certain stones here at Laadin.[81]

The keepers of the Laadin altar set and sometimes shift its stones to claim the space for Ogún. But however the stones are arranged, Ogún's tear-shaped metal hammer (owu) is positioned to relate to the looming rock of the anvil (ota aro).[82] On my visit in 1989, the latter (also sometimes read as Ogún's own body) was so drenched with sacrifice (roasted yams, red palm oil, salt, cornmeal) that it took on life in gritty lights and bluish darks (plate 201).

Fish and crocodile qualify this space as primordial. From the waters of the beginning, hammer and anvil emerge like islands in a sea of rocky laterite. Laadin is older than the famous fifteenth-century kare sansui (dry landscape) at the Zen temple of Ryoan-ji in Kyoto. In both cases, earth and stone combine in an aura of spiritual concentration. But the difference, blood and roughness, gives us back Ogún.

PLATE 201: HAMMER OF OGUN, OGUN LAADIN SHRINE, ILE-IFE, NIGERIA, PERHAPS BEFORE 1000 A.D. The Laadin shrine, in the palace of the Ooni, holds Ogún's hammer and also his rock anvil, considered the god's body, and the site of sacrifice. See also plate 169. Photo: Phyllis Galembo, 1989.

PLATE 202 (OPPOSITE): ALTAR TO OGUN, BENIN
CITY, NIGERIA. The palm fronds hanging from the
ceiling illustrate the iron god's power to cut. Iron
bells and many examples of industrial scrap iron are
gathered in honor of Ogún, who accepts them as a
presence in red. Photo: Phyllis Galembo, late 1980s.

The stones of Laadin also return protection by analogy with their victory over time.
Small wonder the blacksmith warrior is immune to blades and bullets.[83] This explains
why he is the not-so-secret deity of present-day Nigerian Yoruba drivers of taxis and
trucks. They pray to Ogún to protect them from violent ends—from tangles of blood,
metal, and shattered glass.[84]

In antiquity, so it is believed, Ogún brought the iron arts to the Yoruba. Later, when
his followers wished to honor him, they had only to combine some metal pieces and
moisten them with oil to summon his presence:

> [The altar] becomes Ogún once you have placed two pieces of iron together
> and poured oil on it. The shrine needs food to be active. Then you can offer
> prayers to it. As soon as it is put together it stays Ogún and will be Ogún
> forever after. By dismantling the iron one takes Ogún away.[85]

A gun altar to Ogún in the Ketu Yoruba village of Kajola, documented in the summer
of 1989, has a similar rationale. Here devotees set up an altar with the guns of the lead-
ing hunters. When the men are going shooting, they remove the guns of Ogún from the
altar and carry them into the forest. It is believed that Ogún's spirit rides these weapons
in the hunt. Moreover:

> When Ogún is going on a hunt, we first bring his guns [and medicines] and
> invoke him at this point. After which [he gives us luck and] we kill a lot of
> game and the town will be cool [literally "sweet"]. The face [of this altar] is a
> stone, an object which our ancestors covered with his food.[86]

The altar combines not only obligatory iron and sacrifice but some of the medicines
that Ogún long ago shared with Ketu followers of his forest path. An iyeye tree lends
focus to the gathering of the guns, permeating them with values of nobility and collect-
edness of mind. When I saw them they were festooned with three charms. But when two
devotees, Elijah Adelakun and Basini Laimu, asked to be photographed, Laimu removed
the charms and placed them on his body. *Abo*, a square amulet, hangs around the
hunter's neck: "Wear this and see things to shoot—it will work on the brain of animals,
they'll get confused and become an easy mark." The bag is *apo*: "When spiritually 'tied'
in the forest an animal will stop dead in its tracks and become a target." The third
charm, *pante*, is a medicated belt: "It is worn in the forest to make sure bullets miss your
body."[87]

Ogún's vital powers of protection long ago spread beyond the borders of the Yoruba, into Benin, to the southeast, and among the
settlements of the Popo, Fon, and Ewe to the west. The ancient city of Benin boasts many altars to Ogún. Phyllis Galembo
photographed a striking example in the late 1980s (plate 202).

Fresh palm fronds depend from the ceiling. Cut into neat flaglike lengths, they
demonstrate Ogún's boundary-making, line-delineating prowess. Ogún himself presides
at the top of the dais, wrapped in red, color of blood and fire. Iron as military prepared-
ness, iron as saga—all these qualities and more can be read in the deposit of modern and

With the Assurance of Infinity: Yoruba Atlantic Altars

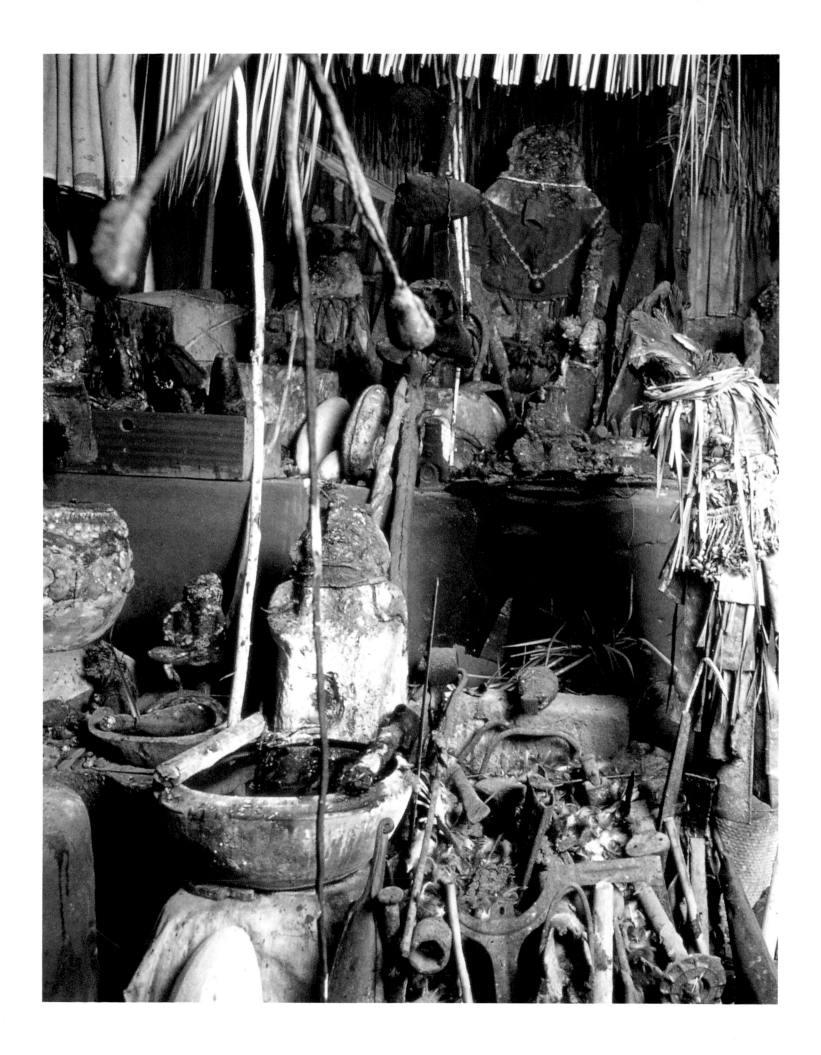

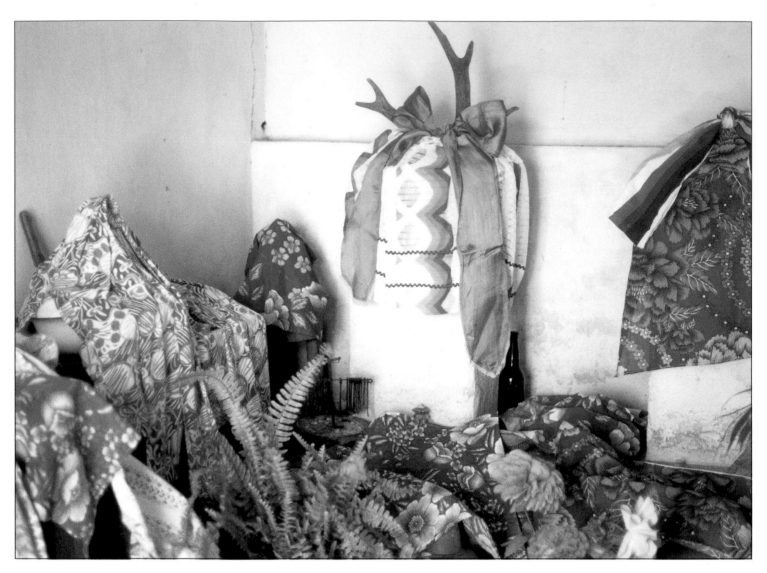

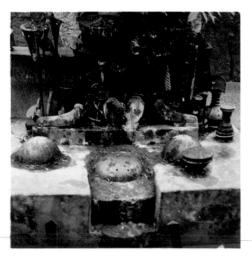

PLATE 204 (BELOW): ALTAR TO GU (THE FON AVATAR OF OGUN), AGBOMEY, BENIN, 1890 OR EARLIER. This shrine to Gu, kept by the family of Vincent Lamadoucelo of the Hountondji section of Agbomey, holds miniature, locally made versions of arrows, spears, blades, lances, and other iron cutting instruments strung in a fringe, along with hardware from the West. Photo: Robert Farris Thompson, January 1968.

traditional metal pieces on the altar. There are several iron bells, which give back voice and festival.

West of Yorubaland, the Fon of Agbomey honor Gu, their version of Ogún, with equal intensity. The family of Vincent Lamadoucelo, in the Hountondji quarter, has tended an altar to Gu since at least 1890 (plate 204). Shown as it was in January 1968, the shrine presents an apocalypse of iron: arrows, spears, blades, lances, and all sorts of cutting instruments are rendered in miniature and strung in a fringelike line. These works of local smiths are set in collision with fragments of military and other hardware from the West. As classified and gathered here they become more than tools or instruments—they are logics of moral intensification.

As the main priest of Gu remarked, Gu's iron can be a key that opens your life or a knife that kills you. His metal brilliance can flare into war or sustain civilization, depending on our moral lights. The wise move is sacrifice. Hence the inverted pottery, meant to receive liquids to cool the emblems of Gu hidden within, predisposing him to release his gifts of victory and self-realization.

Today blacks and whites honor Ogún across the Americas, from New York to Buenos Aires. For a *candomblé* in Cosme de Farias, Bahia, Mai Jocelinha and her helpers prepared an altar to Ogum (Ogún) and his allies, the hunters Logunede and Oxossi (Oshóòsi), in the summer of 1983 (plate 203). She placed his commanding source of

With the Assurance of Infinity: Yoruba Atlantic Altars

PLATE 203 (OPPOSITE PAGE, ABOVE): ALTAR TO OGUM (OGUN) AND TO THE HUNTER GODS LOGUNEDE AND OXOSSI, PREPARED BY MAI JOCELINHA, COSME DE FARIAS, BAHIA, BRAZIL, SUMMER 1983. Pottery vessels containing iron implements, and the bow and arrow of the hunters, are so richly sashed with òjá as to be virtually hidden. Antlers on the ledge above the altar are attributes of the hunter orixa. Photo: Robert Farris Thompson, summer 1983.

energy—emblems of iron—and the metal bow and arrow of Logunede and Oxossi in pottery vessels. Then, in the style of her city, she ceremonially tied each vessel with a rich length of òjá sash. Her colleagues in Agbomey and Benin City moved with conceptual quickness through irons modern and traditional. She does too. Wit and ritual merriment come through on the ledge above the altar, where she symbolizes Ogum with a macho doll, a "superhero" in military gear, enlarging the vocabulary of his powers of attack.

We close with an Umbanda altar to Ogum in southernmost Brazil. Umbanda, as we saw in chapter 3, is a modern Brazilian fusion-faith, blending Kardecist spiritualism from France with Roman Catholic elements, plus the names and concepts of the Yoruba orisha, plus animate medicines of God from Kongo, plus romanticized Native American images from the forests of the Brazilian interior.[88] The mix is rich: we are light years from the traditionalist Yoruba candomblés of Bahia, to say nothing of Yorubaland itself. Nevertheless, for all the change swirling around, we still find Ogún associated with Eshù (Exu in Brazil) and Oshóòsi. The Umbanda Ogum presides over "phalanxes" of Exu possession spirits and caboclos (Native American spirits, creolized with many Kongo touches) who are sometimes also called Oxossi, or related to him, because they too possess bows and arrows as important emblems. If that weren't complicated enough, Ogum in Umbanda syncretizes with São Jorge Guerreiro, Saint George the warrior, for reasons of shared swords and martial aggression. Ogum/São Jorge appears on altars riding a white steed, in direct translation from Roman Catholic chromolithographs.

We come to an altar to Ogum set up by the late Senhora Menezes of Rio Grande, Brazil (plate 205). I date it tentatively to the 1970s; her daughter tends it now. This altar not only constellates ritual speech and act but marks a place where a genius took upon herself the supreme responsibility of an Ogún artist: to handle the spirit of his martial presence, to imagine herself into sweat, blood, and bullets.

First, Menezes turned the wall into a green flag and emblazoned it with a slashing bar of white. This accent comes down at a raking angle, like hammer to anvil, sword to

PLATE 205 (RIGHT): UMBANDA ALTAR TO OGUM, MADE BY THE LATE SENHORA MENEZES, RIO GRANDE, BRAZIL, 1970s(?). Before a green wall blazoned with an aggressive white stripe, three shelves hold implements of iron: handsaws, handcuffs, a chisel, the head of a pick, a chisel, a railroad spike, and other items. Equestrian allusions—horseshoes, a riding crop, a polo player's thigh guards—connect Ogum to a Roman Catholic horseman, Sao Jorge (Saint George); Umbandistas link the two, for their martial skill. Photo: Robert Farris Thompson, January 1990.

assailant. Then, in relation to this aggressive stripe, she assembled three artfully staggered shelves, laden with Ogum's masculine metal.

The world of an urban dweller permeates this vision. Shelves index things that are loved and handled: a used riding crop, horseshoes, and even thigh guards for a polo player give us back mounted São Jorge. All the rest could appear in a room in Edó, or Ketu, or Bahia, and still be immediately accepted as offerings to Ogún: handsaws, handcuffs, a chisel, a pick without a handle, a railroad spike, a bolt grooved to penetrate the hardest concrete, a factory-made machete, and a pulley with chain, to hoist this macho toil to heaven. Senhora Menezes thought herself into leather and metal, making a room incredibly male.

The Sign of the Bow and Arrow: Oshóòsi

Rezo de Ochosi

Ochosi allí loda, alamala ode, sire-sire. Ode mata, ode, ode.

Prayer for Ochosi

Ochosi gets up and creates in fluent whiteness, in confidence. Hunter don't shoot, hunter, hunter.

—Felix Goicochea, *Libreta de Santo*, 1932

The daring of the hunter spirits—Oshóòsi, Erinle, Ibu Alama, Logunede—makes them logical colleagues of Ogún. They are fearless warriors against witchcraft. In this regard they surpass the kings: hunters can see and handle what even a reigning monarch cannot view.

Thus, according to Abiodun, when a king proves tyrannical and the elders decide he must "go to sleep" (i.e., commit suicide), they show him a calabash brimming with taboo: parrot's eggs. Being forced to view the forbidden means: die.[89] The taboo recalls the prohibition against looking inside royal beaded crowns, which are guarded with beaded birds.[90] The crown contains medicines that blind or kill if deliberately transgressed; the bird eggs, viewed, set in motion the ending of a life.

But who brought these eggs to the elders that they might activate the sanctions of the earth? The unusual sight of a nest full of parrot eggs on a treetop, mystically tended by "a mother," is something that only hunters, with their bravery and brawn, can reach and know. An axis of doom extends to the tops of certain trees, particularly the iroko, where the *àwon iyá wa*—"our mothers," women practitioners of sorcery—congregate in feathered form at midnight. This axis is intimated in the cluster of beaded birds atop the royal crown, worn as deliberate moral intimidation.

The same axis extends downward, beneath the surface of water. One of the most important altars of Erinle is at an impressive depth (*ibú*) in the river of this hunter/ herbalist deity, at Ilobu, where there is a dark and swirling pool called Ojuto. It is believed to be so deep that a two-story house would be swallowed up in its indigo currents. From the bottom of Ibú Ojuto, it is thought, pigeons fly up through the water and disappear into the air.[91] At both the top of the iroko and the bottom of the *ibú*, then,

birds cluster. Hunter/herbalists comprehend and harness these powers for the salvation of mankind. Their blessing is sealed in the metal staffs, surmounted by the bird of mind, that they share with Ifá and Òsanyìn. These warn the mothers "how powerful [the herbalists] are about their herbs."[92]

Oshóòsi, the major hunting deity of the Yoruba, links up with the mothers in other ways. In a spectacular myth, he saves the world by firing a mystic arrow into the heart of a gigantic witch-bird that has blanketed the sky with doom.[93] His bow and arrow, rendered on his altars in honorific iron or brass, is consequently more than a sign of hunting. At deeper levels it signifies neutralization of "our mothers," and stays their murderous potential.

In a shrine at Ila-Orangun, a bow and arrow for warding off evil is held sacred to Obatálá, suggesting his link with Oshóòsi.[94] This is explicit at Ilé-Ifè, where a temple to Obatálá is guarded first by an altar to Eshù, at the entrance to the first court, and then, in the middle of the second court, by an altar to Oshóòsi. The latter was described to me as "the hunter working for Obatálá" (*ode Obatálá*).[95] Oshóòsi is Obatálá's scout, his instrument of surveillance. Oshóòsi and Eshù screen persons entering and report to the third and final court, where Obatálá presides over his shrine, in a panoply of appropriate objects and ideographic writings.[96] This is doubtless a root of the "three-*guerreros*" tradition of Cuban Lucumí people in New York, in which the "three warriors"—Eleguá, Ochosi, and Ogún—are positioned by the doors of their apartments.

Lucumí praise-singing reconnects Ochosi to the conceptual whiteness of Obatalá. The music also links him to one of Obatalá's Afro-Cuban avatars, the mountain, the word for which (*oke*) puns on the cry of the hunter deity's devotees (*oke*):

> *Osoosi oloomi*
> *warawara*
> *Oke, oke*
> *Osoosi a yi lo da*
> *Alamalade*
> *Ee, tile-tile.*
>
> *Ode ma ta, ore, ore*
> *Yambeleke iworo, Ode ma takun l'ono*
>
> Oshóòsi my lord
> quickly
> [Rise up like] a mountain, a mountain
> Oshóòsi gets up in the morning and creates
> Whiteness that brings whiteness
> Yes, with confidence.
>
> Hunter, don't shoot—I'm your friend, your friend
> Great Hunter, don't snare me in your rope trap on the road.[97]

PLATE 206: ALTAR TO OSHOOSI, IMEKO, NIGERIA,
1980s. Tangled brambles (igangan) cover a pot
holding stones of the Yoruba orisha of hunting, and
accepting sacrifice. The bramble is Oshóòsi: at home
in the forest, tough, itself one of the snares of which
this god is master. Photo: Phyllis Galembo, August
1989.

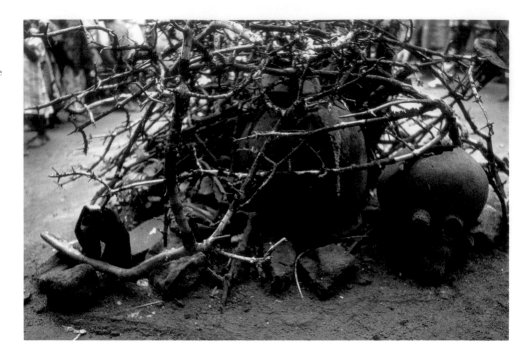

A primary image of Oshóòsi, as a setter of traps and snares, undergoes a sea change in
Afro-Cuban worship. First, as in modern altars to Ogún, handcuffs and manacles appear,
here less for the metal that honors the iron god, more as extensions of ensnarement.
Second, and remarkably, an entire jail, as an ultimate contrivance for catching persons,
can serve as a secret altar in his name. Thus Afro-Cubans in New York, Brown reveals,
once left sacrifice to Ochosi on the steps of the Dyckman police station in Manhattan, in
the dead of night.[98] These are New World developments of an original altar tradition that
in Abeokuta in 1964 consisted simply of a metal bow and arrow in a ceramic dish or
calabash, activated with sacrificial food and liquid.[99]

The New York Yoruba scholar John Mason has suggested various tonal etymologies
for the first two syllables of the deity's name: osó, a snare for large animals, and òso,
thorns used in a pitfall trap.[100] His arguments in hand, we return to a famous African
shrine tradition for Oshóòsi, Ketu "bramble altars," and comprehend a hidden line of
thought. In a small altar documented in Imeko, Nigeria, in August 1989 (plate 206), a
deliberate tangle of brambles (igangan) surrounds and covers an isaasun pot and stones.
Pot, stones, and bramble receive sacrifice. Nearby, a small otun vessel is used for pouring
cool water in prayer. There is also an Òsanyìn staff, for "Òsanyìn and Oshóòsi live here
together." The bramble is Oshóòsi—the thorny snare with which he captures animals, the
thickets through which his tough athletic body moves with nonchalance.[101]

The bramble shrine may echo when Ogún or Ochosi initiates in New York are
brought before a presiding spirit: "He or she is concealed in a moving blind of tree
branches. Each of the priests in the procession holds a branch. With the [initiate] in the
center concealed, there is the illusion of seeing a forest dance toward you."[102] In Brazil,
so far as we know, forest altars made of brambles apparently did not transfer. We find
them, it is alleged, in neither Casa Branca nor Retiro, nor in Gantois.[103] But something of
the sylvan reference remains where Oxossi altars in Bahia show animal skulls and
antlers, the latter sometimes richly wrapped with ornamental ties of silk, in shades of
light blue or light green (see plate 203).[104]

With the Assurance of Infinity: Yoruba Atlantic Altars

PLATE 207: ALTAR TO OXOSSI (OSHOOSI), MADE BY THE LATE AILDES BATISTA LOPES, JACAREPAGUA, BRAZIL, LATE 1970S/EARLY 1980S. Below a photomural of a deciduous forest and a painting of enormous banana leaves, Oxossi stands bejeweled, his antler prey at his feet. In the corner are *quartinha* jars, painted in a light blue appropriate to him. Photo: Robert Farris Thompson, 1985.

Altars to Oshóòsi in the coming century will renew their coherence in the continuity of key principles of the deity's forest world. Aildés of Jacarepaguá, the Afro-Brazilian priestess and architect cited many times in this book, points toward such a future with a remarkable altar to Oxossi that she prepared in the late 1970s and early 1980s (plate 207). She facets a hunter's world with contrasting vistas: a photomural of a deciduous forest on one wall, a tropical sequence of painted banana leaves on another. Warm browns and yellows, autumnal trees and foliage, contrast strongly with the mint-fresh greens of the walls of leaves. The herbs are tall. They stand as persons in a forest hierarchy, bowl of *axe* at their feet. A hunter/herbalist devotion, combining something of the mind of Oxossi and something of the mind of Osanyin, lord of the forest plants, permeates the right-hand panel to this altar: submit to the leaves, God-given instruments of healing.

In the corner, light-blue *quartinha* jars restate the presence of Oxossi, whose tints of blue, frequently turquoise, are in Brazil normally lighter than the indigo of Ogum, his elder brother. The hunter himself stands caparisoned in a rich array of jewelry. There are animal horns before his feet, marks of honor, trophies of the forest. Turning photomurals into visual music, Aildés brings the force and beauty of the forest into the room.

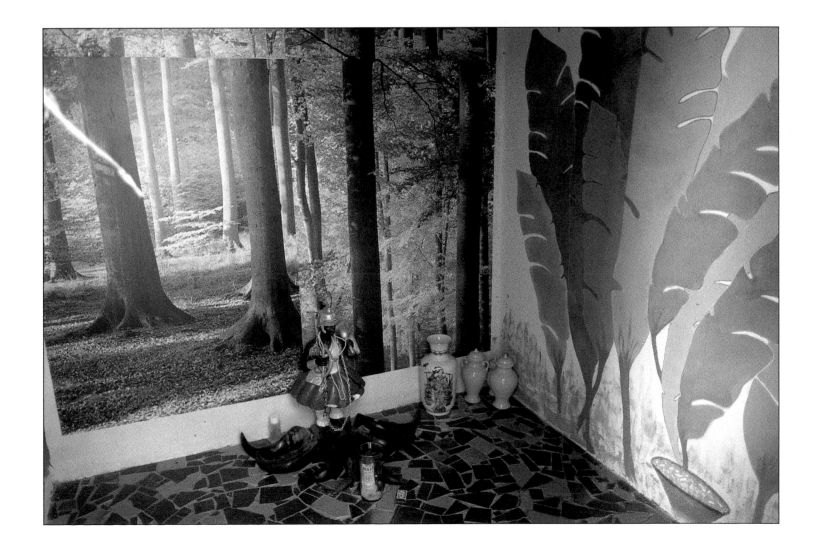

PLATE 207: ALTAR TO OXOSSI (OSHOOSI), MADE BY THE LATE AILDES BATISTA LOPES, JACAREPAGUA, BRAZIL, LATE 1970S/EARLY 1980S. Below a photomural of a deciduous forest and a painting of enormous banana leaves, Oxossi stands bejeweled, his antler prey at his feet. In the corner are *quartinha* jars, painted in a light blue appropriate to him. Photo: Robert Farris Thompson, 1985.

Oshóòsi Redux: The Caboclo Connection in Afro-Brazilian Altars

Whatever the Amerind does, the black man [out of respect] does not undo.
—Afro-Bahian saying, cited in Jocelio Teles dos Santos, "*O caboclo no candomblé*," 1989

West and Central Africans have always been sensitive to the spirits of those who have preceded them in the forests in their migratory search for farmland. Indeed, this was the paradigm: the honoring of Pygmies as "*maîtres de la forêt*" surely accounted for the absorption of forest yodeling in the traditional music of Kongo and other civilizations.

In Brazil, that principle of honor to those met in migrations continued in the recognition of *caboclos*, spirits of Native Americans of the interior. Such homage is in fact a closely guarded element of worship in the Afro-Brazilian *candomblés*. The Amerinds blend in the *candombleiros'* imagination with impulses from both Yorubaland and Kongo. As we saw in chapter 3, Umbandistas associate Tupi and other Amerind people with Oxossi because of the bow and arrow they share, a major instrument of both war and peace. In addition, the feathered headdresses of the Amerinds, real or imagined, were decisively attractive to eyes primed by the feathered bonnets of Kongo *minkisi* and *banganga*. In Umbanda, the *caboclo* element opened the door for a flood of renascent Kongo/Angola elements, including names in Ki-Kongo, gunpowder art, earth blazons, *nganga*-like headdresses recoded Amerind, and so forth. In fact the Brazilian scholar Valdina Pinho argues that the very term *caboclo* is a creolized Ki-Kongo.[105]

The Bahian *candomblés* of Gantois and Ile Axe Opo Agonjú in Lauro de Freitas, noted for the relative purity of their Yoruba traditions, both maintain *caboclo* shrines. Consider the *cabana cabocla*, altar to the *caboclo* spirits, at Agonjú (plate 208), and an accompanying feast for the *caboclo* spirits (plate 209).

Pure gestures to the Amerinds and their outdoor way of life in the middle of Brazil define this altar al fresco, as well as the symbolic use of the colors of the Brazilian flag, green, yellow, and blue. The *cabana* is alive with streamers and wall painting, in patriotic reference to the nation within the nation. This is a way of saying that *candomblé nago* recognizes the spiritual authority of the Brazilian earth's original inhabitants.

Tustáo, a *caboclo* spirit, appears at right; his altar consists of a circlet of feathers exalted at the summit of a large *talha* vessel painted Brazilian blue. A snakeskin glued to the vessel is a seal of the forest. At left are the medicines of another *caboclo* spirit, Flecha Negra (Black Arrow), which include a large earthenware pan covered over and then ornamentally sashed with an *òjá*. In the styling of this outwardly "Native American" element there is also a hint of the circlet of feathers that *nganga* wear.

Pai Balbino prepared his *caboclo* altar flat against the earth, evoking an imagined world far from Western furniture. Similarly, a major feast for the *caboclo* spirits, celebrated in August 1984, was laid out on the floor of the dancing court, the *barracáo*, of the *candomblé*. The beauty of the presentation directly reflected respect for the traditions of the interior as the servitors envisioned them. Plantains, melons, pineapples, roast corn on the cob— "*cosas do mato que eles comiam*" (things of the rain forest that they customarily sat down to eat), explained Balbino—were carefully displayed.[106]

PLATE 208 (RIGHT): ALTAR TO THE *CABOCLO* SPIRITS, MADE BY PAI BALBINO DE PAULA, ILE AXE OPO AGONJU *CANDOMBLE*, LAURO DE FREITAS, BRAZIL, 1970s/EARLY 1980s. The Yoruba candomblé of Agonjú maintains an altar to the *caboclos*, spirits of Indians of the Brazilian interior. Two *talhas* crowned with feathers hold the medicines of the *caboclos* Flecha Negra and Tustáo (left to right). An *òjá*-wrapped earthenware pan for Flecha Negra is outside the photograph, to the left. Photo: Robert Farris Thompson, 1984.

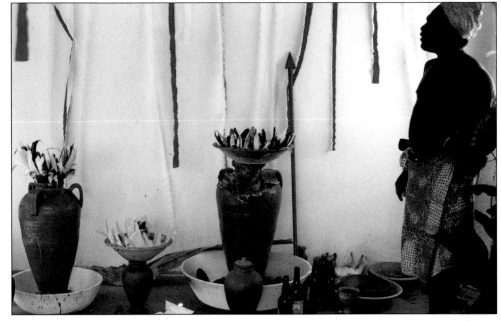

PLATE 209 (RIGHT): FEAST FOR THE *CABOCLO* SPIRITS, ILE AXE OPO AGONJU *CANDOMBLE*, LAURO DE FREITAS, BRAZIL, AUGUST 1984. Pai Balbino has offered the *caboclos* the "*cosas do mato que eles comiam*"—things of the forest that they would eat. Laid out on the floor of the dancing court are plantains, melons, pineapples, corn. As in the *cabana caboclo* in plate 208, the green, blue, and gold of the decorations are the colors of the Brazilian flag, to convey respect for the place in which one finds oneself. Photo: Robert Farris Thompson.

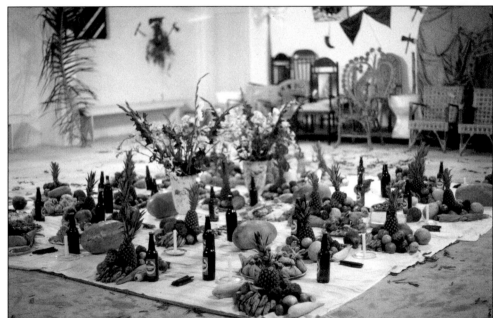

The feast was rich in structure and sequence: the setting of the cloth; the seating of the *candomblé* and guests, Balbino and two seconds at the head; the lighting of candles; the ritual sharing of tobacco; the singing of *caboclo* songs in Portuguese, with handclapping; possession of various *candombleiros* by *caboclo* spirits; a perambulation of the spirits around the cloth, to the beat of a samba on the *atabaque* drums. The samba and the green, gold, and blue national colors predominating in the crepe-paper decorations were a way of saying, "We are Yoruba but we also honor where we are and those who lived here first."[107]

Caboclo spirits themselves conducted the serving of the food—the gods as hosts. They also took charge of breaking up the presentation, sweeping up the flowers and the cloth in a final counterclockwise round, shuffling to samba. Out they filed, smartly wheeling, through and beyond the door of the *barracáo* and into a night lit by stars. The spirits served a large and enthusiastic group that night, and among the guests were the children of the poor.[108]

Oya, Sudden Woman of Wind and Fire

Woman is stronger, Oya is strongest.
> —Judith Gleason, *Oya: In Praise of the Goddess,* 1987

Afefe ejo, ko ma fe lu wa o
Oya owara, bii na joko laaro
Oya alagbara inú afefe.

Wind of justice, spare my home
Oya, sudden, simultaneous, like spreading flames of a single fire
Oya, all-powerful, who lives in the wind.
> —Sikiru Salami, *Canticos dos Orixas na Africa,* 1991

Tempestuous goddess of the river Niger, Oya is master of lightning and the tornado. She is the woman who took both the dangerous iron god and the lord of lightning as lovers and husbands.[109] Oya, "a mother of the night," traveled the world in the form of a big-horned buffalo. She married Ogún, god of iron and war, on condition that he never call her "animal"—i.e., that he never reveal her powers of the night, her familiar. Oya, "mother of nine," gave birth to nine children by Ogún. She remained ravishingly beautiful. Her cowives reacted jealously. Plotting, they got Ogún drunk, and he blurted out the fatal word. In a rage Oya gored the taunting cowives. Then she abandoned Ogún and headed for the forest. Before disappearing, she left behind her horns as mystic protection for her children and, by extension, her followers, saying,

> If anything dangerous threatens you,
> If you need my counsel,
> Strike these two horns together.
> Wherever I may be
> I will hear you,
> I will come to your assistance.[110]

That is why two buffalo horns always appear on the altar of Oya.

In another legend, Oya marries Shangó, the fiery thunder god, on condition that he seal his mouth as to her originating powers, her buffalo familiar, her mystic roaming. The children of Oya and Shangó are twins, specially charged with sacred force and honor. Once again, cowives, driven by jealousy, probe "the secret of the origin of that fabulously beautiful woman."[111] They succeed. Oya leaves Shangó, who begs her back with *akara,* a fritter made of black-eyed peas, her favorite dish. "As a sign of [resumed] alliance, she gives Shangó her two horns for him to strike. one against the other, whenever he needs her."[112] Immediate communication is the secret behind the placement of her horns upon the altar. Knock them together, in a swift, strong way, and the spirit of Oya returns, at once.

The goddess lives in suddenness (*ojiji*).[113] That quality links her to electric shock (also *ojiji*), which in turn recalls her ties with Shangó, master of lightning. Her violence,

With the Assurance of Infinity: Yoruba Atlantic Altars

mysterious and dangerous, resonates in further sound-connected words: fear (*iji*), shade or shadow (*iju*), and, emblematically, tornado (*iji*). Her cyclones are suddenness in air, brought to deadly and destroying pitch.

She is storm as cultural text. She makes us respect the moral warning in a whirlwind or a lightning flash. In her magnificence she also incites desire to honor and to sacrifice, especially with brilliant cloths to cover and praise the masked dead, over whom she presides as legendary mother.

Judith Gleason summarizes this province of the legends: "Oya is supposed to have had difficulty in bearing children. According to Ifá as recited in Nigeria, her . . . nine ancestral spirit-children were produced with the help of termite-mound magic. Soldier ants defaced Egúngún, the youngest of those 'born in the anthill'; so he had to go about veiled."[114]

There is a matching myth from Brazil: Shangó takes Oya sexually. The first eight children are born mute. The ninth, because Oya had properly sacrificed, does speak, but with a strange, gravelly voice some associate with the ijimere monkey.[115]

Egúngún as *orisha* is the ancestor inquisitor, an individual in the legends—son of Oya. More generally, *egúngún* are the ancestral spirits honored and embodied by masked dancers in both Africa and the Americas. Egúngún himself is father of Ato, who is born with a caul over the head, as is Amuisan, holder of the striped staff of authority, but not Agan, "the voice in the night." Oloye Fela Sowande and Oloye Fagbemi Ajanaku, in a critical text, *Oruko Amutorunwa*, sex these powerful grandchildren of Oya: Amuisan is male, Ato female. Both give their names to any child "born with the sack around their head like an *egúngún* masker" (*ti o fi apo re bo ori gegebi bi eegun*).[116] In other words, facelessness becomes a signal trait of Egúngún, ninth child of Oya, and his wondrous progeny.

Oya's connection with the wind will be forever after asserted in the whirling appearance of certain *egúngún* maskers in the dance. In Brazil, her presence is implied in such dancers' transmission of their blessing through the wind of their lifted panel of power, the *bante* (plate 192). Oya's powers, as well as her mysterious connection with intimidating mounds of earth—with the grove of the *egúngún*, the *igbale*—recoalesce in her transatlantic praise songs, to which we now repair. They are cameos of powers and embodiments. They, too, shed light on the structure and meaning of her altars.

From Oyo, city of her fiery husband, Shangó:

Obinrin Shangó
Adeleye, orun wara, bi ina jo oko
Bomibata Orisa ti gbo egbe re mo ile
Pon mi ki o ma so mi obinrin Shangó.

Oya ni o to iwo efon gbe

Wife of the thunder god
Woman of the crown of honor destroys worlds suddenly,
 like a farm in conflagration.

Strong-willed *orisha* who protects her followers upon
 the earth
Carry me on your back, great woman of Shangó.

Oya alone can seize the horns of the rampaging buffalo.[117]

From Ketu:

Oya oloko pupa.

Oya who married a man all dressed in red
[Oya whose husband was Shangó].[118]

From Anagó villages in Benin:

Oya aroju ba oko ku
O palemo bara-bara

Afefe iku

Abesan wo ebiti kosunwom
Efufu lele ti nbe igi ilekun ile anan

Okiki a gbo oke so edun
Igan obinrin ti nko ida
Oya iji ti se ewe tit bajo-bajo

A pa kete, bo kete.

Oya died courageously with her husband
She puts matters in order suddenly

The wind of death

Mother of nine shatters the evil mound of earth
Strong wind demolishes tree by the family door

Rumor in the clouds, hurls down stone ax
Courageous woman, armed forever with a sword
Oya, tornado, sets the leaves of the iti tree in
 brilliant motion

She kills suddenly, she enters suddenly.[119]

With the Assurance of Infinity: Yoruba Atlantic Altars

Songs of Bahia echo images of suddenness, fire, and aerial visitations:

> *Oya geri oke gere gere*
> *Oya li o ji gbe ina io*
> *Igi ibgale li enyin wo*
> *Oya fofo lele a de.*

> Oya mounts the roof suddenly
> Oya, up early, to dance with fire upon her head
> Tree in the sacred grove of the masked judges of the
> dead is watching you
> Oya, fabulous whirlwind, has arrived.[120]

Havana, Matanzas, and Latino New York City provide their own rich sources for the contemplation of her worship and the icons on her altars:

> *Ayaba, ayaba nlo se pele le oke ibi'ku*
> *Osa 'bi ku*
> *Oya we mi l'oro a*
> *O pa akara ko loro*
> *Kala-kala wo, onikara la wo.*
> *Oya Mesan iji*
> *Oya winiwini, Oya winiwini*
> *Ko ma, ko mala, Oya . . . alade*
> *Aya ara bo. Aya ara bo.*

> Royal wife stops the mounds of death from increasing
> The *orisha* who gave birth to the dead
> Oya wrap me in the tradition
> Associate with loudness to learn to be rich
> Look at her [nine] colors, look at the master of all things loud.
> Oya, Mother-of-nine, the whirlwind
> Oya multicolored, Oya multicolored
> Keep on flashing, scintillating, crowned woman
> Thunderwife penetrates, thunderwife has arrived.[121]

Egúngún: The Technicolor Cyclone

Mo forí bo rere O.

I use my head to deify goodness.
—Mason, *Orin Orisa*, 1992

The richness of Egúngún fabric . . . is generationally layered and diachronically segmented to suggest maximal human investment in the swirling art object.
—Gleason, *Oya: In Praise of the Goddess*, 1987

As looming phantoms in brilliant cloth, *egúngún* maskers immortalize the important dead. Dress becomes abstract being. The *egúngún* costume transforms masker into faceless, whirling spirit. It invests the devotee with animal vitalities of fur, voice, and accent. No one theory explains its complexity.

Myth says *egúngún* emerged from the sexual meeting of a woman (Oya in some versions) and a patas monkey.[122] In consequence of this origin they speak with a masked voice, "flutey and high treble," called *séègí*.[123] The voice of *egúngún* is masked in accents from another world. Yoruba relate *séègí* to the cry of the ijimere monkey, or of its spirit.

Following further clues, Henry and Margaret Drewall relate the long tail of the ijimere to the long, trailing cloth worn by some *egúngún*. More telling is the comparison they draw between the yarn topknot (*osu*) that surmounts many *egúngún* maskers and the topknot of fur on the head of the patas monkey.[124] Voice, tail, and topknot color *egúngún* simian.

Facelessness is the other essential trait. Most maskers' faces are completely obscured behind an abstract square of horizontally striped netting. A face absorbed in a sack of cloth compares directly to *egúngún*-related naming tradition: a male born with a caul over his head automatically takes an *egúngún* name. A female born with a caul over her head automatically takes an *egúngún* name.[125] In other words, the facelessness of the dead, returning, mirrors the facelessness of the infant, arriving.

In addition to the ijimere voice, tail, and topknot, and the abstract facelessness that transcends the simian aspect of the *egúngún*, there is also a relation binding Oya Igbale, Oya of the *egúngún* grove, to her ninth child and his spectacular costume. The whirlwind is the mother of these phantoms. And in this image many of them dance spinning, so that their lappets whirl out radially, all displayed at once, a Technicolor cyclone. In addition, the red sawtooth patterning on the edges of the lappets relates directly to the priestly dress of Oya's husband, Shangó—"the same flaring panels with their violent red edge."[126] Above all, it is "the flowing cloth shrouding the performer's body that receives [the] attention [for only] when all parts of the ensemble are brought together and joined in a ritual act does the spirit of the Egungun enter the costume."[127]

The northern neighbors of the Yoruba, the Nupe, have their own *egúngún*-like tradition of tall, whirling, flat-headed maskers. These dancers too wear crimson cloths, like those of Shangó. And they are called *ndako gboya*—senior, towering figures of Oya.

Finally, the dance of the *ndako gboya* includes rapid-fire changes of height and volume, as does that of important *egúngún* at Oyo.

Combining multiple influences, multiple values of splendor and intimidation, *egúngún* are called *ara orun*, shapes from heaven. The more time and money one sacrifices to the richness of their elaboration, the more one's generosity reveals heaven's glamour.

How did these complex instruments of reincarnation get from Nigeria to Rio and Bahia? Mikelle Smith Omari links their advent to reverse diasporization: "Free black merchants regularly traveled between Bahian and African ports. . . . As many as ninety-one such trips were documented for 1848. It is possible that these same merchants were able to trace their families in Africa and to locate their domestic ancestral shrines."[128]

The epicenter of Brazilian *egúngún* is the island of Itaparica, located in the Bay of All Saints, opposite the city of Salvador. Here an African-born Yoruba, Tio Serafim, founded the first center of *egun* (Brazilian *egúngún*) worship in Brazil, in the village of Veracruz, in the second quarter of the nineteenth century.[129] Later in the century more *terreiros de egun* were founded on Itaparica, at Mocambo and Tuntun. By 1950 an offshoot of the Tuntun temple had been established on the mainland, in the Vila America quarter of Salvador. Here Verger took a historically important photograph of an *egun* masker brandishing a morally intimidating *palmatoria* or whipping paddle in his right hand.[130] Other offshoots of Itaparica *egun* include the Casa de Manuel, in Lauro de Freitas, north of Salvador, and the *candomblé* of Aildés of Jacarepaguá near Rio. Both feature the open-air mound altar to Onile, *orisha* of the earth, that is the sine qua non of an *egun* temple.

There is also mention of Nupe maskers in Brazil.[131] And the shared Nupe/Yoruba *ndako gboya/egúngún* performance trait of shifting changes in the height and volume of the masker has transferred to certain Brazilian *egun* dancers.[132] The fusion of Nupe and Yoruba helps explain the strength of the tradition's continuity. Senior maskers (*egun agba*) in Rio and Itaparica, for example, talk in *séègí*, the characteristic flutey, high-pitched voice-mask of African *egúngún*. In the stylized *séègí* cadences, the maskers speak fluent Yoruba, magnificently restoring the ancestral speech on Brazilian soil. These speaking *egun* contrast with *egun aparaaka*, "newly deceased who have not achieved the status of the elder and can neither see nor speak."[133] *Aparaaka* are walking rectangles, in pure white and dark green or blue or black cotton without embellishment. They are distant relatives of western-Oyo *egúngún* called *paaraka*, who have "swirling panels of cloth suspended from a horizontal stick."[134]

Brazilian *egun* maskers also creatively transform African tradition, making dynamic changes and recombinations. Anagó *egúngún* in the Republic of Benin, for example, have canopylike constructions of square cloth that depend from a square top above the actual (hidden) head of the masker. Marc Schiltz reports various *egúngún* types in western Oyo made of appliquéd panels fixed to a round head-tray.[135] But in Itaparica, Bahia, and Rio de Janeiro there are both square-topped and round-topped *egun*, hinting at a blend of Anagó and Oyo sources in the creole expression.

Among some Egbado *egúngún* the essentials of masking include: facelessness, the complete hiding of the wearer's countenance behind an abstract rectangle of netting called the *àwòn* (the net); a woollen tuft (*osu*) at the crest of the costume, in allusion to the patas's tuft; long lappets of cloth with saw-toothed crimson borders, the latter called

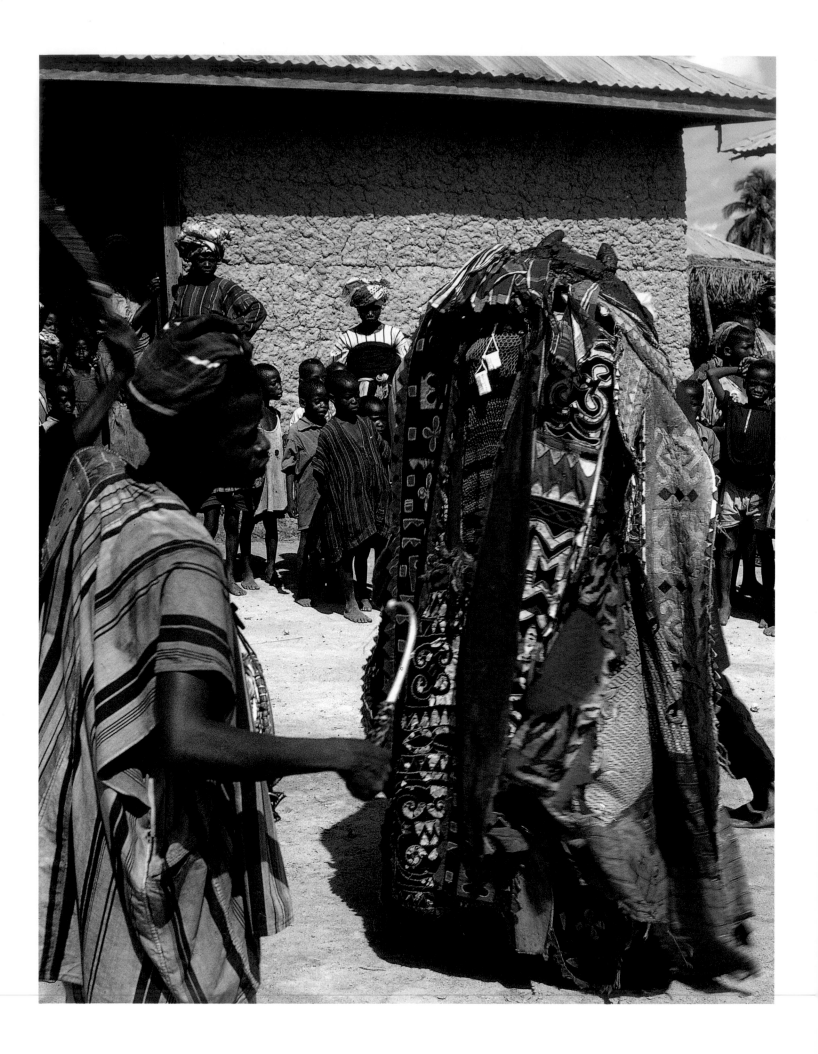

With the Assurance of Infinity: Yoruba Atlantic Altars

laaja (perhaps a pun on *ilaja*, mediation between two worlds); overt medicines of protection and power; and a secret medicated loincloth (*bante*) worn inside the costume.

Brazilian *egun* maskers represent the spirits of important family heads, *egun* priests (*oje*). Their brilliantly combined costumes, called as a unit *axo egun* (cloth of the spirit), combine the small rectangular piece of netting (*imbe*) through which the *egun* see and speak, covered with beaded fringing like the crown of a Yoruba king; cloth panels or lappets streaming down from the square or rounded head (Brazilians call the lappets *abala*, which in classical Yoruba means "piece of cloth"); a face panel (*oju*) of red velvet immediately below the *imbe*, sometimes trimmed at the chin with brass bells, and with three round mirrors simulating the ancestor's eyes and mouth in abstract form; and below the *oju*, the *bante* (loincloth), a panel serving to identify the individual *egun*. Imbued with sacred ingredients, ritual herbs, and leaves, the *bante* contains the spirit's *axe*, and is distinguished by a unique configuration of symbols traced in beads, cowries, and mirrors.

The changes are as amazing as the continuities: gone is the *laaja*, the sawtooth crimson border, but, as if to make up for this loss of protective powers, the medicated inner *bante* is now up front, visible, laden with medicines behind mirrors and cowrie-shell embroidery. The *bante* studded with mirrors in individual patterns apparently sprang up only in Brazil. We can savor continuity and change in all this by comparing a round-head

PLATE 212 (RIGHT): OBA EFUNTOLA OSEIJIMAN ADEFUNMI I INITIATES A FESTIVAL FOR OYA AND *EGUNGUN*, OYOTUNJI, SOUTH CAROLINA, 27 JULY 1991. Adefunmi founded Oyotunji (Oyo-again-rises) in 1970 as a "state . . . based upon traditional African customs." The community synthesizes influences from many parts of Africa, as here, where Adefunmi holds a Benin-style fan in his right hand and a Yoruba royal fly-whisk in his left. The Yoruba *orisha* Oya herself appears at right; compare plate 219. Photo: Christopher Munnelly.

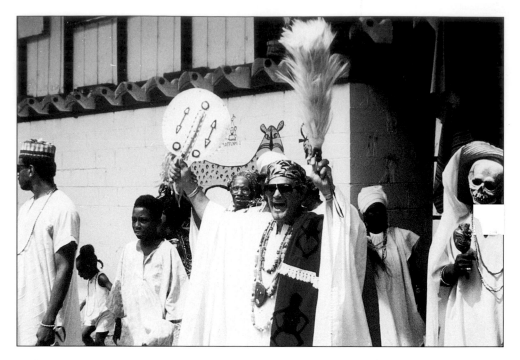

PLATE 213: CARYATID COLUMNS IN THE STYLE OF ANAGO ROYALTY, OYOTUNJI, SOUTH CAROLINA, SINCE 1970. On the wall is a Dahomean-inspired frieze of Shango-Xebiosso, a ram spitting fire. As in plate 212, Oyotunji selects the sources of its culture in primarily Yoruba/Dahomean terms. Photo: Christopher Munnelly, summer 1991.

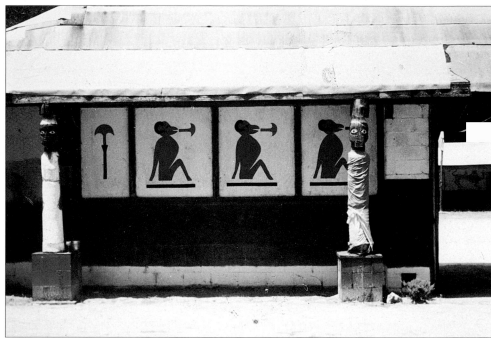

egúngún with appliquéd lappets, called *adawo*, photographed at Ipapo in western Oyo in the summer of 1965 (plate 210), with Egun Ajikeogun at Lauro de Freitas (plate 211) and with Egun Baba Erin (plate 192) from the same locality, both photographed in 1982.

In Nigeria, devotees of ancestral spirits invoke *egúngún* at individual graves (*ojú orí*), family shrines (*ilé run*), and in the sacred grove of the *egúngún* (*igbale*).[136] In Ilesha in March 1982, Omari studied an *egúngún* shrine to lineage ancestors Paje Polobi and Olomonjagba in the main house of the Idasa compound: cloaklike garments corporealizing Paje and Olomonjagba, cowries for divination, a bundle of *isan* switches used to control *egúngún* when they appear in public, skulls of sacrificed animals, secret medicines concealed in vessels.

With the Assurance of Infinity: Yoruba Atlantic Altars

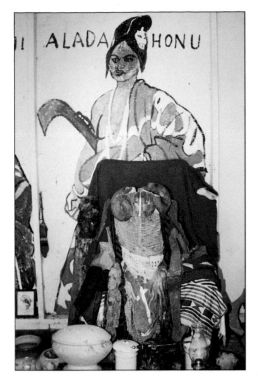

In Brazil, gameleira trees serve as surrogate altars for *egun* on Itaparica, "symbolizing the link between the ancestral spirits and the force contained in the earth, Onile. *Egúngún* at Itaparica are individually represented by holes (*ojubo*) dug in the floor of the shrine into which blood sacrifices and . . . corn gruel and palm oil are placed."[137]

Egúngún images exist at a remove of one in black Cuba. In a classic study, Lydia González Huguet reported that "if the owner of a house is a devotee of Oya, or the person has learned of an accidental death, creating the danger of spirits haunting the house [or] attracting death, one sets up a banner made of pieces of cloth in nine different colors, dedicated to Oya, begging her to make death, or Iku, depart."[138] Suddenness in death is the realm of Oya. Begging her help in such a situation, with a piecework banner in nine different colors, cites the number and the image of her famous child, Egúngún. As an act of spiritual protection the rite recalls Nigerian Yoruba belief: Shangó, husband of Oya, once deadly ill, wore an *egúngún* gown (*eku*). Spirits fomenting his illness scattered when they saw him coming in the multicolored costume of the dead. Despite this vivid condensation of the multicolored garment of Egúngún, it cannot be said that there are *egún* in the *Regla de Ocha*.

This opened up a gap that North American black nationalists were to fill. The main North American venue for *egúngún* is Oyotunji, South Carolina, a vibrant black community devoted to the religious culture of the Yoruba. The spiritual leader of Oyotunji is a brilliant artist/priest named Oba Efuntola Oseijiman Adefunmi I. He created the Harlem Yoruba Temple in New York City in 1960. Then, in 1970, he founded Oyotunji (Oyo-again-arises), near Shelton in southwestern South Carolina, as "an all-Black state in America in which the political, religious, economic and social systems would be based upon traditional African customs."[139]

Adefunmi's gifts for intra-African cultural synthesis are everywhere apparent in his Yoruba Renaissance village. Royal caryatid columns in Anagó style flank a Dahomean-inspired frieze of Shangó-Xebiosso, a ram spitting fire (plate 213). On July 27, 1991, Adefunmi, brandishing a Benin-influenced fan in right hand and a Yoruba royal fly-

whisk in left, initiated a festival for Oya and the *egúngún* (plate 212). A devotee in orange
and red and white beads suddenly appeared to his right, wearing a skull mask: Oya. This
image compares strikingly with Gutenberg's altar in Bahia (plate 219).

Adefunmi and the artists of Oyotunji bring to the radiance of *egúngún* dress their own
manner of expression. In an altar to departed elders, photographed in the summer of
1991, Oyotunji honors its dead bilingually. Cloth phantasms boast lappets with red
Yoruba *jéwòn-jéwòn* (zigzag lining). But the names of the dead written on the wall above
their *egúngún* are Fongbe (plates 214, 215).

Set up essentially as an honorific cloth-sculpture, one *egúngún* altar image, armed
with a gun to defend his spirit, bears twinned lappets that read almost like chasubles
(plate 217). A central band of cloth marks the faceless emblem. Red appliquéd
silhouettes of the crocodile of Shangó add to the splendor.

A strong, solitary *egúngún* masker appeared in the courtyard of Adefunmi during the
festival for Oya (plate 216). Its costume combined canonical zigzag lining in red with
U.S. women's quilt-top diamond stitching. Still and all, the facelessness of this dancing
image reestablished the provenance of thought.

Altars of Oya and Egúngún

The truth of the particular being called Oya, as hinted in her songs and told in her
legends, is linked to mounds of earth. These can become her altars, like a termitary with
a bit of raffia where Oya entered the earth and became immortal. In Jacarepaguá, near
Rio, at a *candomblé* famous for the worship of Oya and *egun*, there is an altar to Onile,
owner of the earth (plate 218). According to Carlos Roberto Bautista da Rocha, this altar
represents the forces "of the right-hand side," whereas the matching mound of "the left-

With the Assurance of Infinity: Yoruba Atlantic Altars

handed ones, 'the mothers,' cannot be seen: it's in the bush." The conical mound is "Onile, rising up out of the earth, [but it is also] Egúngún, rising up out of the earth." As one cultivates generosity in giving mirrors and sequins to *egúngún* dancers for their flashing lappets, so the followers of Onile embedded coins and a death-repelling mirror into the mound "as sacrifice to departed *oje*, departed wearers of the *egúngún* gowns."[140] In honoring Onile, spirit in the earth, the *egúngún* dancers themselves, in bowing down before this point, honor the cognate mound of Oya, the termite heap into which she disappeared.

One knocks three times, number of the earth, before opening the top of the *quartinha* embedded in the mound to pour in sacrificial liquid. "Tiger leaves" or *espadas de Ogum* surround the altar. They are green swords, held by unseen hands, to keep outsiders at bay while at the same time holding power in.

In Oyo territory in northern Yorubaland, altars for Oya often appear in Shangó shrines, and consist of the classic two buffalo horns elevated on a pedestal and placed in a bowl or receptacle as an essence of Oya's *àse*. But Yoruba also enthrone the horns of the sky in other ways. At Banigbe, south of Sakété, among the westernmost Anagó in what is now the Republic of Benin, Verger photographed an altar to Oya in the early 1950s.[141] An upright spear in iron communicated militancy. Her suddenness was intuited in a zigzag serpent/lightning bolt, also in iron. At the top of the lightning appeared the horns of the buffalo, richly curving inward, elevated above the altar. Oya's connection with the ancestors was implied in a third element, a miniature iron altar, called *assein*, to the departed elders. These standards emerged from a small circular enclosure.

Nothing, essentially, changes when we move to the altar of Oya Bale, a Brazilian avatar of Oya, also connected with Egun and the dead. At the *candomblé* of Gutenberg in Bahia, photographed in November 1989 (plate 219), horns and allusions to the dead appear on high, surmounting a shrouded figure. But a new visual vocabulary has been set in motion. Cow horns substitute for buffalo. A skull, not an *assein*, links the goddess to the dead, as does a Christian cross at the summit: "as if from a tomb, symbolizing her relation to Egúngún."[142] The walls of this closetlike altar bear traces of blood from goat, goose, duck, guinea fowl, and pigeon, all sacrificed to Oya at the festivals for her held every July 27. Strips of fine white cloth enshroud her "as a woman of the dead, mistress of the cemetery."[143] Gutenberg has filled a porcelain dish with red kola for Oya and bitter kola for her husband, Xango. Palm fringe (*mariwo*) marks her sacredness and separates her from evil. Finally, *ixan*, staffs of hard coffee-wood, implicitly keep spectators away, precisely as in *egúngún* festivals in Yorubaland.

In Cuba, Oya presides over a ritual called *honras y levantamiento del plato*—honors rendered the dead and the elevation of the dead man's plate. I witnessed such a ceremony on March 14, 1992, in Old Havana, in a narrow patio off Empedrado Street. In honor of a prominent, recently deceased priestess in one of the Cuban Yoruba religions (the *Regla de Ocha*), a feast was given, with two sittings. Then the members of the second sitting lifted the tablecloth in their hands and let all the plates and glasses remaining on it smash into each other and shatter, symbolizing death's breaking power.

The debris filled the cloth like a body. They lifted it high above their heads and began a procession, dancing the cloth and crockery shards away toward an altar to the dead and to Oya in another patio, deeper within the house. Here Oya was symbolized by a

PLATE 219 (ABOVE): ALTAR TO OYA BALE, *CANDOMBLE* OF GUTENBERG, BAHIA, BRAZIL, 1970S/EARLY 1980S. Oya Bale is a Brazilian avatar of Oya. In Yorubaland, shrines to Oya include a pair of the buffalo horns with which this *orisha* allows herself to be summoned. In this candomblé buffalo horns become cow horns, and a skull reinforces the allusion to the dead. Photo: Robert Farris Thompson, November 1989.

PLATE 220 (RIGHT): ALTAR TO OYA WITH FEAST FOR THE DEAD, HAVANA, CUBA, 14 MARCH 1992. Oya's banner has nine colors, one for each of her children. The feast was laid in honor of a most important priestess of the *Regla de Ocha*, a Yoruba-Cuban religion, who had recently died. After dining at a cloth in an outer courtyard, processioneers danced past this altar, where the dead possessed them. Photo: Christopher Munnelly, 14 March 1992.

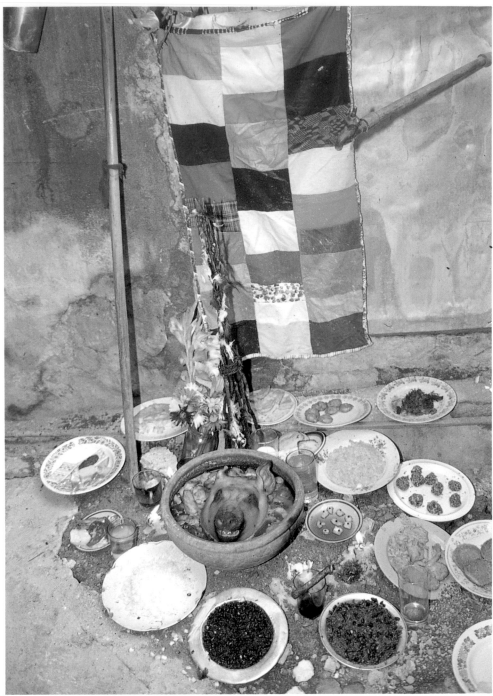

quiltlike banner in nine colors (plate 220). Below her was laid out a feast for the dead.

As the procession passed the altar to Oya the dead came down. They possessed the mourners, who put down the tablecloth and started screaming. These were the cries of the old dead mourning the recent dead. The sounds were extreme: high-pitched shrieks, augmented through the lens of the other world.

The elaborate feast in miniature beneath Oya's multicolored banner included plates of white rice, black beans and yellow beans, coconut, jerked beef, and *tamalitos*. It climaxed with the head of a pig. It was said that this feast soothed the spirits and brought them back to silence. Priestesses distributed branches of *paraíso* leaves to those possessed by the dead and their followers. They and *batá* drummers progressed, around and around, in a counterclockwise circle in the patio, brandishing the herb and blessing the gathering with its powers of attraction of good and separation from evil.[144]

With the Assurance of Infinity: Yoruba Atlantic Altars

The Riverine Goddesses: Owenna

Rivers cut through the land with flashing lines of vital, moving force. They are extensions of God's healing grace. Without them there can be no life.

But the blessing of sweet water one never takes for granted. Rivers are mirrors. Evil angers them. They can flood a careless village, or drown a man who beats his wife and forgets his children. Initiates read parables of love, danger, and moral superiority in their swirling depths.

This is the story of Oshun, Oya, and Yemoja, goddesses of the river. And this is also the story of Owenna, their sister, who flows by the hills of Ekiti, east of Ilesha and Ifè. The altar of Owenna can be spartan: there is a place in western Ekiti where it is essentially two paths coming together at the water's edge, with stones, just within the water, serving as seats (*ijókó*). But this natural altar, water and stones, is the setting of a minor miracle.

Hens, not normally aquatic, are attracted to the goodness of Owenna. Women assured me, in October 1963, "All our hens belong to Owenna. They come at four o'clock to bathe within her waters." I stood above the shrine at half past three. There was only one hen; but she was distinctly walking in the water (plate 221). And by four o'clock, five more had joined her (plate 222). This subtle miracle was occasion for the appearance of the high priestess of Owenna. She held out her hands. She and the women chanted at the altar a song of moral challenge, impossible to forget:

Okun nlo ni O
Oluwa ma a je ate.

As the sea rolls on
God grant that we do not degrade ourselves.

PLATES 221 AND 222 (LEFT TO RIGHT): ALTAR TO THE GODDESS OWENNA, EKITI, NIGERIA. Like Oya of the Niger, Yemoja of the Ogun, and Oshun, who names the waters she rules, Owenna is the goddess of her own river. Her shrine is simple: two paths joining at the bank, with stones set within the water. Each afternoon at four, aquatic hens of Owenna come to bathe. Plate 221, half past three: one hen. Plate 222, four o'clock: six hens. Photos: Robert Farris Thompson, October 1963.

Women were singing. Hens were in the water. In trading elements, land for sea, the hens bore witness to a primordial area. Their presence in the water defined the altar. We were not looking at a river. We stood above an underwater world of attractive moral force.

Oshun: The Flash of Brass in the Fire of Her Eyes

In the first quarter of this century, Oginnin Ajirotitu, master brass-smith of the Nigerian city of Ilesha, made a magnificent fan for Oshun, the goddess of sweet water (plate 223). He made it in her characteristic royal metal, brass.

At the top of the fan Oshun spreads her hands in ecstasy. She holds a brass chain, symbolizing the bringing together of her followers. Owenna-like miracles take place: a hen kisses a serpent. Another hen swims in water beside a serpent and a fish (plate 224).

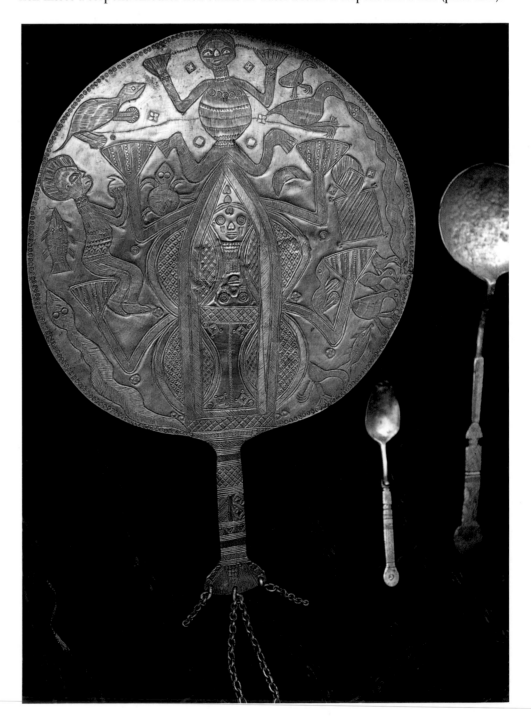

PLATE 223: FAN FOR OSHUN, MADE BY OGINNIN AJIROTITU, ILESHA, NIGERIA, EARLY TWENTIETH CENTURY. Oshun is the Yoruba goddess of sweet water and love. On this brass fan she appears in erotic ecstasy and presiding over watery miracles of communion. Photo: Robert Farris Thompson, 1965.

With the Assurance of Infinity: Yoruba Atlantic Altars

The elements and their respective denizens blur together in a realm beyond all ordinary happening. The hen's and serpent's kiss is echoed by the spirit of Owari, the Ijesha war god, who touches Oshun's sex with the tip of a phallic element. Poised at a moment of ecstasy and contact, this image of Oshun predicts her transmission of an indelible image of amorousness and caring across the seas.

In generating love, Oshun generates herself. She is various, she is multiple. There are as many avatars as depths within her river. This comes out in a strong, illuminating vernacular source, none other than the king of her city of Oshogbo:

> The people of Oshogbo and the ruler of the town, the Ataoja, made a pact with the river Oshun. They believe that the spirit of Oshun, the goddess, lives in the river Oshun and has a palace in the river near Oshogbo. They also believe that all the deep places in the river, from its source at Igede to the Leke lagoon where it empties out its waters, are inhabited by the spirits of all her followers and servitors and friends when she was alive. They call these depths *ibú*.
>
> All the tributaries that flow into the river Oshun are her fingers. All the fish that dwell in her river and her tributaries are her messengers.[145]

So the *ibú* are the depths of the river and the special spirits who live in them. That clustering registers ecstasy and love, even as the hens of Owenna, acting as messengers, frolicked in the water where her presence could be felt, at a point of ecstasy such as attracts all fish to her presence, all men to her side.

Wherever one stands above deep, indigo-colored portions of the river Oshun, there are avatars within. There is Oshun Abalu, the oldest Oshun. There is Oshun Jumu, a flirt; Oshun Aboto, very feminine; Oshun Opara, the youngest and most martial; Oshun Ajagura, another warrior manifestation. There is Yeye Petu, the old and quarrelsome Yeye Oga, the extremely feisty Yeye Kare, and Yeye Oke, also bellicose, as is Yeye Onira. Yeye Oloko lives in the forest. Yeye Ponda is married to Oshóòsi Ibú Alama, and carries a sword. Yeye Merin is another coquette, Yeye Oloke is another warrior, Yeye Lokun has no devotees, and Yeye Odo is goddess of the river's source.[146]

It is an army of marching underwater women. Some are sexual; all fight for their children and their husbands; all are Oshun. She is woman extraordinaire. These qualities, in tumultuous mix, come out in Yorubaland in her praises:

> *A tun eri eni ti o sunwon se*
> *Alase tun se a ki nla oro bomi*
> *Ipen obinrin a jo eni ma re*
> *Osun ma je mo aiye o jó le li erí*
> *Ala agbo ofe a bi omo mu oyin*
> *Otiti li owó adun ba soro po*
> *O ni ra mo ide.*
>
> *O ro wanwan jó wa*
> *O jo lubu ola eregede*

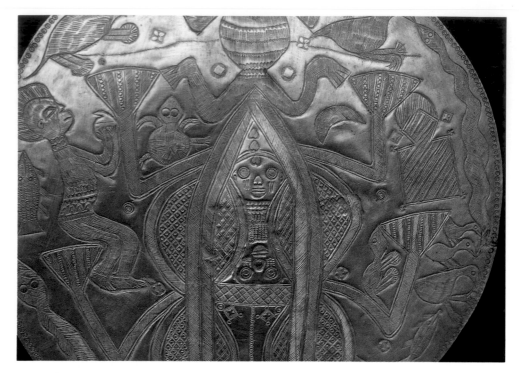

Yeye mi o wa yanrin, wa yanrin.

Alade obinrin sowon
Afinju obinrin ti ko a ide
Osun olu ibú ola
Olo kiki eko.

Ide fi ojú ta iná.

Omi ro wanranwanran wanran omi ro
Afi ide si omo li owo.

Witness of a person's ecstasy renewed
Once again in command of things, she greets the most
 important matter in the water
Most powerful woman who can burn a person
Oshun don't let the world dance evil on my head
Curing without fee, she gives the healing, honeyed
 water to the child
Rich as she is, she speaks sweetly to the multitude
She has bought all the secrets of copper.

Here she comes dancing, making her bracelets tinkle
 like the forest brook
She is dancing in the depths of underwater riches
My mother has hollowed out something in the sand,
 hollowed out something in the sand.

With the Assurance of Infinity: Yoruba Atlantic Altars

Crowned woman is very rare
Elegant in the way she handles money
Oshun, master of the depths of wealth
Owner of innumerable parrot feathers.

The flash of brass in the fire of her eyes.

Water murmuring over stones is Oshun dancing with her
 jewels of brass, dancing with her tinkling rings of brass
Only the children of Oshun have such copper bracelets
 on their arms.[147]

The sound of water in the river, moving noisily over stones, becomes a person jingling Oshun's copper bracelets upon her arm. To have Oshun is to make a river with your body in the dance, and to preserve the water's murmur in the sympathetic jangling of your bracelets of brass. Flesh and brass, water and stones. The dancer becomes the river altar.

Ifá says that Orunmila, god of divination, struck by Oshun's beauty and good works, decreed that she should march with a brass staff of authority, exactly like a man.[148] Her tall staff stands doubled on her main altar in Oshogbo (plate 225). If her tributaries are her fingers, these are her arms—shining arms of brass. At their bottom they have bracelets that jingle musically when her priestesses shake them, bringing to the altar the sound of water over stones.

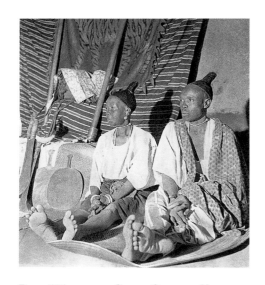

PLATE 225: ALTAR TO OSHUN, OSHOGBO, NIGERIA, TWENTIETH CENTURY. Oshun carries a staff of authority, like a man. It is made of brass. There are two such staffs on Oshun's main altar in Oshogbo; at their bases are bracelets, which jingle like running water when they are shaken. Between them is the image of a great cat, whose power Oshun shares. Priest and priestess wear their hair in the goddess' own coiffure—pointed like the altars shown on a pot from ancient Ifè (plate 165). Photo: Pierre Verger, early 1950s.

In Oshogbo, these staffs, rivers of brass, frame the image of a leopard. Oshun is an *amotekun*, one who knows the leopard's secrets. In heaven as on earth, such power is paired by gender: Oshun is the female leopard, Orunmila the male. This matches the careful pairing of the priest and priestess seated by the altar in the photograph. Note their sharp-pointed coiffure, the hair style of Oshun: her *àse* comes to a point. All her thoughts and understanding, all her destiny (*orì*), are centered on this point, as lightning lights the way with its flash, as the tip of the royal sword can execute when necessary. It is a warning ornament.

Oshun's power to make things happen comes from heaven, which is why the vessel containing her stones and river water, stationed at the center of the Oshogbo altar, is backed with a rich striped cloth, predictive of the cloth-fashioned *tronos* of Yoruba New York. Aràbà Ekó explains: fine cloth is displayed to recapture heaven's glamor.[149] The image of a royal feline and the glory of the textile-laden walls of heaven back the sounding of water in the jingling of bracelets on Oshun's vast arms of brass.

Below stand the brass swords of Oshun's martial avatars, together with the large *agogo* gong that salutes her place in the water. Just as Oshun's peaceful dimension, compared to breeze and honey-medicated water, lies in fans upon the altar, her moral vengeance waits within the arsenal of brass. Fans and swords parallel priestess and priest, as well as all the carefully paired male and female avatars of Oshun in her watery domain. The altar is a meditation on the building of complex character and valor. Her women are expected to combine these powers.

All this prepares us for Oshun in the Americas, where her love of parrot feathers creolizes into the sumptuous peacock-feather fans of black Cuba, and also of Latino New York City. Matanzas and Havana emphasize her valor, her depth of understanding:

Korí d'ekun
Iyá mi ilé odo, iya mi ilé odo.

O se omoro de o de o yakota, o yakota
Aye to olókùn ara ra
Okuta osun a pe ide.

Ko wa ni ye ko wa ni ye yo ro ko nta.

Yeye t'aladé Osun, t'aladé moro
Yeye t'aladé
T'aladé moro gbogbo òrìsà

Aya b'ekun bamba

Osun a la si réré o maa

Age de si kare o
Omi o akete oba osun
Opá ga maa naro.

Grant us the destiny of the leopard
In the house of my mother, the river.

She hails the arrival of the child of tradition. She
 collects river stones, collects river stones
World comes to this owner of the waters to free a
 relative
Ochún's river stone is brass.

Teach us to have understanding.

Mothers march with the owner of the crown
Mothers march with the owner of the crown
Crowned woman who builds the tradition of all the *oricha*.

Royal wives give birth to stalwart leopards

Ochún, we dream of uncovering goodness always

With the Assurance of Infinity: Yoruba Atlantic Altars

Vessel for cooling water, come uncover goodness
Water is the throne of Ochún, the king
Tall staff of the lord, always standing tall.[150]

The Cubans remember the staff that Oshun carries in Yorubaland. In songs collected by Mason, they also show their recall of the medicated water that allows her followers to see again: "World comes to this owner of the waters to free a relative," or, as Mason writes, "She helped her people to survive the Middle Passage, to come out of the death holes of the slave ships and to come once again into the light of day. Like many powerful Lukumí women in Cuba, she is looked to for help in buying the freedom of Lukumí slaves taken in war."[151]

Oshun's care of captives crossing the water in the slave ships is also commemorated in a marvelous outdoor altar to her name in Bahia, at Casa Branca, where a famous *candomblé* is built like a miniature San Francisco against the grain of a rising hill (plate 226). Stairs mount the hill to the various houses of the *orixa*. Anchored to the earth at their foot is a shiplike altar to Oxum, her creole name. In Bahia as in Cuba, her essentials are remembered in poems:

Yeye o a pa osi
Yeye o a pa otun.

Olo titi eko

Omi ro, wanran wanran wanran, omi ro
Afide somo lowo
Omi ro wanran wanran wanran omi ro.

Powerful mother kills on the left,
Kills on the right.

Owner of innumerable red parrot feathers

The water murmurs over stones,
wanran-wanran-wanran the water flows
Only devotees of Oshun have brass bracelets that
 duplicate, in dance, this sound.[152]

A shrine room in Oshogbo was once filled with images of Oshun's followers transformed by dotting into fighting leopards. To be a child of Oshun is to have a valiant heart, home for the leopard's *àse*. When the devotee of Oshun, so Ifá explains, finds herself at a point of danger, she can take the leopard's existential leap quite fearlessly. She can command her heart to cover her target like a cat. The dotted altar figures of Oshun in Oshogbo, in other words, were not spotted decoratively. They were the felinized army of the goddess and her underwater palace.

That army regathers in Bahia, where Verger, in one of his superb documentary photo-
graphs, recorded an Oshun novitiate in the 1950s. She greets Oshun reverentially, making
a ritual handclap (*pabo*) in the name of the goddess, and carrying coded river noises in
the many bracelets she pairs upon each arm. Her head has been "made." Initiation has
transformed her into a fighting leopard of the crowned owner of the river. Her body is
fully spotted.

That image, of woman empowered, carries over into an altar for Osun Opara, a martial
avatar of the goddess, that Verger photographed in the 1950s at a *terreiro* in Bahia (plate
227). There are songs in Cuba and Nigeria about Oshun saving women, saving men; this

With the Assurance of Infinity: Yoruba Atlantic Altars

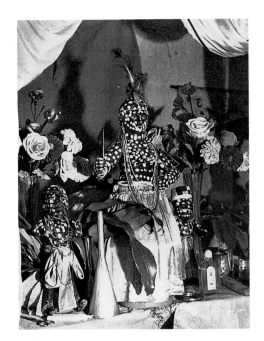

PLATE 227 (ABOVE): ALTAR FOR OSUN OPARA, MADE BY COSME, BAHIA, BRAZIL, EARLY 1950S. Cosme based his altar on the Western stage, with curtains parted as if under a proscenium. Osun Opara, a warlike avatar of Oxum, appears spotted as a leopard, and holding a sword. Her children—twins (*ibeji*), fathered by Oxossi—are spotted also. There are offerings of perfume, roses for Oxum and for Yemanjá, bracelets of yellow metal, and metal bells to summon her. Photo: Pierre Verger, early 1950s.

PLATE 228 (FOLLOWING PAGE, TOP): *TRONO* ALTAR TO OCHÚN, DESIGNED BY JOSIE GARCÍA, WITH COLLARES DE MAZO BY MELBA CARILLO, NEW YORK, MAY 1986. The *sopera* of Ochún is elevated at center; she is supported by other *oricha*—a ship's wheel, for example, identifying an avatar of Yemayá—and particularly by Changó, in some accounts her husband, whose ax appears at right and as a mighty bow of cloth high above. Sweet offerings—cake, meringue, bread, fine candies—earn the devotee proximity to the goddess. Photo: David H. Brown. Copyright © David H. Brown 1989. All rights reserved. Reprinted by permission. See *African Arts* 26(4)(October 1993).

small altar was in effect an ex-voto to that aspect of her power. Its maker, Cosme, was from Recife.[153] There he had gotten into trouble, and had fled to Bahia to start his life anew in serving Oxum. She rewarded him with a valid life and he rewarded her with this altar.

Cosme built a Western stage, its curtains parted. Within the framed space he inserted icons and offerings of liquid, flowers, and metal. The photograph shows yellow roses for Oxum. (There are also white roses and blue flowers for Yemanjá.) Bracelets in yellow metal recall Oxum's jewelry and its associated values. Perfume is one of her favored luxuries, and *agogo* bells summon her from her watery domain.

In the midst of this elegance stands Osun Opara. She holds in her right hand a sword, her left is akimbo on her hip. Transparent beads in shades of yellow bring back her brass, bring back her honey. The color of her shining skirt is yellow too. Like her, the two small figures who accompany her have turned into spotted leopards. They are twins. They are her children. Their father, in the legends of Bahia, was Oxossi, lord of hunters.[154]

In Yoruba New York, Ochún usually marches with other *oricha*. Those who honor her include a woman in the Bronx, who made a splendid *trono de Ochún* that Brown photographed on 16 May 1986 (plate 228). The Bronx recaptures heaven's glamor with sweeping wings of honey-colored cloth, honoring Ochún's connections with that element. She walks with her husband, the thunder lord, whose ax is textilized in the sky. Gold cloth suggests the richness of heaven. Offerings of cake, meringue, bread, and fine sweets, all placed on the floor, earn devotees the right to seat themselves near the divine. The altar enthrones the personification of love, honey, and valor. Here we can study the richness of a person who can love you unreservedly as she loves herself, who has no lack of confidence to slow her loving down.

Before Duchamp: Readymade Cosmograms for Oshun and the Women of Water
Yoruba women and men translate the roundness, the completeness, of the calabash into an emblem of cosmos. The bottom section holds the earth, the top section covers heaven.

Men serving Orunmila, the god of divination, take this concept one step further: their divination trays (*àwon opón ifá*) are often circular, to stand for the calabash of the world. Or the trays render the four corners of the cosmos as a square, planting the client's problem within the cardinal points, where it can be located, analyzed, and resolved. The entire process is guarded by four *odù* (permutation spirits) at the "serious" (cardinal) points.[155]

Women protect themselves from spiritual disturbance with their own cosmographic language. This they inscribe by setting found porcelain plates at the cardinal points of a calabashlike circle, to surround and keep the most important emblems of the goddesses of the rivers and related *orisha*.

Ifá records how Oshun came to be associated with porcelain, as an emblem and, by extension, as a medium of cosmographic order. There was a day when all the deities went to God to receive their emblems. Orunmila got alternating beads of green and yellow (or of blue and tan), Oya got maroon beads, blood dark, and Oshun received brass plus plates and containers of porcelain (*omologanran*).[156] Here Western crockery coming to the shores of the Yoruba, in trade that may have begun as early as the arrival of the Portuguese, in the late fifteenth century, was spiritually reinterpreted. It was something

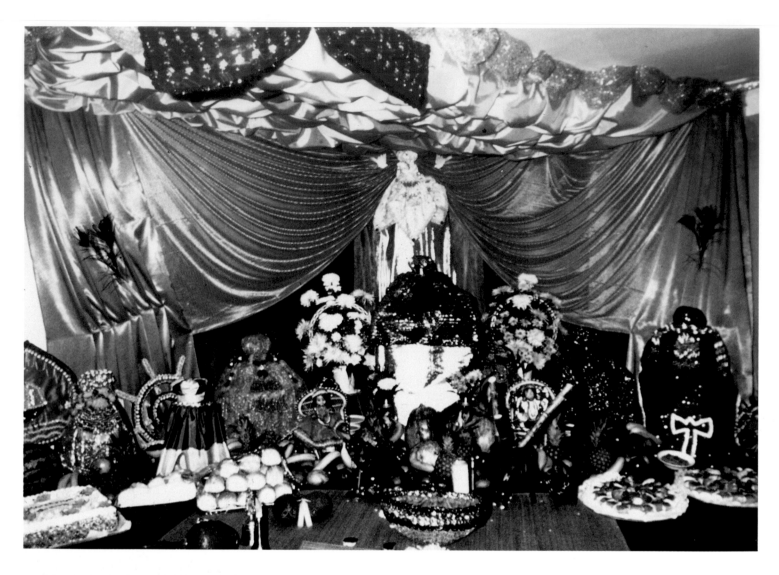

white, like seashells, that arrived from across the seas; hence, like the shells of Olókùn, god of the sea, it became associated with the power and beauty of spirits of the water. Iconographically, then, porcelain aligns with the service of the riverine deities, like Yemoja and Yewa and Oya, as well as with Oshun, goddess of love and sweet water, and with Nana Bukúu (and also with "gentle" gods like Obatálá).

How did the women of Yorubaland cosmologize this import? How did they transform porcelain plates into mythic discourse? By inserting them within the readymade cosmos of the calabash. Round porcelain bowls served the same purpose.

Women mark the cardinal points with four or more vertically positioned plates, as in an altar to Oshun in Ipokia, capital of the Anagó Yoruba, that I saw in 1975 (plates 229 and 230). In a single movement they render the boundaries of the world. This intensifies the capture of the powers of Oshun, closed within four corners. She is theirs.

Mimesis of the economy of hearth and home, not to mention the art of carrying ware head-stacked to market, also plays a role in this important unit of a woman's altar. The universe of Oshun folds in upon itself with plates standing fanlike. Supporting stacked calabashes and porcelain bowls become *agbele*, altar supports, imitating head portage as symbolic column. In this materially coded system of thought, the means of support (the *agbele*), through a pun on a well-known phrase, becomes an image of Oshun's love and grace soaring beyond the porcelain circle to heaven itself: *Agbe, gbe mi dele* (Touraco

With the Assurance of Infinity: Yoruba Atlantic Altars

bird, please carry me home to heaven).[157] Thus ordinary crockery, stacked and accented, becomes a sign of spiritual elevation and enfoldment.

Many Yoruba-influenced Brazilian women are well aware of the links among calabash, porcelain, and cosmos. They too combine these elements in women's altars to the goddesses of sea and river, calling the results *iba*—a creolized version of the Yoruba *igbá*, or calabash. In the summer of 1984 I photographed an *iba Oxum* at the Da Vina Menezes *candomblé* in Lauro de Freitas (plate 232). The philosophy implicit in Yorubaland remains in force, plates standing and guarding the four points of the cosmos. All is elegantly achieved, within the petals of a flower of porcelain.

Some servitors say *iba* are mere housekeeping (*pra arrumar*, to fix things up). But others share a deeper thought: the *iba* close and conceal power within a world. Some go further and claim that the number of plates within the circle announces the different avatars: nine plates for Oya, six for Oxum, seven for Yemanjá.[158] Bahia practice at the Da Vina Menezes *candomblé* contradicts this. Which means a range of elaborative and interpretive discretion confronts us.

The *igbá*-of-cosmos also came to Cuba in the minds of women. In a twentieth-century example at the museum of Guanabacoa (plate 231), the tradition presents itself in the colors of the goddess of the seas. This altar piece holds Yemayá in a crockery enfoldment, splashed with touches of marine blue and marine white, and receiving within the circle

PLATES 229 (OPPOSITE, BOTTOM) AND 230 (THIS PAGE, ABOVE TOP): ANAGO-YORUBA ALTAR TO OSHUN, IPOKIA, NIGERIA, 1975. Women's altars to the river goddesses and other *orisha* may appear as arrangements of porcelain plates, stacked and set vertically around a circle (defined by another plate or bowl). The formation honors the calabash as spherical presentiment of the shape of the cosmos. Photos: Robert Farris Thompson, 1975. PLATE 231 (THIS PAGE, ABOVE BOTTOM): ALTAR TO YEMAYA, HAVANA AREA, CUBA, TWENTIETH CENTURY. Collection of the Museo de Guanabacoa, Cuba. PLATE 232 (RIGHT): ALTAR TO OXUM, DA VINA MENEZES CANDOMBLÉ, LAURO DE FREITAS, BRAZIL, 1984. Photos: Robert Farris Thompson, 1984. Brazilian and Cuban women may link calabash, porcelain, and cosmos, as African Yoruba do, in altars to the goddesses of sea and river.

215

offerings of seashells as signs of her presence beneath the waves. This inventive touch is answered by similar improvisation in black Bahia, where the word *iba* refers not only to standing plates within a circle, but to miniature emblems of the goddesses of water also placed within that round: "combs, spoons, stars, used by Oxum (in brass), Yemanjá (in silver), and Iansá [Oya Yansan] (in copper)."[159] From Nigeria to the Americas, women followers of the *orisha* shape faces of the goddesses within a world of porcelain, achieving in the material language of their gender the capture of *àse*.

Obaluaiye and Omo-Olú: Seed and Broom as Fateful Character

I have since mett with a considerble Number of these Africans, who all agree in One story: That in their Country grandy-many dye of the Small-Pox; But now they learn This Way: People take Juice of Small-Pox and Cutty-skin, and Putt in a Drop; then by'nd by a little Sicky; then very few little things like Small-Pox; and nobody dy of it.

 —Cotton Mather and Zabdiel Boylston, quoted in Eugenia Herbert,
 "Smallpox Inoculation in Africa," 1975

Ina jo iko ko jo irawe.
The fire burns the farm but doesn't burn dry leaves [riddle, with the answer: smallpox].

 —Verger, *Notes sur le Culte des Orisa*, 1957

Traditional Yoruba deify pestilence under the name and being of Obaluaiye. Soponnon is his inner name, dangerous to recite, for fear of unleashing an epidemic. Hence people employ a host of euphemistic titles, such as Omo-Olú, Child of the Lord; Babaligbo, Father of the Forest; Olode, Lord of the Outside; Oluwa, the Lord; and Ile-Gbonon, Earth-Heats-Up. Even English-speaking Christian Yoruba may say "S.P." when talking of Obaluaiye's dread disease, rather than attracting the fever by mentioning its name outright.

Obaluaiye, whom the Fon of Benin style Sakpata, is master of a host of frightening illnesses, climaxed today by AIDS. But he controls these terrors for an essentially moralizing purpose: to instill a sense of social conscience. Obaluaiye, lame, was driven mad by persons making fun of his infirmity, whereupon he took out a broom and some sesame seeds (*iyamoti*) and swept the seeds into the air, charging the atmosphere with fever and epidemic. Thus he warns you not to make fun of the afflicted or of the poor, for "little people" can exact vengeance. He uses the threat of disease to inject humility and caring.

In another myth, Obaluaiye tried to enlist the aid of the Alaafin of Oyo in a war against Dahomey. The Alaafin refused. In a rage, Obaluaiye took out some sesame seeds and scattered them on the soil. He had in his hand scissors attached to a chain, which he hurled against the earth. He disappeared. And smallpox broke out everywhere.[160]

Forever after, brooms, seeds, and perforation associate with Obaluaiye and his mysterious powers of disease. He goes with the stabbing thorns of certain plants, especially the cactus placed or grown upon his altars. Perforated altar pottery stands for his power to spot a body with disease and fever. As for seed imagery, it cuts across jewelry (*langigigba*,

necklaces made from pierced black seed disks) and food offerings to Obaluaiye of kernels of roasted corn and popcorn.

More than a deity of fever and disease, Obaluaiye, as Verger puts it, is the god who punishes evil-doers and the insolent.[161] He is not the smallpox itself, but fever incarnate in moral retribution. We get a sense of his complex nature from his poems of praise:

Azon Niyaniyan
we nu mi e niyan mi lo lo non gbele
e lo gon ma niyan mi lo to non bele
do lo non ta azon niyanniya.

Terrifying malady,
if you chase me the land is ruined
even if you don't chase me the land is ruined
and the terrifying malady will land on the heads of
 even those responsible for our land.

Irawe oju omi wele ni se wele
Okoyiko o gba ode eleran ki o mo mu eran.

The dry leaf balances superbly on the surface of the water
The wolf is out—shepherd, better gather in your flock.

Igi ni Odan enia ni?
Fi ake kan o rí e mo.

Is the odan tree a person?
Strike it with your axe—you'll find out.

Akeke abi iru kokoroko
Paramale o ko oro afojudi
Igangan ti angan.

The scorpion possesses a curved tail
The fanged serpent rejects the impertinent
The thorny bramble is formidable.

Ode dudu kan ti mo si o ko ogun
Igi ganganagan ni ropo
Osanpan eni kansoso ko rin
Igangan tinangan.

A certain black hunter, who knows how to use raffia to
 cover his body
Bramble thorns against your eye

No one should walk alone at noon
The formidable bramble.[162]

These lines are charged with condensed belief. Avoidance of walking about at noon, for instance, alludes to this: "Sopono family members are thought to prowl when the sun is hot, robed in scarlet, [hence] the Yoruba feel they must avoid walking in the sun at midday and also avoid wearing red or other bright color or even a 'loud' pattern lest the spirits be insulted by the mimicry."[163] The poem relating the sting of the scorpion, the fang of the viper, and the thorn of the bramble underscores the various stings, fangs, and thorns of Obaluaiye, who carries a specific weapon for specific maladies. He clubs his victims to bring on physical weakness; he pricks them with a spear to cause boils, pox, or pustules; he pricks them with an arrow, causing rashes. Thorns and cacti appear again and again in his poetry. The line about covering his body with raffia alludes to hiding the ravages of variola from the sight of his peers. It also anthropomorphizes the raffia fibers of a broom, his classic weapon for causing epidemics.

Certain trees are sacred to him, like the odan. In some mysterious way dry leaves are impervious to his fevers. But heat and brooms link dust, dryness, and disease in the world of Obaluaiye. All kinds of illness break out during the dry season, when the harmattan blows. The color of the sky changes from blue to gray. Dust is everywhere. Everyone seems down with a hacking cough. The color red, dust, brooms, the heat of high noon, when even the ground is hot—all these images blur in the terror of his name. Finally he is associated with carrying fire or roasting seeds in *apaadi* or broken potsherds: "The word *apaadi* is mid-way in a consonant gradation which runs from . . . *apaadi*, 'potsherd,' to *agbada*, 'large shallow pot for roasting grains or nuts.' *Apaadi* are broken pots used for fetching burning coals for starting a fire somewhere else. [Hence] the association of sherds and fire [in the Yoruba imagination]."[164]

Altars of Sakpata/Omo-Olu/San Lázaro

In around 1970, devotees of Obaluaiye made an incredibly powerful altar to him near Banhouwé, not far from the Atlantic Ocean in what is now Benin and was then Dahomey. In Benin, Obaluaiye is called Sakpata. Photographed in the summer of 1972, his altar resonates with narratives of moral terror (plate 233).

First, its conical shape, in narrowing toward a point, immediately suggests the presence of the spirit, like the sharp tips of Yoruba crowns and other pointed emblems of *orí* and *àse*. There is also cognation with the clay-pillar altars to masculine ancestors witnessed in Mande-influenced areas north-northwest of Dahomey. The Dahomean break in the rain forest opens a corridor to northern influences. This may explain the resonance.

The altar's most startling features are the rising, flamelike surfaces of the shards of pottery inserted in it. These are *apaadi*, used to carry hot coals to start a fire. They lick their way upward as sienna-colored frozen flames, the flare of fever burning implicitly in every fragment. The altar's crown is his clearest sign: a sphere of inverted pottery, pierced with the holes that symbolize disease. This is an altar that demands humility and the truth.

The exact shape of this intimidating dome of perforated ceramic returns in an altar made by followers of Pai Balbino at Lauro de Freitas, Brazil, in the early 1970s. To these devotees, the holes in *ajere* vessels symbolize the wounds (*chagas*) and marks of disease.

With the Assurance of Infinity: Yoruba Atlantic Altars

PLATE 233: ALTAR TO SAKPATA, NEAR BANHOUWÉ, BENIN, AROUND 1970. Sakpata is the Dahomean avatar of Obaluaiye, the god of smallpox and epidemic. His altars comprise shards of pottery, called *apaadi*, used to carry hot coals to start a fire, or, metaphorically, a fever; and a domed top, pierced with holes symbolizing the pricks and pox of disease. Photo: Robert Farris Thompson, summer 1972.

Illustrated is a detail of the altar's left-hand side, where each woman devotee places her own *assento* (plate 234). (Male offerings go on the altar's right.) *Fijadeira* vessels under each *ajere* contain each initiate's personal stone of Omo-Olu. The bird-topped wrought-iron staff of Osanyin, the healing god of the herbalists, stands over these presentations with a statement of positive intent: "Osanyin symbolizes the leaves that cure the wounds of Omo-Olu."[165] The Bahian sculptor Piao, who, in the early 1980s, made his atelier in the famous Bahian *candomblé* of Opo Afonja, made most of the Osanyin birds, though one or two come from other sources.

The ascending tiers of the altar, called *pepele Omo-Olu* in Yoruba fashion, continue the Yoruba tradition of the dais: "Everything has more power when in close contact with the

PLATE 234: ALTAR TO OMO-OLU, *CANDOMBLÉ* OF PAI
BALBINO DE PAULA, LAURO DE FREITAS, BRAZIL,
EARLY 1970S. Omo-Olu ("Child of the Lord") is one
of the many aliases of Obaluaiye, and is a common
name for him in Brazil. On the left side of his altar,
shown here, women place each their own *assento* or
pottery base for the god's presence. (Men's offerings
go on the right-hand side). *Ajere* dishes, symbolically
perforated like the dome of the Sakpata shrine in
Banhouwé (plate 233), are set upside down. The
underlying bowl, the *fijadeira*, contains a stone for
the god. Bird-topped wrought-iron staffs (most of
those here by the sculptor Piao) balance the spirit's
terror; they are attributes of Osanyin, the *orixa* of
healing. Photo: Robert Farris Thompson, 1984.

earth."[166] The resulting step-wise form concretizes local hierarchies of worship, the lowest
level being given over to the stones of recent initiates, the highest to the offerings of the
oldest servitors. All the tiers display the bird of Osanyin, the bird of mind and knowledge.
Though the altar, like that in Banhouwé, harnesses fear to moral purpose, these birds
transmute and soften, somewhat, the terror of Sakpata's name in Bahian worship.

In the literal form of the feathers of a sacrificed *guineo* or guinea hen, bird emblems
appear also in a remarkable basket-altar in San Juan, Puerto Rico (plate 235). This altar
was prepared by Señora Roena of the Villa Palmera *barrio* in the summer of 1987.
Inserted into ceramic forms of red earthenware (their tops perforated, their bottoms
concealing the presence of the deity within an immortal stone), the *guineo* feathers sign
these vessels in Obaluaiye's name, for their grayish black is spotted with white, the spots
restating the sign of pestilence. Sesame-studded candy offered in a dish continues this
symbolism of speckles. The *guineo* bird was sacrificed on the day Señora Roena asked
the deity's favor by immersing his stone in a soothing herbal decoction, *omi ero*, the
water of calm. This was intended to assuage his heart and guide his thoughts positively in
her direction.

A small earthenware dish contains a grainy piece of brain coral, spotted, once again,
as appropriate to the deity. This element qualifies the particular force being worshiped
here: Asohin, a Dahomean avatar of Obaluaiye. For the coral embodies the spirit of Afra,
Asohin's own private version of Legba, who acts as a "road" to the smallpox god, bearing
messages from the servitors. Above the sesame candy stands the *já* or smallpox broom

With the Assurance of Infinity: Yoruba Atlantic Altars

with which Sakpata/Obaluaiye/Asohin once swept sesame seeds to start an epidemic in Nigeria. Some say that its black-cloth-wrapped handle stands for Asohin mourning the death of his mother, Nana Bukúu.

Yoruba forms collide here with Roman Catholic imagery, for the basket contains an effigy of San Lázaro, or Lazarus, the Catholic saint with whom Obaluaiye (or, in Cuba, Babalu Ayé) syncretizes in Afro-Cuban worship. Lazarus was restored from the dead by Jesus Christ. Catholic chromolithographs show him walking on crutches, bearing on his

PLATE 235 (ABOVE): ALTAR TO ASOHIN, AVATAR OF OBALUAIYE, PREPARED BY SEÑORA ROBERTA ROENA OF THE VILLA PALMERA *BARRIO*, SAN JUAN, PUERTO RICO, SUMMER 1987. An altar is contained within a basket. A virtuoso display of compact symbolic coherence, it holds: a broom, frequent attribute of Obaluaiye, with which he sweeps disease around the world; a dish for a piece of spotted brain coral, the spots a sign of pestilence; an offering of sesame-seed candy, also spotted; and earthenware pottery containing Obaluaiye's stone, and perforated with holes, into which are inserted the feathers—again spotted—of a sacrificed guinea hen. The feathers intimate Osanyin the healer. And the figurine is Lázaro, the Catholic saint brought back alive from leprosy. Photo: Robert Farris Thompson, summer 1987.

PLATE 236 (RIGHT): *TRONO* ALTAR TO SAN LÁZARO/BABALU AYÉ (OBALUAIYE), DESIGNED BY THE LATE RAMÓN ESQUIVÉL, UNION CITY, NEW JERSEY, 17 DECEMBER 1986. Brazil and Cuba associate Obaluaiye with San Lázaro, or Lazarus, who was rescued from death by Jesus, became a bishop, and wore a bishop's purple. Hence the purple cloth that floods this altar with color. Gifts of popcorn reflect the seed imagery associated with this *oricha*, who is described spreading illness by scattering seeds in handfuls. Señora Roena (plate 235) offered the god sesame-seed candy. Photo: David H. Brown. Copyright © David H. Brown 1993. All rights reserved. Reprinted with permission.

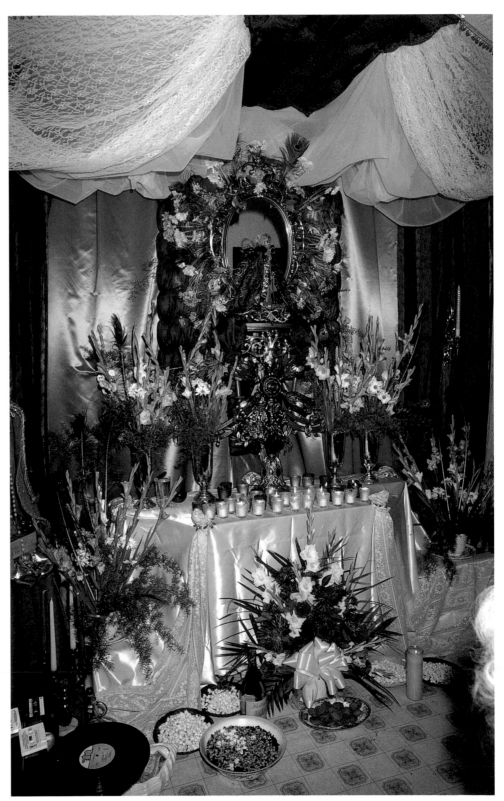

body the marks of leprosy, the dread disease that killed him. Dogs lick these sores. After the miracle of his resurrection, Lazarus eventually became the Bishop of Marseilles, in the time of the Emperor Domitian. He has been associated with a bishop's purple robes ever since. Afro-Cubans modify this regal effect by combining the robes with a shirt of gunny sacking, thus returning to the image of Obaluaiye, alone and roaming the wilderness.

The association of San Lázaro/Obaluaiye/Asohin with ecclesiastical purple reaches a climax in a *trono* made in 1987 in Union City, New Jersey, and photographed by Brown (plate 236). Ramón Esquivel, the late and great Yoruba altar-maker, prepared this visual praise poem on Lázaro's feast day, December 17. The charging of space with purple is remarkable; one senses the spirit's presence and his glory behind the expanse of rich cloth, crowned with hosannas of white gauze. The pomp and sobriety are almost funereal. But the Western atmosphere breaks at the floor, where traditional Yoruba/Dahomey offerings of popcorn bring back the power concealed in grains and seeds.

Nana Bukúu: Mother Hidden in Earth and Straw

> *If we want to know why the goddess Nana does not like an iron knife but prefers one fashioned from bamboo [we wait]. One year later, perhaps, repeating the question point-blank, at last they tell us: it has to do with the belief that Nana lived [before the age of] iron.*
> —Cabrera, *El Monte*, 1954

> *Da ogun meji.*

> She splits war in two
> —Verger, *Notes sur le Culte des Orisa*, 1957

The goddess Nana is old and powerful. She lives in a mound of clay called *ata Bukúu* or *okiti kata*. We learn this from pilgrimages to her in the Republic of Benin and southwestern Nigeria. We also learn from her kaleidoscopic poetry, filled with shifting, compelling images, strangely recombined:

> *Okiti kata*
> *ekun a pa eran ma ni yan*
> *gosungosun on wo ewu eje*
> *omi a dake je pa eni*
> *pele, Nana.*

> *Yeyi mi, ni Bariba li akoko.*
> *Okiti kata*
> *a pa eran ma ni obe*
> *oju iku ko jiwo*
> *owo nle pa l'ode*
> *ekan arugbo*

With the Assurance of Infinity: Yoruba Atlantic Altars

da ero nono
awodi ka ilu gbogbo aiye.

Okiti kata
awa p'ara olosun.

Mound of earth called *kata,*
leopard who kills an animal and eats it raw, unroasted
your camwood-dusted garments resemble blood
your silent waters, outwardly tranquil, kill
go gently, Nana.

My mother, she arrived from Bariba, a long time ago.
Kata mound,
who kills an animal without using a knife
the eye of death is not to be regarded
she trades indoors, kills outside
she is extremely old,
yet can outwrestle the evil traveler, wrestling him
 to the ground,
and, like a bird, circle the world.

Earth mound called *kata*
we cover your body with camwood.[167]

Some of these praises reappear in Bahia:

Okiti kata
obinrin pa aiye
a pa eran ma l'obe.

Earth mound called *kata*
woman who can kill the world
who kills an animal without using a knife.[168]

And in Matanzas:

Akiti kata
maa l'obe ko
Nana Bukúu ikoko ma ye wa
a kama kam'ado,
a we, a we.
Nana, ina maa lo de
pele, Nana, pele.

Earth mound called *kata*

does not use a knife

Nana Bukúu, wide-mouthed pot to whom we turn to win a child

we circle, circle, your gourd of medicine,

we wash you, wrap you.

Nana, fire is your trap

gently, Nana, gently.[169]

An ancient mother, of extraordinary power, emerges indelibly from these verses. Primordial, she was here before the coming of iron. Hence she does not use a knife, or, rather, not a knife of metal, but one of bamboo.

Over the centuries her worship spread from ancient Ifè to Siare, in modern Togo. Herself a warrior—in myth, she overran the armies of the settlement of Teju-ade—she associates with victory, like the winged Nike of Samothrace. This would explain verses on combat, on killing, sung to her. The kings of Asante, Gonja, and Dagomba, it is reported, sent gifts to the Siare altar to Bukúu that they might win in time of war.[170]

The town of Ketu worships Nana, her son Omo-Olú (she is the mother of the small-pox god), and Oshumare, the rainbow/serpent of the sky. It is believed that the worship of these three as a unit came to Ketu from Mahi, the region around Savalou and Dassa-Zoumé, in central Benin. From Ketu they went to Bahia, where the same three powers are worshiped on neighboring altars.

Unlike the rain forests of the Nigerian Yoruba, Mahi is open savanna, and dry. Even Ketu needs wells. The Mahi dry season is hot and prone to dust-borne fevers and bronchitis. That heat, those fevers, so strongly associated with Omo-Olú/Obaluaiye, are also linked to the blood-red camwood of Nana Bukúu.

Care must be taken not to overstate her martial qualities, her sternness. Those who honor her she will protect, even shower with riches. At her famous altar on the hill above Dassa-Zoume, in May 1963, I heard her priest sing *oriki*, praise poems, that stressed how she brings prestige and well-being, even when marching with Obaluaiye:

Mayo ile,

ma bire,

Nana, Obaluaiye, ware.

Happiness in the home,

nobility in the lineage,

Nana, Obaluaiye, together bringing luck.[171]

Nevertheless, Nana, like her son, is an outside god (*olode*). She is too hot, too dangerous, to handle in ordinary domestic settings. Thus G. Parrinder observed in 1949 that "all [African] altars to Bukúu are open to the air."[172] Most still are.

Ketu, Havana, and Bahia all stress the image of Nana as a mound of earth (*okiti kata*). This is precisely how we meet her in Mahi, in her outdoor mountain shrine above Dassa-Zoumé, where the clay dais (now covered with concrete) is punctuated by the *ata Bukúu*, a clay mound hooded in raffia (plate 237). The resulting fibrous surface resembles the

With the Assurance of Infinity: Yoruba Atlantic Altars

ritual garment of Omo-Olu in Rio and Bahia. When the priest sacrifices, he removes the raffia, revealing the *ata Bukúu*, home to Nana's spirit, as a clay structure studded with inverted pottery. Before the *ata*, moistened with sacrifice, servitors kneel and pray. Sacrifices are also made at the foot of the baobab that dominates the altar's northern corner; its base shows traces of blood and palm oil.

The crucial elements of this altar are: outdoor siting (Nana as *olode*), elevation (Nana exalted), and permanence and dryness (the baobab tree, which, like the camwood, correlates with heat and aridity, dovetailing with Nana's legendary lures of fire and with her body, decorated camwood red). But, as in her praise poetry, the mound is central. It is dressed like a broom, twirling on the surface of the altar.

Nana's connections with brooms and camwood fuse in her famous dance-wand, called *ileesin* in Ketu (plate 238) and *ibiri* in Bahia (plate 239). This extraordinary object is made of palm fibers secured in sections with wrappings of leather. Like Nana's body, the fibers are coated with rich encrustations of red camwood paste. The leather is dyed the darkest shade of indigo, like the altar of Eyinle, the underwater king, to remind us that Nana dwells in the depths of the river (her "silent waters") as well as in her mound of clay. A cowrie shell, hint of her wealth, dangles from the *ileesin*'s upper portion.

A striking element of the *ileesin* is its tip, which bends back in a loop. Deoscoredes dos Santos has written that this enigmatic termination, reproduced in the *ibiri* of Bahia, relates to a myth in which the *ileesin* came into the world with Nana on the day she was

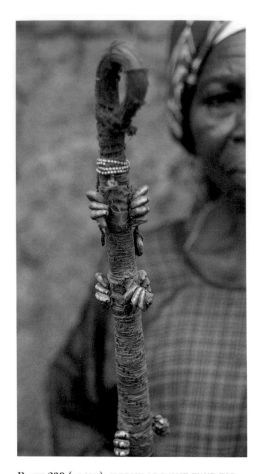

PLATE 238 (ABOVE): *ILEESIN* OR DANCE WAND FOR NANA BUKUU, KETU, BENIN, TWENTIETH CENTURY. Photo: Robert Farris Thompson, 1965. PLATE 239 (ABOVE RIGHT): *IBIRI* OR DANCE WAND FOR NANA, BAHIA, BRAZIL, TWENTIETH CENTURY. Photo: Robert Farris Thompson, 1968. These cognate dance wands from two sides of the Atlantic are both made of palm fibers wrapped with blue leather and encrusted with red camwood paste. The looping tip is variously explained, but particularly suggests links with Obaluaiye and with Oshumare, the serpent *orisha* of the rainbow: with Obaluaiye through his link in praise poetry to the scorpion, and its stinging arched back; with Oshumare through his ability to bend around to bite his own tail.

PLATE 240 (ABOVE): FIGURAL SCULPTURE OF A NANA BUKUU DEVOTEE (RIGHT), ADO-ODO, NIGERIA, 1940S(?). Kneeling, this woman wears a python around her neck—one of many suggestions of Nana's links with snakes. Nana, Obaluaiye, and Oshumare may have passed into the world together as a group, from the Mahi region of Benin; they are often worshiped as a trio. Photo: Robert Farris Thompson, 1963. Private collection.

With the Assurance of Infinity: Yoruba Atlantic Altars

PLATE 241: altar to Nana, Omo-Olu, and
Obaluaiye, made by the late Aildés Batista
Lopes, Jacarepagua, Brazil, 1970. Aildés built
this shrine to the Mahi spirits as a thatched
roundhouse, in the belief that such a structure
would be familiar to them. Obaluaiye and Omo-Olu
are treated here as two separate avatars: Omo-Olu
rising as a low pointed cone from the shrine's center,
Obaluaiye towering on the left. Nana, to the right, is
distinguished by her *bahiana* skirt. All wear raffia
hoods. A red-and-white crepe-paper ceiling
translates the raffia associated with these spirits
(their brooms, the hood over the *ata bukúu* at
Dassa-Zoumé) into a feverish gaiety. The floor, the
"smallpox mask" on the wall, and Obaluaiye's body
are scattered with popcorn (see plate 236). Photo:
Robert Farris Thompson, 1985.

born, at Sabe, in Mahi. It is said that the staff arrived within Nana's placenta. It curled into a loop at the moment of her birth.[173]

That is interpretation one. An Ifá *odù* takes the story in another direction, recording that Bukúu's mother used the center portion of a keg of palm oil—not the keg's head, or top—to make sacred medicine. To repeat, she tapped the keg from the "chest" (*aya*), not the "head." Hence Nana's curved-tip emblem reflects "something not close to the head, something turned away from the head."[174]

That is interpretation two. Inasmuch as both Ketu and Bahia tightly interrelate the worship of Nana, Omo-Olú, and Oshumare, one peruses the iconography of the other two gods for further clues. Like Nana, Omo-Olú makes iron knives a taboo, favoring wood instead, and for the same reason: he came into the world before Ogún, the metal spirit. Like Nana, he keeps a broom in his gear. And his praise imagery includes the *akeke abi iru kokoroko*, the curved-back tail of the scorpion, which resonates visually with the *ileesin*'s curved tip in a terrifying way. The connection, if summoned, would reinforce the moral vengeance that lights up his service.

Even more important is the fact that Oshumare, the rainbow serpent, curls around to bite his own tail. This would seem the staff's strongest association, for from Nigeria to Cuba Nana is associated with snakes. Indeed, in Ado-Odo, Nigeria, we see an image of a devotee kneeling with a python about her neck as a sign of Nana's power (plate 240).

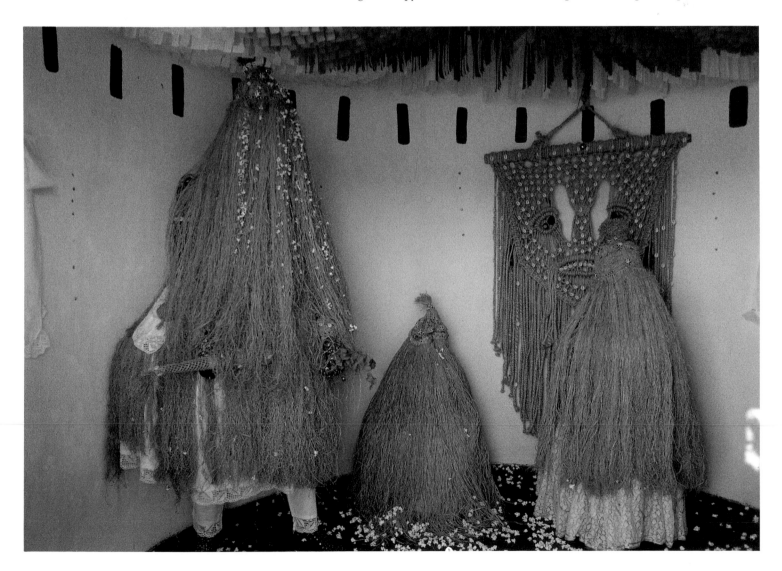

227

And the Yoruba in Cuba say that Nana travels in the form of pythons (*maja*) when she lives in the rivers and springs.[175]

There is no contradiction between the *ileesin*'s origin myths and Nana's nature, for magical birth, mystical healing, and relation to the powers in the tail of a scorpion or a python all spell the working of *àse*. No wonder Nana, "the outside ruler of the town," gives orders like a king, and uses her curved-tip serpent staff for gaining victory and preventing war. With her staff she splits a war in two.

In 1970, the late Aildés of Jacarepaguá built a roundhouse shrine for Nana and Omo-Olu, the Mahi spirits (plate 241). She built this structure "because they like roundhouses covered with thatch." Bypassing curved-tip staffs or spears of fever, she searched for their essence in seeds and fiber: in 1971 she filled the space with living, broomlike, sentient smallpox beings, relating ultimately not only to Omo-Olu but to Nana on the mountain above Dassa-Zoumé.

The ceiling—of crepe paper, cut and dyed red and white—is euphemistic raffia, danger mixed with festival excitement. Abstract rectangles painted on the wall, in the color of blood, create a different kind of visual event: the tacit perforations caused by fever-bearing beings. Omo-Olu, rising from the floor in the shrine's center, reads like a fugitive from Dassa-Zoumé. A creole Nana stands at far right, *bahiana* skirt visible under raffia hood. On the left, Obaluaiye, with broom as scepter (*sasara*), towers over all.

Drawing on both Anagó and Western sources, moving with confidence across worlds, Aildés made a "smallpox mask" to hang upon the wall. The face is of straw, punctuated with popcorn, and animated by eyes that are small electric bulbs. Popcorn is a mystic antidote to the negative powers of the Mahi duo. Aildés tossed it also onto their straw, and onto the floor.

Da/Oshumare, Rainbow Serpent of the Sky

The theologically minded impute conscious intent to the structure of nature.
—John Dewey, *Art as Experience*, 1980

Black, white, and red are the colors which Da puts on at different times: night, day, and twilight.
—P. Mercier, *African Worlds*, 1954

Completing the cycle of three deities worshiped together in Bahia (because of their shared Mahi origins) is the rainbow/serpent Oshumare, known in Dahomey as Da. This god is iridescent, flowing sinuously, "the preeminent motion"—life—mastered and maintained for the benefit of the world. His python scales glittering across the cosmos, Da is the blazing rainbow spectrum, curved from sky to earth.

Logically, in his richness, he comes to signify wealth. When Da touches earth, so it is believed, he leaves behind the coveted blue beads called *nana* (connecting him with Nana Bukúu?) and the beads called *da mi* (rainbow waste). Expensive cloths, beads, and valuables that Dahomeans may find mysteriously abandoned in the forest are attributed to his visits. All of which crystallizes in one of his main motifs, the gorgeous strands of

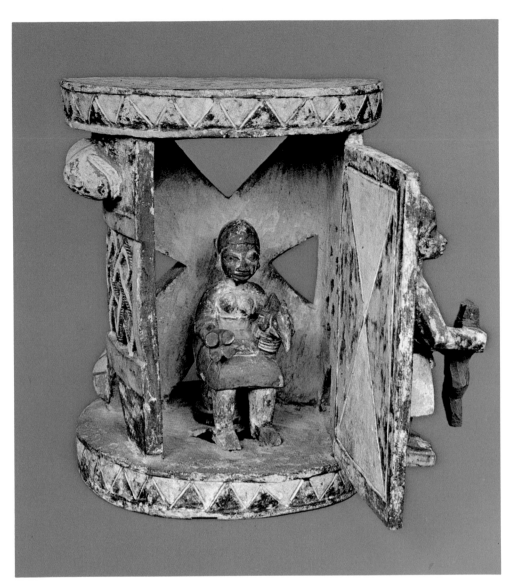

cowries in Bahia called *abraxa*, communicating wealth and richness. These his followers wear about their necks in *candomblés*.

They wear a metaphor. On white thread matching their own color, the cowries are tightly and ingeniously strung in a pattern suggesting both the serpent's overlapping scales and his vertebrae. This gentle reptile, who brings down color and wealth, also helped God build the world.[176] He is a complex saint who requires close reading. On his Dahomean side we learn that

> Da Ayido Hwedo . . . has dual aspects, one male, the other female, and these also are sometimes conceived of as twins. . . . [He is] one being with a dual nature. When he appears as the rainbow the male is the red portion, the female the blue. Together they sustain the world, coiled in a spiral round the earth, which they preserve from disintegration.

> Da set up four iron pillars at the four cardinal points to support the sky, and twisted round them, in spirals, threads of the three primary colours black, white and red, to keep the pillars upright in their places.[177]

Oriki from Ketu add to the image's richness:

Oshumare a gbe orun li apa ira

O pon iyun pon nana

A pupo bi orun

Oko Ijoku dudu ojú e a fi wo ran.

Oshumare lives in the sky, which he traverses with his arm

He is the fountainhead of *iyun* beads, fountainhead of *nana* beads

Overwhelming like the sky

Oshumare, regarding the world, with pinpoint eyes of jet.[178]

In the mid 1960s, Deoscoredes dos Santos documented a carved wooden seat from a Da altar in the Dahomean Yoruba village of Ilara. The chief exemplification of the deity's power in this image is an enormous serpent winding and undulating over the heads of dancing devotees, who are stationed in a circle as caryatids for the snake. Serpents are draped crisscross, too, over their chests and shoulders.

Inside the circle of servitors a priestess is seated in a temple, legs flat across the earth, emblems of Oshumare in either hand. Cowries crisscrossing between her breasts repeat the presence of the god. The overwhelmingness of Da is established in zigzag lines around the top and bottom of the seat, in the snake's undulations above the circle of the devotees, in the snake-scale cowrie necklace, and in the actual serpents worn as living jewelry. As if that were not sufficient, someone has playfully added a wrought-iron altar snake to complete the composition. Similar qualities, especially snake zigzags and a devotee with iron serpent in his hands, characterize a twentieth-century Oshumare seat at the University of California, Los Angeles (plate 242).

In around 1965, the entrance to the Ilara altar to Da was decorated with murals recalling the praise poem's vision of Oshumare as living in the sky, which he traverses with his arm: painted serpents bracketed the door, curving inward, like arms gesturing toward the portal. They cosmologized the wall. They made the entrance a door into heaven.

Pai Balbino created a beautiful altar for Oxumare at Opo Agonjú, in Lauro de Freitas, in the early 1980s. This work, still in progress, is shown as it was in the summer of 1984 (plate 243). A concrete dais, of winglike shape, fills the southwest corner of the shrine room. Uplifting iron serpents on this platform show where Oxumare lives, in heaven. In the middle of the altar Oxumare, crowned with the bird of Osanyin, coils around an iron staff, to support the sky. This staff was made by the sculptor Piao.

As the clay dais of Ketu creolizes into concrete, Dahomey's sculptured pots for Da, circular vessels lidded over with overarching double serpents, here creolize into straightforward Brazilian earthenware. Out of the pots, rainbow serpents rise to seek the sky. At left, on the floor, Da confronts Aida Hueto, his female mirror twin, the twisted iron the work of an Afro-Bahian. The many horned iron avatars of Da, termed *ziki*, were gifts to the altar from Verger, who bought them in Porto Novo, on the coast of Benin.

At the far right, emerging from a white basin on the altar, appears another bird of Osanyin, with coiled double serpents poised beneath. The style, flat and linear, differs from that of the other pieces; Mario Proença, rival of Piao, made it. The vessels are filled with secret medicines (*axe*) sealed in cement, and studded with cowries "because this

PLATE 243: ALTAR TO OXUMARE, MADE BY BALBINO DE PAULA, ILE AXE OPO AGONJU *CANDOMBLE*, LAURO DE FREITAS, BRAZIL, LATE 1970S/EARLY 1980S. The presence of the great snake is stated in zigzags painted on the altar wall, kin to the lining on an Oshumare altar seat from the Ketu area of Benin (plate 242). Iron staffs and serpents by Bahian masters Piao (the tall central staff), José Adario dos Santos (the sinuous, curving snake figures on the floor to the left), and Mario Proença (rising from the white bowl on the dais, at the right), plus many horned *ziki* serpents brought from Benin, embody the deity. The horizontal vessels on the floor in front of the altar commemorate a recently deceased member of the *candomblé*. Photo: Robert Farris Thompson, summer 1984.

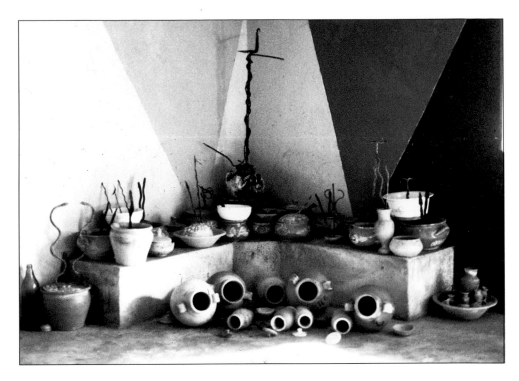

saint is rich." Where each serpent touches the center of a vessel we find these variously patterned shells.

A member of Balbino's *candomblé* had died shortly before the photograph was taken. Fallen *talhas* and *quartinhas* on the floor symbolize her passing. Their open mouths are keening. Balbino orchestrated the falling of the *quartinhas*' covers this way and that, freezing the moment in one seismic shock.

Oshumare is a twin, and is often displayed as such. On the floor against the northern ending of the dais, then, at the far right, we find a miniature *ibeji* altar. All the customary elements of twin-worship pottery are present: the dominating *kolobo*, here used to store the twins' favorite food, *caruru*; the smaller *quartinhas* for wine and water, standing in a shallow earthen bowl (*aguida*); the *aguida* filled with sand to honor the water origins of the twins, whose mother, according to the belief of this *candomblé*, is the River Niger, the goddess Oya.

A world of pottery and iron is completed by the painting on the wall: a leviathan of a rainbow python. In the Oshumare manner, he overwhelms all space behind the altar. Oshumare passes through the room, flexing the colors of the dawn, of the day, of the setting sun, and of the night. The gathering of these sacred images indelibly expresses his richness and his devotion.

Shangó: Storm on the Edge of the Knife

Something is missing in the story of Shangó. We know his saga, as told by the historian Samuel Johnson, himself a Yoruba:

> Sango was the fourth king of the Yoruba and was deified by his friends after his death. . . . He had a habit of emitting fire and smoke out of his mouth [which] so terrified the [ruler of a southern Yoruba kingdom] and his army that they became panic stricken and were completely routed.[179]

Johnson tells us that Shangó was the fourth king of the Oyo Yoruba, an unusually beloved commander of the army ("deified by his friends after his death"), and supreme in the arts of psychological warfare. Jealous of his stature and fearful of his charms (the most famous of which gave him the power to play with fire and lightning), the elders of Oyo seem to have exiled him. Then suddenly, by this version, his friends evaporated, and even his wife, Oya, deserted him. Depressed, he is said to have killed himself at a place called Koso, near Oyo-Ile, putting to an end a fifteenth-century reign extending from Dahomey in the west to the city of Benin in the east.

Why deify a suicidal king whom everyone deserted? Fortunately there are other versions of his legend to help untie the riddle. In one of them Shangó, playing with his lightning charm, accidentally sets fire to his palace, and many of his cowives and children perish. Overcome with grief, he again destroys himself, but this time his wife Oya accompanies him, out of love, in a double suicide.

What is missing in these legends is that Shangó learned from tragic lessons how destructive fire, lightning, and unthinking power can be. Clearly when he came back as a spirit his name and body were forever linked with lightning, meteorites, and all kinds of fire, only now as instruments of moral agency.

In the process, his memory changed—his palace no longer a place of ordinary happening, his court now an army of lightning-related beings charged with the purification of humankind with moral terror. Fear of the Lord, it is written in Ecclesiastes, is the beginning of understanding. The flash of Shangó's lightning, I was told in Ipapo in western Oyo in the summer of 1963, is like a knife in the eye of the liar or the adulterer.

The nobility of Shangó and his followers, and their dedication to moral intimidation, is deepened by the structure of his altars. The altar, Lawal shows us, is his royal court, the altar figures his followers.[180] Wooden mortars (*odo*) support wooden bowls in which rest his deepest sign, the thunder stones he is thought to have hurled from heaven (*edun ara*). The most beautiful stones, seen in Anagó, are darkened with indigo, making them royal, revealing their sacredness. The mortars elevate on high his spirit in dark stones.

Nearly every element of the Shangó altar—the mortar pedestals, the thunder axes, the thunder rattles—celebrates a friend or follower. This helps us restore the missing element of his story: honor and entourage. Honor measures his moral fire within the stones inside the bowl. The entourage, resulting from his status, generosity, and moral worth, is virtually everything else around him on the altar: bodyguards turn into his ax (*oshe*) and rattle (*shere*), Oya remains in her mystic buffalo-horns, their twin children reappear in twin statuettes of affection, his friend Oge resides in the horns of the harnessed antelope

(*iwo igala*), and his elder sister, Dàda-Bàyònnì, presides in a cowrie-studded crown streaming with twelve cowrie-entwined dreadlocks, often set upon a pottery stand.

The altars of Shangó honor the man whose insight and bravery ultimately gave symmetry to fire itself: steadied on his head, and on the heads of his followers and comrades, is a fire of balanced meteorites, his quintessential emblem (plate 244).

The *oriki* of Shangó do not expressly spell out Shangó's lessons—how he became one with the fires that pushed him to his doom, the better to purify and to exalt mankind. But they do build a context in which grace can be perceived in danger, in which persons can be led to selfhood in the presence of a terror that, with bravery and right living, can be morally absorbed and claimed, taming the leopard that leapt from the sky.

From Nigeria and Benin:

> *Oko ibéjì*
> *Eletimo, ojú eri eri*
> *Ó là orun garara.*

> Lord of twins
> Master of knowledge, brilliant eye
> He splits the skies.

> *O sa ogiri eke nigbeigbe*
> *Egun toto bitan li awa yi odo fun*
> *Omi li eba iná li arin orun*
> *Olowo mi edun kan soso li o fi pa enia mefa.*

> He splits the liar's wall superbly
> Masker from the other world, for whom we roll out the
> mortar [as throne]
> Water by the side of fire in the middle of the sky
> My Lord kills six with a single thunder-stone.

> *Ori Ose li o gun lo*
> *Afi enia ti Soponnon eleran ekun ti o gbopa*
> *Ekun Baba Timi*
> *Orun funfun bi aje.*

> He mounts the head of bodyguard Oshe and goes
> Strong person, leopard spotted, like Orisha Obaluaiye
> Leopard Father of the King of Ede
> White sky, sign of richness.

> *Oni laba jinijini*
> *Ala a li ase atata bi okunrin a dugbe*
> *Ekun oke.*

Owner of the terrifying thunder wallet
Owner of *laba* [wallets] filled with *àse*, like seasoned
 warrior
Leopard on the hill.

Agbangba li ojú agada
O gbe iná wo ilé eke.
Shere Ajase
Oshe Orobondo.

Storm on the edge of the knife
He carries fire on his head into the house of the liar.
Victorious Shere [bodyguard of Shangó]
Superlative Oshe [bodyguard of Shangó].

Ki fi ojú bo orule ki o duro iná wonu ekun
Nitorí ayibamo e je ki awa jo sé
Oba tete li o le ale bi osu
Pa-eni, pa-eni, mo ni li ale.

Flash of a leopard's eye can set a roof on fire
Against the unknown, let us do things together
Swift king, appearing like the evening moon
I have an assassin as a lover.

Okunrin gidigba bi Oshe

Stalwart, like Oshe.[181]

"Water by the side of fire in the middle of the sky" frames the lightning in the rain. It decodes the equation written in Shangó's beads of red and white: attack (flash of red) guided by moral probity and purpose (flash of white). Shangó plus Obatálá is another way of saying this.[182] That Zen-like frame returns again in the line "storm on the edge of the knife," with a beauty that dissolves exegesis.

It is ritually impertinent to read objects on Shangó's altar—thunder ax, twin statuette—as furniture. These are colleagues, like "stalwart Oshe," or family, like the twins. Then there is the "terrifying thunder wallet"—terrifying because it carries thunder stones and ritual plunder. (In traditional villages, objects in a house struck by lightning may be forfeit to the thunder priests.)

When a devotee of Shangó appeared in an Oyo town before the camera of Lawal in 1990 (plate 244), his purpose was part marvel and part moral search. Those with a guilty conscience might have worried: for whom were those metaphoric flames intended? Which house, which liar?

When Shangó is called "swift king, appearing like the evening moon," some see him gallop on his horse, Eshinla, across the sky.[183] Others see him at the head of cavalry in

With the Assurance of Infinity: Yoruba Atlantic Altars

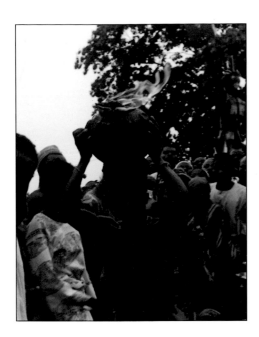

PLATE 244 (ABOVE): FIRE-BEARER FOR SHANGO, OYO COUNTRY, NIGERIA, 1990. Priests of Shangó collect the meteorites that fall on occasion in flames from the sky, emblems of the power of the thunder god. To balance such flame on one's head is to demonstrate one shares such power. Photo: Babatunde Lawal.

PLATE 245 (RIGHT): *ERE ALAAFIN SHANGO*, OYO-ILÉ, NIGERIA, NINETEENTH CENTURY(?). This magnificent rendering of Shangó as mounted warrior-king is a primary monument of Oyo Shangó sculpture. It allegedly came to modern Oyo from a Shangó shrine in the ancient imperial capital of Oyo-Ilé during the period of intra-Yoruba warfare in the early nineteenth century. Photo: Robert Farris Thompson, 1962. Collection of the Nigerian Museum, Lagos.

the days of the Oyo empire. Something of this premise illumines a masterpiece of Yoruba altar art: the *ere alaafin Shangó*, the image of Shangó, king of Oyo, by legend from a Shangó shrine in the ancient capital, Oyo-Ilé (plate 245). Here the legs of Shangó are at one with his mount, stylizing the power of the rider. Left hand on bridle, Shangó unfolds the order of battle. Right hand grasps a spear with fluted ring.

This equestrian statue in wood, perhaps from the nineteenth century, is said to have come to modern Oyo from a major Shangó altar of Oyo-Ilé in 1837.[184] All kings of Oyo had to visit this altar during investiture. An officiant would crown them with a crown of cloth, which would then be placed on the head of an image like the surviving *ere alaafin*

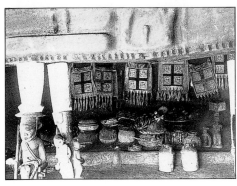

Shangó. The king was never again to visit the shrine. He had, in effect, met Shangó and taken fire into his spirit, then returned the vessel of that power, the crown, to its rightful owner. The *ere alaafin Shangó,* lips compressed, eyes responding to inner pressure, transmits—and anchors—the power of the thunder lord for succeeding generations.

Certainly Ibadan, by the turn of the century, had achieved a counterpart to the glories of the Shangó altar at Oyo-Ilé. From Leo Frobenius's account, around October of 1910:

> A lofty, long and very deep recess made a gap in the row of fantastically carved and brightly painted columns. These were sculptured with horsemen, men climbing trees, monkeys, women, gods, and all sorts of mythological carved work. The dark chamber behind revealed a gorgeous red ceiling, pedestals with stone axes on them, wooden figures, cowrie-shell hangings and empty bottles.[185]

This Agbeni installation (plates 246, 247) dramatically expands the tradition of the "framed altar," such as the altar rendered on a pottery shard from ancient Ifè (plate 165). The "stage" is broader, deeper, and infinitely more populous. Over the entrance to the recess are bas-relief depictions of thunder axes and rattles, symbolizing Shangó's body-guards and battle comrades.[186] These "stalwarts" guard the threshold. On the altar proper, framed by a break in the sixteen columns, Shangó's court has reassembled:

> [Thunder wallets], seven of them, appear on the wall of the altar. They function both as receptacles for ritual paraphernalia and as virtual hangings. . . . Each wallet bears four panels in which appears the figure of a human with tailed headdress [striking] an asymmetrical pose right hand up, left hand down, recalling thundergod choreography.[187]

Who these mysterious four dancing figures with arms in Shangó code might be will be explained to us by the distinguished keeper of an altar in Efon-Alaiye. But let us continue:

> On the altar are placed four terracotta broad-mouthed vessels [*ikoko*], which serve as stands for calabashes in which ritual paraphernalia are stored. The most elaborate, at right, [is] emblazoned with a representation of a fish-legged deity flanked by devotees brandishing thunderaxes [probably for Shangó's close spiritual comrade, Erinle, a riverine spirit]. . . . To the right of the figurated *ikoko* appears the carved wooden image of a seated dog, [an] animal specially associated with Shangó. To the right . . . a thunderax.[188]

Finally:

> In the middle of the altar the eye picks out, stored in an open container, the reclining image of a twin and the jutting point of the horn of the Harnessed Antelope [*iwo igala*] for Orisha Oge, a deity closely associated with the thundergod.[189]

With the Assurance of Infinity: Yoruba Atlantic Altars

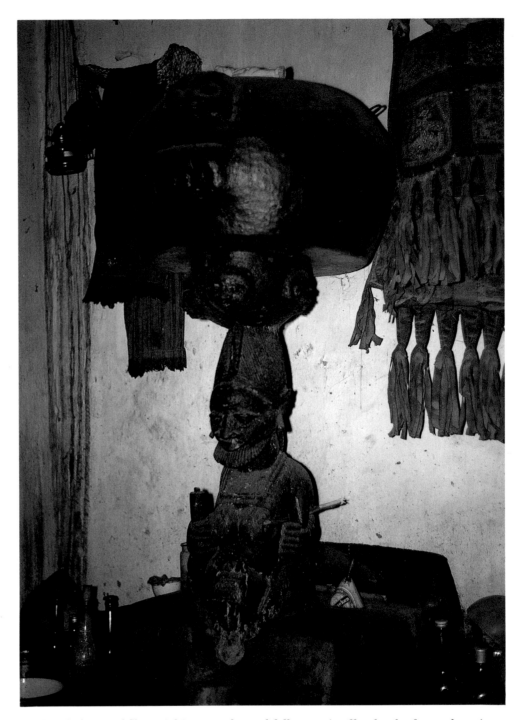

The elevation of Shangó, his comrades and followers, is offset by the forward motion
of the sixteen-column screen. Some figures carved on the columns stand on the head of a
figure beneath, like Shangó "mounting the head of [his bodyguard] Oshe and
moving."[190] In the past, to stand on the head of a follower was the mark of a great ruler.

The horsemen in Shangó's cavalry and the women were his royal relatives and wives.
When I visited the Agbeni shrine in December 1963, and learned this, the priest attrib-
uted many of the carvings there to Agesingbenon, an artist from Ibadan "who died a long
time ago." But the finest works were carved by men "who came from Efon-Alaiye and
did their work within this compound." The four figures to the right in Frobenius's photo-
graph (plate 246) were still standing in 1963 when I photographed them (plate 249). The
most beautiful remained "the daughter of the Alaafin" figure, identified as such by marks
on her cheeks. White face and white column spiritualize her royal presence. She and all

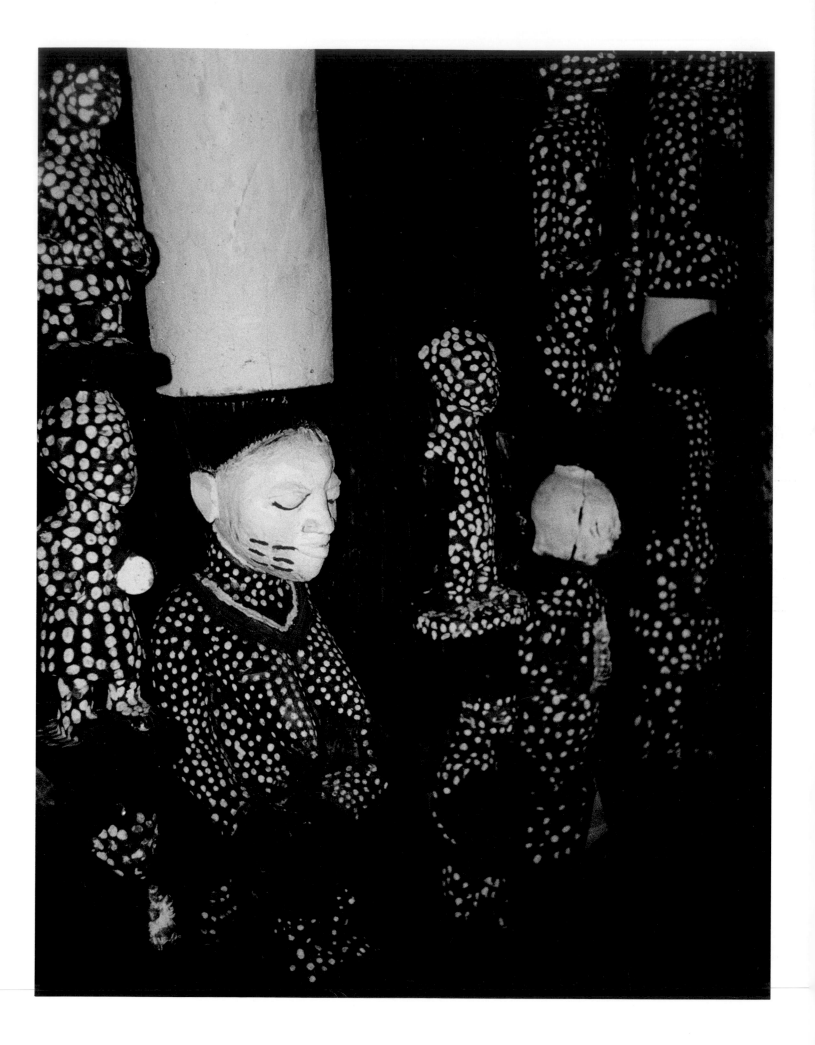

With the Assurance of Infinity: Yoruba Atlantic Altars

her colleagues, fighting for Shangó, have turned into leopards. All are jeweled with the spots of invincibility.

The connection between Shangó and beading is strong; the Efon-Alaiye altar keeper, Oluwuro Adeshina, was a master maker of Yoruba beaded crowns. He maintained a beautiful altar to Shangó that I photographed in December 1963 (plate 248). Adeshina attributed the altar's caryatid figure to a local master, Ajalemo, also known as Agbonbiofe. The date given: around 1903.

The most amazing element of the altar is the uplifted representation of a calabash of power, carved in wood in a manner not unlike the calabash-bowl-carrier (*arugba Shangó*) style of neighboring Ekiti and Igbomina. Herein rest lightning stones and other objects, totally concealed. Painted the darkest black in a gleaming oil, the simulated calabash looms over horse and rider like a thunder cloud. Shangó, mounted, bearded with wisdom, becomes a lightning rod, conducting all the noise and all the power.

Behind the image several *laba Shangó* (thunder wallets) hang upon the wall. When Adeshina's father went to Oyo to purchase one of them, in around 1913, the priests who prepared them told him that the figures on the four panels of the *laba* stood for the four founding chief priests of Shangó worship in Oyo-Ile: Laduba, Kosin, Oranyan, and Aganju. "They became spirits when they died."[191] This fits the association of the thunder ax and thunder rattle with named bodyguards, i.e., the Shangó tradition of commemorating named persons through objects on or near the altar. It also roughly dovetails with a section of praise poetry for Shangó that Verger collected at Oyo in the 1950s, verses that honor four founding *baba mongba* (high priests of Shangó) with special appellations:

> *Ona Mongba ki awa ji ire*
> *Otun Mongba ki awa ji ire*
> *Osi Mongba ki awa ji ire*
> *Ekerin Mongba ki awa ji ire.*

> *Mongba* of the road, awaken our luck
> *Mongba* of the right, awaken our luck
> *Mongba* of the left, awaken our luck
> Fourth *mongba*, awaken our luck.[192]

The up-down zigzag gesture of the four *mongba* on the *laba* brings lightning down to earth.

Edó (Benin City) maintains these elements of dazzling descent in the worship of the cognate deity Esango. Consider an altar that Phyllis Galembo photographed in the late 1980s (plate 250). Esango lives in dimensions of redness. Stones and rattles are upheld under walls bearing spotted streaks of leopard lightning and red streaks of ordinary fire. Each stripe is a stone on fire. Each cloth is Esango in flames. Causing all this mystic light are the stones in the vessels on the mortars. A priest remarked, "You can see where thunder strikes, you can see the different lightnings coming down."[193]

The boldness and the immediacy of the leopard king and his retinue became a legend in the black Americas. He named, in fact, several American extensions of the Yoruba religion, including the Xangos of cities like Maceió and Recife in Brazil and the Shangó worship of Trinidad. As this worship was consolidated, here and there racist elements, fearful of the power they sensed behind the imagery, attempted to stamp out the serving of Shangó. In Maceió, for example, on February 1, 1912, vigilantes attacked and sacked the altar of a defenseless priestess of Dada-Bayonni and Xango.[194]

Similarly, in late-nineteenth-century Cuba authorities apparently tried a black priest named Boku, a servitor of Changó, on charges of sorcery. But "Boku defended himself skillfully before the court. He said that the altar he had in his house was dedicated to a Catholic saint, Saint Barbara, and that therefore he was by no means to be called a witch."[195] A son of Changó had allied himself with Santa Barbara, as cultural camouflage, but also, surely, in a profoundly witty orchestration of spiritual similarity. For Saint Barbara, like Changó, was very brave. She defended her belief in God and Jesus in imperial Rome, for which her callous father turned her over to a court that condemned her to death. Whereupon her father perished, struck by God's lightning. Saint Barbara's chromolithographs in Cuba, which blacks knew well, laud her nobility with a royal crenellated tower and her bravery with a sword clasped firmly in her hand.

A brave saint connected with lightning inevitably fascinated the followers of the thunder lord. By the mid or late nineteenth century some Afro-Cuban altars combined the ax of Changó with the sword of Santa Barbara, the latter striped red and white with pigment.[196] By the end of the century, Changó might wear Barbara's noble tower, in miniature, as a crown: one Changó image was "a doll of wood dressed in [white] linen embellished with red bands . . . and adorned with multistranded beaded necklaces in the same colors. . . . He wears a crown in the form of a [crenellated] wall that seems to have been taken from that which Catholics attribute to Saint Barbara in her imagery."[197] The creole process was well under way. It harnessed the new to the ends of keeping ancient truths alive.

That process includes today a major icon of a national sport of both Cuba and the U.S., the baseball bat. In 1984 Judith Bettelheim, an authority on Afro-Caribbean art and culture, purchased a *bate de Changó* at a botanica on Mission Street in San Francisco (plate 251). The bat symbolizes both Changó's beauty (*para bonito*), in the liquid fire of the red-and-white beading, and his spiritual militancy (*para defensa espiritual*).

Dan Cody photographed a portion of a major altar to Xango at a Kongo-Angola *candomblé* in Bahia, in 1988 (plate 252). The keepers of this altar beautifully restate the essence of Xangó: uplifted thunder-stones. Set in an almost conventlike austerity of plain white walls without emblems or painting, this altar achieves its impact in a drama of stones and wooden mortars. Shangó forgoes the fragile porcelain that honors others among the *orisha*; he chooses wood—because it bursts into flames, because it splits into pieces, when he works his lightning. Stones, bowls, and mortars fuse in a powerfully indented way. Brancusi meets his master in the subtle faceting of the supporting mortars, especially the hourglasslike masterpiece second from the left. Dense, dark, and solid, the stones are Zen-like in their impact. The bowls (*iba xango*) containing them belong to different devotees, each guarding Xango's essence for praise and prayer.

In both Brazil and New York an extension of the thunder god's power and mystery has been discovered in electricity itself. The stratagems are simple: in one Umbanda center in Maceió, when a priest begins to sing the praises of Xango he turns on a red

With the Assurance of Infinity: Yoruba Atlantic Altars

PLATE 250 (RIGHT): ALTAR TO ESANGO, BENIN CITY, NIGERIA, TWENTIETH CENTURY. Esango is the Benin cognate to Shangó worship. According to the priest who tends another Esango shrine in a village near Benin, the red streaks and crimson cloths depict various lightnings of Esango coming down. Photo: Phyllis Galembo, 1988.

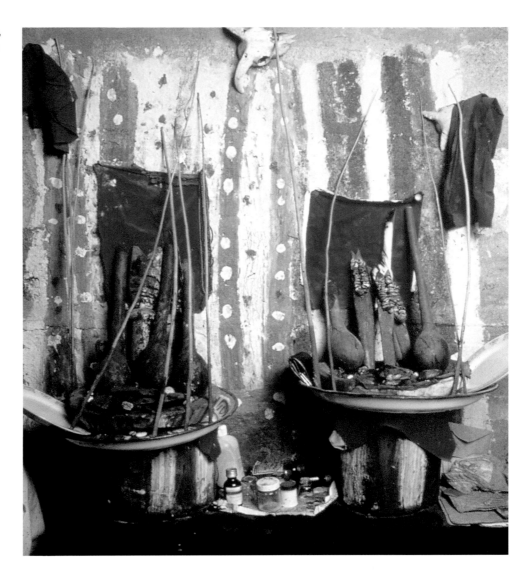

PLATE 251 (RIGHT): *BATE DE CHANGO*, 1984 OR EARLIER. Among the fascinating creolized emblems of Yoruba worship in Cuba and Latino North America is the baseball bat, used as a spiritual weapon and emblem of the thunder god. Oscillating patterns in Changó's characteristic red and white beads bring back the liquid fire of his world of thunder and lightning. This bat was bought by Judith Bettelheim, an authority on Afro-Caribbean culture, in a *botanica* (Yoruba herbal store) in San Francisco in 1984. Photo: Judith Bettelheim, 1984.

light, flooding the altar, filled with *oricha*/saints, with the color of the god's righteous fire (plate 255). And in Brooklyn, in the winter of 1985, the late Charles Abrahamson captured in red paint on white sheeting a giant silhouette of Changó with looming axes on his head (plate 253). This he caused to be back-lit, giving the impression that Changó himself stood behind the cloth, guarding an altar elaborated within a closet.

Celebration of the attributes of Shangó unites more than 150 years of African-Atlantic art. From Havana in the second half of the nineteenth century comes a splendid figural thunder ax (plate 254), collected by Ortiz and now in Havana's Casa de Africa museum. Miniature *mazos* garland Changó's neck. With his ax and his club—the club that was later to become a baseball bat—spotted with feline fluidity and grace, Changó held out to the blacks of Havana a life superior in nobility and excitement.

With the passing of the "salt water" tutors and the succeeding and continuing improvisations of creole chapters, altars for Changó increasingly took their power from cloth, beads, and porcelain, in exquisite orchestrations. The work of the late Ramón Esquivel, disciplined and sensitive, brilliantly creolizes Changó's colors and tempestuousness with prosceniumlike illusions of depth obtained through combinations of sheer and solid textiles. On April 3, 1983, Brown documented one of Esquivel's masterworks, a *trono del*

PLATE 252: ALTAR TO XANGO, NEAR SALVADOR, BAHIA, BRAZIL, TWENTIETH CENTURY. The beautifully sculptured mortars for Xango in this Kongo-Angola *candomblé*, Brancusi-like in their cuts and indentations, enthrone the stones of the thunder god. The chaste plain white walls behind the altar are a characteristic of this *candomblé*. Photo: Dan Cody, 1988.

With the Assurance of Infinity: Yoruba Atlantic Altars

tambor para Changó—a ritual throne for the presentation of an initiate to the sacred *batá* drums (plate 256).

Though the principal spirit honored is Changó, there is, as in the Afro-Cuban *canastillero* and the collection of draped *soperas* on the floor, a gathering of many *oricha*. At far left and far right their honorific cloths (*panos*) break the canon of Changó's red and white, the white cloth at left a splash of Yemayá, the amber coloration that dominates the right-hand accent honoring the goddess of love, Ochún. Obatalá, as in Maranhao and Rio, is at the top, though here he appears not as a statue but as a sparkling shield of silver cloth. Below, on the floor, are the Eleguás and other *guerreros* (Ogún, Ochosi) of the house.

Brown's careful exegesis includes the notation that the wooden tray or bowl and supporting mortar (which we saw in naked Brancusi-like brusqueness in Bahia) is here covered over with red cloth that is cut to the shape of a thunder ax.[198] But just as Claes Oldenburg brought fire stolen from action painting into Pop, making hard phones soft, so Esquivel, in dressing, rather than carving, the thunder ax, makes it lift its arms in a rabbinical manner that speaks across the cultures and the faiths. This gesture is so strong that it forces one to reinterpret the proscenium framing, enacted by diaphanous red curtains, as a muted echo of the thunder ax below.

The *batá* on the floor are consecrated to the *oricha*, *itótele* at left for Changó, *iyá* in the middle for Obatalá, and *okónkolo* at right for Eleguá. This pyramid of sound matches the material pyramid of white and red: Obatalá at the apex, Changó's red and white below that point, the Eleguás on the ground. At the end we recall that in Nigeria, Shangó once played *batá* to bring down rain and fire and thunder. Small wonder that the descending lines of white and red take on body in the horizontal solids of the *batá*. The Nigerian storm on the edge of a knife has become a play of fire and smoke in a corner of New Jersey.

PLATE 256: THRONE FOR A DRUMMING TO CHANGÓ IN WHICH INITIATES ARE PRESENTED TO THE *BATÁ* DRUMS (*TRONO DEL TAMBOR PARA CHANGÓ*), DESIGNED BY THE LATE RAMÓN ESQUIVÉL, NEW JERSEY, APRIL 1983. BEADWORK BY MELBA CARILLO. *BATÁ* DRUMS MADE AND CONSECRATED BY THE *BABALAWOS* OF TEMPLO BONIFACIO VALDES, NEW JERSEY, 1982. Many *oricha* gather, through their *soperas* and cloths: at left, Yemayá; at right, Ochún; presiding as silver near the ceiling, Obatalá. Changó's wooden mortar and bowl are covered with red cloth arranged in the shape of the thunder ax. The *batá* drums—*itótele, iyá, okónkolo*—wait in the foreground. Photo: David H. Brown. Copyright © David H. Brown 1989. All rights reserved. Reprinted with permission. See *African Arts* 26(4)(October 1993).

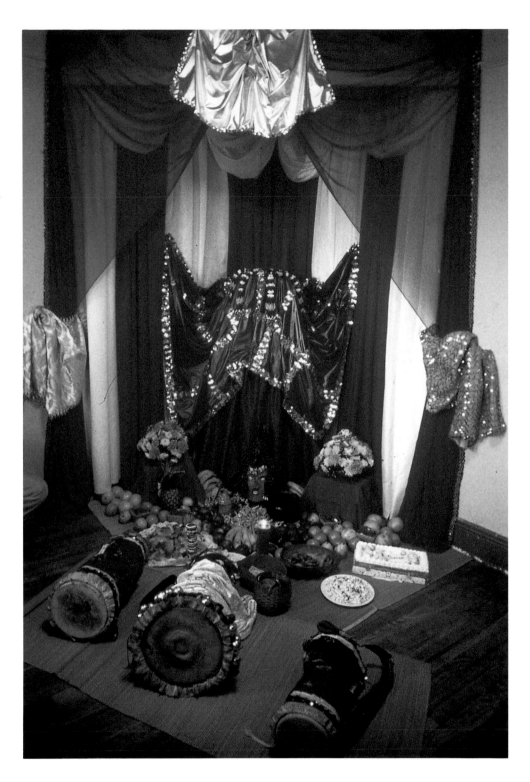

Dàda-Bàyònnì: Gentle Sister of Lord Shangó

Worship of Dàda-Bàyònnì indicates that dreadlocks can be altars.
—Daniel Dawson, July 1993

Bàyònnì kò lè jà sùgbón ó li aburo ti ogbojú.

Bàyònnì is not a fighter but she has a kid brother who's a terror.
—Verger, *Notes sur le Culte des Orisa*, 1957

Bàyònnì is a saintly ruler. She is famous for her gentle character, and also for her splendid crown and coiffure: she was born with thick curly hair, which automatically named her Dàda, a name predictive of a life of money. Such babies are also called *omomolokun*, children of the sea, their hair being likened to seashells, the sea's wealth. Their parents let them grow it long.[199]

Indeed Bàyònnì did become quite rich, as ruler of Oyo. She was famous for her love of peace, of children, and of beauty and artistic decoration. In fact she was too saintly for the hard-nosed world of Oyo imperial politics. They deposed her, by one version. By another she abdicated in favor of her feisty brother, Shangó.[200]

Not only was it too much for aggressive Oyo to find a woman as king, but keepers of tradition have erased Dàda's gender. She is remembered as a weakling who "scarcely ruled," a feckless man. "The question of the gender of Dàda-Bàyònnì," remarks John Mason, "gets thrown back and forth, but the black elders in Cuba who keep to the tradition know that she is a woman."[201] The long tresses of her famous hair, proto-dreadlocks in their structure and spiritual reverberation, are remembered clearly in Matanzas. In fact the elders prepare her crown with strands of human hair, "hair that has to come from a virgin girl."[202]

Money, crowns, dreadlocks, and gentle disposition characterize praises to Dàda-Bàyònnì in Nigeria, Brazil, and Cuba. From Ijebu-Ode, Nigeria:

> *Aládé li éye*
> *Gbonri adé*
> *Gbonrí osì sí iwájú*
> *Gbonrí orò sódò mi*
> *Adé di méjì.*

> Crowned person of befitting character
> Shake your crown,
> To drive away all evil from the front
> To whirl in fortune to my side
> Sacred crown of mirrored power.[203]

Bahia adds:

With the Assurance of Infinity: Yoruba Atlantic Altars

Dada má sun kún mó
Dada fún mi l'owó.

Dada don't cry
Dada make me rich.[204]

And Matanzas answers:

Dadá omo l'owo omo lube 'yo
Ero Dadá
Ma sunkún mo
Fún mi l'owó se mejí
Dadá ma sunkún mo.

Dadá born with cowrie curls, ruler in Oyo, clad in red
Dadá, gentlest of persons
Don't cry
Give me money to double the power of my life
Dadá, please don't weep.[205]

Bàyònnì arrives and departs in kindness, leaving the image of her rich crown and coiffure strung with cowries as an altar to her memory. The leitmotiv linking Matanzas to Bahia is the plea that she not weep: not cry over losing the crown of Oyo in one version, not cry for the death of Shangó, her beloved sibling, in another, not cry in sympathy with the grief and trauma of the world in general. Bàyònnì's tears are a measure of her heart. Hers is the kind of crying that brings people together with unfeigned signs of affection and emotion. Too insightful for politics, she measures herself against the deeper canon of

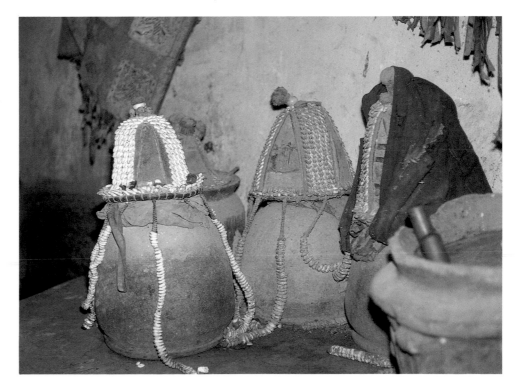

PLATE 257: ALTAR TO DADA-BAYONNI, BAALE KOSO, OYO, NIGERIA, MID TWENTIETH CENTURY. The role of Dàda-Bàyònnì, gentle ruler and sister of Shangó, has been effaced somewhat in Yoruba history and belief. But the rich cowrie-covered casques that celebrate her and her kindness are marvels of art for the family of the thunder god. Photo: Robert Farris Thompson, January 1964.

PLATE 258: COWRIE CROWN (*ADÉ*) FOR DADA-
BAYONNI, WORN BY A PRIESTESS OF MACEIO,
BRAZIL, IN THE LATE NINETEENTH CENTURY. This
rich casque, which on stylistic grounds appears to
have been imported from Yorubaland, is a signal
demonstration of Dàda's presence in the Americas.
Photo: Robert Farris Thompson, 1985. Collection of
the Instituto Histórico e Geográfico de Alagoas,
Maceió, Brazil.

abiding kindness. From his scholarly peregrinations to Matanzas, Mason reports that
"Dadá is the crown of the *babalorisa* and *iyalorisa* and compels them to do good for the
sake of doing good."[206]

The sign of Bàyònnì in the Baale Koso shrine in Oyo is her cowrie crown (plate 257).
Gleaming dreadlocks of threaded cowries compose four intersecting vertical arches.
Others cascade down. This organization of her monied dreadlocks in multiples of four
may reflect her association with the Ifá divination permutation called *irosun meji*, itself
linked with four and four. As one New York priest told me, "Dadá speaks through *irosun
meji*. It is the frontier of Dadá, where Dadá exists."[207]

Each cowrie crown of Bàyònnì at Baale Koso surmounts the body of a generously
curved pottery piece, confirming her gender, for pottery is woman. One is shrouded, like
an elder. All carefully display their gleaming shell-braided locks against the beige and
brown tones of the pottery stands. Possibly more than the famous money-implying curls
of the child born Dàda is flaunted on these pottery stands. For when the devotees take
them to the dancing court, and whirl and shake the fabled snakelike coils, they appar-
ently, per the Ijebu-Ode song, activate protection against evil and attract an aura of luck
or fortune.

The four vertical lappets defining Bàyònnì on this Oyo altar, photographed in January
1964, is not her only style. Overcome by grief at the death of Shangó, Bàyònnì is
supposed to have disappeared in a termite mound marked with palm fringe (*mariwo*) at
Seele, in northern Yorubaland, not far from Oyo-Ile. Here her crown is a casque covered
with a tight weave of cowrie strands.[208] Which is precisely how we meet it, down to the
sharp wooden point that bursts through the sphere of cowrie covering, in an *adé
Bayonni* now in the Instituto Histórico e Geográfico de Alagoas in the city of Maceió, in
northeastern Brazil (plate 258). It is told that Tia Marcelina, the dominant Yoruba priest-
ess of Maceió in the late nineteenth century, "was seen wearing the crown of Dada, sister
of Xango, in the African ceremonies [over which she presided]."[209] It is likely that this
superb piece is the very crown she wore; it was part of a collection of objects taken from

PLATE 260: TWIN FIGURES (*IBÉJI*), SHAKI, NIGERIA, NINETEENTH/TWENTIETH CENTURY. Yoruba consider twins a special gift from God—miniature *orisha*. They are also the children of Shangó and come under his protection. This pair wear the cowrie dreadlocks of his sister, Dàda-Bàyònnì. Collection of Lawrence Gussman.

With the Assurance of Infinity: Yoruba Atlantic Altars

her *candomblé*. The style is close to that of Seele, with an added leather chin-guard to stabilize the wearing. Tio Salu, another famous leader of Yoruba religious life in Maceió in the late nineteenth century, made a pilgrimage to West Africa (like Martiniano do Bomfim in Bahia): "Perhaps through his intercession some of the finest pieces of the Instituto Histórico e Geográfico"—including, perhaps, the *adé Bayonni*—"were brought from Africa."[210]

In contemplating this piece, one can almost sense the kindness of Bayonni pulsing in her mind behind the halo of lustrous cowries.

Bàyònnì's loss of the throne of Oyo did not blur her essential nobility. Higher force exalts her, as it does a Bodhisatva. Which is precisely her aura on an altar in Matanzas photographed in March 1992 (plate 259). The powers and accomplishments of Changó, his red-and-white rattle-scepters, his thunder axes, and his special children, twins—all are cast in quietude and glory under the descending monied tresses of Bàyònnì's Cuban avatar, Dadá Obañene. This compound altar takes its structure and its focus from her shining crown. In Nigeria, emblems for Bàyònnì are displayed by themselves; in Matanzas her cowrie-studded strands touch and frame the seals of Changó with a higher form of character and command.

Esquivel clearly brought this style of apotheosis to New Jersey from Cuba. Recalling a Bahia crown of Bayonni documented by Carybé in 1980,[211] whose opulence it rivals in an inventive creole way, Esquivel's crown is built with twelve cowrie dreadlocks (plate 304). But he uses red and white beads as well as cowries. Obañene floats at the apex, as if let down on a silver cord from heaven. The sister of Changó becomes the Crown of the Saints. Her dreadlocks form her face, her altar.

Ibéjì: Gathering the Firewood of Splendor

Yoruba are known to have the highest rate of multiple births in the world.[212] Twins, because of their double weight upon the uterus, are often born prematurely, and sometimes die at birth. Correspondingly, Yoruba have elaborated the greatest number of twin memorials, carved in wood and called *ere ibéjì*, in the African continent.[213]

Religious conviction informs the tradition: "Twins are a special gift from God. They must be treated with special care for they are . . . sacred beings. If they are made to feel welcome the parents will derive material benefit from them."[214] Twins are miniature *orisha*. If they should die, their parents must replace them with wooden statuettes, which must be honored and kept if the mother wishes to bear more children. This is the engine behind an amazing tradition.

Shangó the thunder lord shelters twin images on his altars. Because he himself is believed to have fathered twins, he is their lord (*oko ibéjì*). The links with the thunder god intensify in the Americas. Cubans hold that twins are the children of Changó and Ochún. Bahians variously believe their parents are Oxossi and Oxum, or Xango and Oya Yansan. The fact that twins are called by Ki-Kongo names in Haiti (*marassa*) and Brazil (*mabasa*) provides a hint: perhaps fragments of belief from Central Africa creolized there along with Yoruba tradition.

Praise poetry for twins in Nigeria usefully formulates their relation to heaven and their moral challenge to the living world. Here are excerpts from a long poem glossed and translated by Dejo Afolayan in 1988:

Se b'Olodumare Oba ni
Oba Odumare lofejire jin o:
Loje ko o bi 'beji le e kan soso o.

Eniti 'nu re ba mo
L'Oluwa fún lore.

Eni Ejire ba n wuu̱ bi laye
ko yaa ni'wa tútù
Ko ni nu u re n loto.

Igi olowo mo se

O jí fi'lu kii bi eni r'Aláàfin orun
A jí jija du ewa.

Omo to wole oloro ti ò de si
Ore alákìsa
O so alákìsa d'onigba aso.

It is Great God Almighty, the King
It is Lord God Almighty who blessed you with your twins
That is why you had two at once.

God grants twins to a person
Whose heart is pure.

Let she who fantasizes having twins
adopt a gentle character
Let him remain transparently honest.

I gather the firewood of splendor

A twin wakes up to the beat of royal drums, like those
 of the Alaafin [king of Oyo] in heaven
Wakes up to fight for the art of beauty.

Twin sees the rich, passes them by
Twin loves persons in rags
Twin will transform person in rags into a paragon of
 royal dress and richness.[215]

The text deepens our understanding: twins are a gift of God. They descend with a
taste for royal drumming, which the king of Oyo played for them in heaven. Some say
that king was Shangó.

With the Assurance of Infinity: Yoruba Atlantic Altars

A pair of twins from Shaki, Nigeria (plate 260), show hair dressed with the four verti-
cal dreadlocks characteristic of the crown of Dàda-Bàyònnì, Shangó's sister. (In Cuba
today, in Matanzas, there are altars that combine Shangó and his children the twins with
the crown of Dadá [plate 259], in a column of united power and assertion.) In addition,
ibéjì images from Oyo sometimes have a lightning pattern (*jéwòn-jéwòn*: zigzags) running
along their bases. Ibarapa-area *ibéjì* from the village of Eruwa have thunder axes incised
on chest or breasts: a prayer that Shangó grant them more twins.

The zigzags and axes of Shangó and the coiffure of his sister do not exhaust the
elements of style that relate twin images to heaven. The most elegantly coded of these is

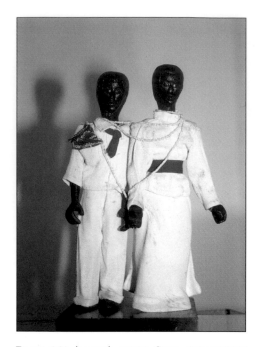

PLATE 262 (ABOVE): *IBEYI*, CUBA, NINETEENTH CENTURY. These twin figures' white costumes connote the ritual purity of the religious initiate; their red sashes identify them as children of Changó. Fernando Ortiz Collection, Casa de Africa, Havana.

the way their hold their arms: parallel to the body, drawing a conceptual straight line, doubled, from heaven to earth. It is a mime, a prayer, to bring blessings down as immediately as possible:

> *Pa apa ibéjì mora*
> *ki ile o le kan oke.*

> Stand, oh twins, with your arms straight and parallel
> to your body,
> that earth might touch the sky.[216]

This miming of spiritual descent reappears in canonical purity in a pair of *ibéjì* from the last quarter of the nineteenth century, now in the Instituto Feminino da Bahia in Salvador (plate 261). Features are identifiably Aworri Yoruba. Evidently the pair was carved in Otta, capital of Aworri, then sold in Lagos, perhaps to someone like Martiniano do Bomfim, who visited Lagos from Bahia to study Ifá and collect ritual objects for his shrine in Brazil.

PLATE 263 (RIGHT): ALTAR TO *IBEJI*, MEKO, NIGERIA, 1950S(?). The altar was made to commemorate a pair of twins who had died. After it was dedicated, another pair of twins came into the family. They stand next to the altar to which their arrival in the world is attributed. Photo: Robert Farris Thompson, August 1989.

With the Assurance of Infinity: Yoruba Atlantic Altars

Twins associate with richness of dress. In a Nigerian twin altar in Meko, in Ketu-Yoruba country, the images are carefully attired and at night are laid to rest on ample flowing cloth. In the photograph, taken in August 1989, two women twins stand beside the altar (plate 263). They are related to the pair of twins whom the altar commemorates; indeed, it is believed these women came into the world because their mother honored the dead twins with these statuettes.

Near the altar are traces of black-eyed-pea paste and palm oil. Sugar cane may also be offered in sacrifice. These are more than votive gifts. Sugar cane (*ireke*) is a sign of continuity; once planted, it spreads, just as once twins enter a family, the lineage will multiply. Red palm oil mystically strengthens the blood. Black-eyed peas (*èwà*) pun on *wa*, "the essence of existence," communicating the deepest kind of prayer. Okra is important too.

In Cuba, twins' love of sugar cane transmuted into love of fruits and candies. Maize and yellow rice replaced black-eyed peas and red palm oil. But association with Shangó was maintained: "In 1868 a [devotee] declared that twins were the brothers of an image . . . that by its description [was] Shangó."[217] Ortiz illustrates an Afro-Cuban altar to *ibeyi* and other *oricha* dating from more than a hundred years ago: "a table laid with an embroidered cloth on which we see three vessels for food offerings. To the left an axe and knives. To the right the twins."[218] An ax for Changó, knives for Ogún, a bow-and-arrow emblem for Ochosi, and a Virgin—fronting, perhaps, for Yemayá—accompanied the double children.

Twin images in nineteenth-century Yoruba-Cuban worship could be beautiful. Witness a pair from Ortiz's collection (plate 262), now in the Casa de Africa Museum in Havana: the immaculateness of their white dress relates them to the ritual purity of initiates. The red sash identifies them as children of Changó.

Catholic-oriented Yoruba-Cuban altars may refer to the Western twin saints Cosmas and Damian (Cuban names for Brazil's Cosme and Damião). But by the early 1950s more creolized altars to twins had emerged in Cuba, and were remarkable: "*ibeji* like candy, toys, and games and they behave like small children. In many of the homes of worshipers are toy houses for the *ibeji*, furnished with tiny chairs, tables, lamps, wireless sets, refrigerators and often electric lights."[219]

This prepares us for equally exciting change in Brazil, but before we look there we should note that Dahomeans came to Bahia before the Yoruba. Thus the Dahomean tradition of honoring twins with two small ceramic pots linked together reappears in Bahian worship, joined with the Yoruba tradition of twin statuettes.

Also, Kongo presence is massive in Brazil, and includes a parallel tradition of honoring dead twins with images. Bakongo believe God chastens those who are not living right by sending them twin children. Inherently bountiful, twins will shock their parents into proper living. Dead twins are buried at the crossroads, which becomes their altar. As in Yorubaland, if one twin dies a statuette will be carved to replace the infant. If both die, two are carved. The images are called *teki kya mabasa* (twin images). In plate 264, showing a pair carved in around 1985 in the village of Mwanda, Zaire, among the Woyo, the twins' mother holds these figures in her lap.

Teki kya mabasa are deliberately modest. "We are uncertain about [twins'] origin, where they come from, what they look like in their original spiritual form, so we keep

their images vague and simple," remarks the Kongo scholar K. Kia Bunseki Fu-Kiau.[220] *Mabasa* in Ki-Kongo literally means "those who come as two." A mother who has had two sets of twins becomes *ma ngudi ansimba*, and her house can overflow with as many twin images as she likes, not just images referring to actual children. The Kongo shift to multiple images of children, not necessarily dead, marks a crucial difference from the economies of Yoruba twin statuettes and Dahomean miniature pottery forms, which are usually paired, or, less frequently, grouped in threes. A similar expansion in number and intensity has clearly taken place in Brazil.

With the Assurance of Infinity: Yoruba Atlantic Altars

Twins, the children of heaven, impose discipline and generosity upon parents the Yoruba world over. Perhaps because of the spark of four traditions flowing together in Bahia—Dahomean, Yoruba, Kongo, and Roman Catholic—the honoring of twins explodes into one of the remarkable feasts of the Black Atlantic world. Each September 27—the day of Cosme and Damião, the twin saints of the Roman Catholic church—many *candomblés* celebrate the *caruru ibeji*, the twin feast, serving an okra-based dish on a tray. As children squat and eat with their hands in African fashion, adults honor them with songs that bring out the ludic joys of childhood:

> *Dois-dois*
> *Dois jogando bola*
> *com ela*
> *Dois jogando bola*
>
> *Cosme e Damião*
> *Ogum e Alaba*
> *Vamos catar conchinha*
> *na beira do mar.*
>
> Twins
> Twins playing marbles
> with her
> Twins playing marbles
>
> Cosme and Damião
> Yoruba iron god, Yoruba child born after twins
> Let's all go look for tiny seashells
> by the edge of the sea.[221]

In the process, twins become protectors of *all* children, and of their games and sense of play. In some *candomblés* the *caruru* feast—chock full with peppers and palm oil, in a return of the foods of the Yoruba coast—involves seven children invited to match "the seven *mabaça* spirits," Cosme, Damiao, Idowu, Alaba, Crispin, Crispiano, and Talabi. The practice blurs together Catholic saints with twins and twin-associated children in the lore of the Yoruba. It calls twins by the Ki-Kongo term to boot.[222]

The logic of the *caruru ibeji* generates the structure of an *ibeji* altar in Cosme de Farias, photographed in the summer of 1984 (plate 265). This narrow room is a miniature *candomblé* presided over by children, guided by a doll representing a priestess of the *orixa*, in crisply starched dress and with miniature *orixa* beads flashing. There are so many toys and medicinal plants and embedded seashells that the eye at first cannot focus. But gradually it becomes apparent that the spirit of the *caruru* is organizing things: seashells from a playful exploration of the beach enliven the decoration of the dais at the left, and marbles and other toys associated with the games of September 27 are everywhere.

The shrine reveals a commitment to beauty (miniature flower baskets, elegantly miniaturized fruit bowls), entertainment (an African doll house, a miniature lamp, toy

PLATE 265: ALTAR TO *IBEJI*, COSME DE FARIAS, BRAZIL, CONTINUOUSLY REWORKED SINCE AT LEAST THE 1950S. Twin worship in Yoruba Brazil flows into the general celebration of *all* children, of whom *ibeji* are seen as the special protectors. At the *carurú ibeji* or twin feast—celebrated every September 27—adults honor their children with songs and play, and treat them to the okra-based dish called *carurú*. This twin altar in Cosme de Farias is clearly informed by the carnival spirit of the twin feast: it is stocked with marbles, an African doll's house, miniature trains, pots, lamp, and other toys, seashells from a trip to the beach, and a pile of coins. Photo: Robert Farris Thompson, 1984.

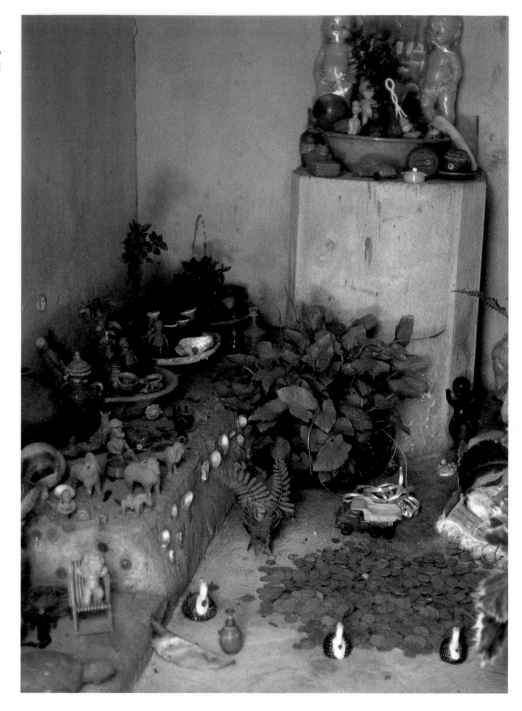

trains), and ritual refreshment (tiny water vessels, coffee pots, containers for honey, tea, and candy). All these accents of play and leisure lead to the formal dais at the end of the lower platform. At the summit stand two large celluloid dolls representing Taiwo and Kehinde (classic Yoruba names for twins). Their Catholic counterparts stand right behind them, with a small doll representing a male child born after twins, Idowu. Here a toy telephone is interpolated, an affectionate touch meant to pamper a modern twin child's love of pretending to telephone friends, playing communication in the midst of seriously conveyed convictions. A large pile of coins scattered on the altar floor presumably manifests the fortune that twins are supposed to bring. But the scattered money would also afford living children, invited to the *carurú*, a chance to discover and play with treasure.

With the *carurú* feast constantly generating and improvising further structure, the honoring of twins in Bahia has expanded into celebrating the sacredness of children

With the Assurance of Infinity: Yoruba Atlantic Altars

PLATE 266: ALTAR TO *IBEJI*, COSME DE FARIAS, BRAZIL, continuously reworked since at least the 1950s. At the same shrine illustrated in plate 265, a pair of ceramic pots laid among toys are sashed with an *òjá*, recalling Dahomean practice. Photo: Robert Farris Thompson, 1984.

(*crianças*) per se and their joyously inventive lives. A quality of carnival occurs again and again in today's *ibeji/mabasa* altars in Brazil. At the same time, the old influences continue to assert themselves, as in the tying of twin ceramic vessels together with a green sash (plate 266) in the shrine just visited. Dahomey and Rome and Yorubaland and possibly Kongo are all present in spirit here in the midst of airplanes and trains. Toy reptiles possibly smack of a trace remembrance that *ibeji* are *simbi*, and hence allied with the denizens of the deep; but perhaps they refer to nothing more than play. In Aracajú, north of Bahia, twins and altars to the *orixa* (plate 267) mutually reinforce one another. The *orixa*/saints are ordered and protective. From niches and shelves upon the wall they look down upon what seems to be a miniature day-care center, toys scattered everywhere. That quality of freedom and spontaneity was orchestrated by living children, small hands exploring and shifting and moving and abandoning toys in actual play.

Aracajú and Cosme de Farias are festivalizing solutions. But there is room for other voices, other concerns, muted and less busy. Consider the small twin altar (*iba ibeji*) at the *candomblé* of Pai Balbino in Lauro de Freitas, photographed in the summer of 1984 (plate 268). Associating twins with Dahomey because the Dahomean rainbow spirit Oshumare is a twin, Pai Balbino places his *iba* right beside the dais for the good serpent of the sky.

The altar consists of pottery containers and essentially nothing else, as in Dahomey. Here we see the gist of the *iba ibeji*: a shallow earthenware bowl called an *aguida*, filled with sand from the sea, in which are positioned miniature *quartinhas* made for twin worship. These *quartinhas* studding the sand often number seven, matching the equation by which we saw children invited to the shrine of the *mabasa*: the universe of twin saints, here named Taiwo, Kehinde, Dou, Alaba, Crispin, Crispiano, and finally Talabi. A large *kolobo* vessel towers over the miniature array of *quartinhas*, their diminutive size immediately communicating connection with children, like a tea set from a doll's house. At the feast of the twins on the September 27 the *kolobo* receives double miniature offerings of *carurú*, and the *quartinhas* hold cool water tinctured with honey or red claret—perhaps a

culinary translation of red palm oil, thought to strengthen the blood of the devotee (by analogy with the equivalence of blood and wine in Roman Catholic liturgy?). Sometimes twinned pairs of *pequarí*, small seashells, are placed in the circle of sand to link the ensemble to Oxum and her underwater realm. Like a formal setting at a banquet, the abstract arrangement of this *iba* cries out for the festivity that animates it, the chirping sounds of delighted children, sipping the wine and dipping sticky fingers in the okra.

Twin art and altars are accented differently from place to place in the Americas, and from period to period. We have seen twins dressed as immaculate initiates, in white sashed with red, in nineteenth-century Cuba, and treasured as heirlooms brought from Africa in nineteenth-century Bahia. We have seen the Fon/Ewe tradition of twins abstractly imaged by double presentations of pottery, as in the symbolically sashed exam-

PLATE 267: ALTAR TO *IBEJI* AND TO THE *ORIXA*, ARACAJU, BRAZIL, TWENTIETH CENTURY. From tiers and niches in the wall, the *orixa* look down in calm order on the scattered toys left by children celebrating *ibeji*. Photo: Robert Farris Thompson, 1988.

With the Assurance of Infinity: Yoruba Atlantic Altars

ple from Cosme de Farias (plate 266). And we have seen all of these traditions explode into further elaborations with circular pottery trays of *quartinhas*, as in Lauro de Freitas, and sprawls of toys and dolls at Aracajú and Cosme de Farias. These altars build ideal material zones of *communitas*, communicating transparent joy in toys and presents, freedom to play in an aura of reassuring love. Any attempt to link these treasures to a single line of influence gets happily and irremediably lost in a chorus of plural voices. Seen as a whole, however, they nonetheless return us to the insights of antiquity: to come, as the elders say in Nigeria, within the aura of the twins is to gather the firewood of splendor (*igi olowo*) and to wake up, prepared to fight for beauty.

Creativity and Salvation: The Avatars of Obatálá

Iwen ti iya ko ola,
a ji nte ibi.

Word that transforms grief into joy
Word that gets up early and stamps the ground, right here.
—Verger, *Notes sur le Culte des Orisa*, 1957

Cancel the world's distraction, activity, and noise, and become fit to hear the essence of things.
—Saul Bellow, *Humboldt's Gift*, 1976

The essence of Obatálá is a white cloth (*ala*), sign of transparent honesty and peace. He is a saint among saints. His praise poems say so, and introduce a number of his famous avatars, Oshagiyan, Oshalufon, and Osaala:

Obatálá ogiri oba Ejigbo

A dake sirisiri da eni li ejo
Oba bi ojo gbogbo bi odun
Ala, ala. Niki, niki.
Oni panpe ode orun
O duro lehin o so tito
Oro oko abuke
[Oshagiyan] jagun o fi irungbon se pepe enu
A ji da igba asa
Ti te opa osoro
Orisa Olu Ifon.
Lasiko fun mi li ala mu so ko
O se ohun gbogbo ni funfun ni funfun
Pirilodi aka ti oke
Ajaguna wa gba mi, O Ajaguna
Ti nte opa oje.

Obatálá, strong king of Ejigbo

At the trial a silent, tranquil judge

The king whose every day becomes a feast

Owner of the brilliant white cloth

Owner of the chain to the court of heaven

He stands behind persons who tell the truth

Protector of the handicapped

Oshagiyan, warrior with a handsome beard

He wakes up to create two hundred civilizing customs

Who holds the staff called *opasoro*

King of Ifon.

Oshánlá grant me a white cloth of my own

He makes things white

Tall as a granary, tall as a hill

Ajaguna deliver me

The king that leans on a white-metal staff.[223]

Obatálá's worship is strong in Ifon and Ejigbo. The praise song matches these places to two of his avatars: Oshagiyan, king of Ejigbo, Oshalufon, king of Ifon. It also introduces further incarnations—Ajaguna the deliverer, Oke the hill. Men call Obatálá "judge" because another famous manifestation is Orisha Oko, whose tribunals at Irawo are well known. Oko wields a famous steel staff, the top of which is male, the bottom female, matching the signs of life, red (menstrual blood) and white (semen), that identify his worship. Such staffs rest carefully in a special trough of wood.

In Cuba the steel staff vanished. But the red and the white remains, striped onto emblems, still set within a trough or concave tile.

An avatar of Obatálá called Oloofin bears a different staff, the *opa oloofin*, with bird, disk, and pendants. I photographed one in Iddo-Ekiti, Nigeria, in the fall of 1963 (plate 269). And other Obatálá avatars carry yet a third staff, the *opasoro*, which becomes a

PLATE 269 (ABOVE): A PRIEST OF OLOOFIN, AN AVATAR OF OBATALA, HOLDS AN *OPA OLOOFIN*, IDDO-EKITI, NIGERIA, FALL 1963. Obatálá is a "white" *orisha*, a saint among saints, a pure judge. A number of his avatars carry staffs of authority and arbitration like this *opa oloofin*, a bird-topped standard. Photo: Robert Farris Thompson.

PLATE 270 (FOLLOWING PAGE): *TRONO* ALTAR TO OXALA, OXAGUIAM, AND OXALUFOM, AVATARS OF OBALUAIYE, MADE BY MAI JOĆELINHA, COSME DE FARIAS, BAHIA, SUMMER 1982. Another staff of Obatala, the *opaxoro*, appears three times here—to the left, and paired behind the *trono*—in versions by Mario Proença. The predominant color is white, with metals of silver and tin. Oxala receives a crown with beaded veil (top) and an enormous *òjá* bow. Two columns (*pepele*) of cement studded with silver-painted stones would appear to relate to antecedents in Yorubaland (see plate 275). Bells, scepters, staffs, swords, and crown tell a story of royalty and nobility. Photo: Robert Farris Thompson, 1982.

famous emblem in Brazil, under a lightly creolized name: *opaxoro*. Three magnificent staffs by the local master Mario Proença flank and guard a shrine to Oxala, Oxaguiam, and Oxalufom in Cosme de Farias, Bahia (plate 270). These Afro-Baroque expressions of creative tinsmithing are *opaxoro*, but the *opa oloofin* is just as clearly their precedent. A whole art history remains to be traced in the complication of the *opa oloofin* and cognate forms into the multicup staffs of Bahia with surmounting bird image and rich metal fringing. In Bahia I have seen *opaxoro* from the last quarter of the nineteenth century that are simpler than the twentieth-century staffs at Cosme de Farias and closer in form to the Iddo-Ekiti staff. I would guess that they came to Bahia through free black traders with connections in Ilesha, which is quite near Iddo.

In Bahia, the Obatala avatar Oxalufom holds the *opaxoro* because he is older than, for example, Oxaguiyam. He needs it as a cane. At Iddo, Oloofin holds the *opa oloofin* for a similar reason—he is older than Obanifon.

Obatálá has many other avatars. One is Oke, lord of the mountain, who reappears as a miniature hill (*oke*) of yam paste on altars to Obatálá in Cuba and in Latino New York City.[224] They relate to the prototype to the left of the Oko altar in Ibadan seen in plate 184. Another avatar is Ajaguna the deliverer, whom we met in the praise poem. It is Ajaguna who guards a splendid *trono* made by the late Juan Bauzo in Brooklyn in 1989 (plate 185): his staff appears at left, brilliantly white, with touches of red. Ajaguna and Obamoro are warrior Obatálá, and red fastening beads (*glorias*) in their *mazos* encode their fighting trim. Bauzo's real Obatálá masterpiece is a praise poem in gauze, a *trono* remade for the Caribbean Culture Center in 1986 (plates 271 and 272).

All the avatars—Obatálá, Oke, Ajaguna, Oshagiyan, Oshalufon—are linked in the use of white robes, white beads, and white metals. The purity implied in these emblems relates to one of Obatálá's main commandments: may your lives be as clear as water drawn quite early in the morning.[225]

Chief Obalale, *Onisoro* Obatálá, presides over one of the most important altars to this *orisha* in Nigeria, in the ancient city of Ilé-Ifè. I visited it in 1989 (plate 273). Entering from the street, one passes through foyers and inner courts guarded respectively by Eshù and Oshóòsi. One enters the main courtyard barefoot in honor of Obatálá. The door to his altar blazes with white hieroglyphs, left, right, and inside on the altar wall. The patterns at right, hypnotically spotted, identify the deity as a leopard, in an ancient allusion to sovereignty and kingship.

At left, a latticelike pattern links ground to roof. It may imply one of his means of reaching heaven, the chain that leads to the courtyard of the sky.

Inside the shrine, the *Onisoro* or priest was willing to discuss the bunches of *isan*, staffs that leant against the altar wall. Speaking softly, Chief Obalale said they were carried along in the Obatálá festival, "persons flogging persons on the way." This acts out a myth, collected by Verger, according to which Obatálá, when unjustly imprisoned by the citizens of Ejigbo, held back the rain until justice was served and malfeasants were flogged. Hence "every year, at the end of the dry season, the inhabitants of the two quarters of Ejigbo . . . hit each other [with *isan* switches] all day long as a sign of contrition and in the hope that rain will begin to fall."[226] *Isan* staffs and Obatálá therefore form an equation of forgiveness and return. Above the *isan* an impressive shield of traditional writing dominates the altar in a blaze of signs. Obalale named them: *eye Obatálá*—deco-

With the Assurance of Infinity: Yoruba Atlantic Altars

PLATES 271 AND 272 (TOP TO BOTTOM): *TRONO* ALTAR TO OBATALA, MADE BY JUAN BAUZO FOR THE CARIBBEAN CULTURE CENTER, NEW YORK, 1986. Plate 271 documents Bauzo's use of gauzelike cloth to establish in visual praise the purity and excellence of Obatálá. In the detail (plate 272) we see his association with the bird of the holy spirit. Photos: C. Daniel Dawson.

rative ideographs in honor of Obatálá. Some of them he gave as Ifá divination signs (*odù*), for instance the double-four marks of *eji ogbe*. It was a generous clue. In the context of Obatálá's grandeur these are *odù* in the fullest sense: chapters (*odu*) in a life of distinction; a full, winning cell (*odu*) in the game of life; a cloth of superlative quality and worth (*odu aso*).[227] In sum, the signs divide the wall with abstract intimations of superlatives in greatness. The wish of Obatálá is that we fit into these patterns.

Obatálá extends his moral invitation by different means at an altar to Oshagiyan, the avatar at Ejigbo (plate 274). Phyllis Galembo photographed this altar in August 1989. Below, on the floor, is an area representing work. Above it is the cloth of sterling reputation, and above that is goal or aspiration. At left, on a supporting vessel, rests equipment for divination. In the middle a circular support (*apere*) uplifts a container filled with sacrificial materials. Further vessels hold cooling water, and a point for sacrifice of blood and food (*ojubo*) has been cut into the earth directly in front of the largest vessel on the ground. The altar quietly structures sacrifice and the insights of divination as unambiguous imperatives.

There are responsibilities behind responsibilities. For the area of aspiration above the cloth of purity and peace includes a screen of rough bush-grass (*koko*). It was the theory of one priest that this praised the deity as a kind of Orisha Oko, a hardy cultivator—cutting grass, making places for life and civilization. If this is so, then *koko* is the *mariwo* (cut palm fronds, symbol of Ogún's aggression) of macho Obatálá.

A remarkable shrine for yet another avatar wearing the white cloth of transparent honesty was built at Ijero-Ekiti in the twentieth century. It had just been refurbished with a new tin roof when I photographed it in the fall of 1963 (plate 275). The architects of this altar intuit the inherent correctness, simplicity, and directness of living that Obatálá advocates. Their means are Zen-like and spartan: lines of carefully selected, carefully washed stones, polished half columns in red clay, and within the altar the moral climax—the *ala*, the white cloth, the sign of the purity of the god's heart.

That quality of reverence by unobtrusive means lives on in the artistic spirit of Juan Bauzo of black Brooklyn. In 1986 he made a magnificent *trono* for Obatalá for the Caribbean Culture Center on West 58th Street in Manhattan (plates 271, 272). Lengths of gauzelike transparent cloth draped the throne of the god of creativity. Their effect was sparkling—like the water Obatalá famously collects at dawn, before the world comes down to sully the stream.

Bauzo was one of the major figures of Afro-Cuban art in New York of the late twentieth century. He loved Obatalá and it shows in his art, even when he was working to praise other *oricha*. As we have seen, his anniversary throne of 1989 (plate 185), though dedicated to Yemayá, asks Obatalá's famous warrior avatars, Ajaguna and Obamoro, to step forward as her bodyguards.

Cabrera's informants in Cuba insisted that given Obatalá's age and moral delicacy, his stones should never suffer the heat of the sun or any inclement condition.[228] Some cover them with the softest, purest cotton. One priestess, it is said, would speak to the god through a piece of cotton. She was filtering the filth of this world out of her words, in honor of his purity.

In terms of shared imagination that priestess could be a sister to Mai Jocelinha of Cosme de Farias, Bahia. It was this remarkable priestess who built the magnificent altar to the three Obatala avatars Oxala, Oxaguiam, and Oxalufom where we earlier saw the *opaxoro* of Mario Proença (plate 270). Mai Jocelinha made the altar in the summer of 1982, working with white cloth, white flowers, white metal, white stones, and white tile. Carefully constructing with a spotless sheet a kind of bed where one might kneel or prostrate oneself before these spirits, she and her helpers built a space uncontaminated by error or perturbation.

She names and places the qualities of Obatala with jewellike precision. At the summit she crowns Oxala with a *capacete do honor*, a crown with beaded veil in the manner of the ancient Yoruba kings. She secures his spirit, she secures his mind, with an enormous tie (*òjá*) of expensive white cloth that she calls by its Yoruba name: *ala*. Two of Proença's silvery *opaxoro* for Oxalufom frame this tied figure, while the third looms closer to us. He made the rear left-hand one in around 1946, the right-hand one in about 1962, and the nearer staff probably in the early 1970s.

A silver crucifix, speaking purity in several languages, guards the hidden chair that enthrones the stones of Oxala. Mai Jocelinha demonstrates the sophistication of her stylistic means by transforming the base of the throne into a unit of modern architecture made of bathroom tile. At the foot of this element she has placed tin bells (*ajijaa*) to summon Obatala, and a silvery ladle for Oxaguiam's beloved pounded yam.

To the right, Oxaguiam's sword guards his mortar. Nearby appear *ixan*, the whipping sticks that we met in Ifè (*isan*), which return to tell the same myth, of punishment and

With the Assurance of Infinity: Yoruba Atlantic Altars

PLATE 274: ALTAR TO OSHAGIYAN, AN AVATAR OF
OBATALA, EJIGBO, NIGERIA, TWENTIETH CENTURY.
This altar divides into three regions, implying a
mode of living: one works, as symbolized by the part
of the altar on the floor; one keeps one's reputation
spotless, as unmarked as the white cloth on the wall;
and one aspires, looking upward to the topmost part
of the altar. Nor is aspiration ethereal or bodiless:
the screen of bush grass implies the responsibility of
creating civilization and judgment out of wildness.
Photo: Phyllis Galembo, August 1989.

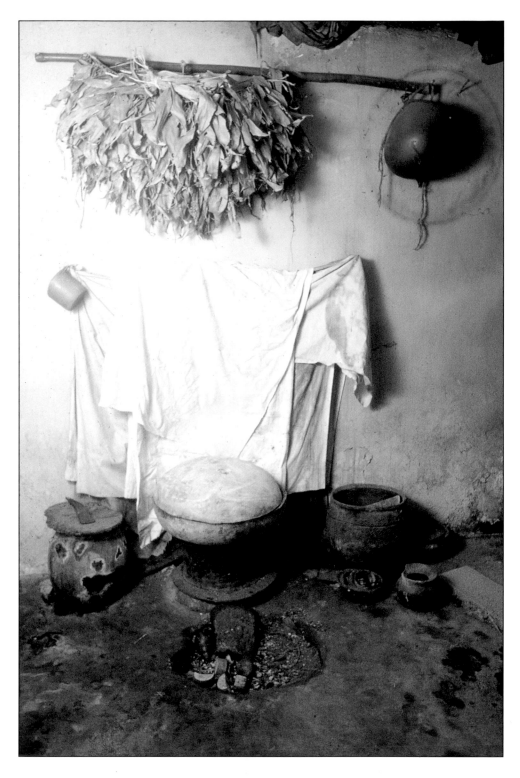

revindication. But with a different nuance: they stand for the followers of Oxaguiam—
Oxaguiam backed up by all the world (*Oxaguiam por tudo mundo apoiado*). A giant
seashell speaks of wealth, and a fan of Oxum adds a note of love.

Two columns, called *pepele* (compare classical Yoruba *pepele*, "clay platform serving
as a bed"), recall the truncated columns at Ijero-Ekiti (plate 275). They are made of
cement studded with stones painted silver, and support containers intended for flowers.

Like a piece of music this altar summons the avatars with scepters, crown, beaded
veil, bells, instruments of feast and festival. In the midst of what is, Mai Jocelinha has
willed Oxala, she has willed the Savior, at once and together. Not only an altar, the space

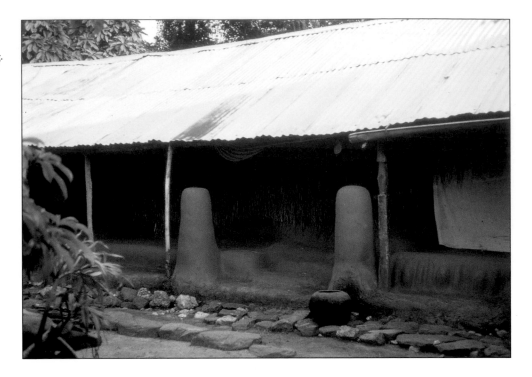

becomes a revelation of the ground of peace, where all pure beings belong to one
another.

With flowers and geometry another woman in another city, Maceió, up the coast from
Bahia, makes her own love of Oxala clear (plate 276). I photographed this Umbanda
shrine in 1985. This perfect pyramid of immaculate whiteness is dominated by a crown
of Oxala. A second crown, on an *opaxoro*, leads the eye upward to the crown at the top
of the altar. Each level of ascent is emphasized by sprays of white flowers. The reverence
begins at the floor, with the white *quartinhas* filled with cool water, and it ends with the
higher coolness of the mind.

We close with a Rio Umbanda shrine to Obatala/Nosso Senhor do Bomfim prepared
by officiants on his feast day in 1972 (plate 277). This altar is an act of praise (*louvor*).
Commendation of the deity's excellence is conveyed by means simple but effective: the
makers situate him in a heaven of metallic paper, like the tinfoil walls of Cortor Black,
like the chrome of Charlie Chisolm, like the throne of James Hampton in Washington.
They praise Obatala ecumenically, comparing him to the grace of Jesus. Leaves float in
heaven, hieroglyphs of healing.

Xango/Saint Jerome is at lower left, Ogum/São Jorge on the right. These saints are
his sons. They fight for his goodness.

Finally they anchor Obatala and his fabled gifts with a large white knot. Against a
backdrop of perfection they tie us all to Oxala *e sua paz*, to the peace that surpasses
understanding.

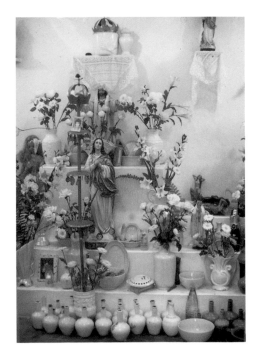

PLATE 277: UMBANDA SHRINE TO OBATALA/NOSSO SENHOR DO BOMFIM, RIO DE JANEIRO, BRAZIL, 1972. Obatala, syncretized with Jesus, appears in a silver heaven of foil. Xango and Ogum escort him. A white bow honors him. Photo: Elsbeth Selver, 1972.

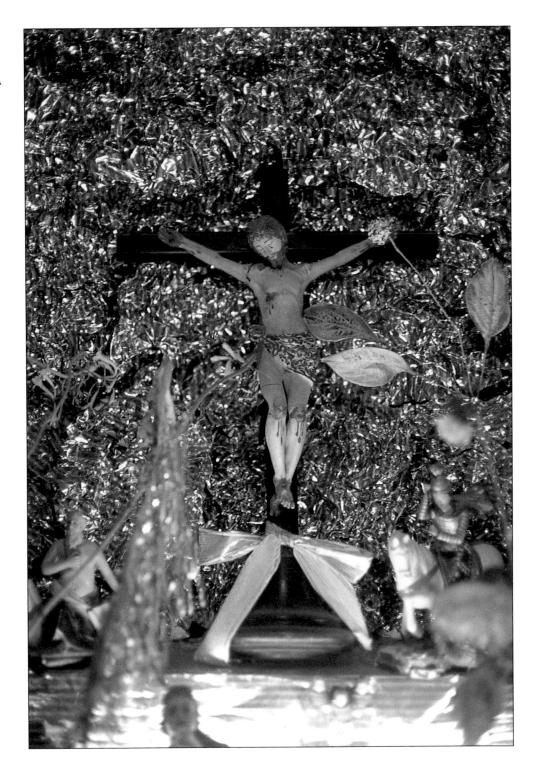

Altar on the Face of Water, Yemoja Resolved to Stones and Sea

Kò jé dáhùn ni ilè
Ojú omi ni jé ni kóró

Through land, she will not answer
At the altar of water she responds at once.
 —Verger, *Notes sur le Culte des Orisa*, 1957

The goddess Yemoja resides in the sacred depths of the Ogun river, which flows past
Abeokuta. Here her devotees espouse an ancient theory of the spirit: water that is alive
in sound and motion identifies the presence of a goddess. Her river also sculpts the
stones it touches, leaving them smooth and time-resistant. Smooth stones and rushing
water together make a music: the murmur of immortality. The river is forever, as are the
stones therein. Hence the prayer: "May it please God that I be stone in water, may it
please God that I live forever."[229]

Stones and water complete the image of this most important woman. We gather her
rounded pebbles at the river and place them in river water in vessels on the altar "to
create society" (*a kóta pé l'égbé*), to survive (*yè*) and live out our God-given days. Water
is the altar where we ask her blessings. But the fluid must be fresh. Liquid taken from a
stagnant pool, a well, or a faucet is inappropriate. Hers is untamed water, direct from
nature.

Sound reflects this quality of aliveness. A parallel is struck between the jingling of
Yemoja's many metal bracelets and the murmur of the brook, the slap of the river against
the wharf, and, when her drums so state, the *fortissimi* of the surf in the rising storm. In
Havana the women of Yemoja (creolized to Yemayá) orchestrate the rising of the sea,
bent down, swirling, swirling.

The legendary Afro-Cuban drummer Chano Pozo, a passionate follower of the *oricha*
and of the Abakuá faith, introduced the New York jazz world to Yemayá on December
22, 1947:

> *Iyá, mo dupe, f'Oba èè*
> *Iyá, mo dupe, f'Oba éò*
> *Oba nlá toto aro, ago l'ona*
> *Iyá, mo dupe, f'Oba, Iyalode*

> Kingly mother, I thank you
> Kingly mother, I thank you
> Powerful king, fearful indigo depth within the river,
> make way for her,
> Kingly mother, I thank you, mother of the world.[230]

Pozo praised Yemayá's overwhelming dark-blue presence in the ocean and the river
depths. We are warned to respect her, to make way for a force beneath the blue. And,

With the Assurance of Infinity: Yoruba Atlantic Altars

indirectly, we are told that alone among women she and the goddesses Ochún and Oya wear the male crown with veil, sign of the divine king.

In the spring of 1958 another master drummer from black Cuba, Julito Collazo, arrived in New York, took up the microphone, and threaded a song for the riverine goddess along key moments from a myth:

Yemayá olodo
Obalufe, Yemayá olodo
Yemayá olodo,
Obalufe, Yemayá olodo.

Didun lobe, Yemayá lògerègerège
Okéré, 'mo de O.

Báròyé ò, Báròyé ò
Okéré, ayádòó rà
Yemayá ayádóò rá
Obalufe
Ayádòó rà é
Yemayá ayádóò rà é

Pàròyín O
Pàròyín O,
M'Okéré mi dé
Omídína!

Lord of the river, Yemayá
Sovereign of Ifè, Yemayá, lord of the river
Yemayá, lord of the river,
Sovereign of Ifè, Yemayá, owner of the river.

The sweetness of the soup prepared by Yemayá, flowing,
 flowing, flowing with delicious oil,
Okere comes, bringing the fortune of children.

Within her word children are born, within her word
 children are born
Okere [confronted by a woman], who stealthily buys the
 magical gourd,
Yemayá, who stealthily buys the magical gourd
King of Ifè
Stealthily buys the magical gourd
Yemayá stealthily buys the magical gourd

She pronounces the riddle, then solves it
She pronounces the riddle, then solves it,
Okere arrives and puts on his magic performance
[But nothing avails over our mother], great water that
 blocks the road![231]

Collazo's mother, an important Cuban priestess of Yemayá, taught him these verses. In them lie embedded cryptic allusions to the myths of the water goddess. To a version collected by Verger, I have added key words from the Collazo *oriki* in brackets:

Yemoja was the daughter of Olukun, goddess of the sea. She went to Ifè, where she became the wife of Olofin Oduduwa [Obalufe]. She gave him six infants. All became *orisha*, one of them Osumare, "who travels with the rain and keeps the fire in his fists." She had ten children in all and this made her breasts colossal. Then she journeyed to the "evening-in-the-west," the ancient Yoruba name for the West and thus she got to Abeokuta. Here, Okere, king of Shaki, fell in love with her and begged her to marry him and bear him children [*Okéré, 'mo de O*]. She agreed on condition that he never make fun of her enormous breasts.

At first all went well, with Yemoja making fabled soups, endlessly flowing [*lògerègerège*] with oil. As fluent as palm oil, as fluent as speech was the endless emergence of children from her fertile womb [*Báròyé O, Báròyé O*]. But then Okere got drunk. He mocked her breasts. Yemoja, in a rage, fled running.

She had received from her mother Olókùn a mystic calabash container with a magical preparation [*ayádóò rà é*]. Olókùn had told her: who knows tomorrow—in case of danger, break the container, throwing it on the earth. Fleeing from Abeokuta Yemoja stumbled and fell and the container smashed open and became the river named Ogun. Yemoja became a stream. Okere, no mean magician himself, turned into a mountain [*M'Okéré mi dé*] and blocked her currents on the left and on the right. Then Yemoja called on the thunder god, Shangó, to help her. Shangó smashed an opening through the mountain of Okere and she flowed on safely to the sea. And now she is master of all the waters [*Yemayá olodo*].[232]

Ifá tells us that when Yemoja, at the beginning of the world, received her beads of blue and white, she also received *awo tanganran* (crockery) and chinaware from beyond the sea (*omolaganran*). Henceforth her world has been radiant with white ceramic vessels, punning on seashells and on kaolin, the white clay from the bottom of the stream. Her porcelain plates typify the kinds of wealth emergent from the sea, pouring and storing her water in a sophisticated way. And so it is that one of her main Atlantic avatars has taken the name Awoyó, Crockery-in-heroic-quantity (literally, "Crockery becomes replete").

Cuban poems underline her link with crockery (*Yemoja, mo wi Awoyó*), her queenly status (*ayaba*), her corpulence (*òrá*), her possession through the sound of the stream

(*Wolo-wolo sun o ni Yemoja*), her sacredness to swimmers. Those who swim to see her always swim home safe and sound. Those who desire long life also discover this "foremost woman," whose broth of stones and water imparts hardness and resistance. Guarding the receptacle that holds this *aché* is a surrounding palisade of crockery, which can bind death (*awoyó so'ku*). Yemoja's long-lasting stones are safe in water, and so are we, so long as we give her rich, full honor.[233]

Nigeria answers this Caribbean poetry, confirming its antiquity, and the authenticity of its theory of the spirit. In the Ibara quarter of her city of Abeokuta, Yemoja is indeed a queen (*ayaba*) who lives in the depths. She will not speak through earth but she will respond through water. Its surface (*ojú omi*) is her altar.

The verses of Abeokuta run: "She is the depth that seizes sand, where the light of the water dims and turns a fearsome indigo."[234] Ibadan calls her Awoyó, as do Ketu, Bahia, and Havana. In Ibadan we rediscover her strong association with mystic charms: she is Talisman-Mother, who makes all waters yield to her command (*oogun iyá ke olodo*).

In sum, this powerful woman, who peoples the earth with infants as she peoples the sea with fish, becomes an "ultimate symbol of motherhood."[235] To the culturally prepared, her altars in Ibadan, Bahia, and Havana emerge as pages from a single scripture.

There is a small and beautiful altar to Yemoja behind the King's Market in Ibadan, variously photographed by Verger, in about 1952, by Tim Gordon and Michael Lancaster, around 1960, and by Katherine Coryton White, in 1966. These photographs grant us a privileged occasion to study what changes, and what does not, across two decades.

Yemoja circa 1952 towers over the King's Market altar (plate 278). She is the main figure; all the other icons and objects are her children or otherwise within her power. From a tent of cloth, textile architecture, about her head emerge her spectral eyes, completely filled with chalk, and her famous breasts. Her daughter, to her left, is similarly caparisoned with cloth. These fabrics link the two women to "the mothers" and their cloth-emblazoned festival of Gelede, itself a word recalling her ponderous movement.

Everything connecting to her power is underlined with chalk: her eyes, her breasts, her chiming bracelets. Leopard dotting about her neck whispers transforming powers. A policeman guards her from behind the cloth, a secret bodyguard. An image of a standing woman with proffered calabash establishes a tone of sacrifice. Rooster and hen, male and female presences combined, signify the ingredients of her famous soup, also flavored with *eku*, bush-rat, which instills medicinal powers from the forest. Her loyal cat (*ologbo*), who goes out and catches the *eku* and brings it to her, is also on the altar.

Toby jugs dissolve in the solvent of her iconography. Divested of their Englishness, they stand for corpulent, red-faced black infants lovingly decorated with crimson camwood paste, such as colors the body of Yemoja herself, towering above. Behold, she seems to say, the power of my breasts, framed and protected by the cloth of "the mothers." In the power of my body, in the power of my porcelain vessels, I can unbind the most barren of wombs. I will speak to you through water, I will heal you with stones immersed in water, in the vessel to my right. There you will find a sailing ship that signs the water in my name.

By around 1960 a rich brocade back-cloth had been added to the shrine, and Yemoja's Tobys, her children, had moved closer to her body. Constant were her eyes and

PLATE 278: ALTAR TO YEMOJA, IBADAN, NIGERIA, TWENTIETH CENTURY. In a shrine behind the King's Market in Ibadan stands Yemoja, goddess of the river Ogun and ultimately of the Atlantic. Yemoja is the large-breasted mother of many children, some of them present here, as Toby jugs. She makes a soup, famously delicious and abundant, ultimate end, perhaps, of the fowl at her feet. A cat marks her as playful but powerful. The policeman figure behind her is a bodyguard. Photo: Pierre Verger, about 1952.

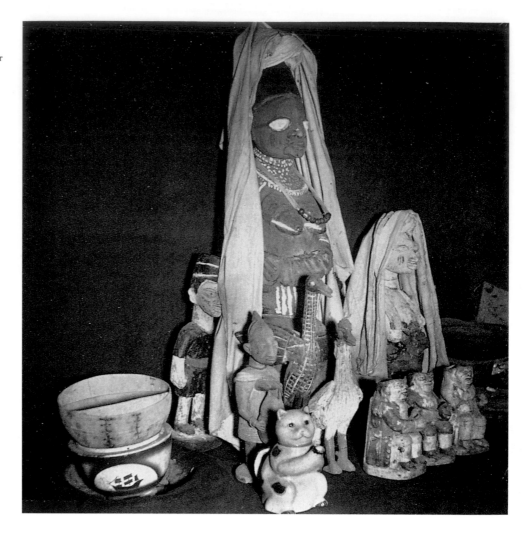

breasts. In 1966 her drape had diminished and her powerful red body stood exposed (plate 279). The children, the cat, the hen, remain. Through all the years, despite the changes, the altar stays coherent, like a family.

Strongly linking the altars of Yemoja in Nigeria and Benin to her altars in the Americas is the *iba* (a creolization of *igba*, "calabash of the world") that guards her vessel of stones and water: a circle of vertical porcelain plates, four in number, each standing at a cardinal point. They are inserted within a larger, enclosing porcelain vessel, a base for the vessel of stones, itself usually covered with a fifth, horizontal plate. Pai Balbino prepared such an altar to Yemanjá at Alto da Vila Praiana, Brazil, in the winter of 1984.

New World followers of Yemoja dramatize her water, constructing pools or fountains with bathroom tiles and filling them with river or ocean fluid. Alejo Carpentier saw one in Havana in the 1920s: "Caridad, an old devotee of the Yoruba deities, who lived in a suburb of Havana, and who served as an informant during the time in which I was planning my novel, *Ecue-Yamba O!* [written in 1928], had in her house an aquatic altar more 'surrealist' than anything I saw in Paris." What made this work aquatic? Carpentier continues, "In one corner of a large room was a fountain full of sea water. Live fish, taken from the harbor of Havana, swam in this water. The bottom was covered with seashells, sea-smoothed pieces of glass, starfish, fan-shells, and different colored stones."[236] The early solution vessel/stones/water, with or without further signs of the sea, has become baroque.

With the Assurance of Infinity: Yoruba Atlantic Altars

The tendency applies richly to certain Bahia *candomblés*, for example the Cosme de Farias. Here, around December 1983, Mai Joselinha fashioned an altar to Yemanjá in a room dedicated to the *ayabas* Yemanjá, Oxum, and Oya Yansan. Architect and artist, Mai Jocelinha set the sea goddess' altar in the center of a room. Essentially it is a cloth-covered column rising from a pool of water, and set between altars to Oxum and Yansan. The latter shrines are set flush against the opposing walls.

In Ibadan, vessels with river stones had stood beside images draped with cloth. Mai Jocelinha ingeniously recombines these valences. On the top of the tall pedestal emerging from the pool's center is a porcelain vessel, its stones and water concealed by two cloths: the inner, white, the outer, marine blue, with floral patterning in gold. A white metal crown rides the summit of this cloth construction, proclaiming the royalty of the woman from Ifè. The artist has filled the pool with seawater and placed seashells and coral around its edge. A tea set and jar turn blue for the sea. Shells are blue as well. A giant conch shell (*aje*) rests on the floor, remembered in Bahia for what it was in Nigeria: the emblem of Aje Shàlúgà, deity of luck and wealth, proving the overflowing bounty of the sea. The white and the blue, the shells and the porcelain, all celebrate the ocean.

PLATE 279: ALTAR TO YEMOJA, IBADAN, NIGERIA, TWENTIETH CENTURY. Fifteen years or so after the photograph by Verger (plate 278), the main image and the Tobies remain, but even the length of honorific cloth has changed. Most altars of the Afro-Atlantic world change constantly, reflecting the restless creative tastes of their makers. Photo: Katherine Coryton White, 1966.

275

Rio's Altars by the Sea: New Year's Eve at Copacabana and Ipanema

On the beach at Copacabana and Ipanema, in Rio in Brazil, surf and sand become one vast altar to Yemanjá on New Year's Eve. Here, in a tradition apparently tracing back to at least the 1920s, thousands come to the beaches to make altars to Yemanjá, requesting her blessing and good luck in the coming year. Brazilians build these altars continously, up and down the beaches, usually starting in the middle of the afternoon and continuing right up to the stroke of midnight, when candles flicker in hand-dug cavities in the sand for as far as the eye can see.

In Brazil, and also in Cuba, Dahomean impact was continuous and strong. In some cases it preceded the Yoruba influx by decades. And so, before proceeding to Rio, we consider a beach altar built by devotees of *hula vodun*—spirits of the sea—among fishermen of the Ewe village of Avefodzo, between Lomé and Anécho on the coast of Togo. This sea altar dates from the early 1970s.[237]

The fishermen spread out a vast fishing net, flat against the sand. They aim it at the sea. It becomes earth art, compelling in the way the blue netting reads as trunk and arms. Two paddles, signatures of the men's profession, frame an altar in the sand where two small cones of earth stand for tutelary spirits of the sea. Over these small pillar altars sacrificial liquid has been poured. Netting and paddles, from the economy of the ocean, state where the men request protection. The Atlantic dwarfs these implements, and makes of them virtual scale models, though they are gathered at actual size.

These prayers to the *hula vodun* of the sea are echoed by the great Cuban painter Manuel Mendive. Around 1968, Mendive painted a virtual altar piece for Yemayá (plate 280). The goddess is enthroned in aquatic glory. Two fish rest upon her lap. A third fish she cradles in her arms like the infant Jesus. Two fish flank her head like underwater angels. Coral restates wealth. With creole genius, Mendive takes Lucumí leopard-dotting, seal of initiation and nobility, and makes it read as bubbles. The queen of Ifè has become the Virgin of Regla, beneath the waves.

The Yoruba toss flowers into the river at Oshogbo, in honor of Oshun, and sacrifice rams at the deepest part of Erinle's river at Ilobu. Building on that heritage, the makers of the beach altars of Rio have elaborated one of the most dramatic altar traditions in the Western Hemisphere. Mostly Umbandistas, they also include those who serve the *orixa* in Bahian *nago* style. From as far away as Belo Horizonte and even Manaus they bring miniature barques painted blue and white. These they have filled with *pedidos*, requests for the New Year written on paper, and with things that Yemanjá loves, like bottles of perfume and combs and mirrors. They will launch these prayer-boats into the first strong breaker that rolls in from the sea at the stroke of midnight. If the water pulls it out and the vessel disappears, Yemanjá accepts the sacrifice and all is well.

Some Umbandistas trace Kongo-influenced cosmograms (*pontos*) in the sand. They light up the lines of these drawings with candles and sit beside or inside them to meditate and pray. Others build in the sand elaborate Catholic-influenced altars (plate 281) that later become foci for possession dancing and divination by the spirits. At one such shrine, near midnight in 1986, Yemanjá came down in the body of a young woman and shouted to the crowd, "Be careful, careful, careful, this coming year with sex. Be careful, careful, careful, SIDA [AIDS] is everywhere!" Then she added: "Do not degrade yourselves, in any way. I demand this."

With the Assurance of Infinity: Yoruba Atlantic Altars

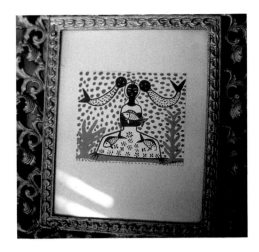

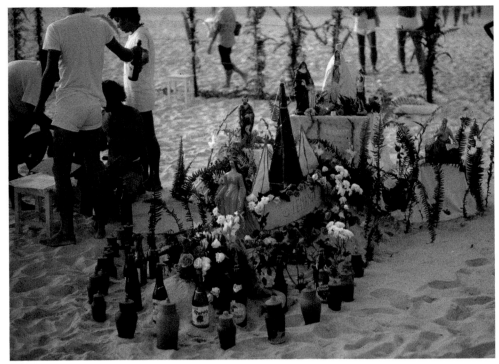

PLATE 280 (ABOVE LEFT): PAINTING OF YEMAYA (YEMOJA), BY MANUEL MENDIVE, HAVANA, CUBA, CA. 1968. The Christ Child becomes a fish in the lap of Yemayá; angels turn into fish above her head. Leopard dotting, which marks power and initiation in the Yoruba religion in Cuba, is intensively and wittily handled to indicate bubbles in the sea. This painting, combining several languages of vision, is a pluperfect example of creole genius in African-American art. Photo: Robert Farris Thompson, 1988.

PLATE 281 (ABOVE RIGHT): SAND ALTAR TO THE ORIXA, COPACABANA BEACH, RIO DE JANEIRO, BRAZIL, NEW YEAR'S EVE 1985. The orixa honored here are Omo-Olu/Sao Lazaro, Nana/Saint Ann, Oxum, and, in the boat, Yemanjá. Such altars are built to bring luck in the New Year. Photo: Robert Farris Thompson, 1985.

All such altars look toward the sea. The face of the goddess is the sea, and the sand becomes her sanctuary.

Addressing this ultimate altar, a woman may stand with floral offerings for the goddess in both hands, hold them aloft ceremonially, like banners, make a prayer, then hurl them into the sea. Or she may embed white roses in the sand, position them vertically, and leave. Others, hurried or distracted, make a quick prayer and leave roses lying on the sand. Still others write careful cosmograms with roses in the form of circles, squares, or stars. The rising tide accepts the gestures and washes them out to sea.

Candles, set in cavities dug down in the sand to guard the flame from wind, add illumination to the spirits. Luis Simas, a passionate Umbandista, told me in 1989, "It's like my own house altar where I light a candle for my guardian spirit, so he can see." Candles guide Yemanjá to her altars and the prayers being said beside them. As dusk falls on Copacabana and Ipanema, a thousand flickering lights guide her in. She will find these altars and bless them with her waves. Each New Year's Eve, as more and more altars in the sand are dug out and illuminated, the beach takes on power (plate 282). Copacabana is cratered with light as far as the eye can see (plate 283).

One person in 1984 laid down an elaborate offering to the twins and the goddess of love: two white paper plates brimming with water-freshened yellow grapes for *ibeji* and Oxum. With its wind-break reading like a mountain range, and in the tricky distances of sea and beach, this altar (which gives this volume its cover) resembled two gleaming circles from outer space, momentarily resting on the strand.

One year later near this spot, Clark Hood Thompson photographed a devotee praying to the sea (plate 284). In blue shirt, blue shoes, and white trousers, the obeisant had keyed his body to the sea's colors. To protect himself against contingency in the coming year he had performed an elaborate ritual with votive foods. His altar paralleled the sea. The white of the tablecloth echoed the white of the breakers, as if the offerings had washed up on the shore. The devotee had "closed" the corners of the mystic banquet

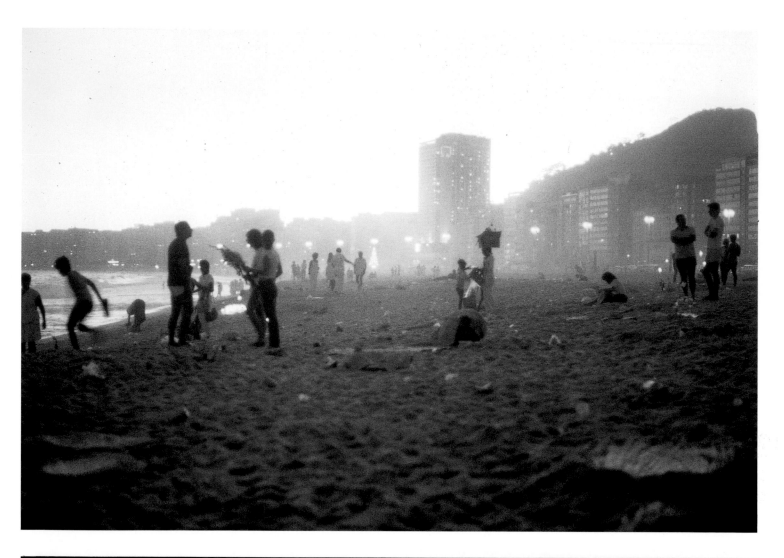

With the Assurance of Infinity: Yoruba Atlantic Altars

PLATE 282 (OPPOSITE, TOP): SAND ALTARS TO
YEMANJA, SOUTH END OF COPACABANA BEACH, RIO
DE JANEIRO, BRAZIL, FIVE P.M. NEW YEAR'S EVE
1985. Prayers are offered at these miniature altars
scooped out of the sands and filled with candles.
The faithful, as they make them, ask for blessings in
the New Year in the name of Yemanjá. Each
craterlike altar represents another person's offering.
Photo: Robert Farris Thompson, 1985.

PLATE 283 (OPPOSITE, BOTTOM): SAND ALTARS TO
YEMANJA, NORTH END OF COPACABANA BEACH, RIO
DE JANEIRO, BRAZIL, NINE P.M. NEW YEAR'S EVE
1985. As midnight approaches the sands of
Copacabana and Ipanema glitter with miniature
candle-lit sand altars as far as the eye can see. The
tradition apparently emerged with the rise of
Umbanda in the 1930s. It is strong now, involving
thousands of adherents of the Umbanda faith.
Photo: Robert Farris Thompson, 1985.

PLATE 284 (RIGHT): SAND ALTAR WITH FEAST FOR
THE ORIXA, MIDDLE OF COPACABANA BEACH, RIO DE
JANEIRO, BRAZIL, NEW YEAR'S EVE 1985. A
tablecloth has been spread and the devotee, shown
clad in colors honoring the blue and the white of
the sea of Yemanjá, asks blessings by offering the
favorite dishes of orixa, especially the popcorn of
Obaluaiye, the latter begging freedom from illness in
the coming year. Photo: Clark August Hood
Thompson, 1985.

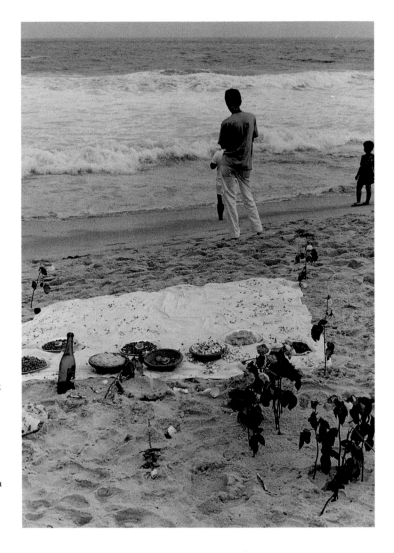

with white roses for Yemanjá, like the four white plates of the *iba* that protect indoor
altars. He had prayed for "good hunting" (in job, happiness, lover) by setting down at far
left a dish of *axoxo*, the sacred food of the hunting gods Oxossi and Logunede. He had
asked favors of the goddess of love, Oxum, with a gift of cooked *fradinho* beans, onions,
and palm oil (*molokun*) covered with sliced hard-boiled egg. And, for general protection,
he had put down *ebo*, a light-yellow food for Oxala and Yemanjá. This was a *candomblé
nago* altar in the sand.

There was also popcorn (*gúgúrú*) galore. This was of course for Omo-Olu, for freedom
from illness. The man had uttered his visual prayer emphatically, not only with a brim-
ming dish of the white kernels but also by scattering white dried maize across the whole
of the tablecloth. Finally there was a yellow plate of fermented corn purée for Oxum and
Exu. Champagne had been poured, "a noble drink, for a noble woman, bubbling up like
the ocean."[238] He added two yellow roses for Oxum and two white roses for Yemanjá and
stood them in the sand. Roses, considered by devotees "the most perfect of flowers,"
became an audience to both the goddesses and the culinary salutations of their name
gathered on the cloth.

279

We end with a simple altar: devotee, candles, roses.

On the afternoon of December 31, 1986, a black woman, clothed in white as a mark of purity, took off her shoes, tucked her heels against her thighs, and prayed (plate 285). Her devotion placed her body in spiritual affinity with the ancient image of a woman kneeling before an altarlike circle in the area of ancient Djenné (plate 110), an image dated to the Middle Ages. The color of her roses identifies the spirits with whom she has conversed, Oxum and Yemanjá. A priestess of Xango looked at this photograph, smiled, and added her own prayer: *Dupe, Olokun* (Ocean, I give thanks). In availing herself of the frontier between land and sea as a natural altar, the woman became, at the end, an ultimate embodiment of the *oriki* for Yemayá collected in Matanzas by John Mason:

> *Aààlà, mo dáa se.*

> Boundary, I am acting alone.

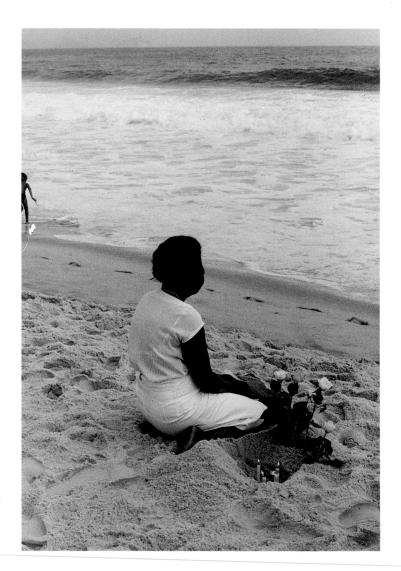

PLATE 285: A SERVITOR OF YEMANJA, COPACABANA BEACH, RIO DE JANEIRO, BRAZIL, NEW YEAR'S EVE 1985. Servitor, candles, and flowers resume the essence of the Rio sand altar for Yemanjá. Photo: Clark August Hood Thompson, 1985.

With the Assurance of Infinity: Yoruba Atlantic Altars

Envoi: The Place of Belief and the Site of Transformation

The Afro-Atlantic altar meets the spiritual economy of the West with its own logic and its own self-definition. The challenge begins with the foragers.

Tree, stone, blood, and fire are nodal points of both Pygmy and San worship. In placing offerings of food in the fork of a tree, Pygmies focus a point of immortality and power. As in other world religions, trees come "to express everything that religious man regards as preeminently real."[1] Henceforth in many West and Central African faiths, the grove becomes the literal academy of the spirit, the place of initiation and spiritual seclusion.

From the beginning of humanity, rock, stones, and the earth itself provided points beyond human life, powerful points upon which to enact prayer, aspiration, and belief. When //Xegwi San painted shamans and shamanic happenings on rock shelters in the Drakensberg Mountains, the rock was already painted by nature with brilliantly weathered lines and weathered shapes. More important: in ledges, cracks, and breaks in the surface of the rock, San visionaries recognized points of spiritual entrance and disappearance through which their painted figures would pass between this world and that. These cracks apparently symbolized breaks in ordinary time and being, not unlike the breaks in the patterns of the expected, signs of spiritual presence, that Pygmies and the people of many Bantu civilizations saw in distorted roots and branches.

Break-pattern art, a road to transcendence, has abided over time. It informs the *cassée* (break) in the beat that triggers possession by the gods in Haiti. It charges African-American quilt tops with energy and spirit. In Africa, among Pygmy and San, break-pattern passages turn chanting into wordless cries and yodels. Ecstatic yodeling brings the forest spirits (*mokoondi*) to the western Pygmies. It announces the coming of *n/um*, the power to heal, in the body, blood, and sweat of dancing San shamans. San dancers "boiling" (going into trance) around the fire, and Pygmies attracting the forest spirits by exquisitely orchestrated yodeling, extend the Western definition of the altar. In the West, altars are raised surfaces for sacrifice and focused reverence. The forager definition includes fixed points, usually a fire, but incorporates circles of ecstatic dancers, moving and singing as sacrificial action. To the static point of reverence is added an altar of happening and motion, climaxed by possession. To repeat, the concept "altar" becomes double: the fixed (tree, fire, shelter of rock) and the motion (the yodeling round) that leads ultimately to trance, or to visitation by the forest spirits.

The unusually twisted branches, taken direct from the forest, that Pygmies see as signs of spirit are cognate with the unusually shaped roots placed in Kongo *minkisi*, which in turn influence root charms in the maroon societies of Suriname and in black North America. Among Aluku maroons, "curved, zig-zag sticks or bush vines are called *koon tiki, kokoti,* or *kongo busi.* The last name is the most commonly used. *Kongo*

Envoi: The Place of Belief and the Site of Transformation

busi are bursting with dangerous spiritual power."[2] In the United States today, Bessie Harvey, of eastern Tennessee, Joe Light, of black Memphis, and other visionary African-American artists of the 1990s preach of God's spirit with unusual root formations taken direct from nature, as did Siras Bowens in the 1930s in tidewater Georgia. An extraordinary example of the same tradition turned up around 1941 in a Kongo/Angola *candomblé* of Rio: carving major and minor branches off a bough, a *candombleiro* fused the *figa*—an ancient Mediterranean charm of luck, a hand with thumb between two fingers—and wood inflected with spirit in the Kongo manner.[3] All the twisting and turning, the meshing of forces, is amazing, and takes us back to the usage of phenomenal wood in the *amati oni ganza* of Bira and Ituri Pygmies, and in major *minkisi*, like *mbenza*, in Kongo.

Millions in North America have seen conga lines and heard conga drums, danced sambas and mambos, without realizing that a vast panorama of sacred medicines and altars opens up beyond these popular manifestations. The essence of the Kongo altar is the crossroads, taken as a reference to the point where the world of the living and the world of the dead, the true source of power, meet and intersect. The crossroads altar can be literal, a meeting of two roads. But it can also be a tomb, or a corner of a room, or a cross chalked upon the ground—or a portable miniature tomb called an *nkisi*, filled with spirit-embedding earths and spirit-admonishing material ideographs.

To keep one's soul intact and moving is a main point of Kongo Atlantic art and altars. Soul is a tiny circle, a miniaturized, shining particle of the sun, moving in a round. Hence the importance of the Kongo-American equivalent of the Catholic Saint Christopher's medal and the Jewish *mezuzah*: a pierced dime on a string, worn to *lunda lukongolo lunga* (keep the circle of one's soul complete). Continuity of the soul can be coded in a ring shout, in the obsessive appearance of wheels and hubcaps and pinwheels and arches in the yards of the North American visionaries, and in many other ways.

Yet because Kongo Atlantic art cuts across so many media and disciplinary interests— "folk art," "material culture," "art history," "anthropology," and that shameless verbalism masquerading as a category, "outsider art"—it was initially easy to divide, conquer, and deny. Face vessels went to folk-art museums, yard shows were "environments," dimes pierced and worn as anklets reflected "superstitions," burial decorations were viewed apart from yard and house even though the same themes reoccurred there. Today, art historians and social scientists such as Grey Gundaker and Judith McWillie are seeing things whole at last, making the points in scholarship that Renee Stout of black Washington, D.C., has made in art with her famous neo-*minkisi* for at least the past ten years. Note that all three women are artists. Artists and poets almost always anticipate the findings of scholars. Arthur Carraway of black America was working out a personal synthesis of images from the American Old Time Religion and Kongo *nkondi* statuary in the 1970s. Wallace Stevens divined the defiant shout of immortality in the glitter of glass and porcelain on Florida black graves in 1935.[4]

The circling of the soul around the cross of the intersecting worlds—the rhetorical point of the Kongo cosmogram (*dikenga*, "the turning")—echoes throughout the black Americas. The circle is "written" in a curved length of green garden hose on a headstone in black Austin (plate 286) and echoed by a design on the Henry Johnson family stone in Markham, Virginia (plate 287), among other examples. Another instance of cryptic sparking of soul and continuity, with an image of the sun in motion, is an object-studded inner

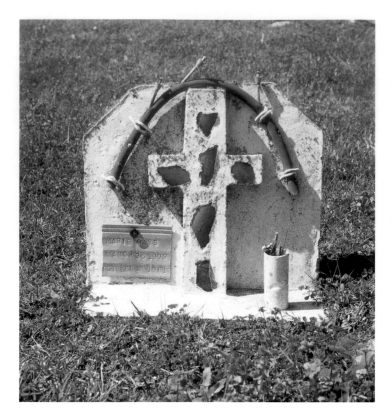

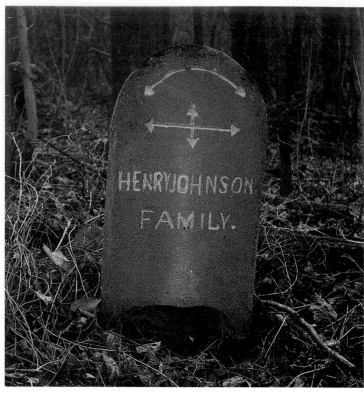

PLATE 286 (ABOVE LEFT): AFRICAN-AMERICAN GRAVE, AUSTIN, TEXAS, TWENTIETH CENTURY. PHOTO: ROBERT FARRIS THOMPSON, 1992. PLATE 287 (ABOVE RIGHT): AFRICAN-AMERICAN GRAVE, MARKHAM, VIRGINIA, TWENTIETH CENTURY. PHOTO: Maude Wahlman, 1982. In far-apart regions of the United States, two grave markers seem to recode the cross-within-circle *dikenga* sign of Kongo with a remarkably similar configuration: a cross and enclosing arc. One is three-dimensional, made from a length of green garden hose curved around a cross, the other is incised in the headstone, the arrows intimating dynamic motion.

garden built around a cedar tree by Gyp Packnett of southwestern Mississippi. To this artist visionary, the inner garden is "the other world."[5] And the gate leading to it (plate 98) is "a bed frame topped with sunrise/sunset"[6]: in the form of a wheel, the sun cycles over a gate, a crossroads, as it does in José Bedia's *munansó* altar in Havana (plate 44) and on the walls of a Kongo-Angola *candomblé* in Bahia (plate 38). Packnett's testimony, defining wheels as suns, leads toward a spiritual interpretation of the car-tire planters with radiant flanges—"crowns"—that appear so often in American yard shows (plate 78). These are "soul art," designed to protect whole properties and set them in spiritual motion.

Afro-Cuban migration, ever more intense, has introduced the crowning glory of Kongo sacred art, the *nkisi*, to New York. Felipe García Villamil has brought the Kongo-influenced altar-making of Matanzas right into the Bronx. In the 1980s, in a closet in a third-floor apartment, he constructed an altar peopled with powerful *minkisi* (plate 288).

At the top of the closet straw hats (*sombreros de guano*) hang in readiness. García Villamil dons one or the other of these hats when he is possessed by the spirit of his *nkisi*, Sarabanda Rompe Monte. Mirror-stopped cow horns of clairvoyance (*vititi menso*) surround the top of the principal *nkisi* with four eyes. The other *minkisi* below, Centella (a lightning charm) at left and Madre de Agua (mother of the waters, an aquatic, creolized form of Kongo *simbi* spirit) at right, each have their own mystic eye, or *mpaka*. All too have thunder stones (*matari*) signed with cosmograms, to focus their celestial might and intimidation.

One material metaphor of strength and motion crowds another in the crowning of Rompe Monte (breaks the forest): spiritual hooks of forest wood (*lungowa*), plus iron—horseshoes, scissors, knives, heavy chain. Twenty-one branches of forest wood are "nailed" à la *nkondi* into the iron *nkisi* vessel containing Sarabanda's power. These woods include *palo hueso, guayaca, palo siguaraya, vence batalla, siete rayos,* and *palo*

Envoi: The Place of Belief and the Site of Transformation

ramon, hard woods, muscular woods, woods that don't break but stand and fight, all the militant forces of the forest mobilized to protect the soul and destiny of García Villamil and his family. If that were not enough, the *nkisi* cauldron is further cosmologized and deepened by accretions of earths from a train track, water from the Hudson River, and earths from before a courthouse and a hospital, i.e., by medicines of continuity, justice, and healing.

Even the purest Kongo expression here, the red *nkisi* bag, with feathers, in the lower-right-hand corner of the closet, has been creolized. We meet the same feathers inserted in the perforated pottery of the *oricha* Babalu Ayé in the house of Señora Roena, in Villa Palmera, San Juan de Puerto Rico (plate 235). This particular *nkisi*, Kobayende, has

PLATE 288: FELIPE GARCIA VILLAMIL, ALTAR FOR THE SPIRIT SARABANDA ROMPE MONTE, THE BRONX, NEW YORK, MID 1990S. A closet in a third-floor apartment becomes an urban *munansó*, the enclosure for an altar. At the top hang straw hats for Sarabanda Rompe Monte to wear as a sign of his presence. The *munansó* also contains *nkisi* of Centella (a lightning charm) at left, Madre de Agua (mother of the waters) at right, and Kobayende (at lower right, with red cloth and feathers). At the back of the closet hangs a flag or *bandera* with the *gandó* of Rompe Monte (see plate 47). Photo: C. Daniel Dawson, 1993.

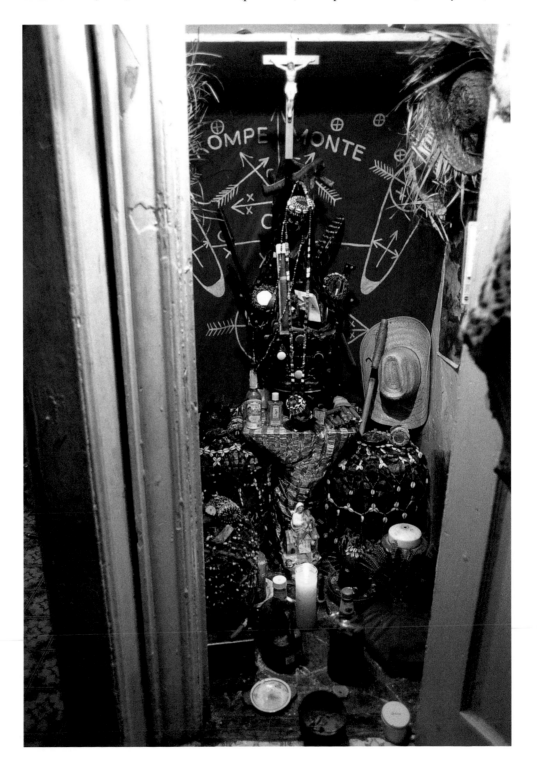

PLATE 289: UMBANDA *CENTRO*, BUENOS AIRES, ARGENTINA. Prominent in this altar are the seated figures of African-descended spirits from Kongo and Angola (*pretos velhos*). Oxala/Jesús stands at the summit of the altar, an imagined African dwelling. Photo: Peter Kloehn, July 1990.

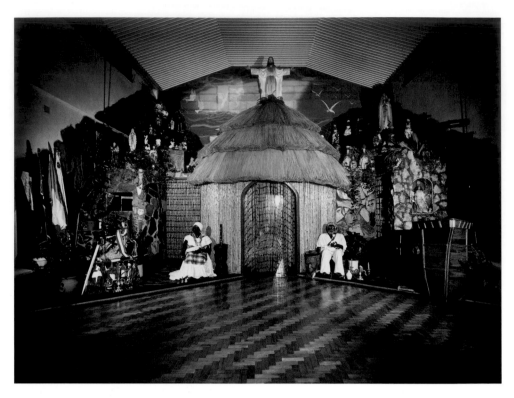

been syncretized to the powers of San Lázaro/Babalu Ayé.

The flag that sets García Villamil's charm in motion, marching in victory over spiritual disturbance, blazes with mediatory red and with Sarabanda's hieroglyph signature. Though flat against the closet wall, the flag nevertheless vaunts spirit[7] qualities not unlike those intuited in the high flag altars to the ancestors at Asindoopo and Dii Tabiki in Suriname. There are at least a hundred *nkisi* (*prendas*) like this one in New York and New Jersey today. Many were made and ritually prepared by García Villamil.

Meanwhile, in Argentina, the Kongo-influenced Umbanda faith continues to spread at a fast pace. Peter Kloehn, an American photographer, in collaboration with the Afro-Americanist Alejandro Frígerio, has made a photographic survey of several Umbanda altars, from which we excerpt one recent example in the province of Buenos Aires (plate 289). As in the earlier Umbanda altars of Brazil, Oxala/Jesús still dominates. But honor to the women and men of Kongo takes on larger force. No longer relegated to the bottom shelf, as in periods when European Kardecist elements blocked the rise of overtly Africanizing presences, here near-life-size *pretos velhos*, black elders from the days of slavery, are seated before an imagined architecture in traditional Africa. An arklike boat dramatizes the transatlantic arrival of their healing insights. A mortar and pestle recall how herbs are pulverized into medicine and Amerind foodstuffs pounded into African cuisine. Umbanda iconography, as it passes across the urban centers of the province of Buenos Aires, lights up like an electric field.

Worshipers before Mande and Mande-related altars sometimes mirror the statuary. As the terra-cotta woman on the altar kneels, the officiant kneels before her. Moreover, in certain Akan and Suriname forms of worship an officiant comes to an altar that supports a sacred vessel. She takes that vessel, places it upon her head, and becomes as it were the altar. Priestess is identical with column-supporting vessel. Priest is identical with column-supporting vessel.

Mande/Akan altars of vessels supported on a clay or wooden column compare intriguingly with the *ayawa* "carry-oracles" of the eastern maroons in Suriname. As Ken Bilby

remarks, "Divination is central to the intersection of spiritual/social/political life in these societies, and a very substantial portion of the ongoing divination that is a part of daily life is done through the carrying of oracles on the head."[8]

The connections between maroons, divination, and altars is strong. Altars and divination were vital in their history of liberation: "Divination is the social and political lifeblood of contemporary Aluku society. Much divination, whether *kiin ain* ('clean eye') or during possession by *yooka* [ancestors] or others, is grounded in communication with ancestors or deities, and the *faaka tiki* and other shrines are privileged places for such communication."[9] Flag altars also back and validate other important events, for instance marriage.[10]

PLATE 290: NDJUKA ALTAR TO THE KUMANTI SPIRITS, FANDAKI, SURINAME, 1960s(?). The Kumanti image (left) has mirrors for eyes, shells for ears, and red and white cloth tied around the forehead. The catlike nose and whiskers may impart feline qualities of spiritual attack and defense. The flat-sided figure to the right reveals a continuity with a nineteenth-century image now in the Herrnhut Volkerkundemuseum, Germany: abstract, with faceted head and rectangular body (plate 145). Photo: Robert Farris Thompson, December 1978.

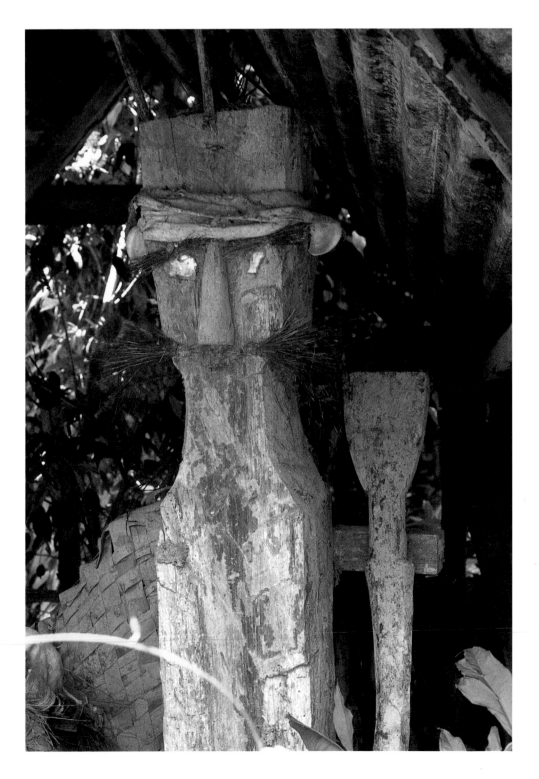

Maroon flag altars are relatively new configurations. Akan, Ewe, Fon, and Anagó tree altars with strips of honorific cloth, the Kongo tomb as altar with brandished flags of victory over death, plus all sorts of beliefs and artistic practices observed by blacks in contact with Western tombs and military flags, have fused to form a creole art. *Faáka páu* and *faaka tiki* are among the most visually compelling altars of the Afro-Atlantic world. This is especially true where they soar to the sky as draped T-form crosses with elevated platforms for votive offerings, as at Asindoopo and other villages of the Pikílío and Gaánlío.

An earlier literature voiced an impression of maroon religious statuary as rather lacking in aesthetic appeal.[11] But in those days sites like Gódo and Soolán, and the traditions behind them, were relatively unknown. In fact maroon figural altars to the Kumanti spirits, and the statues that Saamaka call *pindi*,[12] set before some *faáka páu*, have a stark beauty and a complex art history. Historically critical Saamaka altar art collected by Moravian missionaries in the nineteenth century, now in the Volkerkundemuseum in Herrnhut, Germany, gives tantalizing glimpses of quality and temporal depth. Now we can see, for example, a continuity between a nineteenth-century image at Herrnhut—superbly abstract, with faceted head, diamond-form neck, and rectangular body (plate 145)—and a similarly flat-sided figure, even more abstract but with cognate cuts at shoulders and neck, seen standing beside a Kumanti altar figure at Fandaki on the lower Tapanahoni in December 1978 (plate 290).

The Kumanti image itself looms up in its shelter with omniscient mirror eyes, catlike nose and whiskers, and strips of red and white cloth tied around the forehead just above appended shells representing ears. The fabrics make the top of the image read as crown, culminating with featherlike appendages of wood. With a few attachments, a flat board becomes expressive.

The austere beauty of these figures links up with the Kumanti doctrine of perfecting mind and body through fasting, dedication, and identification with supernatural forces. With strong stance and spiritual embodiment (anointment of kaolin, mirror eyes), the two images preach how to conquer fear.[13] Kumanti priests in possession, dancing without harm on broken glass with naked feet, answer the valor and resistance standing here.

That quality of bravery is phrased anew, equally strongly, among followers of the *orisha* in Yoruba-influenced portions of the Americas. The Yoruba believe that the whole of life is sanctified by proximity and sacrifice to the essential emblems of the major deities under God. The clay pillar of Eshù-Elégba, the bow and arrow of Oshóòsi, the irons of Ogún, the river stones of the goddesses Yemoja, Oshun, and Oya, the thunder stones of Shangó, and the cowrie crown of Dàda-Bàyònnì appear on altars both in Nigeria and across the seas.

In black Cuba, some of these emblems may be placed in tureens or other receptacles and garlanded with *mazos* of multistranded beads. Afro-Brazilians often tie *axe*-containing vessels with the classic Yoruba women's sash, the *oja*. *Atabaque* drums, wedge tuned or peg tuned, bring down the gods in Bahia. In Cuba and North America, three *batá* attract them to the dancing areas, as these drums once attracted lightning from the sky for King Shangó.

The altars of the Yoruba goddesses and gods underwent a sea change in Cuba and Brazil. The creoles turned inventively to pottery and cloth to find their truths. The *tronos* of New York and the *oja*-exalted altars of Bahia represent a visual praise poetry

Envoi: The Place of Belief and the Site of Transformation

of dressed shapes and dressed spaces. The seed of this genius was already present in Nigeria, in the draped images of Oko and Yemoja seen in Ibadan (plates 184, 278, 279). It reemerges in Rio de Janeiro in the rich cloth honoring *egun* (the Nigerian ancestral masked spirits *egúngún* under another name). Plate 291 shows a member of a complement of *egun* maskers who accompanied the worship of Oya at the important *candomblé* of Aildés of Jacarepaguá in January 1987. Images of owls appear on the lappets of this *egun*, in tacit assertion of power, spiritual intimidation, and moral vigilance.

The zigzag-patterned lining of *egúngún* gowns in Oyotunji, South Carolina, and the garment of the *elegun shangó*, the high priest of Shangó (for Shangó once wore the gown of Egúngún as a ruse against death), in Africa, serves in itself as a symbol of the triumph of Yoruba art and altars in the black New World. For the zigzag is stylized lightning, and has *asè* because of what it does: *Orí apara ni apara*. Lightning thrusts its head to split open the earth.[14] This becomes a metaphor for that which can pierce or penetrate—*jé*—

and spread—*wòn*. Hence the zigzag, *jéwòn-jéwòn*, hidden in the Havana thunder ax, exalted in the white and red cloths of the *tronos* of Ramón Esquivel, and carried into a South Carolina courtyard by the citizens of Oyotunji, form one vast metaphor for the power and diffusion of Yoruba Atlantic art.

The diffusion of African faiths through the Americas is so pervasive and strong that our book and exhibition can only begin to outline the contours. I conclude with two examples, Haiti and, briefly, Ejagham, both deserving of far more extensive treatment, as hints at the territory remaining to be explored.

In March 1975, Danger-Malheur, an avatar of the Haitian spirit of the cemetery and god of death, Baron Samedi, was photographed presiding in the body of a possession priest at his altar table near Gressier in southern Haiti (plate 292). The context is one of

Envoi: The Place of Belief and the Site of Transformation

PLATE 293 (RIGHT): A PRIEST OF VODUN DRAWS A *VEVE* FOR A *SIMBI* SPIRIT, CARREFOUR, HAITI, MARCH 1968. A *vèvè* is a drawing on the ground, dedicated to a spirit, like the blazons traced on the ground in Dahomey, or the chalk or clay *pontos riscados* of South American Umbanda (see plates 107, 300). The priest, Jean de Carrefour, echoes both the Dahomey tradition and the cosmography of Kongo: note the cross within circle at the center of his drawing, and the circle's scalloped edge (compare plate 29). Photo: Graham Stuart McGee.

PLATES 294 AND 295 (BELOW): MURAT BRIERRE, METAL EMBLEM FOR BARON SAMEDI, CA. LATE 1960S/EARLY 1970S. A crucifix wittily transmutes into the sign of the Vodun god of death. Compare the North American gravestones featuring crosses and semicircles (plates 286, 287), and the legged crosses of Kongo (plates 25, 27). Collection of the Davenport Art Museum, Davenport, Iowa. Photo: Robert Farris Thompson, 1982.

the two sides or branches of Haitian Vodun, Petro-Lemba, the Kongo/Angola side. Appropriately, then, Danger sits next to a mock grave with cross, at left—a Kongo-like crossroads or point of contact between this world and that of the dead. His table supports playing cards for divination, a skull for moral intimidation, and a bag with feathered panache—a pure transatlantic manifestation of the long-stemmed *nkisi mbumba mbondo* charm from Yombe in Kongo. Petro-Lemba altars, intense and dramatic, reflect "military" spirits of attack. They often include a *pacquet congo*, Haiti's version of the *nkisi*.

Dahomean and Yoruba cultures play a different part in Vodun, being active in the religion's other branch, the Rada side. Rada altars repantheonize space with icons of the deities of Dahomey and Yorubaland, plus, sometimes, chromolithographs of syncretized Roman Catholic saints—Saint Patrick for Damballah, for example, or Saint James the Elder for Ogun Ferraille.

The ancient city of Benin, Nigeria, preserves a rich tradition of ground blazons for such deities as Olokun. This tradition is apparently connected in some way with a more simplified ground-blazon practice among the Fon of Dahomey, where women and men, stooping with calabashes of cornmeal in one hand, trickle lines and figures on the ground with cornmeal held between thumb and forefinger of the other hand. The squares and other geometric signatures that they describe summon spirits like Sakpata.[15] This was a primary source for Haitian *vèvè*, the ground blazons of Vodun, also drawn on the ground with cornmeal sifted through thumb and forefinger.

But *vèvè* have also absorbed elements from Kongo iconography. At Carrefour in 1968, a priest drew the *vèvè* of *simbi* before his altar (plate 293). His stooped drawing posture was Dahomean, but his sign, with its central cosmogram, was Kongo. Note also that he rephrased the age-old Kongo concept of a line of water dividing this world from the next, in the fluid pattern of scalloping that runs along the edges of his circle. This recalls the scalloped pattern encircling the "face" of the Tsaaye Kidumu-society mask that we saw in chapter 3 (plate 29).

Vèvè, stylized geometric appellations calling spirits from the other world, have exerted a strategic influence on Haitian museum art since its first "renaissance," in around 1947 to '49. Take, for example, a metal emblem for Baron Samedi by Murat Brierre, which entered the Davenport Art Museum in Davenport, Iowa, in 1973 (plates 294, 295). As a skull and crossbones wittily transmutes into an abbreviated Christ upon the Cross, the cruciform pattern reflects the essence of the Kongo type of *vèvè* drawing. And the cross takes on legs, and becomes human—a walking cross, like the Kota *mbulu ngulu* and associated Kongo cosmograms (plates 25, 27). A circle around the intersecting lines links up this Kongo-influenced sculpture to decorated headstones seen in Texas and Virginia.

Flags are important ritual presences in Haiti as in Suriname and Cuba. With their bearers, usually women, they march into peristyles to announce the coming of the gods. Their function seems cognate with that of the *banderas* mystically moving *prendas* in Cuba, of the flags that announce the presence of Tempo in Brazil, and of *faáka páu* and *faaka tiki* standing to mark the spots where spirit can be praised among the maroons of Suriname. In Haiti, flags come off the *T*-form hoists they ride in Suriname, or off the staffs of Tempo or the closet walls of *minkisi* in the Cuban Bronx, and join the faithful in the dance.

A ceremony for Damballah seen at Jacmel in the spring of 1981 included a flag dance that enacted the building of a cosmogram. Two women bearing matching flags, accompanied by *la place* (the master of ceremonies), himself brandishing a sword, came in and rushed to the east and kissed the ground, rushed to the west and kissed the ground, and continued so until they had saluted all the cardinal points. Then they danced up to the *poteau mitan*, the central post in the middle of the dancing court, and saluted it with flags and knelt and kissed the ground there too. Like Harriet Jacobs kissing the ground at her parents' grave, their gesture mapped lines of spiritual presence and emergence. Soon women were possessed by spirits. They came, seemingly, from all directions.

Flags herald the advent of spirit in other ways in Haiti. A Petro-Lemba altar on the south peninsula includes a large and meteoric-looking stone believed to have dropped from heaven onto a farm. On this altar, photographed in April 1975 (plate 296), a red flag and a black flag, unfurled and standing, honor the stone and its arrival.

Ejagham people hear God in the sounding of a voice behind an altar. From Calabar to the Cameroon grasslands, this is the core element of the institution variously known as the Ngbe or Ekpe or leopard society, which has functioned for several centuries as a parallel form of government and as a festivalizing tradition built around an ultimate authority: the moral rumbling of God's voice. The sound is accompanied by silent masked messengers, as witnessed in nuclear Ejagham territory at Ndebaya, Cameroon, in 1969 (plate 297). With ideographic costumes, mime, and gesture, these messengers emphasize that they are only lieutenants, as it were—that only God has the voice that matters.

That voice and those masked messengers came to Cuba from Calabar in the early-nineteenth-century slave trade. In the process the Ekpe society was renamed Abakuá, apparently after the Abakpa Ejagham of Calabar.

Masterpieces of Abakuá messenger costumes from the twentieth century and earlier, now in the Casa de Africa collection in Havana (plate 298), blaze with ideographic appliqué and checking. The patterns relate their muscle and their prowess to the noblest animal of God's forest, the leopard. Ejagham and Cuban leopard-society altars show their historical connection in the similar importance both give to sacred staffs, which titled members only may hold as a sign that they have a right to converse with God. In both Cuba and Calabar, God's voice sounds from behind a cloth, also ideographically emblazoned.

Writing and Altars South of the Sahara and in the Americas

African altars often intersect with writing. Kongo cosmograms, Ngbe or Ekpe signs in Calabar, and the ground blazons of Olokun in Benin and of Sakpata in Agbomey all indicate the importance of forms of writing in the altars of key civilizations. The Jewish altar upholds the Torah. Similarly, major African faiths, especially those of Ejagham and Kongo, rely on sacred ideograms with precise systems and rules of interpretation. Moral knowledge is imparted by such signs, which sometimes function as altars in themselves.

Likewise in the Americas. Cuban Abakuá has its ideographic altars, the *Regla de Mayombé* its *firmas* and *gandós*. And in Brazilian Umbanda, as in Belo Horizonte in 1987 (plate 300), one draws *pontos riscados* upon the ground—ideographic signatures of the gods, in effect miniature altars. These signatures summon the spirits, who, through the possession of servitors, in effect reclothe the *pontos* with living flesh and blood. The altars-become-flesh then sit and converse with troubled supplicants, charitably hearing their problems and giving counsel, as at the Fraternidad Pai Joaquim in Buenos Aires in March 1990 (plate 301).

But every altar in this realm of culture, whether elevated, drawn, or reenacted in spirit possession, is subtly, always, changing. We have seen an Umbanda altar shift from simplicity to sophistication in the space of sixteen years (plates 102, 103). Black Atlantic altars share with African architecture constant creative change. They are phenomena of process. Rarely are they "finished" in an absolute sense. For this reason we describe them "as in 1968," or "as in 1971," to avoid the impression of a space that once finished is never touched again.

This is especially true of yard shows: one can admire a given constellation of objects one year and come back later to discover a restless rearrangement. Some elements may remain, others have flowed away and disappeared. Actually, I would connect the yard show aesthetic with a black American art form specifically designed to make use of time's flow, to swim in it and punctuate it with rhythm: popular music. The collection of high-

Envoi: The Place of Belief and the Site of Transformation

PLATE 297 (RIGHT): MASKED-MESSENGER DANCER (*OKUMNGBE*), NDEBAYA, CAMEROON, 1969. In the Ejagham institution variously known as the Ngbe, Ekpe, or leopard society, the voice of God sounds from behind an altar. Accompanying it are dancers—their heads covered by conical masks, Janus faced, with throat ruffs of raffia—whose silence accentuates that voice's power. Photo: Robert Farris Thompson.

PLATE 298 (BELOW): *IREME* COSTUMES, HAVANA, CUBA, EARLY TWENTIETH CENTURY. Translated to Cuba, the Ekpe society became known as Abakuá. Continuity is shown by the conical heads, Janus faces, and straw versions of Ejagham raffia ruffs in these Cuban forms of the Ekpe messenger costume. Photo: Robert Farris Thompson, 1989. Collection of the Casa de Africa, Havana.

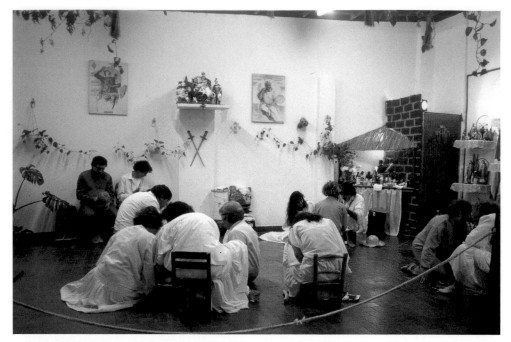

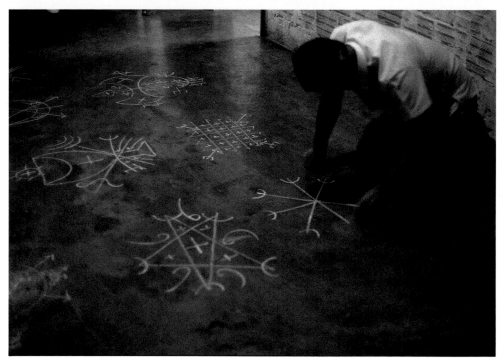

PLATE 299 (ABOVE): UMBANDA ALTAR TO ZE PILINTRA, MANAUS, BRAZIL, 1980S. Ze Pilintra, typically attired in white suit and red cravat as a black Rio dandy of the 1930s, is a Brazilian Exu spirit. Like Sarabanda Rompe Monte visiting the New York *munansó* of Felipe García Villamil (plates 288, 302), when he comes down to this shrine he shows himself by putting on his hat. The idea that an altar can be constituted of living flesh as well as material object goes back to the African San peoples discussed in chapter 2. Photo: Christopher Munnelly, summer 1990.

PLATE 300 (BELOW RIGHT): AN UMBANDA PRIEST DRAWING *PONTOS RISCADOS*, BELO HORIZONTE, BRAZIL, 1 JANUARY 1986. The *ponto riscado*, drawn in chalk upon the ground, is an ideographic signature of the gods, and a miniature altar to summon the spirits. Here, a *ponto* for mabasa twin spirits appears at the lower center; the priest is drawing a *ponto* for Exu Mirim. Compare with the Haitian *vèvè* (plate 293) and the Cuban *firma* and *gandó* (plates 46–50, 288, 302). Photo: Robert Farris Thompson.

PLATE 301 (ABOVE RIGHT): UMBANDA POSSESSION SPIRITS CONSULTING WITH CLIENTS, FRATERNIDAD PAI JOAQUIM, BUENOS AIRES, ARGENTINA, JUNE 1990. The spirits at work here are *caboclos* (Native Americans of the interior) and *pretos velhos* (black elders of Kongo and Angola origin). See also plate 107. Photo: Robert Farris Thompson, June 1990.

hat cymbals, drums, and so forth tied together at the formation of the jazz battery, especially in "spasm bands," follows principles of layering, organization, and improvisation very close to the repetitive phrasing of hub cabs and white-painted wheels in the yards of America. So-called bottle trees, too, are appreciated for their protective sounds as well as for their evil-repelling flash.

Spirit possession makes some altars the wardrobes of the gods. In García Villamil's closet altar for Sarabanda Rompe Monte in the Bronx we have seen the sombreros that Sarabanda wears when he possesses the body of his priest (plates 288, 302). An Umbanda altar to Ze Pilintra in Manaus, photographed by Chris Munnelly in the summer of 1990 (plate 299), offers the god the same service. In white suit and red cravat, Ze Pilintra is the spirit of a black Rio dandy of the 1930s.[16] When he comes down to this shrine he comes up to the altar and picks up his hat. Eventually he will engage in one-

Envoi: The Place of Belief and the Site of Transformation

PLATE 302: FELIPE GARCIA VILLAMIL, ALTAR FOR THE SPIRIT SARABANDA ROMPE MONTE, THE BRONX, NEW YORK, MID 1980S. Like the Manaus Umbanda priest whose altar to Ze Pilintra is shown in plate 299, Villamil—himself originally from Matanzas, Cuba—has provided the spirit with clothing, a choice of hats. The cross at top center, though undoubtedly Christian in origin, here reflects reverence for the Kongo supreme spirit, Nzambi Mpungu. Photo: C. Daniel Dawson, 1993.

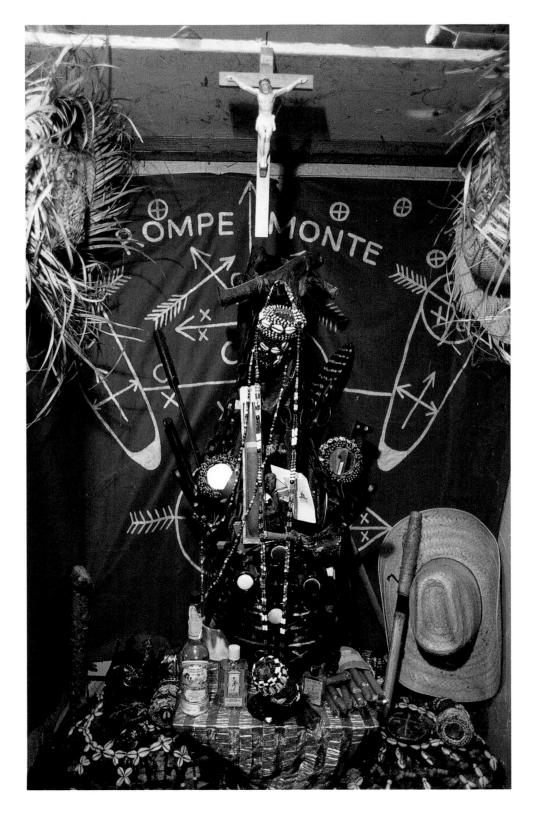

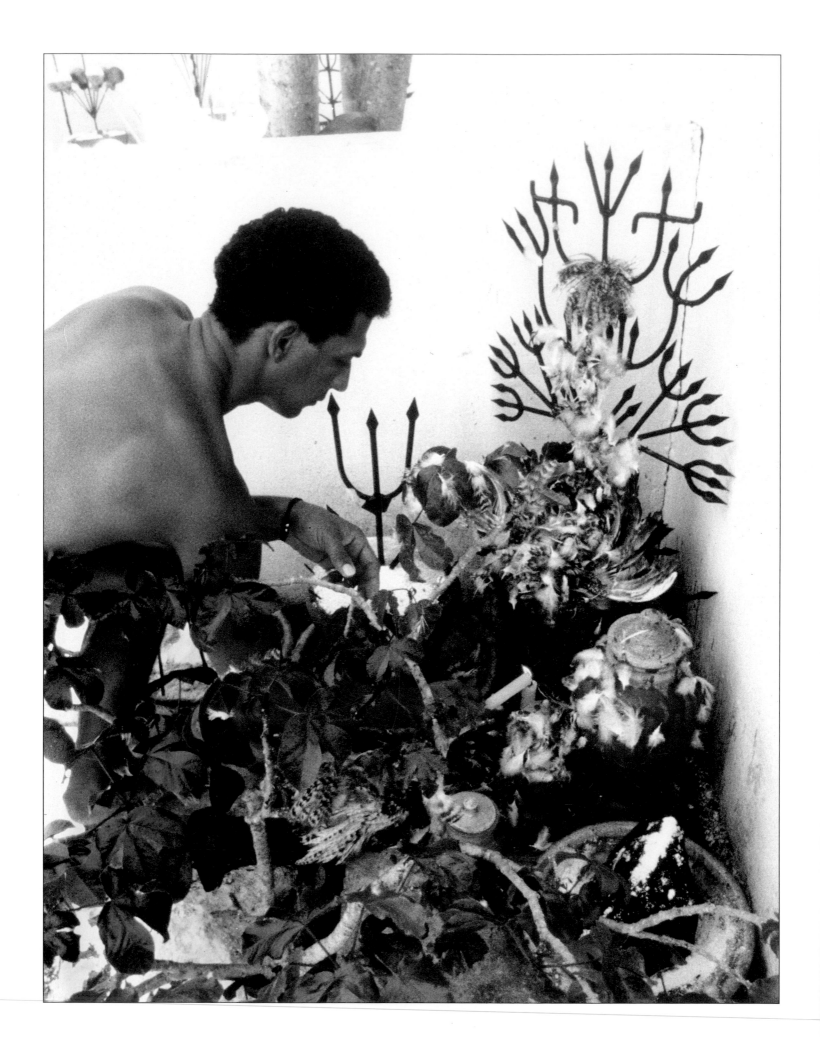

Envoi: The Place of Belief and the Site of Transformation

PLATE 303 (OPPOSITE): ALTAR FOR EXU ABRE-CANCELAS (EXU WHO OPENS THE GATES), BAHIA, BRAZIL, EARLY 1980s. A sacrifice of a chicken has been made to Exu Abre-Cancelas, and its blood has been poured on the god's *quartinhas* (water vessels) and on his iron standard. With its many tridents and forks, this staff, made by José Adario dos Santos in the early 1980s, is crammed with crossroads, and vividly evokes life's circuitousness. The priest hangs the chicken's feathers on it. See also plate 198. Photo: Robert Farris Thompson, November 1989.

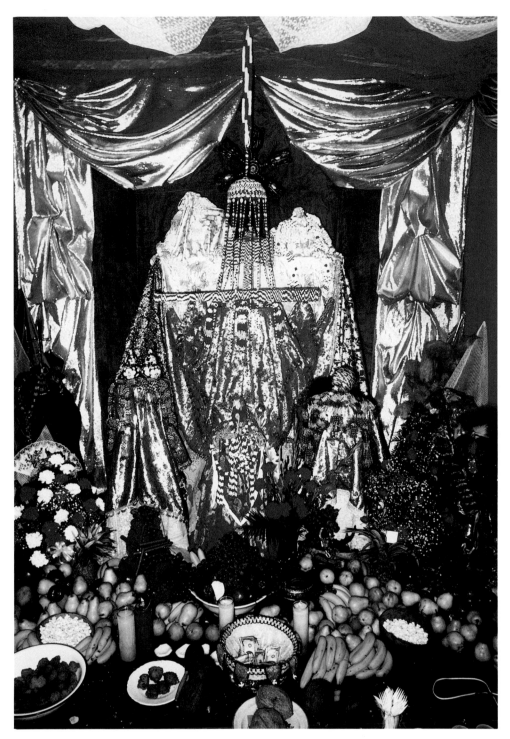

PLATE 304: BIRTHDAY *TRONO* ALTAR TO CHANGÓ WITH CROWN OF DADÁ, DESIGNED BY RAMÓN ESQUIVÉL, UNION CITY, NEW JERSEY, 1985. BEADWORK BY MELBA CARILLO, EXCEPT CROWN OF DADÁ, WHOSE MAKER IS UNKNOWN. Typifying Esquivel's contribution to the Afro-Cuban altar tradition, the cowrie-studded crown of Dadá descends on a cord from a heaven of cloth. A feast for the gods is laid out below. Photo: David H. Brown. Copyright © David H. Brown 1993. All rights reserved. Reprinted with permission. See *African Arts* 26(4)(October 1993).

on-one conversation with the clients of the house. However "slick" and "cool" his dress and his demeanor, he will hear the questions of the anxious sympathetically, and will answer them.

The radical jump in scale between the size of the icon and the size of the hat shows that two altars are involved here, not one. In miniature, the god anchors the material altar. The other altar transcends the first with living flesh and speech. Ze, as concept, and Ze, as embodied spirit, combine in the touchingly familiar usage of his image as a hat rack.

All of which leads straightaway to the consideration of the altar in action. In November 1989, for instance, Gutenberg, head of a Kongo/Angola *candomblé* in Bahia,

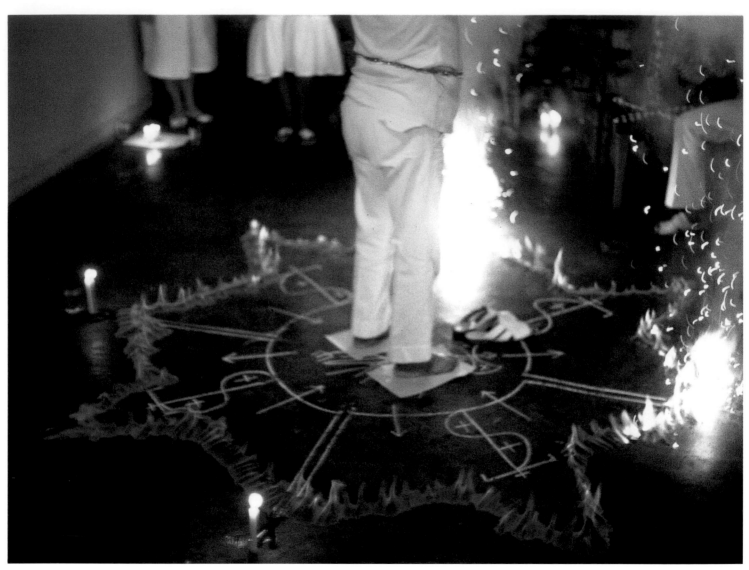

PLATE 305: *PONTO DE DESCARREGAR* (IDEOGRAM TO BLAST AWAY BAD LUCK) DRAWN AT AN UMBANDA *CENTRO* IN BELO HORIZONTE, MINAS GERAIS, BRAZIL, MARCH 1988. In the Umbanda gunpowder *ponto* small piles of gunpowder are made at the cardinal points of a circle drawn around the client, in this case a man wishing to be "immunized" against the serious misfortune he had suffered. He stands barefoot on two rectangles of colored paper, there to absorb some of his bad luck. Blazons within the circle include the *S*-curve signatures of Exu Tranca Rua. Photo: Robert Farris Thompson.

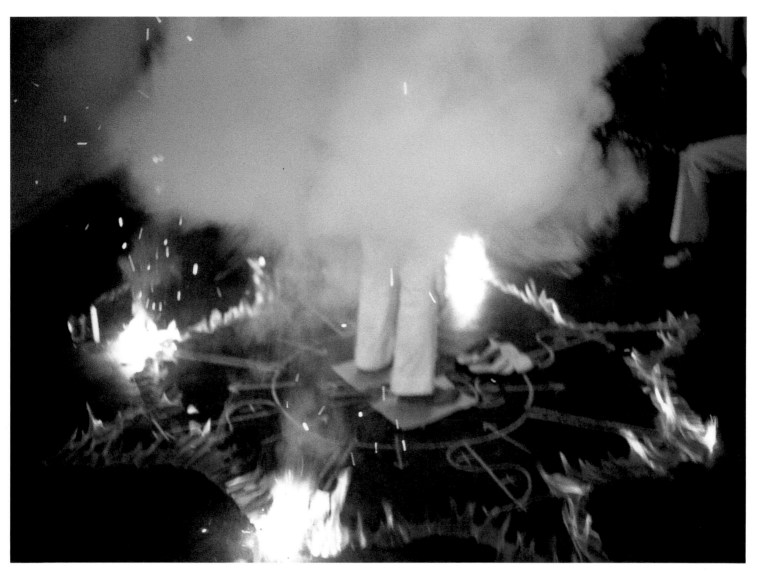

PLATE 306: *PONTO DE DESCARREGAR* (IDEOGRAM
TO BLAST AWAY BAD LUCK) DRAWN AT AN UMBANDA
CENTRO IN BELO HORIZONTE, MINAS GERAIS,
BRAZIL, MARCH 1988. The four blasts of
gunpowder and the circle of burning alcohol
enclose the supplicant in a round of spiritual
protection. Photo: Robert Farris Thompson, 1988.

PLATE 307 (ABOVE): GELEDE IMAGE, SOUTHWEST NIGERIA, NINETEENTH CENTURY. This wooden face, its eyes wide with *àse*, appears to have been brought to Bahia from Lagos in the last quarter of the nineteenth century, as Brazilians of African descent were able to make pilgrimages to the Old World and to return with things they needed, objects of both use and inspiration. Photo: Robert Farris Thompson, 1985. Collection of Didi and Juana dos Santos, Salvador, Brazil.

PLATE 308 (ABOVE): IMAGE OF A DEVOTEE OF ORISHA POPO, OGBOMOSHO, NIGERIA, EARLY 20TH CENTURY. Orisha Popo is a spirit of creativity and an avatar of Obatálá. The coiffure is royal, the eyes wide and magnificently spiritualized. Photo: Robert Farris Thompson, 1963.

Envoi: The Place of Belief and the Site of Transformation

heard a client's plea for the spiritual resolution of a certain problem. Divination revealed that a small sacrifice (*ebo*) to Exu Abre-Cancelas was needed; and so a chicken was taken to his altar and sacrificed. A priest poured the blood of the chicken on the god's *quartinhas* (water vessels) and on his iron standard, which shows three-way crossroads and the winding paths of life (plate 303). The priest lit a candle. He appended the feathers to the staff: head feathers at top, neck feathers in the middle, wing feathers spread out left and right below. Standard and *quartinhas* took on life. The deity's metal signature became an instrument of flight, soaring mystically to heaven with prayers and requests.

The altar in action is equally exciting in Umbanda. Witness a *ponto de descarregar* (ideogram to blast away bad luck) drawn at a leading Umbanda *centro* in Belo Horizonte, capital of the state of Minas Gerais, in the interior of Brazil, in March 1988 (plates 305, 306). The ceremony is a complex, baroque creolization of a Kongo rite called *tula mfula mu mafula*, which means, and involves, placing gunpowder protectively at the points of entrance to a person's life.[17] Detonating a small pinch of gunpowder at the four cardinal gates to a village, for example, blasts away evil at critical points of entrance.

In the Umbanda gunpowder *ponto* as practiced in Belo Horizonte, Kongo's "four gates of the village" become cardinal points marked with small piles of gunpowder around a client, in this case a man who had suffered serious misfortune and wished to be "immunized against such suffering." Umbanda officiants first stood him barefoot on two rectangles of colored paper, so that their fibers could absorb some of his bad luck. Then the main priest drew a giant *ponto* around the client in *pemba branco* (sacred white chalk). He added many blazons within the circle. Small piles of gunpowder were placed at the four cardinal points, as in Kongo, but with the innovation of a circular connecting line of alcohol poured upon the ground.

Within the circle, like a great peace doubled, appeared two intersecting staffs of Oxala/Jesús, governing the moon, the stars, the ocean. The priest also drew smaller *pontos* within the grand circle "to equilibrate [the client's] guardian angels." Among these designs he interspersed the image of a figure with cruciform head, downward-indicating arms, and an S-curve enclosing two tiny crosses—the *ponto* signature of Exu Tranca Rua, guarding the cardinal directions and the points between. Exu's awesome powers were spelled out by arrows drawn across an inner circle. Going out, they stood for the opening of the doors of life; going in, for the opposite. But positives and negatives now connected to a higher purpose, as the machine for restoration of luck was activated.

The priest lit the alcohol. Blue flame raced around the borders of this miniature cosmos, igniting gunpowder east, north, west, and south. Smoke rose over the supplicant like a miniature mushroom cloud (plate 306). The priest explained that the four blasts exerted spiritual pressure on the man's behalf at the points where most was needed. As in Kongo, it was said that they "awakened spirit." The running flame of blue "unified the blast points" and enclosed the person in a circle of purity and protection.

The purpose of this heroic fusion of altar, writing, and performance was to change the petitioner, making him aware of new possibilities of existence. The priests left nothing to his imagination. Carefully they led him from the *ponto de descarregar*, still smoking, to a series of other *pontos* chalked upon the floor. At the *ponto de Exu* they prayed that his change of luck be permanent; then they stood him on *ponto Omo-Olu* to protect him from disease; on *ponto Xango* they bathed his body in handfuls of cascading coins, asking

the lord of lightning to help him make his way financially. Finally they stood him on *ponto ibeji*, the sign of the divine twins, where he was given a children's drink made of milk, honey, and sugar and blessed that he be cared for as a mother loves her child. The linked cosmograms constituted a symphonic sequence of confidences and benedictions. At these tiny drawn altars, faith and ritual met body to effect a heightened healing.

The unfolding and sharing of spirit is the richest gift of the Afro-Atlantic altar. The healing poise of the servitor of a god of creativity, Orisha Popo (an avatar of Obatálá), is the point of an altar image from the city of Ogbomosho, Nigeria, photographed in May 1963 (plate 308). That poise, that spiritually illumined gaze, reflecting pressure from within (*oju inu*), or insight, traveled from Yorubaland to Brazil in both possession faces and sculpture. Note the divinized eyes and lips of a Nigerian Gelede image that came in the pilgrimage trade from Lagos at the turn of the century (plate 307).

Similarly, long after the establishment of the earliest Cuban beachheads of relatively pure Yoruba visual tradition, Ramón Esquivel worked out his own creole solutions in New Jersey (plate 304). Sculpture is there, but the main focus now is draped cloth and *mazos*, hieroglyphs of glory. Esquivel recognized the subtle goodness of Dadá, and crowned her above all *oricha*. He caused her to descend on a cowrie-studded cord from heaven.

Such images, and the sway they maintain on far-separate Atlantic shores, symbolize the need for a whole new history of religious thought and action. The beauty and the moral splendor of the altars we have seen here, from Africa to the Americas, from antiquity to the present, reveal Afro-Atlantic faiths as world religions, never again to be considered "cults," never again to be excluded from the calculus of world religious history. All this sainted difference is what God wants: as Thomas More noted in *Utopia*, "God made different people believe in different things, because He wanted to be worshiped in many different ways."[18]

Catalogue

Cat. 1
Mask
Vili, Republic of Congo
Collection of Kirsten and Hanus Grosz

CAT. 2
Sequinned banner
Haiti
Collection of Virgil Young

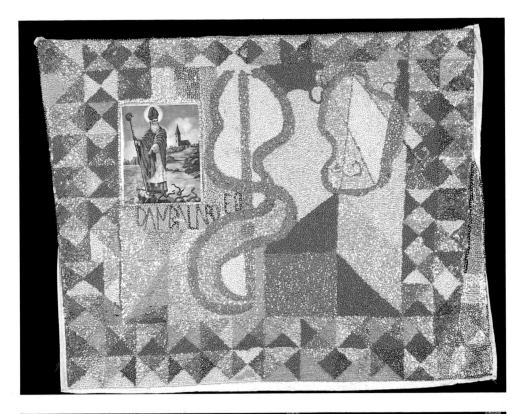

CAT. 3
Sequinned banner
Haiti
Collection of Virgil Young

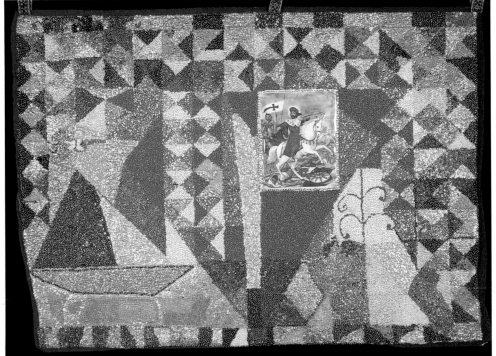

CAT. 4 (BELOW)
Female altar figure
Yoruba, Nigeria
Collection of Irwin and Madeline Ginsburg

CAT. 5 (RIGHT)
Bowl for Shangó
Yoruba, Nigeria
Private Collection, New Jersey

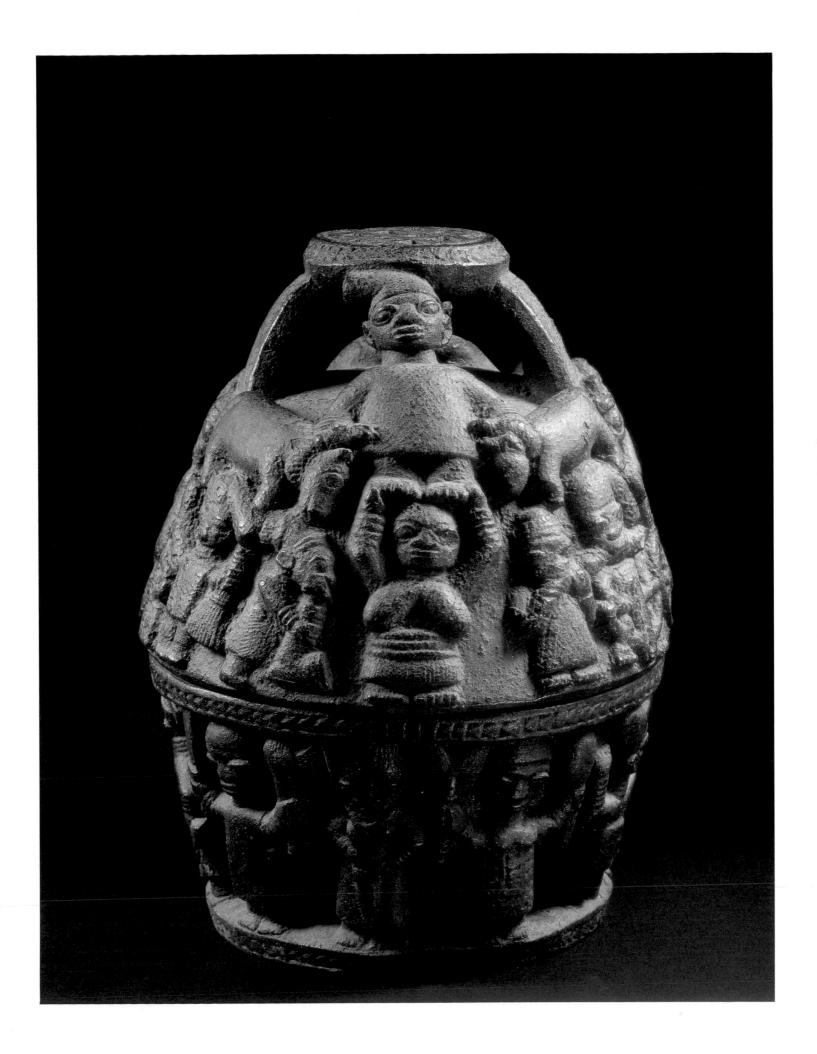

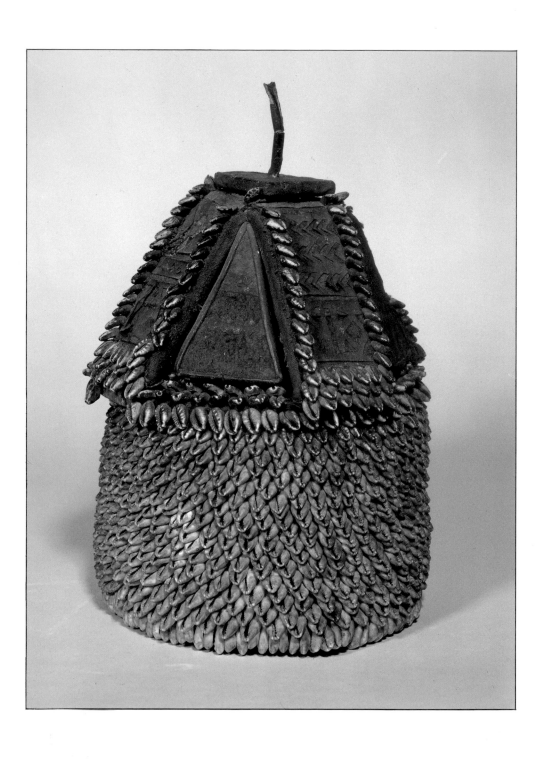

CAT. 7
Oshe Shango, dance wand
Yoruba, Nigeria
Collection of Drs. Jean and Noble Endicott

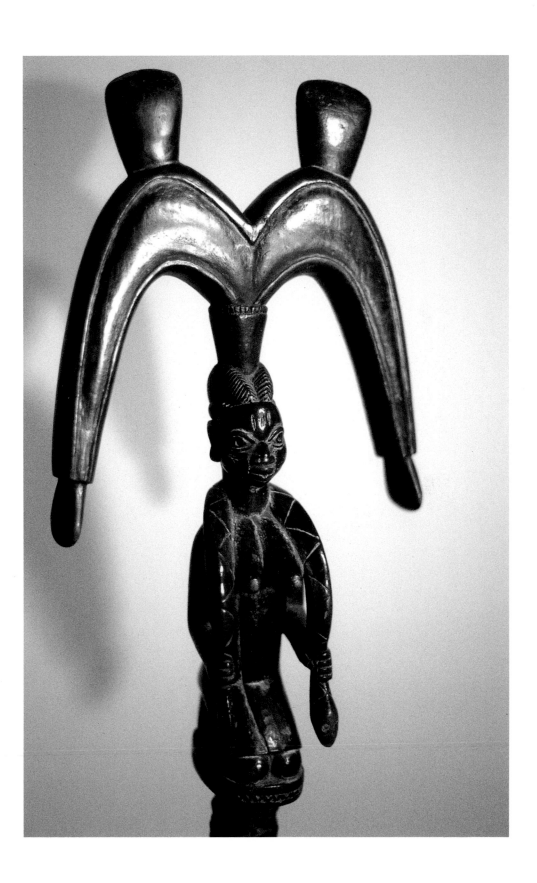

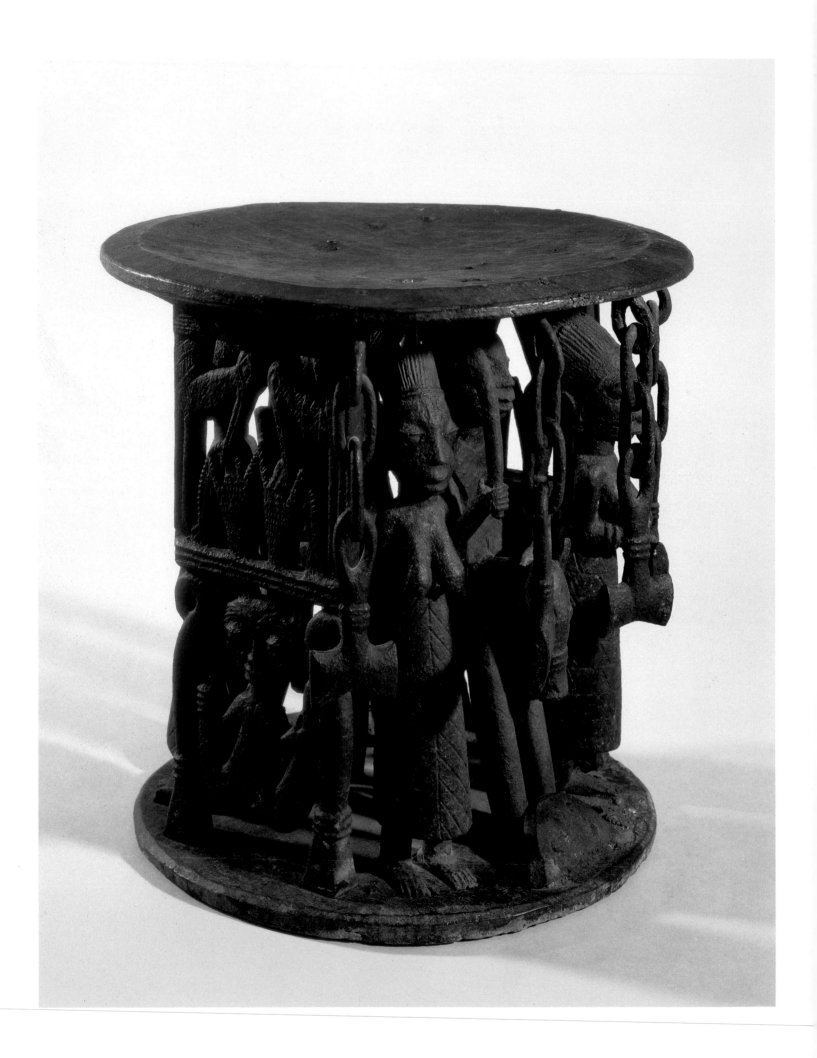

CAT. 8 (LEFT)
Shangó stool
Yoruba, Nigeria
Collection of Morton Dimondstein

CAT. 9 (RIGHT)
Arugba, female figure with calabash
Yoruba, Nigeria
The Paul and Ruth Tishman Collection of African
Art, loaned by the Walt Disney Company

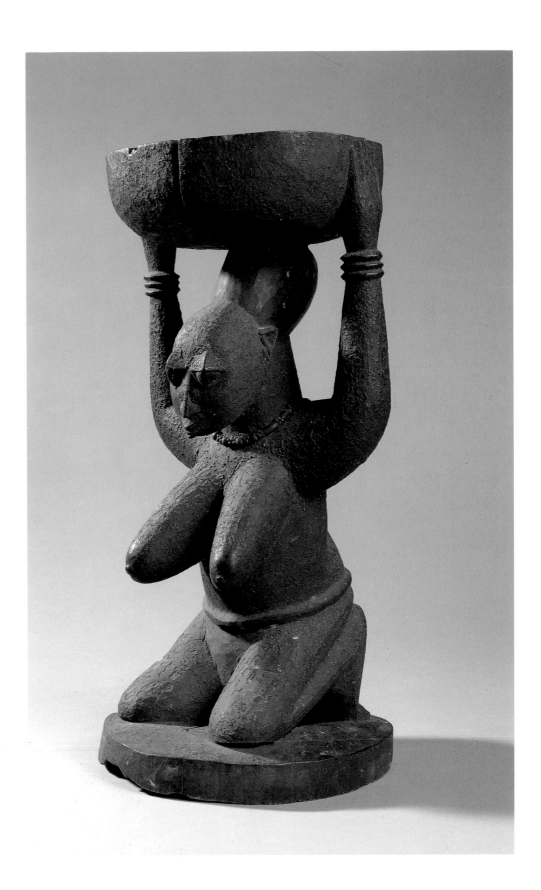

CAT. 10
Oshe Shango, dance wand
Yoruba, Nigeria
Collection of Leonard and Judith Kahan

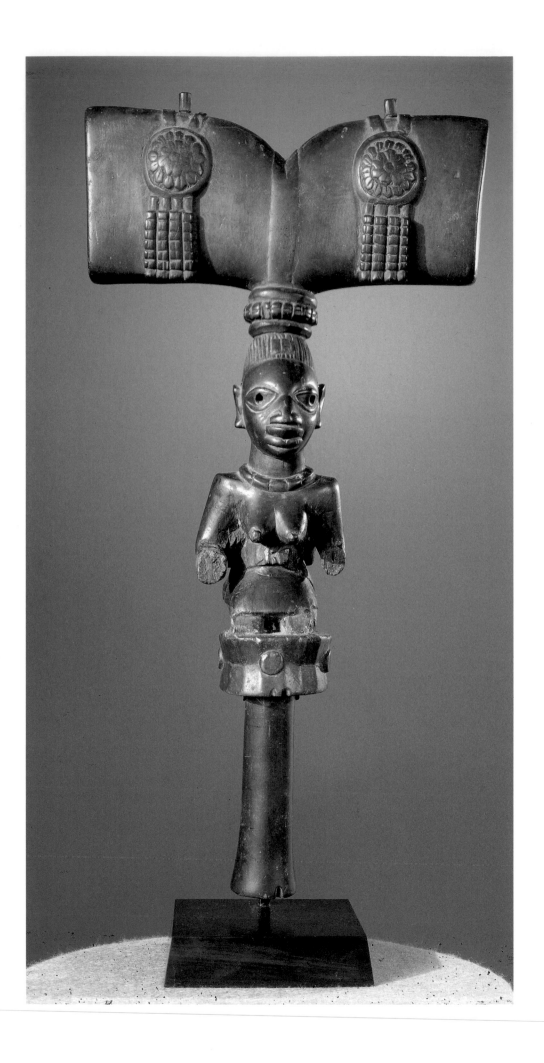

CAT. 11
Eshu maternity figure
Yoruba, Nigeria
Collection of Ida and Hugh Kohlmeyer

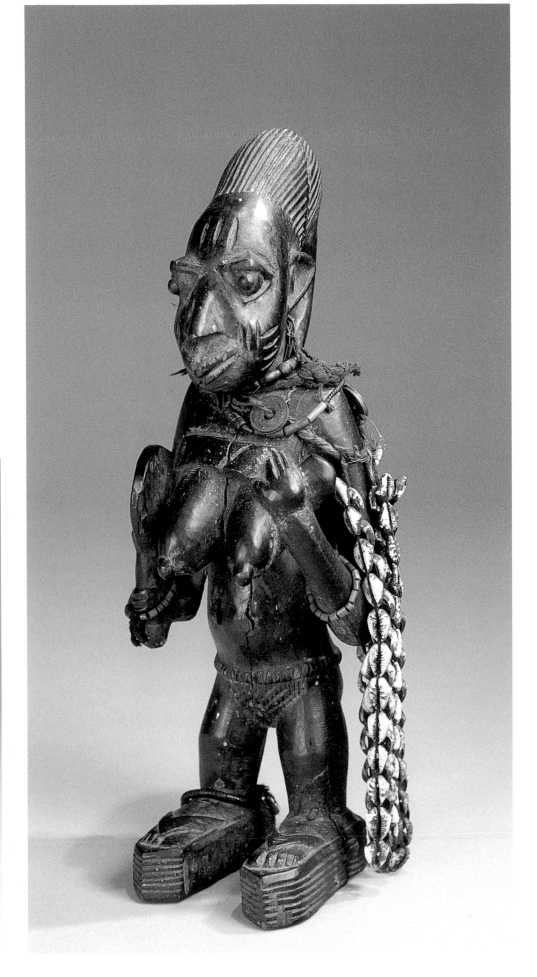

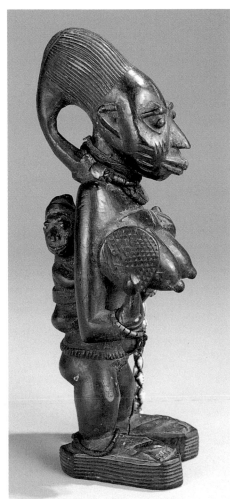

Staff and sheath for Orisha Oko
Yoruba, Nigeria
The Paul and Ruth Tishman Collection of African
Art, Loaned by the Walt Disney Company

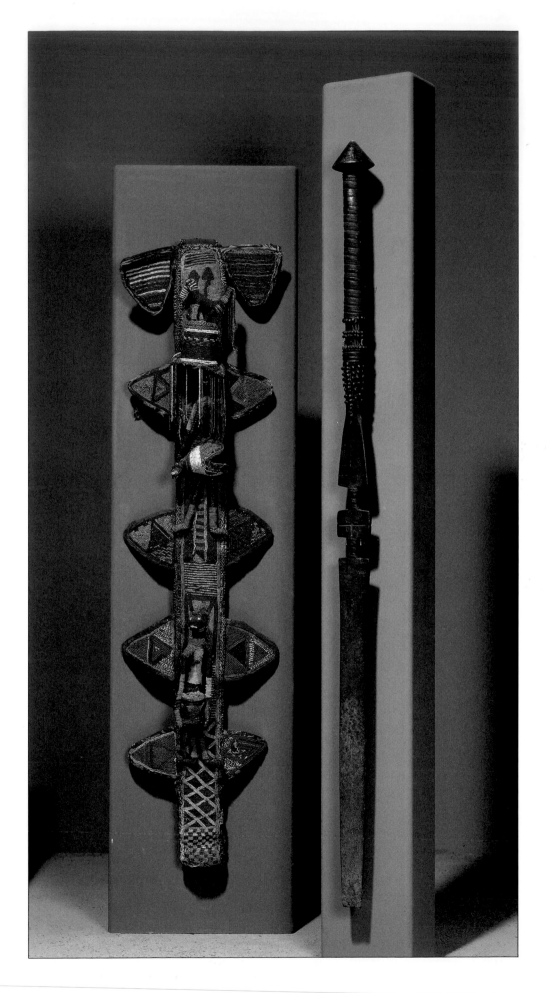

CAT. **13** (ABOVE)
Eshu figure
Yoruba, Nigeria
Collection of Irwin and Madeline Ginsburg

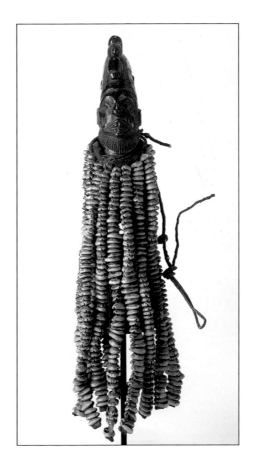

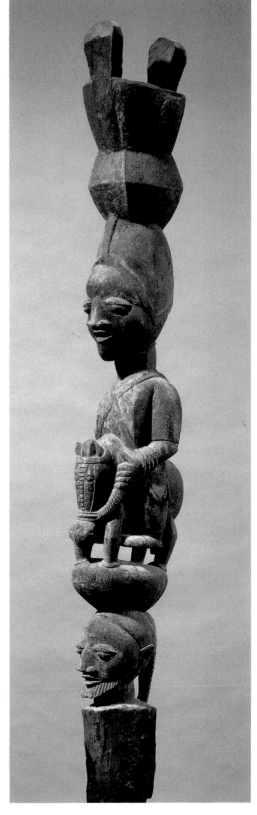

CAT. **14** (RIGHT)
Veranda post
Yoruba, Nigeria
Collection of Edwin and Cherie Smiley

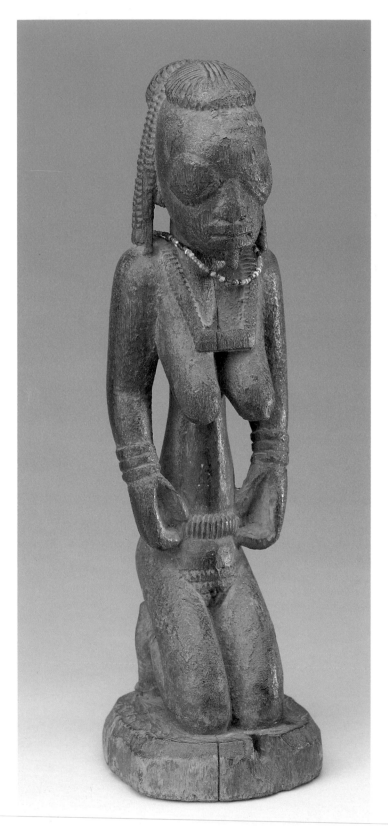

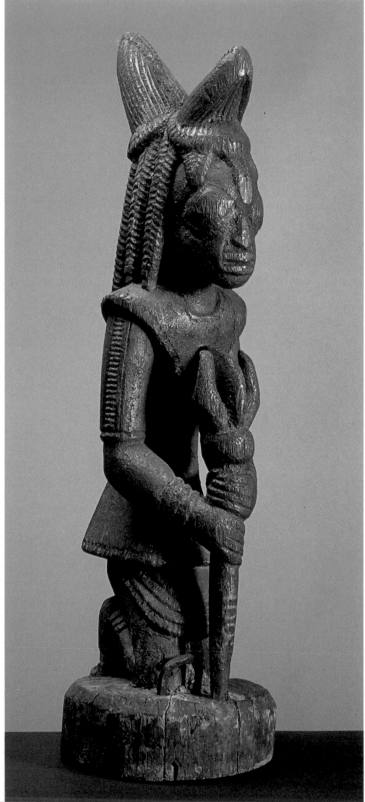

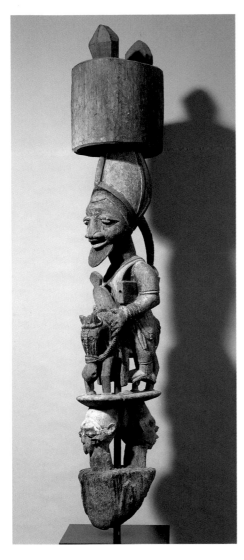

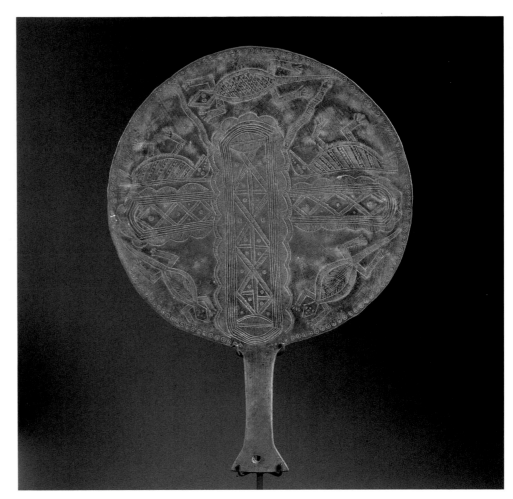

CAT. 17 (ABOVE LEFT)
Veranda post
Yoruba, Nigeria
Collection of Edwin and Cherie Silver

CAT. 18 (ABOVE RIGHT)
Brass fan for Oshun
Yoruba, Nigeria
Collection of Arthur R. Thomson

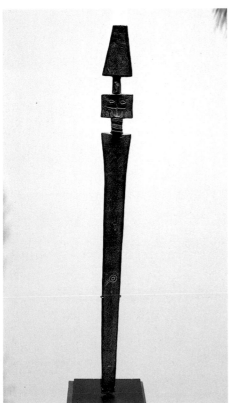

CAT. 19 (BELOW LEFT)
Staff for Orisha Oko
Yoruba, Nigeria
Collection of Jacques and Brigitte Hautelet

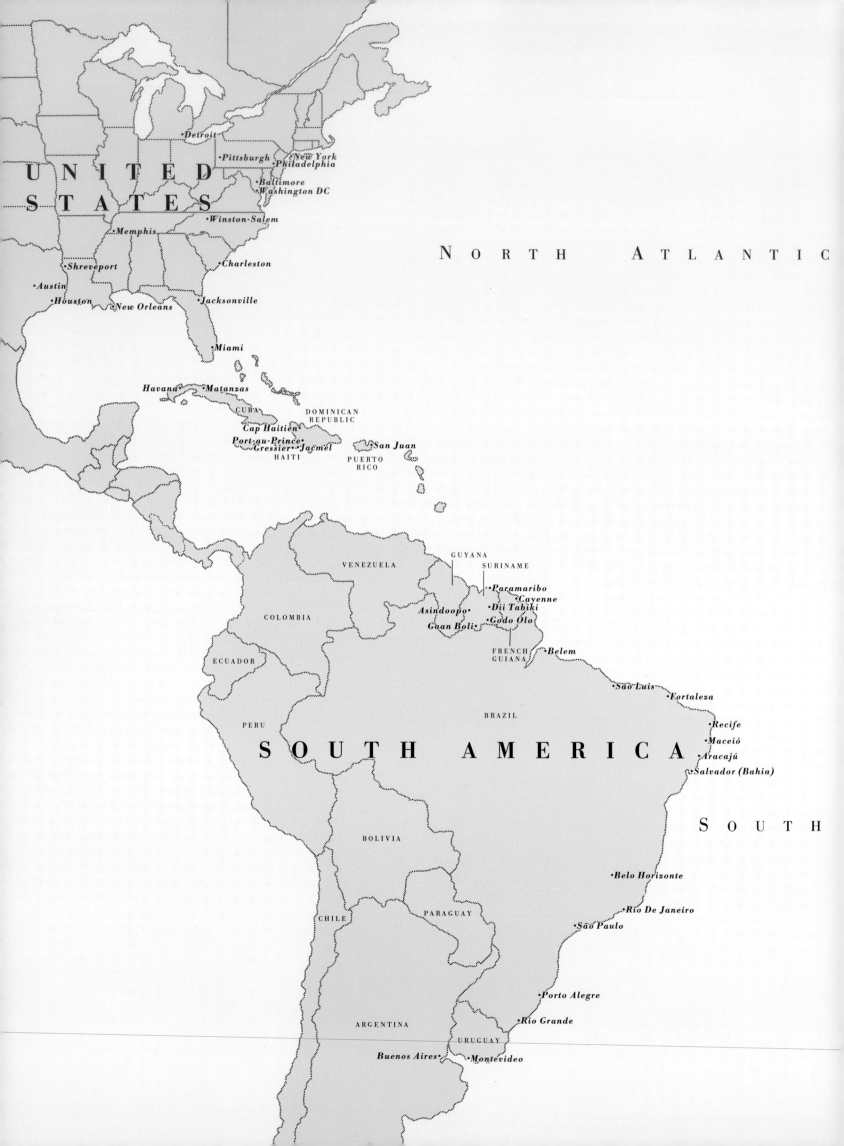

UNITED
STATES

•Detroit

•Pittsburgh •New York
•Philadelphia

•Baltimore
•Washington DC

•Winston-Salem

•Memphis

•Charleston

•Shreveport

•Austin

•Houston

•New Orleans

•Jacksonville

•Miami

NORTH ATLANTIC

Havana• •Matanzas

CUBA DOMINICAN
REPUBLIC

Cap Haitien• •San Juan
Port-au-Prince• PUERTO
Gressier• •Jacmel RICO
HAITI

VENEZUELA GUYANA
SURINAME

•Paramaribo
•Cayenne
Asindoopo• •Dii Tabiki
COLOMBIA •Godo Olo
Guan Boli•

FRENCH •Belem
GUIANA

ECUADOR

•São Luis •Fortaleza

BRAZIL

PERU

SOUTH AMERICA

•Recife
•Maceió
•Aracajú
•Salvador (Bahia)

SOUTH

BOLIVIA

•Belo Horizonte

CHILE PARAGUAY •Rio De Janeiro

•São Paulo

•Porto Alegre

ARGENTINA •Rio Grande

URUGUAY

Buenos Aires• •Montevideo

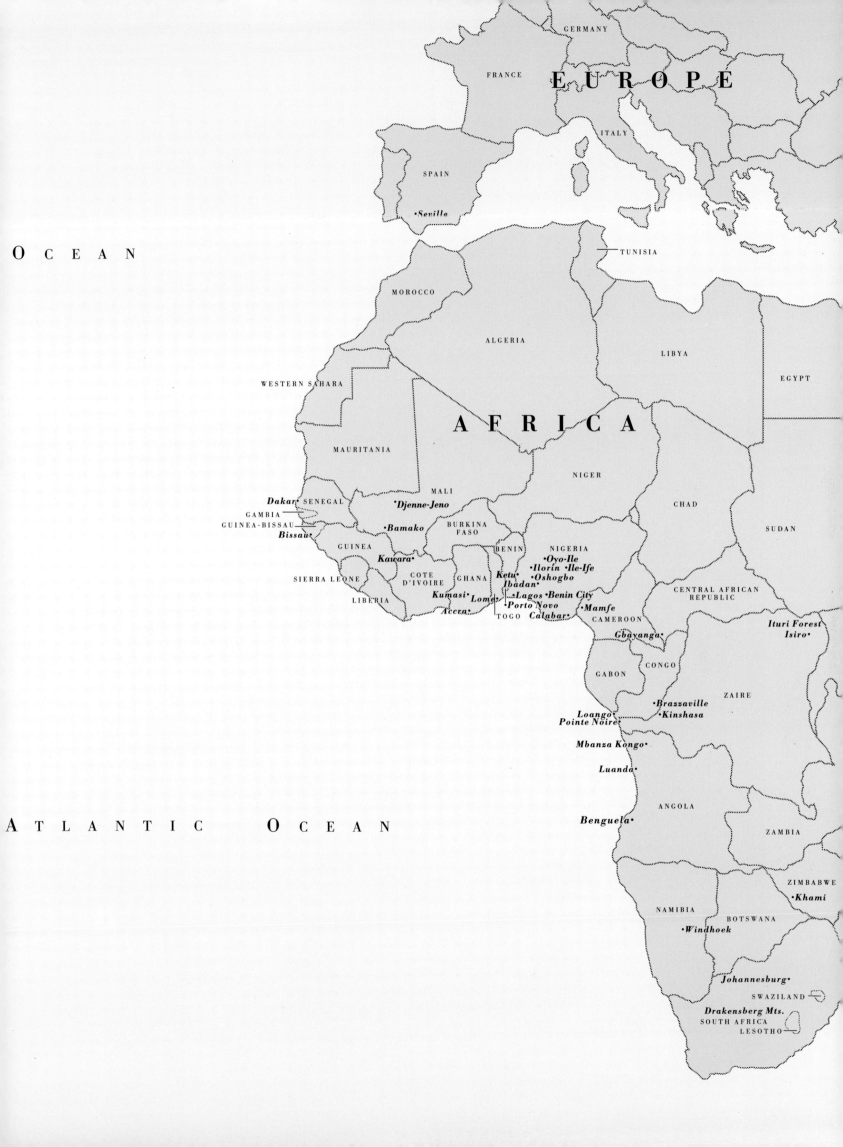

OCEAN

EUROPE

FRANCE

GERMANY

ITALY

SPAIN

•Seville

TUNISIA

MOROCCO

ALGERIA

LIBYA

EGYPT

WESTERN SAHARA

A F R I C A

MAURITANIA

NIGER

CHAD

SUDAN

MALI

Dakar• SENEGAL

•Djenne-Jeno

GAMBIA

GUINEA-BISSAU

Bissau•

•Bamako

BURKINA
FASO

BENIN

NIGERIA

•Oyo-Ile

•Ilorin •Ile-Ife

•Oshogbo

CENTRAL AFRICAN
REPUBLIC

GUINEA

Kawara•

Ketu•

Ibadan•

SIERRA LEONE

COTE
D'IVOIRE

GHANA

Kumasi•

Lome•

LIBERIA

Accra•

TOGO

•Lagos •Benin City

•Porto Novo

Calabar•

•Mamfe

CAMEROON

Gbayanga•

Ituri Forest

Isiro•

CONGO

GABON

•Brazzaville

ZAIRE

•Kinshasa

Loango•

Pointe Noire•

Mbanza Kongo•

Luanda•

ANGOLA

Benguela•

ZAMBIA

ZIMBABWE

•Khami

NAMIBIA

BOTSWANA

•Windhoek

Johannesburg•

SWAZILAND

Drakensberg Mts.

SOUTH AFRICA

LESOTHO

A T L A N T I C O C E A N

Notes to "Overture: The Concept 'Altar'" pp. 19–32.

1. *The Shorter Oxford English Dictionary*, prepared by William Little, H. W. Fowler, and Jessie Coulso, Third Edition, II vols. (Oxford: Clarendon Press, 1973), 1:53.
2. See Sheila Rule, "Folklorist Offers Insight into Cultural Connections," *The New York Times* (4 July 1992), p. 14.
3. Richard Price, *Alabi's World* (Baltimore: The Johns Hopkins University Press, 1990), p. 372. Price is alluding here to the Saamaka religion, but the point applies to all of the religions embraced in the present text on Afro-Atlantic spirituality.
4. See Robert Farris Thompson, *The Four Moments of the Sun* (New Haven: Eastern Press Inc., 1981).
5. From an interview with Alejo Carpentier during his visit to Yale University, March 1979. He told me he learned this legend when thrown in prison with Abakuá members in his youth.
6. See Lydia Cabrera, *El Monte*, 1954 (fifth edition Miami: Ultra Graphics Corporation, 1983), illustration 54 of an unnumbered series of plates at the back of the volume.
7. See ibid., illustration 7.
8. See Gary Edwards and John Mason, *Onje Fun Orisa*, second edition (New York: Yoruba Theological Archministry, 1987), p. 69.
9. Price, *The Guiana Maroons: A Historical and Bibliographic Introduction* (Baltimore: The Johns Hopkins University Press, 1976), pp. 13–14.
10. R. E. Dennett, *Seven Years among the Fjort* (London: Sampson Low, Marston, Searle, & Rivington, 1887), facing p. 105, pp. 177–179.
11. Karl Edward Laman, *Dictionnaire Kikongo-Francais: M-Z*, 1936 (reprint ed. Hants: Gregg Press, 1964), p. 580.
12. Labelle Prussin, *Hatumere: Islamic Design in West Africa* (Berkeley: University of California Press, 1986), fig. 3.9a.
13. See Pamela McClosky, *Praise Poems: The Katherine White Collection* (Seattle: The Seattle Art Museum, 1984), fig. 4.
14. Prussin, plate 14.
15. H. U. E. Thoden van Velzen and W. van Wetering, *The Great Father and the Danger* (Leiden: KITLV Press, 1991), p. 20 ff. Antoon Dociie and Jan Voorhoeve, in *De Saramakaanse Woordenschat* (Amsterdam: Bureau voor Taalonderzoek in Suriname van de Universiteit van Amsterdam, 1963), give *faáka* (p. 30) and *páu* (p. 85), but curiously do not combine them in a standard phrase for altar, *faáka páu*, the existence of which I confirmed in conversation with Price in 1972 and in the field in Asindoopo, capital of the Saamaka, in December 1978.
16. From an interview with *Gaanman* Gazon Matoja, paramount chief of the Ndjuká, in Dii Tabiki, the Ndjuká capital, Suriname, December 1981.
17. Dominique Malaquais, "Towards an Understanding of the Afro-Atlantic Altar," unpublished manuscript, Yale University, 1984, p. 1.
18. *The Shorter Oxford English Dictionary*, p. 53.
19. Ibid.
20. Ibid.
21. John Hollander, personal communication with the author, 1993.
22. I am endebted to Hollander for bringing this poem to my attention.
23. Hollander, *Vision and Resonance* (New York: Oxford University Press, 1975), p. 264.
24. Ignazio M. Calabuig, O.S.M., *The Dedication of a Church and an Altar: A Theological Commentary* (Washington D.C.: International Committee on English in the Liturgy, 1978), p. 25.
25. Father Baranowski, personal communication with the author, 1993.
26. Laman, p. 574.
27. John Szwed, "Vibrational Affinities," *The Migrations of Meaning* (New York: Intar Gallery, 1992), p. 59. For a recent summary of Grey Gundaker's and my own research into these matters, see my "The Song That Named the Land," in Robert V. Rozelle, Alvia Wardlaw, and Maureen A. McKenna, eds., *Black Art: Ancestral Legacy* (Dallas: Dallas Museum of Art, 1989), pp. 123–124.
28. See Babatunde Lawal, paper delivered at College Art Association annual meeting, Washington, D.C., 1991.
29. Lawal, personal communication with the author, 1991.
30. Ibid.
31. John Mason, personal communication with the author, 1989.

Notes to "Tree, Stone, Fire, and Blood: Dawn of the Black Atlantic Altar," pp. 33–46.

1. In this volume I use "Pygmy" to stand for all forest foragers from northeast Zaire to scattered groups in Gabon and Cameroon. I use "San" to replace the earlier term "Bushman."
2. John E. Yellen and Richard B. Lee, "The Dobe-/Duda/da Environment," in Richard B. Lee and Irven DeVore, eds., *Kalahari Hunter-Gatherers: Studies of the !Kung, San, and Their Neighbors* (Cambridge, Mass.: Harvard University Press, 1976), p. 38.
3. Barry S. Hewlett, *Intimate Fathers: The Nature and Context of Aka Pygmy Paternal Infant Care* (Ann Arbor: The University of Michigan Press, 1991), p. 156.
4. Alan Lomax, personal communication with the author, New York City, 1978.
5. Luigi Luca Cavalli-Sforza, ed., *African Pygmies* (New York: Academic Press, 1986), p. 365.
6. J. D. Lewis-Williams and T. A. Dowson, *Rock Paintings of the Natal Drakensberg* (Pietermaritzburg: University of Natal Press, Ukhalamba Series, 1992), p. 18.

7. For more on the Koroca, see George Peter Murdock, *Africa: Its Peoples and Their Culture History* (New York: McGraw-Hill, 1959), p. 53–54: "This isolated group in coastal Angola, numbering about 15,000, comprise the Luheka (Valuheke) on the seacoast, the Zorotua (Vasorontu) on the edge of the [Kalahari] and the Kwise (Bacuisso, Moquisse, Vakuise) in the mountain foothills." I thank Daniel Dawson for bringing this research to my attention. As to the Southern Bantu blood types, I am grateful to Dawson again for bringing to my attention the work in this field by Dr. Patricia A. Fraser, M.D., director of pediatric rheumatology at Brigham and Women's Hospital, Boston, and to Fraser herself for sharing with me unpublished data in a personal communication, summer 1993.
8. Lewis-Williams and Dowson, p. 18.
9. *Yeyi adye eboka baitu; a kaba yoma*. Robert Farris Thompson and Serge Bahuchet, *Pygmées?* (Paris: Dapper Museum, 1991), p. 52.
10. See Colin M. Turnbull, "The *Molimo*: A Men's Religious Association among the Ituri BaMbuti," *Zaire* 14(4) (1960), pp. 307–340, fig. 47; and Bahuchet and Guy Phillipart de Foy, *Pygmées: Peuple de la forêt* (Paris: Editions Denoel, 1991), pp. 89–93. According to Hewlett, Dzengi's dance is organized and directed by the *tuma*, "the great hunter." See Hewlett, pp. 30–31. As to Ejengi and his lair (*janga*), see Louis Sarno, *Song from the Forest: My Life among the Ba-Bnjelle Pygmies* (Boston: Houghton Mifflin Co., 1993), pp. 238–244.
11. Hewlett, p. 31.
12. Sarno, pp. 35–36.
13. See Wilhelm Dupré, *Religion in Primitive Cultures* (Paris: Mouton, 1970), pp. 153–154, and Bahuchet and de Foy, p. 90.
14. Dupré, p. 153.
15. Ibid., p. 154.
16. Ibid.
17. Turnbull, "The Mbuti Pygmies: An Ethnographic Survey," *Anthropological Papers of the American Museum of Natural History* 50(3), 1965, p. 236.
18. Turnbull, *The Forest People: Studies of the People of the Congo* (New York: Simon & Schuster/Touchstone, 1961), p. 98.
19. Bahuchet, personal communication with the author, 1993.
20. For an excellent ethnographic introduction to the San and their culture see Lee and DeVore.
21. Lee, "Trance Cure of the !Kung Bushmen," *Natural History* (November 1967), p. 33 ff.
22. Lorna Marshall, "The Medicine Dance of the !Kung Bushmen," *Africa* 39(4) (1969), p. 368.
23. Marshall, "!Kung Bushman Religious Beliefs," *Africa* 32(3) (1962), p. 251.
24. Ibid.
25. Ibid., p. 249.
26. Ibid., p. 251.
27. Marshall, "The Medicine Dance of the !Kung Bushmen." In *Africa* 39(4) (1969), p. 352.
28. Lewis-Williams, *Discovering Southern African Art* (Johannesburg: David Philip, 1990), p. 30.
29. Ibid., p. 53.
30. Marshall, "The Medicine Dance," p. 30.
31. O. Kohler, "Ritual Hunt among the Kxoe-San of Mutsiku," in Brigitte Steinfort and Margret Stobberg, eds., *Festschrift Zum 65. Geburtstag Von Helmut Petri* (Vienna: Bohlau Verlag, 1973), see plate 3 and legend facing p. 24.
32. Lewis-Williams and Dowson, p. 16.
33. Lewis-Williams, personal communication with the author, September 1992.
34. It is important to note, as Professor Lewis-Williams kindly points out (ibid.), that "some of the most densely painted shelters are not near the top of the escarpment, where, owing to the geology, there are in fact very few shelters. Rather, many (not all) densely painted shelters are tucked away, down in little valleys where they have practically no view."
35. Lewis-Williams and Dowson, "Through the Veil: San Rock Paintings and the Rock Face," *South African Archaeological Bulletin* 45 (1990), p. 14.
36. Patricia Vinnicombe, "The Ritual Significance of Eland (*Taurotragus oryx*) in the Rock Art of Southern Africa," *Valcamonica Symposium '72: Actes du Symposium Internationale sur les Réligions de la Préhistoire* (Capodiponte: ed. del Centro, 1975), p. 395.
37. Lewis-Williams and Dowson, "Through the Veil," pp. 7–8.
38. Ibid., p. 15.
39. Ibid.
40. Ibid., p. 14.

Notes to "A Chart for the Soul: The Kongo Atlantic Altar," pp. 47–108.

1. Karl Edward Laman, *The Kongo* (Uppsala, Sweden: Studio Ethnographica Upsaliensia XII, 1962), p. 217.
2. K. Kia Bunseki Fu-Kiau, personal communication with the author, March 1993.
3. Ibid.
4. Efraim Andersson, *Messianic Popular Movements in the Lower Congo* (Uppsala, Sweden: Studio Ethnographica Upsaliensia XIV, 1958), p. 162.
5. See Marie-Claude Dupré, "Apropos d'un masque Teke de l'ouest Congo," *Objets et*

Mondes 8(4) (1968), and "*Apropos du masque Teke de la collection Barbier,*" *Connaissance des arts tribaux: Bulletin du Musée Barbier-Muller* 2 (1979).

6. John Thornton, *Africa and Africans in the Making of the Atlantic World, 1400–1680* (Cambridge: at the University Press, 1992), pp. 183–205.

7. Lydia Cabrera, *Vocabulario Congo (El Bantu que se habla in Cuba)* (Miami: Daytona Press, 1984), p. 43.

8. Sterling Stuckey, *Slave Culture: Nationalist Theory and the Foundations of Black America* (New York: Oxford University Press, 1987), p. 11.

9. Wyatt McGaffey, *Religion and Society in Central Africa. The Bakongo of Lower Zaire* (Chicago: at the University Press, 1986), p. 161.

10. McGaffey, *Astonishment and Power. The Eyes of Understanding: Kongo Minkisi* (Washington, D.C.: The National Museum of African Art, Smithsonian Institution, 1993), p. 83.

11. Fu-Kiau, personal communication with the author, February 1993.

12. McGaffey, *Art and Healing of the Bakongo Commented by Themselves: Minkisi from the Laman Collection* (Stockholm: Folkensmuseum Etnografiska, 1991), p. 53. For information on the Annapolis research, see George C. Logan, Thomas W. Boder, Lynn D. Jones, et al., and Principal Investigator Dr. Mark P. Leone, *1991 Archaeological Excavations at the Charles Carroll House in Annapolis, Maryland* (College Park: University of Maryland, 1992).

13. Mark Twain, *The Adventures of Huckleberry Finn*, 1884 (reprint ed. New York: Simon and Schuster, Inc., 1973), p. 9.

14. Shelley Fisher Fishkin, *Was Huck Black?* (New York: Mark Twain and Oxford University Press, 1993).

15. Ralph Ellison, *Invisible Man* (New York: Random House, Inc., 1947), p. 206.

16. Newbell Niles Puckett, *Folk Beliefs of the Southern Negro* (Chapel Hill: University of North Carolina Press, 1926), p. 288.

17. Grey Gundaker, personal communication with the author, spring 1993.

18. Informant quoted in Cabrera, *Reglas de Congo Palo Monte Mayombe* (Miami: Peninsular Printing, Inc., 1979), p. 15.

19. Ibid., p. 24.

20. Fernando Ortiz, *Hampa Afro-Cubana: Los Negros Brujos* (Madrid: Editorial America, 1906), p. 184.

21. Ibid., p. 251.

22. Cino Colina, "*La Regla de Palo Monte,*" *Granma* (26 August 1990), p. 12.

23. Ibid.

24. David Hilary Brown, personal communication with the author, May 1993.

25. Cabrera, *Vocabulario Congo*, p. 44.

26. McGaffey, *Astonishment and Power*, p. 95.

27. Ibid., p. 61.

28. Felipe García Villamil, personal communication with the author, 1993.

29. Informant quoted in Cabrera, *Reglas de Congo*, p. 59.

30. Fu-Kiau, personal communication with the author, November 1992.

31. Rafael L. López Váldez, *Componentes Africanos en el Etnos Cubano* (Havana: Editorial de Ciencias Sociales, 1985), p. 114.

32. Karl Edward Laman, *Dictionnaire Kikongo-Francais: M-Z*, 1936 (reprint ed. Hants: Gregg Press, 1964), p. 963.

33. Zoë Strother, personal communication with the author, June 1993.

34. Clodomir Menezes da Silva, personal communication with the author, summer 1986.

35. Olga Gudolle Cacciatore, *Dicionario da Cultos Afro-Brasileiros* (Rio de Janeiro: Forense Universitaria/SEEC-RJ, 1977), p. 235.

36. See John Janzen, *Lemba, 1650-1930. A Drum of Affliction in Africa and the New World* (New York: Garland Publishing, Inc., 1982), p. 3.

37. Valdina Pinho, "*O M'kisi Teempu: Festa de Teempu no Tanuri Junçara,*" in *Seminario "Reflexao sobre a Atualidad da Cultura Afro-Braziliera"* (a pamphlet published in Salvador, August 1985), p. 4.

38. Documented by the author during fieldwork in Rio de Janeiro, December 1985.

39. Olfert Dapper, *Description de l'Afrique*, 1668 (reprint ed. Paris: Fondation Dapper, 1990), pp. 241-263.

40. Ibid., p. 263.

41. E.g. ibid., pp. 250, 261.

42. Gundaker, "African American History, Cosmology, and the Moral Universe of Edward Houston's Yard," unpublished paper, 1993, p. 21.

43. Angelika Kruger-Kahloula, personal communication with the author, 1983.

44. Mark Leone, personal communication with the author, May 1993.

45. James Weldon Johnson, *Black Manhattan* (New York: Da Capo Press, Inc., 1930), p. 4.

46. Albert Raboteau, *Slave Religion* (New York: Oxford University Press, 1978), p. 66.

47. Daniel Dawson, personal communication with the author, 1993.

48. Paul Radin, *God Struck Me Dead: Religious Conversion Experiences and Autobiographies of Ex-Slaves* (Nashville: Fisk University, 1945), p. 18.

49. Raboteau, p. 163.

50. Radin, p. vi.

51. Theodore Ford, *God Wills the Negro* (Chicago: Geographia Institute Press, 1939), p. 72.

52. Raboteau, p. 68.

53. Leland Ferguson, personal communication with the author, June 1993.

54. Fu-Kiau, personal communication with the author, March 1992.

55. Fu-Kiau, personal communication with the author, March 1993.

56. Ibid.

57. Radin, pp. 8–9.

58. Ibid., p. 32.

59. Raboteau, p. 215.

60. Harriet Jacobs, *Incidents in the Life of a Slave Girl*, 1861 (reprint ed. Miami: Mnemosyne Publishing Co., 1969), p. 138.

61. Joseph van Wing, "Bakongo Incantations and Prayers," *Journal of the Royal Anthropology Institute* LX (1930), p. 416ff.

62. Shirley Ann Grau, "Margaret," *The Keepers of the House* (New York: Alfred A. Knopf, 1964), p. 101.

63. John Nunley, personal communication with the author, May 1993

64. Ibid.

65. Lyle Saxon et al., *Gumbo Yaya* (New York: Bonanza Books, 1945), pp. 542–543.

66. Ramona Austin, personal communication with the author, May 1993.

67. Mary Granger, *Drums and Shadows* (Athens: University of Georgia Press, 1940), pp. 20–21.

68. Alvia Wardlaw, personal communication with the author, October 1992.

69. Miles Davis, in Rashied Ali, personal communication with the author, New York City, winter 1989.

70. Gundaker, p. 1.

71. Ibid., pp. 7–8.

72. Ibid., pp. 18–19.

73. Robert Farris Thompson, *The Four Moments of the Sun* (New Haven: Eastern Press, Inc., 1981), pp. 146–147.

74. Gundaker, "Tradition and Innovation in African American Yards" *African Arts* XXVI(2) (April 1993), p. 61.

75. Diane deG. Brown, *Umbanda: Religion and Politics in Urban Brazil* (Ann Arbor: UMI Research, 1986), p. 39.

76. Ibid, p. 73.

77. Helena Theodoro Lopes, "Umbanda and Other Religions of Bantu Origin in Rio de Janeiro," in *African Cultures: Proceedings of the Meeting of Experts on the Survival of African Religious Traditions in the Caribbean and in Latin America* (Sao Luis de Maranhao: UNESCO, 1985), pp. 24–28.

78. Dona Julia, personal communication with the author, Rio de Janeiro, 24 December 1985.

79. McGaffey, *Astonishment and Power*, p. 33.

80. Fu-Kiau, personal communication with the author, 1993.

Notes to "The Face of the Past: Staff Shrines and Flag Altars," pp. 109–144.

I wish to thank Ken Bilby heartily for his very close reading of this chapter. His comments on orthography and ethnographic detail were invaluable, as were the most helpful comments of Richard Price.

1. Susan and Roderick McIntosh, "Finding West Africa's Oldest City," *National Geographic* 162(3) (September 1982), p. 398.

2. Bernard de Grunne, "Ancient Art of the Niger River: A Study of the Terra-Cotta Statuary from the Inland Niger in Mali," unpublished Ph.D. thesis, Yale University, New Haven, 1986, pp. 89–90.

3. Al-Bekri, quoted in Nehemia Levtzion, *Ancient Ghana and Mali* (New York: Africana Publishing Co., 1980), p. 25.

4. McIntosh and McIntosh, p. 411.

5. Charles Monteil, *Djénné Société Metropole du Delta Central du Niger*, 1903 (reprint ed. Paris: Société d'Éditions Géographiques, 1932), p. 136.

6. De Grunne, n.p. (front matter).

7. Ibid., p. 57.

8. Mama Kontao, quoted in ibid., p. 89.

9. Ibid., p. 91.

10. Labelle Prussin, "The Architecture of Djenne: African Synthesis and Transformation," unpublished Ph.D thesis, Yale University, New Haven, 1973, p. 179.

11. See de Grunne for further discussion of Bankoni style, pp. 158–159.

12. Ibid., p. 135.

13. Dominique Zahan, *Sociétés d'initiation bambara* (Paris: Mouton, 1960), p. 209. Translated by the author.

14. Ibid., p. 211.

15. Ibid.

16. Ibid., p. 89.

17. R. S. Rattray, *Religion and Art in Ashanti* (Oxford: Clarendon Press, 1927), p. 2.

18. Ibid., p. 3.

19. Eva L. R. Meyerowitz, *The Akan of Ghana: Their Ancient Beliefs* (London: Faber and Faber Ltd., 1958), p. 58.

20. P. Knops, *Les Anciens Senufo: 1923–1935* (Berg en Dal: Afrika Museum, 1980), p. 77.

21. Prussin, *Hatumere: Islamic Design in West Africa* (Berkeley: University of California Press, 1986), p. 69.

22. Ibid., p. 235.

23. Malcolm D. McLeod, *The Asante* (London: British Museum Publications, Ltd., 1981), pp. 57–58.

24. De Grunne, p. 17.
25. Maurice Delafosse, in Prussin, "The Architecture of Djenné," p. 193.
26. Prussin, ibid., pp. 173–174.
27. Ibid., p. 178.
28. M. Be Sao, quoted in ibid., p. 197.
29. Quoted in Richard Price, *Alabi's World* (Baltimore: The Johns Hopkins University Press, 1990), p. 123.
30. Richard Price, *The Guiana Maroons: A Historical and Bibliographic Introduction* (Baltimore: The Johns Hopkins University Press, 1976).
31. Philip Curtin, personal communication to Price, cited in ibid., p. 15, note 9.
32. Price, ibid.
33. Ibid., p. 19.
34. See ibid., p. 161.
35. Rattray, cf. pp. 53 and 74.
36. Silvia de Groot, "Migratory Movements of the Djukas," *Isolation Towards Integration* (The Hague: Martinus Nijhoff, 1977), p. 88.
37. Ibid., p. 98.
38. H. U. E. Thoden van Velzen and W. van Wetering, *The Great Father and the Danger* (Leiden: KITLV Press, 1991), p. 13.
39. Richard Price, *First-Time. The Historical Vision of an Afro-American People* (Baltimore: The John Hopkins University Press, 1983), p. 102.
40. Richard Price, *To Slay the Hydra. Dutch Colonial Perspectives on the Saramaka Wars* (Ann Arbor: Karoma Publishers Inc., 1983, p. 230.
41. Thoden van Velzen and van Wetering, p. 45.
42. Marcel Chatillon, personal communication with the author, August 1992.
43. John Gabriel Stedman, *Narrative of a Five Years Expedition against the Revolted Negroes of Surinam*, 1790 (reprint ed. Baltimore: The John Hopkins University Press, 1988), p. 520.
44. Melville J. and Frances S. Herskovits, *Rebel Destiny* (York: The Maple Press Co., 1934), p. 150.
45. Thoden van Velzen and van Wetering, p. 54.
46. Morton C. Kahn, *Djuka: The Bush Negroes of Dutch Guiana* (New York: Viking Press, 1931), p. 144.
47. K. Martin, *Bijdragen tot de Taal Land en Volkenkunde van Nederlandsch-Indie* ('S Gravenhage: Martinus Nijhoff, 1886), see plate 3, facing p. 76. Translated by the author.
48. Herskovits and Herskovits, p. 162.
49. Sally Price, *Co-Wives and Calabashes* (Ann Arbor: The University of Michigan Press, 1984), p. 90.
50. Richard Price, personal communication with the author, 1979.
51. Herskovits and Herskovits, p. 240.
52. Martin, plate 2.
53. C. H. de Goeje, *Verslag der Toemoekhoemak - expedite* (Leiden: Tijdschrift van het Koninklijk Nederlandsch Aardrijkskundg Ganootschap, 1908), p. 5.
54. Richard Price, *First-Time*, p. 5.
55. Ibid., p. 6.
56. Stedman, p. 537; Thoden van Velzen and van Wetering, p. 183.
57. Richard Price, *First-Time*, p. 110.
58. Martin, p. 35.
59. K. Kia Bunseki Fu-Kiau, personal communication with the author, 1993.
60. Stedman, p. 84.
61. Johannes King, quoted in Richard Price, *Maroon Societies: Rebel Slave Communities in the Americas*, second edition (Baltimore: The Johns Hopkins University Press, 1979), pp. 302–303.
62. Ibid., p. 303.
63. Fu-Kiau, personal communication with the author, summer 1982.
64. Fu-Kiau, personal communication with the author, winter 1985.
65. John Womack Vandercook, *Tom-Tom* (New York: Harper and Brothers, 1926), p.77.
66. Herskovits and Herskovits, p. 80.
67. P. J. Benoit, *Journey through Suriname: Description of the Possessions of the Netherlands in Guiana. Adapted from Voyages à Surinam de P. J. Benoit*, 1839 (reprint ed. Zutphen: De Valburg Press, 1980), plate 36.
68. *Gaanman* Gazon Matoja, personal communication with the author, December 1981.
69. Thoden van Velzen and van Wetering, pp. 45–46.
70. *Gaanman* Gazon Matoja, personal communication with the author, 1981.
71. Ibid.

Notes to "With the Assurance of Infinity: Yoruba Atlantic Altars," pp. 145–282.

1. Aràbà Ekó, personal communication with the author, January 1983.
2. Roland Abiodun, personal communication with the author, May 1993.
3. A. O. Ogunfowora, "Space Concepts and Architecture of Yoruba Shrines," unpublished paper submitted to the Department of Architecture, University of Ifè, Ilé-Ifè, 1988, p. 45.
4. Babatunde Lawal, paper delivered at College Art Association annual meeting, Washington, D.C., 1991.
5. Roland Abiodun, personal communication with the author, March 1993.

6. King Sunny Ade, "*Já fúnmi*," written by King Sunny Ade. Copyright © 1982, 1983 Afrison Ltd. and Clouseau Musique SA. All rights in the United States and Canada administered by Songs of PolyGram International, Inc. Used by permission. All rights reserved. From King Sunny Adé and His African Beats, *Juju Music* (Island Records LP MLPS 9712), side A, band 1 (1982).
7. Sean Barlow, personal communication with the author, June 1993.
8. Abiodun, personal communication with the author, June 1993.
9. Lawal, "The Significance of Yoruba Sculpture," mimeographed paper read at the Conference on Yoruba Civilization, University of Ifè, Ilé-Ifè, 1976, p. 9.
10. Robert A. Levine, *Dreams and Deeds: Achievement Motivation in Nigeria* (Chicago: at the University Press, 1966), p. 89.
11. Henry Drewall, "Ife: Origins of Art and Civilization," in Drewall, John Pemberton III, and Roland Abiodun, *Yoruba: Nine Centuries of African Art and Thought* (New York: The Center for African Art/Harry N. Abrams, 1989), p. 59.
12. Ibid., p. 61.
13. See Robert Farris Thompson, "Divine Countenance: Art and Altars of the Black Atlantic World," in Phyllis Galembo, *Divine Inspiration* (Albuquerque: University of New Mexico Press, 1993), p. 12.
14. Aràbà Ekó, personal communication with the author, January 1983.
15. Sharon Zukin, personal communication with the author, 4 December 1986.
16. John Szwed, personal communication with the author, January 1983.
17. Philip Curtin, personal communication with the author, winter 1972.
18. Pierre Verger, *Flux et Réflux de la traite des Nègres entre le Golfe de Bénin et Bahia de Todos os Santos* (Paris: Mouton, 1968), p. 673.
19. Ibid., p. 8.
20. Gilberto Freyre, *The Masters and the Slaves*, 1933 (reprint ed. Berkeley: University of California Press, 1986), p. 470.
21. Gary Edwards and John Mason, *Onja Fún Orisa: Food for the Gods* (New York: Yoruba Theological Archministry, 1987), pp. 69, 90.
22. Dejo Afolayan, personal communication with the author, March 1988.
23. Richard Burton, quoted in Stanley J. Stein, *Vassouras* (New York: Atheneum, 1970), p. 202.
24. Ibid.
25. Lydia Cabrera, *El Monte* (Havana: CR, 1954), pp. 405–406.
26. Freyre, p. 318.
27. Ibid., p. 474.
28. Wande Abimbola, *Yoruba Oral Tradition* (Ilé-Ifè: University of Ifè, 1975), p. 389.
29. E. Bolaji Idowu, *Olodumare: God in Yoruba Belief* (London: Longman's, 1962), pp. 7–9.
30. Alaperu of Iperu, personal communication with the author, fall 1962.
31. Joseph M. Murphy, "Ritual Systems in Cuban Santeria," unpublished Ph.D. thesis, Temple University, Philadelphia, 1981, pp. 227–228.
32. David H. Brown, "Garden in the Machine: Afro-Cuban Sacred Art and Performance in Urban New Jersey and New York," 2 vols., unpublished Ph.D. thesis, Yale University, 1989, 1:92.
33. Nerys Gómez Abreu, *Estudio de la Casa Templo de Cultura Yoruba: El Ile-Ochatula, Islas* 71 (1982), pp. 113–138.
34. Gisèle Binon Cossard, "*Contribution à l'Étude des Candomblés au Brésil: Le Candomblé Angola*," doctorat de troisième cycle, Sorbonne, Paris, 1970, p. 92.
35. Ibid., p. 37.
36. Ibid., p. 39.
37. Ibid.
38. See ibid., p. 353.
39. J. Lowell Lewis, *Ring of Liberation* (Chicago: at the University Press, 1992), p. 179.
40. Olga Gudolle Cacciatore, *Dicionario da Cultos Afro-Brasileiros* (Rio de Janeiro: Forense Universitária/SEEC-RJ, 1977), p. 190.
41. Cabrera, *Yemayá y Ochún* (Madrid: Forma Gráfica, 1974), p. 177.
42. Ibid., p. 176.
43. Ibid., p. 176.
44. Cf. Brown II:plates 16, 17.
45. See Brown I for a full discussion.
46. Brown II:381.
47. William Bascom, *Ifa Divination* (Bloomington: Indiana University Press, 1969), p. 29.
48. Karl Reisman, "Review," *Journal of African Languages and Linguistics* 5 (1983), p. 81.
49. Cossard, p. 307.
50. Deoscoredes dos Santos, *West African Sacred Art and Rituals in Brazil* (Ibadan: University of Ibadan, mimeographed ms., 1967), p. 28.
51. Aildés Batista Lopes, personal communication with the author, 1990.
52. Brown, II:508.
53. Felipe García Villamil, personal communication with the author, summer 1993.
54. Darius Thieme, *A Descriptive Catalogue of Yoruba Musical Instruments* (Ann Arbor: University Microfilms, 1969), p. 186.
55. John Mason, *Orin Orisa* (New York: Yoruba Theological Archministry, 1992), p. 6.
56. Thieme, p. 195.
57. Mason, p. 12.
58. García Villamil, personal communication with the author, summer 1993.
59. Ibid.

60. Ibid.

61. Thompson, *Flash of the Spirit* (New York: Vintage, 1984), p. 95.

62. This discussion represents a composite of several interviews with Pai Balbino de Paula on the iconography of the Alto da Vila Praiana altar between 1982 and 1985.

63. See Labelle Prussin, "The Architecture of Djenne: African Synthesis and Transformation," unpublished Ph.D. thesis, Yale University, 1973, illustrations 3.23a and 3.23b. Prussin's examples, and they are dramatic ones, are Bobo and Lobi.

64. Joan Wescott, "The Sculpture and Myths of Eshu-Elegba, the Yoruba Trickster: Definition and Interpretation in Yoruba Iconography," *Africa* XXXII(4) (October 1962), p. 338. "The Yoruba of Oyo call this large laterite pillar the 'father of all the other Elegba.'" For Eshu and his art among Igbomina, see John Pemberton III's excellent essay "Eshu-Elegba: The Yoruba Trickster God," *African Arts* 9(1) (October 1975), pp. 20–26, 66–70.

65. Aràbà Ekó, personal communication with the author, January 1983.

66. In a forthcoming article I shall discuss the Bariba-Yoruba connection.

67. Chief M. A. Fabunmi, *Ifè Shrines* (Ifè: University of Ifè Press, 1969), p. 12.

68. Aràbà Ekó, personal communication with the author, January 1983.

69. Thompson, *Flash of the Spirit*, p. 18.

70. Aràbà Ekó, personal communication with the author, 3 January 1983.

71. Ibid.

72. See N. A. Molina, *Na Gira dos Exu* (Rio de Janeiro: Editora Espiritualista Ltda., n.d.), p. 81.

73. Ibid., p. 150.

74. Teixeira Alves Neto, *Pomba-Gira* (Burbank, Ca.: Technicians of the Sacred, 1990), p. 33.

75. The classic text is Sandra T. Barnes, ed., *Africa's Ogun: Old World and New* (Bloomington: Indiana University Press, 1989).

76. Aràbà Ekó, personal communication with the author, 3 January 1983.

77. Emese Oloriidoko, personal communication with the author, Ilé-Ifè, 9 August 1989.

78. Drewall, p. 49.

79. Abiodun, personal communication with the author, Ilé-Ifè, 9 August 1989. Professor Abiodun accompanied me on certain of my field trips at this time. He strongly enriched my comprehension of iconographic problems.

80. Abiodun, personal communication with the author, 21 February 1993.

81. Oloriidoko, personal communication with the author, 9 August 1989.

82. Other accounts include C. H. Elgee, "The Ifè Stone Carvings," *Journal of the Royal African Society* 7 (1907–1908), pp. 338–343; Montserrat Palau Marti, *Le Roi-Dieu au Benin* (Paris: Editions Berger-Levrault, 1964), pp. 164–165; and Drewall.

83. Compare R. I. Ibigbami, "Ogun Festival in Ire-Ekiti," *Nigeria* nos. 126–127 (1978), p. 44: "Because [Ogún] was the first to produce and use iron weapons and is believed immune to their adverse effects people called him 'the god of iron.'"

84. Persons also offer thanksgiving to Ogún after escaping from a motor accident. See Olu Akinyeye, "Ogun–God of Iron," *West Africa* (12 June 1978), p. 1, 127.

85. Barnes, *Ogun: An Old God for a New Age* (Philadelphia: ISHI, 1980), p. 37. Add to this excellent source Jerome O. Ojo, "Yoruba Customs from Ondo," *Acta Ethnologica et Linguistica* no. 37 (1976), p. 62: "Any piece of iron, from a pin to an American limousine, will do as a shrine [for Ogún]."

86. Elijah Adelakun and Basini Laimu, personal communication with the author, Kajola, in Ketu Yoruba territory near Imeko, Nigeria, 19 August 1989. I thank Phyllis Galembo for accompanying me on this field trip, and for excellent photographs of Ogún shrines.

87. Ibid.

88. To restore detail and depth to my drastic abbreviation of the nature of Umbanda, consult Diana DeG. Brown, *Umbanda: Religion and Politics in Urban Brazil* (Ann Arbor: UMI Research Press, 1986), and her bibliography. See also Patricia Birman, *O Que E Umbanda* (São Paulo: Editora Brasilense, 1983).

89. Abiodun, personal communication with the author, Ilé-Ifè, Nigeria, August 1989.

90. Thompson, "The Sign of the Divine King," *African Arts* 3 (1970), pp. 7–8, 74–80.

91. Baba Elerinle of the Ojuto shrine near Ilobu, Nigeria, personal communication with the author, 15 August 1989. His Highness Alhaji Oba A. O. Olaniyan II facilitated research in this region and I thank him heartily. I am also grateful to Abiodun for translating the responses of Baba Elerinle on the banks of Ibú Ojuto, and tracing their nuances.

92. Chief of Epa, Igogo-Editi, summer 1965.

93. Verger, *Oxossi, O Cacador* (Salvador: Editora Corrupio, 1981), n.p. See plates 3 and 4.

94. Pemberton, "A Cluster of Sacred Symbols: Orisa Worship Among the Igbomina Yoruba of Ila-Orangun." In *History of Religions* 17(1) (August 1977), p. 10. Pemberton confirmed the link in a personal communication, spring 1993.

95. Chief Obalala, *Onisoro* Obatálá, personal communication with the author, Ilé-Ifè, Nigeria, 15 August 1989.

96. Ibid.

97. My translation stems from Afolayan, checked against Mason's *Orin Orisa* and Felix Goicochea's unpublished *Libreta de Santo*.

98. Brown, II:369.

99. As documented by the present writer near Olumo Rock in early January 1964.

100. Mason, p. 81.

101. Reading the brambles as snare and forest is my own interpretation but is based on convergence with the lore of the Yoruba of the Americas. Baba Olorisa Oshóòsi himself said, at Imeko on 18 August 1989, that brambles were Oshóòsi's dress (*aso*), which he wore to "make clear to the people the powers that he possesses."

102. Mason, p. 50, note 29.

103. Aildés Batista Lopes, personal communication with the author, January 1991.

104. As documented by the present writer in Matatu, Bahia, in the summers of 1985, 1986, 1987, and 1988.

105. I thank Daniel Dawson for bringing this unpublished aspect of Valdina Pinho's research to my attention.

106. See Carmem Ribeiro, "Religiosidade do Indio Brasileiro no Candomblé da Bahia," *Afro-Asia* no. 14 (1983), p. 64.

107. Pai Balbino, personal communication with the author, 1982.

108. Cf. Jocelio Teles dos Santos, "O caboclo no candomblé," *Pade* vol. I (June 1989), pp. 10–21.

109. For the legends of Oya see Verger, *Légendes des Orichas* (Salvador: Editora Corrupio, 1981), pp. 44–48.

110. Ibid., p. 48.

111. Verger, *Notes sur le Culte des Orisa et Vodun à Bahia, la Baie de Tous les Saints au Brésil, et à l'Ancienne Côte des Esclaves en Afrique* (Dakar: IFAN, 1957), p. 403.

112. Ibid.

113. Judith Gleason, *Oya: In Praise of the Goddess* (Boston: Shambhala Publications, 1987), p. 22.

114. Ibid., p. 142.

115. Ibid.

116. Oloye Fela Sowande and Oloye Fagbemi Ajanaku, *Oruko Amutorunwa* (Ibadan: Oxford University Press, 1969), p. 59.

117. Verger, *Notes sur le Culte des Orisa*, pp. 414–415.

118. Ibid., p. 415.

119. Ibid., pp. 417–418.

120. Ibid., pp. 419–420.

121. Mason, pp. 321–335.

122. Henry and Margaret Drewall, "More Powerful Than Each Other: An Egbado Classification of Egúngún," *African Arts* XI(3) (April 1978), p. 585.

123. R. C. Abraham, *Dictionary of Modern Yoruba* (London: at the University Press, 1958), p. 585.

124. Drewall and Drewall, p. 30.

125. Sowande and Ajanaku, p. 59.

126. Gleason, p. 89.

127. Norma Wolff, "Egungun Costuming in Abeokuta," *African Arts* 15(3) (May 1982), pp. 66–67.

128. Mikelle Smith Omari, "The Role of the Gods in Afro-Brazilian Ancestral Ritual," *African Arts* 23(1) (January 1989), p. 57.

129. Deoscoredes dos Santos, "O Culto dos Ancestrais na Bahia: O culto dos Egun," *Oloorisa: Escritos sobre a religao dos orixas* (Sao Paulo: Agora, 1981), p. 159.

130. Verger, *Dieux d'Afrique* (Paris: Paul Hartmann, 1954), plate 158.

131. See Roger Bastide, *Le Candomblé de Bahia (Rite Nago)* (Paris: Mouton, 1958), p. 125.

132. Ibid., p. 123.

133. Omari, pp. 58–59.

134. Drewall and Drewall, p. 16.

135. Marc Schiltz, "Egungun Masquerades in Iganna," *African Arts* 11(3) (April 1978), p. 77.

136. See S. O. Babayemi, *Egúngún Among the Oyo Yoruba* (Ibadan: Board Publications Ltd., 1980).

137. Omari, p. 59.

138. Lydia González Huguet, "Domestic Altars in Yoruba-Cuban Worship," *Etnologia y Folklore* no. 5 (1961), p. 39.

139. Carl M. Hunt, *Oyotunji Village: The Yoruba Movement in America* (Washington, D.C.: University Press of America, 1979), unnumbered acknowledgment page.

140. Carlos Roberto Bautista da Rocha, personal communication with the author, winter 1990.

141. Verger, *Dieux d'Afrique*, plate 59.

142. Gutenberg, personal communication with the author, November 1989.

143. Ibid.

144. See Cabrera, *El Monte*, pp. 510–511.

145. Verger, *Notes sur le Culte des Orisa*, p. 408.

146. Ibid.

147. Ibid., p. 422ff.

148. Aràbà Ekó, personal communication with the author, January 1983.

149. Ibid.

150. Mason, p. 337ff.

151. Ibid., p. 366.

152. Verger, *Notes sur le Culte des Orisa*, pp. 434–435.

153. In a conversation with me in 1984, Verger told me, "Cosme is now dead; his *terreiro* off Vasco de Gama is no more, it's just a marsh."

154. Clodomir da Silva, personal communication with the author, 1986.

155. Aràbà Ekó, personal communication with the author, January 1972.

156. Aràbà Ekó, personal communication with the author, January 1983.

157. Abiodun, personal communication with the author, winter 1992.

158. Bautista de Rocha, personal communication with the author, January 1990.

159. Cacciatore, pp. 140–141.
160. Aràbà Ekó, personal communication with the author, January 1972.
161. Verger, *Orisha: Les Dieux Yoruba en Afrique et au Nouveau Monde* (Paris: Editions Métailié, 1982), p. 210.
162. Verger, *Notes sur le Culte des Orisa*, pp. 264–265.
163. Raymond Prince, "The Problem of Spirit Possession as a Treatment for Psychiatric Disorders," *Ethos* 2(4) (1974), p. 318.
164. Modupe Odudoye, *The Vocabulary of Yoruba Religious Discourse* (Ibadan: Daystar Press, 1971), p. 127.
165. Pai Balbino, personal communication with the author, August 1984.
166. Ibid.
167. Verger, *Notes sur le Culte des Orisa*, pp. 282–289.
168. Ibid., p. 290.
169. Mason, pp. 266–267.
170. Verger, *Notes sur le Culte des Orisa*, p. 277. Verger is quoting the report of Count von Zech, from 1898.
171. Chief-Priest of Buku, personal communication with the author, Dassa-Zoume, May 1963.
172. G. Parrinder, *West African Religion* (London: Epworth Press, 1961), pp. 28–29.
173. Deoscoredes dos Santos, *West African Sacred Art and Rituals in Brazil*, p. 60.
174. Aràbà Ekó, personal communications with the author, January 1972 and January 1983.
175. Cabrera, *El Monte*, p. 460.
176. Paul Mercier, "The Fon of Dahomey," *African Worlds* (London: Oxford University Press, 1954), p. 212.
177. Ibid., pp. 212–214.
178. Verger, *Notes sur le Culte des Orisa*, pp. 237–238.
179. Samuel Johnson, *The History of the Yorubas* (London: Routledge & Kegan, 1920), p. 34.
180. Lawal, *Yoruba Shangó Sculpture in Historical Retrospect* (Ann Arbor: University Microfilms, 1970), p. 37.
181. Verger, *Notes sur le Culte des Orisa*, pp. 342–381.
182. For the links between Shangó and Obatálá, see Verger, *Légendes des Orichas*, 1982.
183. Cabrera, *El Monte*, p. 78.
184. Frank Willett, *African Art* (New York: Praeger, 1971), p. 105.
185. Leo Frobenius, *The Voice of Africa*, 1913 (reprint ed. New York: Benjamin Blum, 1968) I:4.
186. Aràbà Ekó, personal communication with the author, January 1972.
187. Thompson, *Black Gods and Kings* (Los Angeles: UCLA Museum of Ethnic Arts, 1971), p. 12/4.
188. Ibid.
189. Ibid.
190. Verger, *Notes sur le Culte des Orisa*, p. 343: *orí ose li ó gún lo*.
191. Oluwuro Adeshina, personal communication with the author, 4 December 1963.
192. Verger, *Notes sur le Culte des Orisa*, p. 383.
193. Eziza, personal communication with the author, Benin City, 23 August 1989.
194. Abelardo Duarte, *Catálogo Ilustrado da Coleçao Perseverança* (Maceió: Departamento de Assuntos Culturais da Secretaria de Cultura de Algoas, 1974), p. 12.
195. Fernando Ortiz, *Hampa Afro-Cubana: Los Negros Brujos* (Madrid: Editorial America, 1906), p. 58.
196. Ibid., p. 140.
197. Ibid., p. 58.
198. Brown, II:566.
199. Drewal, p. 27.
200. Araba Ekó, personal communication with the author, 1972.
201. Mason, personal communication with the author, June 1993.
202. Ibid.
203. Verger, *Notes sur le Culte des Orisa*, p. 398.
204. Ibid.
205. Mason, pp. 164–165.
206. Mason, p. 158.
207. Mason, personal communication with the author, June 1993.
208. Gleason, p. 90.
209. Duarte, p. 19.
210. Ibid., pp. 15, 19.
211. Carybé, *Iconografia dos Deuses Africanos no candomblé da Bahia* (São Paulo: Editora Raizes Artes Graficas, 1980), p. 159.
212. Mitchell Crenin and Louis G. Keith, "The Yoruba Contributions to Our Understanding of the Twinning Process," *The Journal of Reproductive Medicine* 34(6) (June 1989), p. 380.
213. Lawal, "A Pair of *Ere Ibeji*," *Kresge Art Museum Bulletin* IV (1989), p. 12.
214. T. J. H. Chappell, "The Yoruba Cult of Twins in Historical Perspective," *Africa* 144 (1974), p. 259.
215. Afolayan, personal communication with the author, 1988.
216. Ibid.
217. Ortiz, p. 74.
218. Ibid, p. 107.

219. Bascom, "The Yoruba in Cuba," *Nigeria* 37 (1951), p. 51.
220. K. Kia Bunseki Fu-Kiau, personal communication with the author, 1988.
221. Odorico Tavares, *Bahia: Imagens da Terra e do Povo* (Rio de Janeiro: Technoprint Grafica, 1967), p. 155.
222. Ibid.
223. Verger, *Notes sur le Culte des Orisa*, p. 466ff.
224. Brian Wilson and Mason, personal communications with the author, spring 1993.
225. Idowu, p. 73.
226. Verger, *Légendes des Orichas*, p. 68.
227. Idowu, p. 34.
228. Cabrera, *El Monte*, p. 55.
229. Cited in my presence by the Alaperu of Iperu, October 1962. Denis Williams collected a similar prayer from Ogboni sources.
230. Dizzy Gillespie Orchestra, *Dizzier and Dizzier* (Victor LP LJM-1009), side 2, band 2.
231. Tito Puente, *Top Percussion* (RCA Victor LPM-1617, 1958), side 1, band 5.
232. Verger, *Légendes des Orichas*, pp. 59–60.
233. See Mason, pp. 299–318.
234. Verger, *Notes sur le Culte des Orisa*, p. 299.
235. Mason, p. 286.
236. Alejo Carpentier, "Los Altares de la Caridad," *Islas* 10(1) (1968), p. 224.
237. See Gert Chesi, *Vodun: Africa's Secret Power* (Wörgl: Perlinger, 1981) p. 205.
238. Bautista de Rocha, personal communication with the author, January 1990.

Notes to "Envoi: The Place of Belief and the Site of Transformation," pp. 283–306.

1. Mircea Eliade, *The Sacred and the Profane* (New York: Harcourt, Brace, Jovanovich, 1959), p. 149.
2. Ken Bilby, personal communication with the author, 7 June 1993.
3. The *figa* was all over the ancient Mediterranean, including Egypt (in the Roman period) and Pompeii, and endures in more recent times. It traveled to Brazil via Portugal; indeed, *figa* is its Portuguese name. See Liselotte Hansmann and Lenz Kriss-Rettenbeck, *Amulett und Talisman: Erscheinungsform und Geschichte* (Munich: Verlag Georg D. W. Callwey, 1966), pp. 200–201.
4. See Wallace Stevens, *The Palm at the End of the Mind* (New York: Vintage, 1971), pp. 102–109. The first stanza of this poem, inspired by an African-American cemetery, is eerily Kongo in resonance:
 In the far South the sun of autumn is passing
 Like Walt Whitman walking along a ruddy shore
 He is singing and chanting the things that are part of him
 The worlds that were and will be, death and day
 Nothing is final, he chants. No man shall see the end. . . .
5. Gyp Packnett, personal communication with the author, July 1993.
6. Grey Gundaker, personal communication with the author, 23 June 1993.
7. Compare Ki-Kongo *mpeeve*, defined as "flag, wind, spirit" in Karl Edward Laman, *Dictionnaire Kikongo-Francais: M-Z*, 1964 (reprint ed. Hants: Gregg Press, 1964).
8. Bilby, personal communication with the author, 7 June 1993.
9. Ibid.
10. Richard Price, *Saramaka Social Structure* (Rio Piedras: Institute of Caribbean Studies, 1975), p. 56.
11. See Philip Dark, *Bush Negro Art* (New York: Aleo Tiranti, 1954), p. 34.
12. Bilby, personal communication with the author, 7 June 1993.
13. See H. U. E. Thoden van Velzen and W. van Wetering, *The Great Father and the Danger* (Leiden: KITLV Press, 1991), p. 45.
14. Roland Abiodun, personal communication with the author, summer 1993.
15. Pierre Verger, personal communication with the author, 1982.
16. See Maria Helena Farelli, *Ze Pilintra: O Rei da Malandragem* (Rio de Janeiro: Editora Catedra Ltda., 1987).
17. K. Kia Bunseki Fu-Kiau, personal communication with the author, summer 1988.
18. Thomas More, *Utopia*, 1965 (reprint ed. London: Penguin, 1982), p.119.

Bibliography

ABIMBOLA, WANDE
1975 *Yoruba Oral Tradition.* Ilé-Ifè: University of Ifè.

ABRAHAM, R. C.
1958 *Dictionary of Modern Yoruba.* London: at the University Press.

ABREU, NERYS GOMEZ
1982 *Estudio de la Casa Templo de Cultura Yoruba: El Ile-Ochatula.* In *Islas* 71.

AKINYEYE, OLU
1978 "Ogun—God of Iron." In *West Africa* (12 June).

ALVES NETO, TEIXEIRA
1990 *Pomba-Gira.* Burbank, Ca.: Technicians of the Sacred.

ANDERSSON, EFRAIM
1958 *Messianic Popular Movements in the Lower Congo.* Uppsala, Sweden: Studio Ethnographica Upsaliensia.

BABAYEMI, S. O.
1980 *Egúngún Among the Oyo Yoruba.* Ibadan: Board Publications Ltd.

BAHUCHET, SERGE AND GUY PHILLIPART DE FOY
1991 *Pygmées: Peuple de la forêt.* Paris: Editions Denoel.

BARNES, SANDRA T.
1980 *Ogun: An Old God for a New Age.* Philadelphia: ISHI.

BARNES, SANDRA T., ED.
1989 *Africa's Ogun: Old World and New.* Bloomington: Indiana University Press.

BASCOM, WILLIAM
1951 "The Yoruba in Cuba." In *Nigeria* 37.
1969 *Ifa Divination.* Bloomington: Indiana University Press.

BASTIDE, ROGER
1958 *Le Candomblé de Bahia (Rite Nago).* Paris: Mouton.

BELLOW, SAUL
1973 *Humboldt's Gift.* Reprint ed. New York: Avon, 1976.

BENOIT, P. J.
1839 *Journey through Suriname: Description of the Possessions of the Netherlands in Guiana. Adapted from Voyages à Surinam de P. J. Benoit.* Reprint ed. Zutphen: De Valburg Press, 1980.

BIRMAN, PATRICIA
1983 *O Que E Umbanda.* Sao Paulo: Editora Brasilense.

BROWN, DAVID H.
1989 "Garden in the Machine: Afro-Cuban Sacred Art and Performance in Urban New Jersey and New York," 2 vols. Unpublished Ph.D. thesis, Yale University, New Haven.

BROWN, DIANE DEG.
1986 *Umbanda: Religion and Politics in Urban Brazil.* Ann Arbor: UMI Research Press.

CABRERA, LYDIA
1954 *El Monte.* Havana: CR. Or fifth edition, 1983, Miami: Ultra Graphics Corporation.
1959 *La Sociedad Secreta Abakuá.* Havana: Ediciones CR.
1974 *Yemayá y Ochún.* Madrid: Forma Gráfica.
1979 *Reglas de Congo Palo Monte Mayombe.* Miami: Peninsular Printing, Inc.
1984 *Vocabulario Congo. El Bantu que se habla en Cuba.* Miami: Daytona Press.

CACCIATORE, OLGA GUDOLLE
1977 *Dicionario da Cultos Afro-Brasileiros.* Rio de Janeiro: Forense Universitária/SEEC-RJ.

CALABUIG, IGNAZIO M., O.S.M.
1978 *The Dedication of a Church and an Altar: A Theological Commentary.* Washington, D.C.: International Committee on English in the Liturgy.

CARPENTIER, ALEJO
1968 "Los Altares de la Caridad." In *Islas* 10(1).

CARYBÉ
1980 *Iconografia dos Deuses Africanos no Candomblé da Bahia.* Sao Paulo: Editora Raizes, Artes Graficas.

CAVALLI-SFORZA, LUIGI LUCA, ED.
1986 *African Pygmies.* New York: Academic Press.

CHAPPELL, T. J. H.
1974 "The Yoruba Cult of Twins in Historical Perspective." In *Africa* 144.

CHATILLON, MARCEL
1989 *Images de la Révolution aux Antilles.* Basse-Terre: Société d'Histoire de la Guadeloupe.

CHESI, GERT
1981 *Vodun: Africa's Secret Power.* Wörgl: Perlinger.

COLINA, CINO
1990 "La Regla de Palo Monte." In *Granma*, Havana (26 August).

COSSARD, GISELE BINON
1970 "Contribution a l'Étude des Candomblés au Brésil: Le Candomblé Angola." Doctorat de troisième cycle, Sorbonne, Paris.

CRENIN, MITCHELL AND LOUIS G. KEITH
1989 "The Yoruba Contributions to Our Understanding of the Twinning Process." In *The Journal of Reproductive Medicine* 34(6) (June).

DAPPER, OLFERT
1668 *Description de l'Afrique.* Reprint ed. Paris: Fondation Dapper, 1990.

DARK, PHILIP
1954 *Bush Negro Art.* New York: Aleo Tiranti.

DE GOEJE, C. H.
1908 *Verslag der Toemoekhoemak—expedite.* Leiden: Tijdschrift van het Koninklijk Nederlandsch Aardrijkskundg Ganootschap.

DE GROOT, SILVIA
1977 "Migratory Movements of the Djukas." In *Isolation Towards Integration.* The Hague: Martinus Nijhoff.

DE GRUNNE, BERNARD
1986 "Ancient Art of the Niger River: A Study of the Terra-Cotta Statuary from the Inland Niger in Mali." Unpublished Ph.D. thesis, Yale University, New Haven.

DEBRET, JEAN BAPTISTE
1834–39 *Voyage Pittoresque et Historique au Brésil.* Paris: Firmin Didot Freres.

DENNETT, R. E.
1887 *Seven Years among the Fjort.* London: Sampson Low, Marston, Searle, & Rivington.

DEWEY, JOHN
1980 *Art as Experience.* New York: G. P. Putnam.

DITTMER, K.
1961 *Die Sakralen Hauplinge der Gurunsi im Ober-Volta Gbiet.* Hamburg: Museum für Volkerkunde.

DOCHE, ANTOON AND JAN VOORHOEVE
1963 *De Saramakaanse Woordenschat.* Amsterdam: Bureau voor Taalonderzoek in Suriname van de Universiteit van Amsterdam.

DOS SANTOS, DEOSCOREDES
1967 *West African Sacred Art and Rituals in Brazil.* Ibadan: University of Ibadan, mimeographed ms.
1981 "O Culto dos Ancestrais na Bahia: O culto dos Egun." In *Oloorisa: Escritos sobre a religao dos orixas.* Sao Paulo: Agora.

DREWALL, HENRY
1989 "Ife: Origin of Art and Civilization." In Drewall, John Pemberton III, and Roland Abiodun, *Yoruba: Nine Centuries of African Art and Thought.* New York: The Center for African Art/Harry N. Abrams.

DREWALL, HENRY AND MARGARET
1978 "More Powerful Than Each Other: An Egbado Classification of Egúngún." In *African Arts* XI(3) (April).

DUARTE, ABELARDO
1974 *Catalogo Ilustratdo da Coleçao Perseverança.* Maceió: Departamento de Assuntos Culturaio da Secrataria de Cultura de Algoas.

DUPRÉ, MARIE-CLAUDE
1968 "Apropos d'un masque Teke de l'ouest Congo." In *Objets et Mondes* 8(4).
1979 "Apropos du masque Teke de la collection Barbier." In *Connaissance des arts tribaux: Bulletin du Musée Barbier-Muller* 2.

DUPRÉ, WILHELM
1970 *Religion in Primitive Cultures.* Paris: Mouton.

EDWARDS, GARY AND JOHN MASON
1987 *Onje Fún Orisa: Food for the Gods.* New York: Yoruba Theological Archministry. Second edition.

ELGEE, C. H.
1907–1908 "The Ife Stone Carvings." In *Journal of the Royal African Society* 7.

ELIADE, MIRCEA
1959 *The Sacred and the Profane.* New York: Harcourt, Brace, Jovanovich.

ELLISON, RALPH
1947 *Invisible Man.* New York: Random House, Inc.

FABUNMI, CHIEF M. A.
1969 *Ifè Shrines*. Ifè: University of Ifè Press.

FARELLI, MARIA HELENA
1987 *Ze Pilintra: O Rei da Malandragem*. Rio de Janeiro: Editora Catedra Ltda.

FERGUSON, LELAND
1992 *Uncommon Ground: Archaeology and Early African America 1650–1800*. Washington, D.C.: Smithsonian Institution Press.

FISHKIN, SHELLEY FISHER
1993 *Was Huck Black?*. New York: Mark Twain and Oxford University Press.

FORD, THEODORE
1939 *God Wills the Negro*. Chicago: Geographia Institute Press.

FREYRE, GILBERTO
1933 *The Masters and the Slaves*. Reprint ed. Berkeley: University of California Press, 1986.

FROBENIUS, LEO
1913 *The Voice of Africa*. Reprint ed. New York: Benjamin Blum, 1968.

GLEASON, JUDITH
1987 *Oya: In Praise of the Goddess*. Boston: Shambhala Publications.

GOICOCHEA, FELIX
1932 *Libreta de Santo*. Unpublished ms., Havana.

GONZALEZ HUGUET, LYDIA
1961 "Domestic Altars in Yoruba-Cuban Worship." In *Etnologia y Folklore* no. 5.

GRANGER, MARY
1940 *Drums and Shadows*. Athens, Georgia: University of Georgia Press.

GRAU, SHIRLEY ANN
1964 "Margaret." In *The Keepers of the House*. New York: Alfred A. Knopf.

GUÉBHARD, P.
1911 "*Notes sur la réligion, les moeurs, les coutumes des Bobo*." In *Revue d'Ethnographie et de Sociologie* no. 2.

GUNDAKER, GREY
1993 "African American History, Cosmology, and the Moral Universe of Edward Houston's Yard." Unpublished paper.
1993 "Tradition and Innovation in African American Yards." In *African Arts* XXVI(2) (April).

HANSMANN, LISELOTTE AND LENZ KRISS-RETTENBECK
1966 *Amulett und Talisman: Erscheinungsform und Geschichte*. Munich: Verlag Georg D. W. Callwey.

HEGEL, G. W. F.
1807 *The Phenomenology of Mind*. Reprint ed., with introduction by George Lichtheim, New York: Harper Colophon Books, 1967.

HEIDEGGER, MARTIN
1954 *What Is Called Thinking*. Reprint ed., New York: Harper & Row, 1968.

HERBERT, EUGENIA
1975 "Smallpox Inoculation in Africa." In *Journal of African History* XVI.

HERSKOVITS, MELVILLE J. AND FRANCES S.
1934 *Rebel Destiny*. York: The Maple Press Co.

HEWLETT, BARRY S.
1991 *Intimate Fathers: The Nature and Context of Aka Pygmy Paternal Infant Care*. Ann Arbor: The University of Michigan Press.

HOLLANDER, JOHN
1975 *Vision and Resonance*. New York: Oxford University Press.

HUNT, CARL M.
1979 *Oyotunji Village: The Yoruba Movement in America*. Washington, D.C.: University Press of America.

HURSTON, ZORA NEALE
1938 *Tell My Horse: Voodoo and Life in Haiti and Jamaica*. Reprint ed. New York: Harper & Row, 1990.

IDOWU, E. BOLAJI
1962 *Olodumare: God in Yoruba Belief*. London: Longman's.

IBIGBAMI, R. I.
1978 "Ogun Festival in Ire-Ekiti." In *Nigeria* no. 126–27.

JACOBS, HARRIET
1861 *Incidents in the Life of a Slave Girl*. Reprint ed. Miami: Mnemosyne Publishing Co., 1969.

JANZEN, JOHN
1982 *Lemba, 1650-1930. A Drum of Affliction in Africa and the New World*. New York: Garland Publishing, Inc.

JASPERS, KARL
1957 *Socrates, Buddha, Confucius, Jesus*. Reprint ed. New York: Harcourt, Brace, Jovanovich, 1990.

JOHNSON, JAMES WELDON
1930 *Black Manhattan*. New York: Da Capo Press, Inc.

JOHNSON, SAMUEL
1920 *The History of the Yorubas*. London: Routledge & Kegan.

KAHN, MORTON C.
1931 *Djuka: The Bush Negroes of Dutch Guiana*. New York: Viking Press.

KNOPS, P.
1980 *Les Anciens Senufo: 1923–1935*. Berg en Dal: Afrika Museum.

KOHLER, O.
1973 "Ritual Hunt among the Kxoe-San of Mutsiku." In Brigitte Steinfort and Margret Stobberg, eds., *Festschrift Zum 65. Geburtstag Von Helmut Petri*. Vienna: Bohlau Verlag.

KRÜGER, CHRISTOPH ET AL., EDS.
1969 *Sahara*. New York: G. P. Putnam's Sons.

LAMAN, KARL EDWARD
1936 *Dictionnaire Kikongo-Francais: M-Z*. Reprint ed. Hants: Gregg Press, 1964.
1962 *The Kongo*. Uppsala, Sweden: Studio Ethnographica Upsaliensia.

LAWAL, BABATUNDE
1970 *Yoruba Shangó Sculpture in Historical Retrospect*. Ann Arbor: University Microfilms.
1976 "The Significance of Yoruba Sculpture." Mimeographed paper read at the Conference on Yoruba Civilization, University of Ifè, Ilé-Ifè.
1989 "A Pair of *Ere Ibeji*." In *Kresge Art Museum Bulletin* IV.
1991 Paper delivered at College Art Association annual meeting, Washington, D.C.

LEE, RICHARD B.
1967 "Trance Cure of the !Kung Bushmen." In *Natural History* (November 1967).

LEE, RICHARD B. AND IRVEN DEVORE, EDS.
1976 *Kalahari Hunter-Gatherers: Studies of the !Kung, San, and Their Neighbors*. Cambridge: Harvard University Press.

LEON, ARGELIERS
1990 "*Paleros y Firmas Congas*." In *Unión* (Havana).

LEVINE, ROBERT A.
1966 *Dreams and Deeds: Achievement Motivation in Nigeria*. Chicago: at the University Press.

LEVTZION, NEHEMIA
1980 *Ancient Ghana and Mali*. New York: Africana Publishing Co.

LEWIS, J. LOWELL
1992 *Ring of Liberation*. Chicago: at the University Press.

LEWIS-WILLIAMS, J. D.
1990 *Discovering Southern African Art*. Johannesburg: David Philip.

LEWIS-WILLIAMS, J. D. AND T. A. DOWSON
1989 *Understanding Bushman Rock Art*. Johannesburg: Southern Book Publishers [Pty] Ltd.
1990 "Through the Veil: San Rock Paintings and the Rock Face." In *South African Archaeological Bulletin* 45.
1992 *Rock Paintings of the Natal Drakensberg*. Pietermaritzburg: University of Natal Press, Ukhalamba Series.

LOGAN, GEORGE C., THOMAS W. BODER, LYNN D. JONES, ET AL., WITH PRINCIPAL INVESTIGATOR DR. MARK P. LEONE
1992 *1991 Archaeological Excavations at the Charles Carroll House in Annapolis, Maryland*. College Park: University of Maryland.

LOPES, HELENA THEODORO
1985 "Umbanda and Other Religions of Bantu Origin in Rio de Janeiro." In *African Cultures: Proceedings of the Meeting of Experts on the Survival of African Religious Traditions in the Caribbean and in Latin America*. Sao Luis de Maranhao: UNESCO.

LOPEZ VALDEZ, RAFAEL L.
1985 *Componentes Africanos en el Etnos Cubano*. Havana: Editorial de Ciencias Sociales.

MALAQUAIS, DOMINIQUE
1984 "Towards an Understanding of the Afro-Atlantic Altar." Unpublished manuscript, Yale University.

MARSHALL, LORNA
1962 "Kung Bushman Religious Beliefs." In *Africa* 32(3).

1969 "The Medicine Dance of the !Kung Bushmen." In *Africa* 39(4).

MARTI, MONTSERRAT PALAU
1964 *Le Roi-Dieu au Benin.* Paris: Editions Berger-Levrault.

MARTIN, K.
1886 *Bijdragen tot de Taal-Land en Volkenkunde van Nederlandsch-Indie.* 'S Gravenhage: Martinus Nijhoff.

MASON, JOHN
1992 *Orin Orisa.* New York: Yoruba Theological Archministry.

MAUPOIL, BERNARD
1961 *La Géomancie à l'ancienne Côte des Esclaves.* Paris: Institut d'Ethnographie.

MCCLOSKY, PAMELA
1984 *Praise Poems: The Katherine White Collection.* Seattle: The Seattle Art Museum.

MCGAFFEY, WYATT
1986 *Religion and Society in Central Africa. The Bakongo of Lower Zaire.* Chicago: at the University Press.
1991 *Art and Healing of the Bakongo Commented by Themselves: Minkisi from the Laman Collection.* Stockholm: Folkensmuseum Etnografiska.
1993 *Astonishment and Power. The Eyes of Understanding: Kongo Minkisi.* Washington, D.C.: The National Museum of African Art, Smithsonian Institution.

MCINTOSH, SUSAN AND RODERICK
1982 "Finding West Africa's Oldest City." In *National Geographic* 162(3) (September).

MCLEOD, MALCOLM D.
1981 *The Asante.* London: British Museum Publications, Ltd.

MERCIER, P.
1954 *African Worlds.* London: Oxford University Press.

MEYEROWITZ, EVA L. R.
1958 *The Akan of Ghana: Their Ancient Beliefs.* London: Faber and Faber Ltd.

MOLINA, N. A.
n.d. *Na Gira dos Exu.* Rio de Janeiro: Editora Espiritualista Ltda.

MONTEIL, CHARLES
1903 *Djénné Société Metropole du Delta Central du Niger.* Reprint ed. Paris: Société d'Éditions Géographiques, 1932.

MORE, THOMAS
1965 *Utopia.* Reprint ed., London: Penguin, 1982.

MORRISON, TONI
1977 *Song of Solomon.* New York: Signet.

MOTHERWELL, ROBERT
1944 "The Modern Painter's World." In *The Collected Writings of Robert Motherwell.* New York: Oxford University Press, 1992.

MURDOCK, GEORGE PETER
1959 *Africa: Its Peoples and Their Culture History.* New York: McGraw-Hill.

MURPHY, JOSEPH M.
1981 "Ritual Systems in Cuban Santeria." Unpublished Ph.D. thesis, Temple University, Philadelphia.

NSUKA, YVON
1970 "Une Prière d'Invocation Kongo." In *Cahiers des Religions Africaines* (July).

ODUDOYE, MODUPE
1971 *The Vocabulary of Yoruba Religious Discourse.* Ibadan: Daystar Press.

OED
1973 *The Shorter Oxford English Dictionary,* prepared by William Little, H. W. Fowler, and Jessie Coulso, Third Edition. Oxford: Clarendon Press.

OGUNFOWORA, A. O.
1988 "Space Concepts and Architecture of Yoruba Shrines." Unpublished paper submitted to the Department of Architecture, University of Ifè, Ilé-Ifè.

OJO, JEROME O.
1976 "Yoruba Customs from Ondo." In *Acta Ethnologica et Linguistica* no. 37.

OMARI, MIKELLE SMITH
1989 "The Role of the Gods in Afro-Brazilian Ancestral Ritual." In *African Arts* 23(1) (January).

ORTIZ, FERNANDO
1906 *Hampa Afro-Cubana: Los Negros Brujos.* Madrid: Editorial America.

PARRINDER, G.
1961 *West African Religion.* London: Epworth Press.

PEMBERTON III, JOHN
1975 "Eshu-Elegba: The Yoruba Trickster God." In *African Arts* 9(1) (October).
1977 "A Cluster of Sacred Symbols: Orisa Worship Among the Igbomina Yoruba of Ila-Orangun." In *History of Religions* 17(1) (August).

PINHO, VALDINA
1985 *"O M'kisi Teempu: Festa de Teempu no Tanuri Junçara."* In *Seminario "Reflexao sobre a Atualidad da Cultura Afro-Braziliera",* a pamphlet published in Salvador (August).

PRICE, RICHARD
1975 *Saramaka Social Structure.* Rio Piedras: Institute of Caribbean Studies
1976 *The Guiana Maroons: A Historical and Bibliographic Introduction.* Baltimore: The Johns Hopkins University Press.
1979 *Maroon Societies: Rebel Slave Communities in the Americas* (second edition). Baltimore: The Johns Hopkins University Press.
1983 *First-Time: The Historical Vision of an Afro-American People.* Baltimore: The Johns Hopkins University Press.
1983 *To Slay the Hydra. Dutch Colonial Perspectives on the Saramaka Wars.* Ann Arbor: Karoma Publishers Inc.
1990 *Alabi's World.* Baltimore: The Johns Hopkins University Press.

PRICE, RICHARD AND SALLY
1991 *Two Evenings in Saramaka.* Chicago: at the University Press.

PRICE, SALLY
1984 *Co-Wives and Calabashes.* Ann Arbor: The University of Michigan Press, 1984.

PRINCE, RAYMOND
1974 "The Problem of Spirit Possession as a Treatment for Psychiatric Disorders." *Ethos* 2(4).

PRUSSIN, LABELLE
1973 "The Architecture of Djenné: African Synthesis and Transformation." Unpublished Ph.D. thesis, Yale University, New Haven.
1986 *Hatumere: Islamic Design in West Africa.* Berkeley: University of California Press.

PUCKETT, NEWBELL NILES
1926 *Folk Beliefs of the Southern Negro.* Chapel Hill: University of North Carolina Press.

RABOTEAU, ALBERT
1978 *Slave Religion.* New York: Oxford University Press.

RADIN, PAUL
1945 *God Struck Me Dead: Religious Conversion Experiences and Autobiographies of Ex-Slaves.* Nashville: Fisk University.

RATTRAY, R. S.
1927 *Religion and Art in Ashanti.* Oxford: Clarendon Press.

REISMAN, KARL
1983 "Review." In *Journal of African Languages and Linguistics* 5.

RIBEIRO, CARMEM
1983 *"Religiosidade do Indio Brasileiro no Candomblé da Bahia."* *Afro-Asia* no. 14.

ROBERTS, ALLEN
1986 "Social and Historical Contexts of Tabwa Art." In *Tabwa, The Rising of a New Moon: A Century of Tabwa Art.* Ann Arbor: University of Michigan Museum of Art.

RULE, SHEILA
1992 "Folklorist Offers Insight into Cultural Connections." *The New York Times* (4 July).

SALAMI, SIKIRU
1991 *Canticos dos Orixas na Africa.* Sao Paulo: Editora Oduduwa

SALIEGE, J. F., ET AL.
1980 "Première datation de tumulus préislamiques du Mali: site megalithique de Tondiarou." In *Compts Rendres de L'Académie Scientifique de Paris,* series D, vol. 291 (December).

SARNO, LOUIS
1993 *Song from the Forest: My Life among the Ba-Bnjelle Pygmies.* Boston: Houghton Mifflin Co.

SAXON, LYLE ET AL.
1945 *Gumbo Yaya.* New York: Bonanza Books.

SCHILTZ, MARC
1978 "Egungun Masquerades in Iganna." In *African Arts* 11(3):48-55, 100.

SOWANDE, OLOYE FELA AND OLOYE FAGBEMI AJANAKU
1969 *Oruko Amutorunwa.* Ibadan: Oxford University Press.

STEDMAN, JOHN GABRIEL
1790 *Narrative of a Five Years Expedition against the Revolted Negroes of Surinam.* Reprint ed. Baltimore: Johns Hopkins University Press, 1988.

STEIN, STANLEY J.
1970 *Vassouras.* New York: Atheneum.

STEVENS, WALLACE
1971 *The Palm at the End of the Mind.* New York: Vintage.

STUCKEY, STERLING
1987 *Slave Culture: Nationalist Theory and the Foundations of Black America.* New York: Oxford University Press.

SZWED, JOHN
1992 "Vibrational Affinities." In *The Migrations of Meaning.* New York: Intar Gallery.

TAVARES, ODORICO
1967 *Bahia: Imagens da Terra e do Povo.* Rio de Janeiro: Technoprint Grafica.

TELES DOS SANTOS, JOCELIO
1989 "*O caboclo no candomblé.*" In *Pade* I (June).

THIEME, DARIUS
1969 *A Descriptive Catalogue of Yoruba Musical Instruments.* Ann Arbor: University Microfilms.

THODEN VAN VELZEN, H. U. E. AND W. VAN WETERING
1991 *The Great Father and the Danger.* Leiden: KITLV Press.

THOMPSON, ROBERT FARRIS
1970 "The Sign of the Divine King." I *African Arts* 3.
1971 *Black Gods and Kings.* Los Angeles: UCLA Museum of Ethnic Arts.
1981 *The Four Moments of the Sun.* New Haven: Eastern Press, Inc.
1984 *Flash of the Spirit.* New York: Vintage.
1989 "The Song That Named the Land." In Robert V. Rozelle, Alvia Wardlaw, and Maureen A. McKenna, eds., *Black Art: Ancestral Legacy.* Dallas: Dallas Museum of Art.
1993 "Divine Countenance: Art and Altars of the Black Atlantic World." In Phyllis Galembo, *Divine Inspiration.* Albuquerque: University of New Mexico Press.

THOMPSON, ROBERT FARRIS AND SERGE BAHUCHET
1991 *Pygmées?.* Paris: Dapper Museum.

THORNTON, JOHN
1992 *Africa and Africans in the Making of the Atlantic World, 1400–1680.* Cambridge: at the University Press.

TOWNSEND, RICHARD FRASER
1979 *State and Cosmos in the Art of Tenochtitlan.* In *Studies in Pre-Columbian Art and Archaeology* no. 10.

TURNBULL, COLIN M.
1960 "The *Molimo:* A Men's Religious Association among the Ituri BaMbuti." In *Zaire* 14(4).
1961 *The Forest People: Studies of the People of the Congo.* New York: Simon & Schuster/Touchstone.
1965 "The Mbuti Pygmies: An Ethnographic Survey." In *Anthropological Papers of the American Museum of Natural History* 50(3).

TWAIN, MARK
1884 *The Adventures of Huckleberry Finn.* Reprint ed. New York: Simon and Schuster, Inc., 1973.

VAN WING, JOSEPH
1930 "Bakongo Incantations and Prayers." In *Journal of the Royal Anthropology Institute* LX.

VANDERCOOK, JOHN WOMACK
1926 *Tom-Tom.* New York: Harper & Brothers.

VERGER, PIERRE
1954 *Dieux d'Afrique.* Paris: Paul Hartmann.
1957 *Notes sur le Culte des Orisa et Vodun à Bahia, la Baie de Tous les Saints au Brésil, et à l'Ancienne Côte des Esclaves en Afrique.* Dakar: IFAN.
1968 *Flux et Réflux de la traite des Nègres entre le Golfe de Bénin et Bahia de Todos os Santos.* Paris: Mouton.
1981 *Légendes des Orichas.* Salvador: Editora Corrupio.
1981 *Oxossi, O Cacador.* Salvador: Editora Corrupio.
1982 *Orisha: Les Dieux Yorouba en Afrique et au Nouveau Monde.* Paris: Editions Métailié.

VINNICOMBE, PATRICIA
1975 "The Ritual Significance of Eland (*Taurotragus oryx*) in the Rock Art of Southern Africa." In *Valcamonica Symposium '72: Actes du Symposium Internationale sur les Réligions de la Préhistoire.* Capodiponte: ed. del Centro.

WESCOTT, JOAN
1962 "The Sculpture and Myths of Eshu-Elegba, the Yoruba Trickster: Definition and Interpretation in Yoruba Iconography." In *Africa* XXXII(4) (October).

WILLETT, FRANK
1971 *African Art.* New York: Praeger.

WOLFF, NORMA
1982 "Egungun Costuming in Abeokuta." In *African Arts* 15(3) (May).

YELLEN, JOHN E. AND RICHARD B. LEE
1976 "The Dobe-/Duda/da Environment." In Richard B. Lee and Irven DeVore, eds., *Kalahari Hunter-Gatherers: Studies of the !Kung, San, and Their Neighbors.* Cambridge: Harvard University Press.

ZAHAN, DOMINIQUE
1960 *Sociétés d'initiation bambara.* Paris: Mouton.

Index

333